DOUBLE EXPOSURE

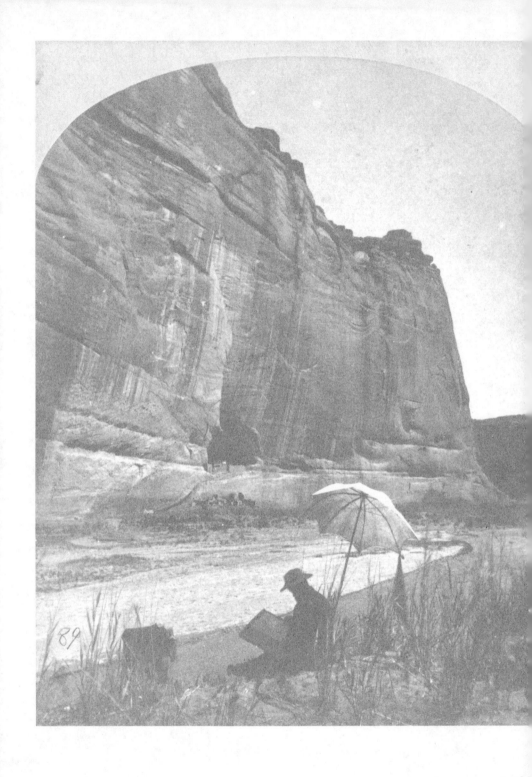

DOUBLE EXPOSURE

Resurveying the West with
TIMOTHY O'SULLIVAN,
America's Most Mysterious War Photographer

ROBERT SULLIVAN

FARRAR, STRAUS AND GIROUX NEW YORK

3333333

333

Farrar, Straus and Giroux
120 Broadway, New York 10271

Copyright © 2024 by Robert Sullivan
All rights reserved
Printed in the United States of America
First edition, 2024

Grateful acknowledgment is made for permission to reprint lines from "Home" by Paula Meehan, from *As If by Magic: Selected Poems* (Wake Forest University Press, 2021).

Unless otherwise noted, all photographs are by Timothy O'Sullivan from the Library of Congress or the National Archives. All maps were drawn by the author.

Library of Congress Control Number: 2023045716
ISBN: 978-0-374-15116-4

Our books may be purchased in bulk for promotional, educational, or business use. Please contact your local bookseller or the Macmillan Corporate and Premium Sales Department at 1-800-221-7945, extension 5442, or by email at MacmillanSpecialMarkets@macmillan.com.

www.fsgbooks.com
Follow us on social media at @fsgbooks

1 3 5 7 9 10 8 6 4 2

On the title page: *Distant View of Ancient Ruins in lower part of Cañon de Chelle, N.M. Showing their position in the walls and elevations above the cañon.*

For Suzanne

During our late war we had photographic representations of battle-fields, which are now valuable as historical material, both for present and for future use . . . The veteran artillerists who manned the battery from which the views were made wisely sought refuge in the bomb-proofs to secure themselves from the heavy shellfire which was opened upon their fortification; but the photographer stuck to his work, and the pictures made on that memorable occasion are among the most interesting of the war. Many of the best photographs of events that occurred during the war were made by the adventurous artist who now furnishes pictures of scenes among the High Rockies, and narrates the adventures incident of the long journey during which the photographs were made.

—from "Photographs from the High Rockies," by John Samson, in *Harper's New Monthly Magazine*, September 1869

I was delighted to ride thus alone, and expose myself, as one uncovers a sensitized photographic plate, to be influenced . . . No tongue can tell the relief to simply withdraw scientific observation, and let Nature impress you in the dear old way with all her mystery and glory, with those vague indescribable emotions which tremble between wonder and sympathy.

—Clarence King, *Mountaineering in the Sierra Nevada*, 1872

What ideas might O'Sullivan's photographs be reflecting back to us from the nineteenth century? That's the question I want to raise here, and I think that answering it ultimately requires a certain willingness to speculate, an imaginative leap beyond the limits to which sound historical research can carry us. The fact is that no amount of scholarly legwork is ever going to track down the origins of O'Sullivan's pictures.

—Colin Westerbeck Jr., *Artforum*, 1982

To remember a battle in which he has taken part, a man must make himself innocent again—innocent of newspapers, books and movies. He must remember his actual life, the life of the body. Everything else is journalism.

—Louis Simpson, in a remembrance of the Battle of the Bulge, *North of Jamaica*, 1972

Contents

PART I

FISSURE

How I came to study the western landscape photography of Timothy O'Sullivan, the unknown photographer who made the most famous pictures of the Civil War.

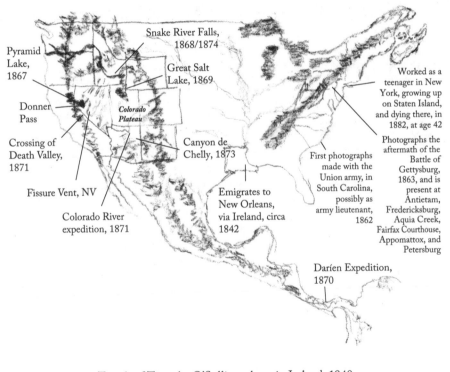

Snake River Falls, 1868/1874

Pyramid Lake, 1867

Great Salt Lake, 1869

Donner Pass

Colorado Plateau

Worked as a teenager in New York, growing up on Staten Island, and dying there, in 1882, at age 42

Crossing of Death Valley, 1871

Canyon de Chelly, 1873

Photographs the aftermath of the Battle of Gettysburg, 1863, and is present at Antietam, Fredericksburg, Aquia Creek, Fairfax Courthouse, Appomattox, and Petersburg

Fissure Vent, NV

First photographs made with the Union army, in South Carolina, possibly as army lieutenant, 1862

Colorado River expedition, 1871

Emigrates to New Orleans, via Ireland, circa 1842

Daríen Expedition, 1870

Travels of Timothy O'Sullivan, born in Ireland, 1840; died on Staten Island, NY, 1882

1

Fissure Vent at Steamboat Springs, Nevada, 1867

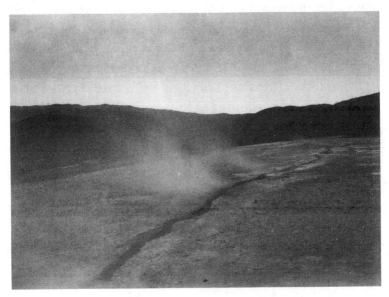

(Metropolitan Museum of Art)

This is an image of a fumarole, an opening in the crust of the earth that emits steam and volcanic gas, and it was made in 1867, in what was then the three-year-old state of Nevada, where the photographer set up his camera in a small, dry basin that is still today an area of significant geothermal activity. It is an in-between place, or feels like it: the Sierra Nevada mountains rise a few miles to the east, and the hills of the Virginia Range are to the west and even closer. At the very moment this photographic plate was exposed, the Virginia Range was being hollowed out for copper: regiments of men were digging through cave-ins and explosions, mining bigger and bigger cavities in the earth. None of this activity is captured by *Fissure Vent*, as the image is titled, nor is the molten rock that lies a thousand feet down, propelling steam

up through crystalline cracks in the earth so fast as to cause the ground itself to rumble, an enginelike sound that, in the 1860s, earned the fumarole a nickname, Steamboat Springs.

Also not pictured is the nearby resort, built to exploit the adjacent hot springs. The springs were well-known to the Northern Paiute and Washoe peoples, who, after pointing them out to settlers, were themselves now being monitored by white militias and by U.S. soldiers at nearby forts. If this picture seems to have less to say about resorts and leisure and more about violence, if it resembles a rift or a scar or even a wound, note that the man who made it had recently arrived in Nevada as an employee of the U.S. Army. Note, too, that from 1861 through 1865 he had served as a photographer alongside the Union army, following the troops as they fought against the Confederate soldiers in the eastern United States. For the army he photographed maps and views of potential battle sites, and for publishers he photographed soldiers and battlefields and dead bodies. His pictures alternately depict the mundane and the horrifying, and together they make up what are today the most widely known images of the war. The photographer's name was Timothy O'Sullivan.

To make this image of the fumarole, O'Sullivan used a camera that looked less like what we think of today as a picture-making device—a camera or a smartphone—and more like a large, lightproof wooden box, the size of an old TV set or a mini fridge, the front punctuated by a heavy brass lens, the polished glass protruding like a cross between a nose and an eye. Inside the box, in the darkness of its lightproof interior, a rectangular plate of glass waited like an empty movie screen for the light that would be focused through the lens—in this instance, light reflecting off a jagged valley floor in the winter of 1867.

If you've ever looked up at the beam of light from a movie projector or noticed a sunrise flashing on a bedroom wall, you know that light is alive, or appears to be. In order to capture the light of that very day and then to hold on to it—to construct, in other words, an image using that 1867 Nevada winter light—O'Sullivan covered his photographic plates with collodion, a nearly clear, syrupy liquid that was then further treated with a solution of light-sensitive silver nitrate. The method was (and still is) referred to as the wet plate collodion process. Collodion was employed in various other capacities around the time of the Civil War. It was used as a liquid bandage—when smeared on broken skin

and allowed to dry, it patched up cuts and lacerations. The essential ingredient in collodion is nitrocellulose, also known as guncotton, which was made by treating cotton with sulfuric and nitric acids. Guncotton was an explosive, used to power some of the artillery shells that cratered the battlefields O'Sullivan photographed. My point being that the same materials that offer us a view of this fumarole in the aftermath of what is referred to today as the Civil War were key ingredients in that very war: the cotton picked by enslaved people on Southern plantations and the silver extracted from mines blasted out of Indigenous lands. When O'Sullivan removed the lens cover, the ingredients were, by a timed-out entrance of light, exposed.

To the West

Timothy O'Sullivan is America's most famous war photographer, a man whose photographs you most likely know even if you don't know his name. In 1867, when he made this image of the fumarole, O'Sullivan had just arrived in the Great Basin to begin documenting a journey across an expanse of land that would, when he finished almost eight years later, total millions of acres. It was an arduous campaign, sending him through landscapes that are today part of Wyoming, Utah, Nevada, Arizona, New Mexico, Idaho, and California, regions that are more broadly described as the Great Basin, the Colorado Plateau, and the southern Great Plains. He did this work on behalf of two different commanders, one a civilian, one an army officer, but on both occasions under contract with the U.S. Army, for which he had worked over the course of the Civil War, making plates very much like this one—sharp, practical, and wondrously and often preternaturally straightforward.

Or perhaps not so straightforward. If you are like me and your eyes focus slowly on the picture of the fissure at Steamboat Creek, it might take you a moment to see the half-hidden man standing behind the steam. That figure might be O'Sullivan, though more likely it is a packer that the survey assigned to help him load and unload the plates and chemicals and cameras from a mule or the back of a wagon. But these are the sorts of uncertainties you encounter when you follow O'Sullivan. How you see that mist-shrouded figure, or whether you see him at all, might say something about you or about how you see the West. For my

own part, I see it as a self-portrait by O'Sullivan, or a portrait of a photographer who is not yet done photographing the war.

When O'Sullivan began his camera work in 1861, primarily while following the Army of the Potomac, he was at the outset of four years of making glass plate negatives in and around battlefields. He first photographed coastal South Carolina, immediately following the Confederate attack on Fort Sumter, the opening shots of the war. He then made hundreds and hundreds of wet plate negatives, all across the corpse-strewn woods and pastures of Virginia, Maryland, and Pennsylvania, where cities and towns are connected and separated by the various smaller ranges that make up the Appalachian Mountains. Toward the end of the conflict, he photographed the ravaged environs of Richmond, Virginia, the capital of the Confederate States of America, vistas of battlements and bombproof shelters, men living, after months of siege, like rats burrowed into a field. After working for Mathew Brady, the renowned New York–based photographer, O'Sullivan assisted Alexander Gardner, who had photographed Lincoln at the White House. In the spring of 1865, for one of his very last wartime pictures, he photographed the site where General Robert E. Lee surrendered his army, at the Appomattox Court House in Virginia's Piedmont plateau. Shortly thereafter, he worked with Gardner to photograph the execution of Lincoln's assassins and—it is rumored, though the photo has never been found—of Lincoln's corpse.

An image he took approximately halfway through the war is perhaps his most famous, still in wide circulation today in textbooks and magazines and on websites, then as now almost always presented as a symbol of the war. It shows the Gettysburg battlefield littered with corpses, the dead seeming maybe still alive, the living looking on at a distance through a palpable mist, appearing to be, like the mist-shrouded man in O'Sullivan's picture of the Nevada fumarole, apparitions. This picture is titled *A Harvest of Death*.

In considering O'Sullivan's pictures, it's important to keep in mind the role of photographs in the 1860s. They were praised for a kind of accuracy that eluded artists, extolled alternatively as technical achievements and acts of magic. Newspapers would eventually print photos through various photomechanical processes, but at first they printed etchings based on photographs brought back from a scene. Meanwhile,

photographic prints were popular consumer items in the 1860s, collected in various forms and very often viewed at home, as entertainment. As a war photographer, O'Sullivan was making pictures at the dawn of what would become a photo-saturated and then photo-obsessed culture, proof of which is in your camera, which is also armed with a phone and a personal computer and a tracking device of sorts, surveying you. For several months after he made his last war photos at Appomattox, O'Sullivan's pictures were printed by the thousands as cartes de visite or as stereographs, the latter viewed in handheld stereo viewers—precursors to the virtual reality headsets of today—often sold door-to-door by college students working for their tuition. "The Stereoscope is now seen in every street, it is found in almost every drawing-room; philosophers talk learnedly upon it, ladies are delighted with its magic representation, and children play with it," *The Art Journal* reported in 1856.

To make these prints, glass photographic plates were laid down on paper treated first with albumen, a paste made primarily from egg whites, next with silver nitrate; light, typically through a photography studio's glass ceiling, slowly burned an image into the paper, which was then treated with a solution of sodium thiosulfate, to fix the exposure, and sometimes toned with selenium or gold. Undoubtedly, prints made from O'Sullivan's glass plate images were for sale wherever he could sell them, depending on who owned the plates he made and depending on his rights to print them, if he held any of those rights. Often he was paid by the print, a few cents for each, or sometimes not paid at all.

After Appomattox, O'Sullivan bounced between addresses until the spring of 1867, when he packed up some box cameras, a stereo camera, several lenses, and various supplies and headed west, to the territories the United States had only just begun to incorporate prior to the Civil War. In 1867 the land west of the Mississippi was, for the most part, a national project that the internecine military conflict had put on hold, and the war had been fought in part over the West and its future, the brutal details of how slavery and land inhabited by Native Americans would be handled as the country expanded. After years of surveying potential routes, workers had begun building the transcontinental railroad in 1862, but construction slowed when the Confederates fired on Fort Sumter. Now, O'Sullivan's first job in the West was to make the photographs that would accompany the publication of a great scientific

survey of the Great Basin. It would also describe the region in terms of business opportunities, highlighting potential coal deposits and the profitability of silver mining in the very territories that two state-sponsored corporations—the Central Pacific Railroad and the Union Pacific Railroad—were only a few months away from linking by rail.

Exciting serenity

Today you can see a print of O'Sullivan's picture of the fumarole at Steamboat Springs, Nevada, in the Library of Congress or online on their website. You can see a print at the National Archives, as well as in the collections of various museums. The Metropolitan Museum of Art attributes what it calls "the picture's mystery" to how little we know of the plate's provenance. "For some of the most mesmerizing photographs made for ostensibly documentary purposes, we have only clues to elucidate the original intention," the museum writes. The catalog then goes on to hypothesize. Hypothesizing, I have noticed over the years, is an almost inevitable result when you are considering O'Sullivan or his photography or any combination of the two:

> Surely the shadowy figure is on the edge of an abyss, but whether he is to be swallowed up by it or has just risen from it is unclear. Maybe the point is his very ambiguity in the infernal, Dantean space. Or perhaps he is the anchor in a depiction of an amorphous geological event—the familiar entity by which all things are measured, including the density of vapor and the passage of time.

Like the Metropolitan Museum, I have some ideas about the thinking that went into making this photo, many of them biased by the fact that I have spent my life living as a freelance, as did O'Sullivan, a cameraman whose work was almost always at the bidding of his various survey bosses—hired and fired at will, working or not working at the pleasure of a scientist or a commanding military officer or publishers back in New York. I have other ideas, too, all more biased, I suppose, by other aspects of my personal history as well as by years of writing about the American landscape in the West and the East: driving through it,

studying it, working things out for the sake of assignments or survival in storms or tired cars, or some combination of these things—always trying to understand what I can see and, more important, what I cannot.

My first guess is that if O'Sullivan was working to make a point while making the picture at Steamboat Springs, that point probably had less to do with the Dantean space and more to do with trying to earn a living, which can be Dantean in itself. He had to sell the picture, either to his boss at the time (a geologist who thought of himself as an artist and was thus interested in the Dantean) or to the photography publishers back in New York, who were generally interested in what could be called spectacle, something this fumarole image broadcasts in abundance. Ideally, he would sell it to both—if, that is, he could manage to secure the right to use it himself, to print again from the plate, which, thanks to the process, allowed infinite reprinting.

I'm not saying that highlighting the infernal wasn't part of his thinking; it would have been had his bosses wanted it to be, as they very well might have. I'm arguing that selling photos any way he could was part of O'Sullivan's training, that marketing his pictures was part of his genetic makeup as a photographer in post–Civil War America, trying to make a living as a photographer in a world full of photographers taking pictures of many of the very same places and things.

Yet I am far from alone in noticing that, in comparison with the small but renowned group of a dozen or so photographers working at the same time and selling to the same markets and the same government survey directors, O'Sullivan's work is different. Modern critics and photographers alike have described something striking, something that is being said but is just beneath the surface.

"His photographs are singular when compared with the work of other western photographers of the period," writes Joel Snyder, a photographer and critic. For Snyder, O'Sullivan's photos are at odds with the work of such late nineteenth-century contemporaries as Carleton Watkins, whose mammoth plate photos of Yosemite celebrate what might be called the romantic beauty of a valley that he depicted as empty and primeval. Not coincidentally, Watkins's photos prompted Congress to declare Yosemite the first national park. O'Sullivan's photos, by contrast, don't appear to romanticize the western landscape; no one opened a national park after he made a picture, though I have a

theory about what happened after he made his pictures, a theory that I hope to explain. As with a park, my theory has to do with cordoning off land. Often O'Sullivan's photos seem to do the opposite of romanticizing the landscape. "They repeatedly deny what Watkins's photographs characteristically confirm, namely, the possibility of comfortable habitation, of an agreeable relation of humans to the natural landscape," Snyder writes. "They portray a bleak, inhospitable land, a godforsaken, anesthetizing landscape."

Robert Adams, an East Coast–born photographer who has photographed extensively in the western United States over the past few decades, has cited his admiration for O'Sullivan's photos above all the other post–Civil War survey photographers. He has equated them with poetry, concerned primarily with what's not there. "O'Sullivan's goal," Adams wrote, "seems to have been, as Cézanne phrased it, 'exciting serenity.'"

But over and over, if you are looking for O'Sullivan's intentions, you realize that it's all guesswork—his intentions concerning his photographs, his intentions concerning anything. "The fact is," wrote Colin Westerbeck in *Artforum* in 1982, "that no amount of scholarly legwork is ever going to track down the origins of O'Sullivan's pictures."

The length of exposure

The only things that can be said with certainty about O'Sullivan's photographs concern how they were made. The wet plate process was cumbersome, especially in the field, a term that in this case doesn't accurately represent a cold, windswept desert valley where steam billows from the bowels of the earth. After lugging his camera to the fissure, after choices about a lens and the opening therein (the so-called aperture), after carefully framing the image to his liking—in this case, adjusting the wooden legs of his tripod and tilting the lens a few degrees to the left in order to align the steam vent and the human figure behind it—O'Sullivan then prepared his plate, slowly pouring collodion on an eight-by-ten-inch rectangle of glass. Pouring collodion in this way is known as "flowing the plate," and when done expertly, the procedure resembles a waiter carefully balancing a drink on a very small tray or, more precisely, using one hand to slowly pour a drink onto the tray that he holds with the

other, the tray in this case being a pane of glass. The first time I saw someone do it, it looked like a carefully executed mistake: a faint layer of collodion coated the glass, a perfect sheen, the excess slowly poured back into a jar.

After flowing the plate, O'Sullivan would have hurried to a small portable darkroom, racing to complete the next step in the process before the collodion dried or evaporated. The darkroom was a stand-up tent or a tent-covered desk, a workroom-for-one perched on a tripod. Inside, he carefully poured a solution of silver nitrate onto the collodion-covered plate, sealing it up in a slim, lighttight wooden holder, something like a boxed-up picture frame. He would have put that holder inside the camera, fixing it opposite the lens. Carefully, while the plate was still inside the camera, he would have removed the metal front of the wet plate holder. Now the prepared plate was poised for exposure—in the case of Steamboat Springs, waiting to be exposed by the light of this geothermal hot spot that straddles the towering Sierras and the undulating expanse of arid peaks and alkaline valleys that comprise what geologists call the Basin and Range.

Finally, with everything in place, O'Sullivan removed the cap covering the camera's lens—and waited as the film was exposed. He waited anywhere from a few seconds to a few minutes, depending on how cloudy a day it was or how bright, depending on how much sky was in the scene as he framed it, how dark the nearby rocks or shady a canyon. He might have used a stopwatch, or he might have simply estimated, given his experience as a veteran of thousands of plates made in the field during the preceding military conflict that was, in 1867, not yet called the Civil War. He began photographing battle scenes when he was only twenty, his pictures sent back to galleries for hurried viewings or reproduced as etchings in newspapers and magazines eager to exploit images of the war. Every detail was considered; it had to be for a wet plate photographer, and O'Sullivan used angles and light, time and chemistry to make photographs that were not like what other photographers made, pictures that seemed to be seeing things in the western landscape, things other people didn't see.

In some ways, determining the length of exposure is a cold calculation, a mere measure of the amount of light available. Then again, if you think of the world as a place vibrating with varying degrees of intensity,

you can imagine the time he waited as dependent on the intensity of
the world at that moment and in that place. Either way, we know that
in a matter of minutes in the winter of 1867, the light that reflected off
this rumbling volcanic fissure entered the camera; that the light then
touched the silver solution coating the wet glass plate; that the light re-
acted with the silver; and, when the plate was exposed just long enough,
that the photographer covered the lens again, to cut off the light and
seal up the wooden box in hopes of avoiding an overexposure, in which
case the light would strip away details or even wash the scene away.

At this point, with the plate exposed, O'Sullivan had to hurry, or
hurry yet again, the tortured technical logistics allowing only a few
minutes to work. Thus, he quickly slid the rectangular metal sheet back
into the glass plate holder, still attached to the back of the camera. Once
the plateholder was resealed, he removed it from the back of the camera
and went quickly back to his standing darkroom. In this instance, the
darkroom was set up alongside the mule-drawn wagon that he used to
carry supplies, a converted U.S. Army field ambulance, the same kind

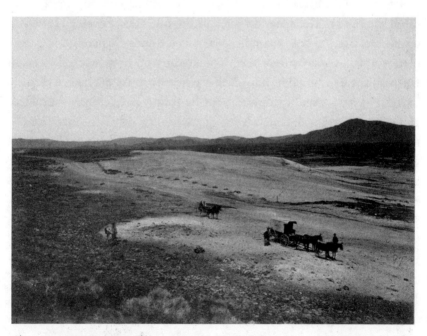

Steamboat Springs, Washoe, Nevada, 1867 (left to right: portable standing
darkroom, mules and men, mule-drawn ambulance turned darkroom)

that, during the war, treated casualties on the battlefield. His wagon is seen in the photograph on the facing page, made from another vantage on the same outing, a behind-the-scenes look that in its flatness emphasizes the work he did to make *Fissure Vent at Steamboat Springs.*

At last, the camera operator (as he would have been referred to in 1867) developed his photograph, alone in the dark inside that standing tent. A small amount of light came in through a tiny colored lens in the canvas tent's high corner, dimly illuminating his hands and the trays of liquids and the plate—allowing him, most importantly, to see the solution on that plate change from a rectangle of cloudy nothing into a warm, alive-seeming impression of a fumarole. In those seconds, the picture would have appeared lit like clouds by a moon, developing slowly, as if out of nowhere: clear water that suddenly rippled with gray streaks and white streams, a plate-size dream appearing and sharpening. The first time you see a wet collodion plate develop, and very often thereafter, the process seems like magic, or like ghosts materializing— what in fact seems to be happening not only in many of the photographs O'Sullivan made during the Civil War but also in this picture of a fumarole.

The image would continue to develop, and even develop away, if it weren't (to use the photographer's technical phrase) fixed. Fixing the plate halts the chemical process. Most likely, O'Sullivan fixed this plate with potassium cyanide, cyanide being a solution at the time also employed in gold mining, assassinations, and suicides. After the cyanide, and before painting the plate with clear varnish, he washed it with water to completely shut down any remaining chemical reactions. Water was also transported in O'Sullivan's ambulance, though precisely where he collected the water necessary to make this image can't be said for certain. Very little about this photograph can be said for certain. Very little can be said about O'Sullivan, for that matter, even though he made hundreds of the most enduring visual touchstones in the history of the United States of America, by now long fixed in the national memory book.

Perhaps water was carried to the site in jugs through the often water-scarce conditions of the Great Basin, or perhaps drawn from the nearby stream, called Steamboat Creek. Steamboat Creek drains Washoe Lake and, like nearby Lake Tahoe, its waters flow into the Truckee River,

ending up at Pyramid Lake, from where it goes nowhere. The Truckee goes nowhere; lakes in this part of the country are within what hydrologists refer to as an endothermic drainage system, also known as a closed or terminal basin. In a terminal basin, water doesn't ever get to the sea. It remains in the lakes, where it seeps deep into the ground or evaporates, or just seems to disappear.

If you spend some time studying this photo, you begin to think that the photo doesn't so much obscure the man at the very center of the image as portray him clearly as something between a man and an apparition, standing in an in-between place. You begin to see what's captured in the plate as akin to a prehistoric creature caught in amber, only in this case the creature is the light of that day and all its interactions with the fissure and its surroundings, with the people of the Great Basin and the land and all its shapes and textures and emanations, with all the things the land holds.

At least that's how I see it. I also think that *Fissure Vent at Steamboat Springs* is a good example of how O'Sullivan's plates capture things that are typically missing in photos of the West, and when I spend time thinking about how this picture was made, I think of things that are not so much preserved or captured as communicated, as if the picture were a map of neurons firing, as if the bodies involved, and their long-ago interactions with this dry terminal basin, are still palpable.

That extra dimension of feeling

For me, O'Sullivan is like the man in his photograph of the volcanic fissure. He is the nearly invisible presence at the center of the picture, the person we can't see who frames the plate that very often highlights what's missing, or what's there but not quite. When you consider all he did to make the picture of the fumarole—all the decisions about the view and the angle of the lens, as well as the exposure that allows a figure to be seen but not completely, and the various decisions that brought him to this moment, this point in his working life and his life as an American standing in the Great Basin—you begin to see this picture as a performance. The glass plate image and its subsequent print become a receipt or an old ticket stub, not just a record, but an actual report on the resonances of that place.

I also see his photographs as clues, the reason I have spent so many years considering them, the reason they never cease to interest me, the reason I wrote this book, which—please note!—is *not* a biography, but an exploration of O'Sullivan's surveys and the landscapes he photographed. Over the years since they were made, his survey photographs—like the photographs of other photographers hired to make pictures alongside government surveyors after the Civil War—have been described in terms of adventure, but if there is any adventure to be undertaken, I see it as an effort to understand the ways in which we allow each of these magnificent photos to reframe not just the American landscape but the stories we tell ourselves about America, the things we believe and feel.

We don't have a good sense of Timothy O'Sullivan's life—despite the iconic status of many of his best-known plates, despite his interactions with everyone from Abraham Lincoln to Ulysses S. Grant to the enslaved African Americans he saw freed en masse at coastal South Carolina plantations. The bulk of the biographical information about O'Sullivan comes from a series of recommendations for a job with the U.S. Treasury that he applied for in 1880, only months before he died, at age forty-two, of tuberculosis. He is described in the journals of people he worked for and with as either braggadocious and loud or reticent and quiet. When he makes appearances in the correspondence of those with whom he traveled through the West, he is always the journeyman, working to find a view, to make a plate under the most complicated circumstances, to picture the scene as the job required. If he wrote letters to friends and family, as it seems he might have, then none apparently survive.

Even the very few photographs of O'Sullivan that do survive are not necessarily what they seem. A few years ago, a self-portrait that he was said to have made in 1871, while he accompanied a team of U.S. marines surveying Panama, was discovered to have been a self-portrait made by someone else, John Moran, the Philadelphia-based photographer who in recent years scholars have begun to refer to as America's first art photographer.

All of which makes O'Sullivan a bona fide mystery, a mystery that has intrigued me for decades and that, it occurs to me, is stoked by the trajectory of his reputation. In 1867, when he photographed this fissure in the Nevada landscape, photographers and their fans were just beginning

to make an argument that photography could be art, an expression of
the photographer's imagination. For the most part, the press portrayed
photography as educational and practical, historical and archival, some-
thing made by a machine and its operator.

But as ubiquitous as O'Sullivan's work was during the war, once
Robert E. Lee surrendered, O'Sullivan began to fade away. He worked
for two commanders in the West: first, Clarence King, a civilian sci-
entist who reported to the army, and later an army lieutenant, George
Wheeler. King, the geologist for whom he photographed the fissure at
Steamboat Springs, did bring O'Sullivan's photographs to the 1876 cen-
tennial exhibition in Philadelphia, the first American World's Fair, and
Wheeler published stereographs of O'Sullivan's Colorado River trip as
a set, for sale to the public. But by the time O'Sullivan died, in 1882,
his pictures had begun to be forgotten, possibly because their aesthetic
power was far greater than that of the texts they illustrated: an instance
of that which was not art disguising or concealing or distracting from
that which was. Mostly, they were stored away as prints in govern-
ment files, the plates themselves often relegated to university geology
departments.

Then, in the late 1930s, O'Sullivan's photographs were rediscovered,
first by Ansel Adams. By the time of his death, in 1984, Adams had
become America's most beloved landscape photographer, but in 1937
he was a jazz pianist who, as a member of the Sierra Club, had begun
making powerful large-format photos, pictures that (as he wrote of an
early image of Yosemite's Half Dome) captured the place as he expe-
rienced it versus how it appeared. "I had been able to realize a desired
image: not the way the subject appeared in reality but how it felt to me
and how it must appear in the finished print," he wrote in 1927. When
he encountered O'Sullivan's work, it was as if he had suddenly met an
artist who had achieved what Adams himself was working so hard to
achieve. At the end of the 1930s, when Adams wrote to Beaumont and
Nancy Newhall, the husband and wife photography critics, he described
O'Sullivan's images as "technically deficient, even by the standards of
the time but nonetheless, surrealistic and disturbing."

In particular, Adams and the Newhalls marveled at an image O'Sul-
livan had made at Canyon de Chelly, a sacred site from which the
U.S. Army had forcibly expelled the Navajo in 1864. By 1873, when

O'Sullivan visited, the Navajo had just recently managed to reoccupy the area. Adams and the Newhalls showed a print to Alfred Stieglitz, the photographer and New York–based gallerist who had made great progress in convincing Americans that photographers could be artists. "There is something in that print," Adams wrote to Stieglitz in 1937, "that out-surs the sur-realists to say nothing of its magnificent tonal scale." A storied technical master, Adams would later change his opinion on the technical quality of the pictures, after coming to understand for himself the harsh conditions O'Sullivan worked under as well as the idiosyncrasies of his technique. "O'Sullivan had another level of vision . . . that extra dimension of feeling," Adams said in a 1972 interview. "You sense it, you see it."

O'Sullivan's rediscovery in 1937 and his gradual revival say as much about his photos as they do about the general public's expanding interest in photography. In the 1960s, O'Sullivan's work began to appear in more museum shows and collections along with other Civil War photographers. In 1966, *The Boston Globe*, in a review of a book on O'Sullivan, called him one of America's greatest photographers. "His pictures of the Western frontier are unsurpassed," the paper said. As critics and historians became more interested in photography, collectors and curators became more interested in purchasing old prints and plates, increasing their value, which in turn increased interest. "The rise in values for vintage prints in the 1970s led to a hunt for old material," wrote Peter Barberie, the curator of photography at the Philadelphia Museum of Art. "Museums and libraries transferred whole bodies of work from archives and library shelves to exhibition spaces and art storage."

Another result of O'Sullivan's move from the archives to museums was that a fight broke out. On one side were the museums and photographers praising the old survey photographers, and on the other side were critics questioning the inclusion of these photographers' work in museums. Among the former was John Szarkowski, who was, in addition to being a photographer himself, a historian and critic and the director of photography at the Museum of Modern Art. He praised the nineteenth-century landscape photographers as artists, and O'Sullivan in particular. "We know the names of a dozen or more of these photographers and they were all wonderful, in the same sense that all fifteenth-century Italian painters were wonderful," Szarkowski wrote,

"The freshness of the problem and the scale of the opportunity presumably filtered out the fainthearted. Nevertheless, some of the western pioneer-photographers were better than others. I think the best of all was Timothy O'Sullivan."

Others, however, questioned O'Sullivan's actual intentions and asked if the curators weren't just playing Monday-morning quarterback, using academic terms that might have startled O'Sullivan if he were alive. The critic Rosalind Krauss asked if it wasn't a kind of lie, or, as she said, "false history," to put him in a museum, when he himself might not ever have imagined making pictures for museums. That fight continued for more than three decades as O'Sullivan's reputation was commandeered by one faction or another. There was Timothy O'Sullivan the documentarian, whose photos merely reflected the government he worked for—a bureaucracy that, the historian Alan Trachtenberg observed, "promoted a public willingness to support [a] government policy of conquest, settlement, and exploitation." And there was Timothy O'Sullivan the visionary artist, who made art he didn't necessarily know was art, though of course that brings up the question of who decides what art is, who is authorized to make such a call. In a 1981 review of a show of O'Sullivan photos, the *New York Times* photography critic Andy Grundberg wrote, "And what brilliant and original work it is, especially coming from a man with no known training in the arts."

In my mind, training is in the eye of the beholder, and partly because of how captivating O'Sullivan's photos are, the dust hasn't settled and probably never will, despite tepid attempts by both O'Sullivan factions to make peace. In 2010, Toby Jurovics, then curator of photography at the Smithsonian American Art Museum in Washington, D.C., introduced a show titled "Framing the West: The Survey Photographs of Timothy H. O'Sullivan," and in remarks at the opening, he suggested that meaning could in fact be teased out of the pictures if you worked at it. "Even in the absence of much biographical material, we can still discern what his pictures mean by looking carefully at them," Jurovics said at the time.

Jurovics also emphasized that the wet plate collodion process—head under a dark tent, meticulously framing a view while perspiring in the desert sun or freezing on an alpine snowfield, or even attending to the revelation of each careful chemical interaction—is meditative and pa-

tient, patience giving way to a moment when the world rushes in, like collodion flowing over a plate in a dark tent, or, in a field hospital, collodion as liquid bandage flowing into a wound. "What we wanted to show," Jurovics said, "is that O'Sullivan's photographs could contain multiple meanings, that he was hired by the government to make images for [Clarence] King and later for [George] Wheeler but that you don't spend seven years with your head under a dark cloth without thinking about what you are doing. And that the very act of making a large-format photograph is a particularly intimate one."

A flood of awareness

Making a large-format photograph *is* intimate, as are large-format photographs themselves—they express not the binary exactness of a digital print, but the fleshy tones of film, beginning with fluids and ending with milky whites, chocolaty browns, infinities of grayness. I am not a photographer, but in my line of work, I have worked alongside a lot of them over the years and even worked for a few. More than that, I've always been inspired by photographers and eventually even married one, first assisting her thirty years ago, when *The New Yorker* commissioned a large-format film print, at the time a rare appearance of film in a magazine then primarily illustrated with drawings. On a winter day at the beginning of 1989, she set up her hooded tripod in Manhattan, in the middle of Forty-Second Street, which was both intimate and, owing to traffic, harrowing. It was around that time that my wife introduced me to the western landscape photos of Timothy O'Sullivan, and when we moved to Oregon shortly after that Forty-Second Street photo shoot, I got to experience the landscapes O'Sullivan experienced firsthand, all revelations for me, especially since I'd grown up in the East. In returning to the places he photographed—first while living in the West and then after moving back east while visiting Civil War battlefield sites again—I took inspiration from the work of a team of photographers from the 1970s. They called themselves the Rephotographic Survey Project, or RSP, and they attempted to re-create the specific intimacies and accuracies involved in making specific photos in their specific places, including photographs taken by Timothy O'Sullivan.

The RSP was conceived by Ellen Manchester, an independent photography curator who, in 1978, had organized an exhibition called *The Great West: Real/Ideal* at the George Eastman House, in Rochester, New York, the birthplace of Kodak film. The show featured old western survey photos as well as photos of Earth taken by NASA satellites. The contemporary photographs featured were works by several photographers who had come to be known as the New Topographics. At a time when fine art photographers were embracing the use of color film, the New Topographics photographed mostly in black and white, often taking inspiration from the seemingly banal subject matter of the old survey plates. The New Topographics could be overtly critical of the landscapes they were photographing, or even ironic, given that the nineteenth-century surveyors they were referencing paved the way for railroads, mines, the damming of western waterways, the weapons-induced irradiation of the Great Basin, and the attempted destruction of Native nations. Also at play in the work of some of the New Topographics was a sense of the social nature of photography, an idea that had been evolving since the 1960s that saw photographs as equivalences, things that contain the interactions between humans and the world. Photos, some of these photographers were saying, contain experiences.

When Manchester, along with the photographers JoAnn Verburg and Mark Klett, began the RSP, they worked with a geologist from the U.S. Geological Survey (USGS) to search for the sites where each of the earlier western survey photographers—William Henry Jackson, Carleton Watkins, Alexander Gardner, and Timothy O'Sullivan, among others—had made their wet collodion plates. The next year, RSP brought on two more photographers, Gordon Bushaw and Rick Dingus, who proceeded to "rephotograph" in Colorado, Nevada, Utah, New Mexico, Idaho, California, and Arizona. In the field, the rephotographers pointed their cameras with what they termed "extreme precision," making not just large-format photos but charts and diagrams indicating focal lengths and distances, in addition to notes on locations and the time of day of exposures. As they spread out into the West looking for the vantage points of their nineteenth-century predecessors, they became intimately familiar with western light and with seasons and time. In 1978, Klett photographed at Canyon de Chelly, in New Mexico— just as O'Sullivan had—and took a photo every twenty minutes, from

midmorning until just after one p.m., and in so doing determined that O'Sullivan had taken the cover off his lens on a summer day in 1873 at between 1:03 and 1:06 p.m. "The shadows in a photograph made in July are impossible to duplicate in November," Klett wrote.

Revelations came to them before they even exposed their film, and very often, as they were exposed to new landscapes, what *wasn't* in the photo was a revelation. Photos of places that in O'Sullivan's photos seemed remote to contemporary viewers were often just off a well-traveled road or a rail line. Geographical names had changed; huge nineteenth-century mining operations had become twentieth-century ruins, or were nonexistent. Even as an observer, when you study the results, looking at the old photo alongside the more recent one, you see things, as if your brain is working to mine the differences. You begin to think about time, to imagine it not so much as dates in what we call our history, but as a connection between spaces.

"My experience at each site," wrote Rick Dingus, "became an inter-action, a kind of double funnel: a flood of awareness poured in from the site, and my selected responses seemed to pour back into it." Returning to these sites was a way to engage with the past that wasn't romantic or nostalgic, but focused on the present. "Like an antiphonal choir, where two groups sing in answer to one another," wrote JoAnn Verburg in the book that collected the RSP's results, "the photographs are read together, back and forth, as the viewer discovers similarities and differ ences, checking detail against detail."

When I first read about the RSP, the idea of returning to the sites of the photos struck me as a still-powerful tool, though over the years, as I visited some sites and studied others from afar, I began to develop my own variation on the approach—a variation suited to someone who, despite the occasional snapshot, is (to repeat) not a photographer. Just as RSP photographers approached an old site with modern large-format cameras using the old wet collodion plates as their guides, so I began to approach these sites—and even the photos themselves—with an up-dated view of Timothy O'Sullivan and his work. I came to the sites with new views of the work of the people he worked for, and of the people he seemed to be working against, or who were working against him. And given that the RSP had worked to consider the scenes from the stand-point of O'Sullivan's lens, noting angles and focal points and lighting, I

decided to consider the sites from the vantage point of the photographic plates themselves, the collodion- and silver-treated glass inside O'Sullivan's camera that reacted with the light-emanating world. My own re-photography project was a matter of simply being open to what a place could communicate to a person—standing in what was often a place that felt very far away, looking around to experience the panorama through my own experience, as if I were in that box of wood on a tripod, as if I were, to use the nineteenth-century photography term, a sensitive plate.

When I set out to resurvey Timothy O'Sullivan's surveys, I wasn't entirely certain what I would see, but it quickly became clear that each site was like a portal for new explorations into an America that I not only hadn't seen but that, as I came to understand, I was trained not to see at all—and certainly not to feel or to perceive in any deeper way. But over the course of my resurvey—about eight years, working on and off, which in an odd and even terrible coincidence was the very same amount of time that O'Sullivan spent surveying the West himself—I came to understand that O'Sullivan, despite being advertised as such in museums and the occasional history book, was not a Civil War photographer who ended up going to the West to make extraordinary pictures of the largely unsettled landscape. Instead I began to see, first of all, that the war he photographed wasn't the war I thought I understood, and second, that when O'Sullivan traveled west, he was photographing *another* war that was in a way an extension of the first one, and then various other wars.

O'Sullivan had opened up his lens on the fumarole that was now adjacent to a Nevada rail line. It was within a few miles of what was the world's largest silver mine and also in the territory of the Washoe Tribe—who, just a few years before I passed through, had managed to persuade the Environmental Protection Agency to declare a hundred-and-fifty-year-old mine in the hills along the California-Nevada border a Superfund site. The tribe hoped to enact the necessary cleanups that would eventually bring health back to the streams and eventually bring health back to the people who had gotten sick from living in proximity to those streams. When O'Sullivan made this picture at the fumarole, he wasn't a former war photographer at all. On the contrary, he was still in a war zone, covering a war or a series of wars that are still raging today, and the more you explore his pictures, the more evident are the battle lines.

By no means a trifling matter

These days, I live on the East Coast, but several years ago I flew out to
find the fumarole at Steamboat Springs. It was a summer day in the
Great Basin that, in retrospect, was too hot for an ill-prepared search,
and too hot for me. I didn't have a survey grant or an army appointment.
I just had some spare time after finishing a job that had taken me out to
the Great Basin on a reporting assignment. I didn't have a lot of time,
so I was in a kind of hurried state. I was also under the weather or, I
guess I'd say, beginning to understand that I was sick in a way that was
not yet clear to me, about which I will say a little more later in this,
my own survey report. I had researched O'Sullivan's plate, made "about
ten miles from Reno," according to what seemed the most accurate old
report I had on hand at the time. Later, I would realize that there were
more accurate accounts to rely on, but again, this was a spur-of-the-
moment trip, and I decided that if I was going to be in the vicinity of
the fumarole, I ought to try to find it, not knowing when or if I'd return.

Back when O'Sullivan visited, the fumarole was a tourist attraction
largely due to the spectacle of geothermal activity: on cool mornings,
steam was reported to rise in six-story columns. To visitors at the time,
it didn't seem as Dantean as it did salubrious and, for promoters, prof-
itable: people took to the heated waters in the area for their purported
healing properties. According to *A History of the Comstock Silver Lode
& Mines*, published in 1889, "At the springs is a fine and commodi-
ous hotel, bathing houses for vapor baths, and every desirable accom-
modation." An earthquake near the turn of the century is said to have
short-circuited a geyser also at the site, and in 1901 a wildfire burned
down the hotel. New geothermal power plants nearby surely would have
sapped the fissure's strength more, but I packed my maps and photos
hopefully.

On the day of my search, I was moving slowly and got a late start,
setting out in the afternoon toward Reno along the old state road, the
Carson-Reno Highway. The Sierra Nevada was on my left, the Virginia
Range on my right, and Lake Tahoe somewhere north and east of me.
Very quickly, I went downhill on a freeway bridge and entered what
the 1891 USGS map called Steamboat Valley. As I did, I felt certain
I would see a sign for old springs, something with the word *steamboat*

in it. But I did not, and I ran into a question that surveying O'Sullivan often presented me with: Who knows what else I didn't see?

Suddenly, in what seemed like only a few minutes, I was on the out-skirts of Reno, and as best I could tell, I was well past the area where the old springs ought to have been and now seeing all the signs you see in malls across America. The late-afternoon light made even the mall look beautiful, with mountains in the distance, but for me the view signaled failure. Thus, I U-turned and started back south to try again, though I was already more frustrated than I should have been—owing in large part to my illness, I can say in retrospect—and suddenly not at all certain that the fissure still existed. For various reasons, I was feeling increasingly angry that day, failing to find the fissure—feeling, specifi-cally, as if I were banging on a window to get at something I desperately needed and could just make out but couldn't reach.

I repeated the short drive two more times, to no avail, each time turning around in the mall's parking lot and somehow feeling trapped—and suddenly thinking about how the twentieth-century shopping mall itself was originally modeled after nineteenth-century British prisons. The store names shouting at me, I realized, made vague references to various empires: Victoria's Secret and Banana Republic. As I headed south one last time, I passed Washoe Lake yet again, though this time, despite everything, seeing it more clearly somehow or perhaps recogniz-ing it anew. I can say that at this point I immediately felt better in view of this body of water—big, gray, open, textured with whitecaps—though not until I got home would I realize that it empties into Steamboat Creek. It's a lake known for winds that are supercharged in a funnel created by the edge of the Sierras and the Virginia Range—winds that, to this day, are known to topple tractor trailers.

Setting off on what I now decided would be my final trip north on the Carson-Reno Highway, I stopped to ask a few people for directions, and I'm sure I showed myself as an agitated mess—as mentioned, I had rushed this trip, in fact had been sick for some time, and was just begin-ning to understand that maybe I wasn't going to get better. At one point I went into a roadside chocolate store that was near to closing. I was brandishing a photocopy of O'Sullivan's fissure photo, and I questioned a woman behind the counter who was dealing with a lot of last-minute customers. Though I probably shouldn't have, I persisted in questioning

her, to such an extent that she nodded warily toward her boyfriend, a very tall young man, probably in his early twenties, who appeared to be waiting to take her home after her shift. He had a vague idea of the site I was referring to and handled me with a cautious positivity that was, as I think about it, maybe a little like that of a hostage negotiator.

"I think I know what you're talking about," he said. "I'd say it's just right before you get to the mall."

I can't shake the idea that he might have just been trying to move me along, but as I remember it all, I can clearly see him smiling kindly as he looked down on me, a picture of mercy. I am certain I over-thanked him.

"No problem," he was saying. He shook my hand. "Good luck."

I got back into the car, trying to breathe calmly, and began to wonder why it meant so much to me to find this fracture in the ground. I looked again at the photo. Something was wrong, I thought—wrong with the photo, wrong with how I approached the site, or tried to, and undoubtedly wrong with me. I felt oblivious, and somehow disconnected. But I tried again, one last time. Sure enough, a little less than ten miles up, I saw a small sign on a slope down away from the road, down to a dry, parched landscape. Some kind of spa appeared to be nearby, the still-active vestiges of what was once a renowned resort community. In 1932, Jack Dempsey trained here, preparing to fight Max Baer, and in 1940, Dr. Edna Carver, who had drilled a well and built a hospital that burned a few years earlier, wrote a prospectus for another resort, extolling the healing power of the springs. Now I could see that the angle of the sign in relationship to the highway had made it difficult to see from the state road.

HISTORIC STEAMBOAT VILLA
HOT SPRINGS

A century and a half later it was still a coarse, dry spot, as in the picture. Hot mineral-injected liquids had spent centuries percolating up to create a chalky, calcified surface that made earth's skin look scarred and pocked. All cracked and barren rock, it looked as if it had been bombed. As opposed to O'Sullivan's picture, the scene was almost undramatic, though there was something menacing about the place, something that

immediately made me wary. I didn't like being there. As I drove slowly, a six-thousand-foot hill was watching me from across the highway; on my side, the small houses were quiet until, as I slowed the car, I heard a dog begin to bark. Dogs barking in places I am investigating upset me, but I was distracted by how invisible this place had been to me while I'd driven back and forth all afternoon. I still couldn't see a giant fissure, but I could sense that if a giant fissure was anywhere, it was here.

I reached for my camera and pointed it out the window, clicking the shutter repeatedly while driving slowly, like a NASA rover on Mars or a Mars-like planet. After just a few seconds I thought I saw steam rising from the ground. I squinted and looked again and couldn't believe it, but I did see steam, which was faint in the summery afternoon light, the opposite of O'Sullivan's cold winter day, when presumably his breath was visible in the air. You could not hide a man or much of anything behind the steam I was seeing, but it was steam, pressure relieved from the raging intensity hidden in the earth just below.

I pulled over and got out of the car, the dog now barking more. Stepping closer, I spotted more steam, and then, bending down in the brittle field, I saw it: the great long crack, a fissure in the scarred and scraped-up earth. It was sealed in part, or seemed to be, in comparison with what appears in O'Sullivan's photo, but it was a fumarole. Steam continued to percolate, and the dog continued to bark, as I crouched down slowly and carefully to touch the parched, crumbling, broken earth.

2

A Harvest of Death, 1863

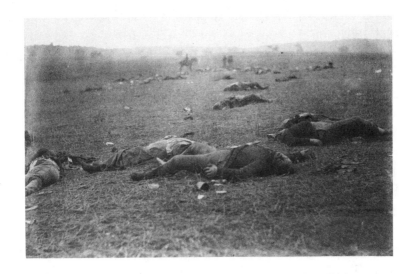

As a reminder here at the outset of my survey: this book is not a biography of Timothy O'Sullivan. It is a survey, in large part because the mode of the survey is something I am familiar with, having spent most of my life trying to understand why one plot of land is valued over another. Surveys are built into the American story, but as quiet infrastructure. If this were a biography of O'Sullivan, it might not be much more than a page or two, given the record he left behind at the time of his death—some appearances on the census, a few job recommendations, place-names and numbers scratched on thousands of photographic plates.

What we know is that he was born in Ireland in 1840, though precisely where is not known. Approximately two years later, with his parents, Anne and Jeremiah, he immigrated to New Orleans and later

showed up in the census records in Louisiana in the first year in a long
stretch of years that saw the arrival of famine refugees from Ireland.
Again, we don't know precisely how the famine affected O'Sullivan's
family, or where he landed, though the Irish fleeing starvation could sail
straight from Ireland to Canadian ports, or to Boston or New York, but
they might also first sail to Liverpool, where ships filled with Southern
cotton might otherwise return empty to New Orleans. Captains and
agents in what was once England's slave-trafficking capital were, since
Britain had ended slavery in its colonies in 1834, looking for ways to
fill their holds on the trip across the Atlantic, happy to take starving
passengers as paying ballast. After Boston and New York, New Orleans
was the most frequent port of arrival for the Irish, who were put to work
in the swamps and bayous, digging levees and canals, frequently dying
of malaria. "Green as shamrocks," wrote the November 1841 New Or-
leans *Picayune*, adding, "What a valuable acquisition they will prove in
carrying out the internal improvements."

By the time O'Sullivan was a teenager, he was living in New York
and, at some point, had begun to work at the photography studios of
Mathew Brady, whose gallery was in Lower Manhattan and home was
on Staten Island, where O'Sullivan's family lived. When he was about
eighteen, he transferred to Brady's new Washington, D.C., studio,
where he worked alongside Alexander Gardner, Brady's studio man-
ager, who broke off from Brady and set out with O'Sullivan to photo-
graph a war that was, on the Union side, anticipated as a brief federal
action against rebellious Confederate troops. O'Sullivan appears to
have been a member of an army unit for a time, and he photographed in
South Carolina, in 1861 and '62, the ruins of Fort Pulaski and the Black
men, women, and children who were suddenly free, plantation owners
having fled the advancing Union army. For the remainder of the war,
his title, according to Gardner, was Superintendent of the Field or Copy
Work to the Army of the Potomac. He made hundreds of photos that
were published under Gardner's name, as *Photographic Incidents of the
War from the Gallery of Alexander Gardner, Photographer for the Army of
the Potomac*.

Four years after photographing the Appomattox Court House,
where Robert E. Lee surrendered to Ulysses S. Grant, O'Sullivan was
hired by the army again, this time alongside western survey teams to

survey the Great Basin and then the Colorado Plateau. He interrupted his western surveys once, hired by the navy to document a survey of what is today called Panama, traveling with the Marine Corps. In 1874 he returned to Washington, D.C., where the year before he had married Laura Pywell, the sister of another war and survey photographer. In Washington, he worked freelance, printing his survey pictures for the army and for the newly formed U.S. Geological Survey, though, after he left the West, he seems to have stopped making pictures altogether. He almost disappeared from the record in the late 1870s, dying in 1882 at his parents' home on Staten Island. In all that time, he left neither letters nor diaries. The record of O'Sullivan is the record of the sites he visited, as evidenced by the photos that survive, his best-known photograph being *A Harvest of Death*, taken a few days after the Battle of Gettysburg in a farmer's trampled pasture.

A Harvest of Death is included in *Gardner's Photographic Sketch Book of the War*; and O'Sullivan's death series, as his Gettysburg pictures are known, are the centerpiece of the book. Sometimes called the first American photo book, the *Sketch Book* was designed by an ardent abolitionist and social reformer to encourage Americans to reflect on the aftermath of the great national fight. It was intended as a visual guide that used scenes from the past to envision a path forward, and Gardner provided notes, extended captions that were sometimes nearly stories or sketches in their own right. Of *A Harvest of Death*, Gardner wrote, "Such a picture conveys a useful moral: It shows the blank horror and reality of war, in opposition to its pageantry. Here are the dreadful details! Let them aid in preventing such another calamity falling upon the nation." But the useful moral that Gardner mentions is complicated and, as such, ends up being useful only inasmuch as it keeps things complicated. Like so many of O'Sullivan's pictures, *A Harvest of Death* is a characteristically straightforward image that is, on second look, just as characteristically complicated. Four corpses are at the center of the frame, as if at center stage, but details in the out-of-focus distance direct the viewer to questions. More bodies, then horses, then men on horses, men standing, dark figures in the background either oblivious or watching, or possibly waiting, some of them maybe not men but trees: What's going on?

What's going on isn't clear, partly because of the mist that envelops the image. Notes made by survivors of the battle report that on

the day O'Sullivan made this picture—July 6, 1863—it was hot and muggy in the farmland surrounding Gettysburg, Pennsylvania, and it had just rained: saturated ground and quickly warming air are a recipe for a morning fog or haze, and it's hard to imagine O'Sullivan not understanding the value, in terms of light, of getting an early-morning start. Then again, the mist in the photo might have been emphasized by a technical maneuver—a calculated diminishment, for instance, in the size of his camera's lens opening, referred to technically as the aperture. The smallest aperture would have allowed for a longer exposure, making whatever mist was there more pronounced and, in the same way that you can see the particulars of a field in the harsh sun when you squint, an almost shut-down aperture could account for the sharp details close in: the buttons on the uniforms of the dead, the individual blades of trampled grass and hay, the lifeless head, and the bloated, mottled hands that so excruciatingly cannot touch or feel the world.

Whatever decisions O'Sullivan made in the field about focus and exposure were made with the lightning speed of a journeyman. Not only did his chemicals dry quickly, the landscape he was picturing was in flux. The army burial parties, composed primarily of African American men, were working fast, burying acres of corpses—stacking the decomposing bodies, moving them and moving them again, organizing the chaos. Residents of the area and visitors to the site insisted that the view of dead soldiers defied description, though they made attempts, each sounding like notes on O'Sullivan's picture. "The dead are frightfully smashed," recalled John Haley, a soldier from Maine, "which is not to be wondered at when we consider how they crowded up to our guns, a mass of humanity, only to be hurled back an undistinguishable pile of mutilated flesh, rolling and writhing in death. No tongue can depict the carnage, and I cannot make it seem real: men's heads blown off or split open; horrible gashes cut; some split from the top of the head to the extremities, as butchers split beef."

The opening of the *Iliad* is a song of rage—"black and murderous, that cost the Greeks incalculable pain . . . countless souls," their bodies left "to rot as feasts for dogs and birds"—and so O'Sullivan's photo describes the horror that Gettysburg's combatants said they saw: a soldier from Vermont wrote, "Most of them lay on their backs, with clothes commonly thrown open in front, perhaps by the man himself in his

dying agony, or by some human jackal searching for money on the corpse, and breast and stomach often exposed." But notice that the descriptions are often not heroic at all, and to communicate the horror, the witnesses repeatedly rely on tropes, stoking both Union and Confederate soldiers' darkest fears. The Vermont soldier continues: "The faces, as a general rule, had turned black—not a purplish discoloration, such as I had imagined in reading of the 'blackened corpses' so often mentioned in descriptions of battle-grounds, but a deep bluish black, giving to the corpse with black hair the appearance of a negro, and to the one with light or red hair and whiskers a strange and revolting aspect."

A marketplace of commodities and spectacles

Contained in *A Harvest of Death* is the history of Timothy O'Sullivan's working life up to this point, a history that sets the stage for the pictures he will make in the West, that saturates them. In it, you can see the flair for drama, as practiced by his first boss, Mathew Brady, the great American photographic impresario. It is a straightforward picture, because that's what the public expected from a photographer, the brutal facts and details of the war, but it's theatrical too, as was Brady. Brady is remembered today as a photographer of wars and statesmen, and by his nickname "Lincoln's cameraman," despite being more successful financially (though less celebrated) as the photographic arm of P. T. Barnum, the huckster and promoter whose expertise was above all spectacle. The other influence you can see in this photograph of the Battle of Gettysburg's aftermath is that of O'Sullivan's second boss, Alexander Gardner, who chose this plate for his photo book and, for this edition, printed it himself. O'Sullivan's death scene is used as a poignant and graphic example of the cost of fighting a war that Gardner and his fellow abolitionists argued was for the sake of the Union and freedom. What makes the picture characteristically O'Sullivan's is the presence of his trademark opposites: in the infinite expanse of the flat field, the living resemble the dead in the far background, and just beyond the also dreamy foreground, the dead are presented with the detail of the living.

When O'Sullivan arrived in Gettysburg on the evening of July 5, 1863, he was accompanied by Gardner as well as a few other photographers, their wagons loaded with dark bottles of photographic chemicals

and windowpane-size glass plates. The small crew had raced to the bat-
tlefield, beating Mathew Brady's team to the scene by a week. It was a
scoop for Gardner, though it was Brady who, at the war's outset, had
first mined the public's interest in battlefield photos. In 1862, *The New
York Times* lauded the images Brady's team had made at Antietam. "If
our readers wish to know the horrors of the battle-field, let them go
to BRADY's Gallery, and see the fearful reproductions which he has
on exhibition, and for sale," the *Times* wrote, again noting a horror in
blackened faces. "In all the literal repulsiveness of nature, lie the naked
corpses of our dead soldiers side by side in the quiet impassiveness of
rest. Blackened faces, distorted features, expressions most agonizing, and
details of absolute verity, teach us a lesson which it is well for us to learn."

Precisely what year O'Sullivan started with Brady is not known—
"from boyhood," was how Brady described the duration of their acquain-
tance, when the older man wrote him a job recommendation in 1881,
the year before O'Sullivan died. They likely met on Staten Island, where
they were both transplants, Brady by 1850, O'Sullivan's family between
1855 and 1860. Brady had been trained by Samuel F. B. Morse, the
painter and early photographic pioneer who was an ardent supporter of
slavery and a nativist, the latter attribute likely complicating his relation-
ship with Brady, who often told people he was born in upstate New York
although he had emigrated from County Cork, Ireland, possibly the
same county O'Sullivan's family had emigrated from. Being a propo-
nent of slavery was a not at all unpopular position in New York City, the
northern U.S. metropolis most friendly with the South owing to its role
in financing Southern slavery. In 1860, J.D.B. De Bow, a prominent
slavery apologist living in New Orleans, described New York as "almost
as dependent on Southern slavery as Charleston itself."

In the early years that O'Sullivan spent working for Brady, he was
headquartered in America's media capital. Lower Manhattan was the
center of a burgeoning national press, home to various newspaper, mag-
azine, and book publishers, as well as museums and galleries that were
exhibiting giant landscape paintings or room-size panoramic paintings
and mounting extravaganzas of all kinds. It was what one scholar called
"a marketplace of commodities and spectacles," as well as a traffic jam
of people, horses, carts, and ideas—ideas high-minded and not so high-
minded. Tammany Hall was down the street from City Hall, both a

few blocks from Wall Street, and the adjacent harbor was afloat with
the products of Southern slavery that were the city's economic lifeblood:
cotton, tobacco, and the sugar that charged the growth of the city of
Brooklyn in particular. Lower Broadway was the city's first Times
Square, a confluence of power and entertainment populated by politi-
cians and businessmen, publishers and writers, along with crowds of the
less famous—all off to P. T. Barnum's museum to see Indians from the
West or cannibals from the Pacific Islands, or off to the nearby theaters
where they could see, as one presenter billed it, America's "Infernal Re-
gions," by which, in this case, he meant Ohio.

The world in which Timothy O'Sullivan apprenticed was a crazed
competition—in other words, where editors and writers worked to either
translate spectacle from the edges of the expanding American empire
or just create it, and in so doing draw the biggest possible crowds. By
1856 or '57, when Brady had established his photographic emporium, a
seventeen-year-old O'Sullivan would have seen crowds lined up to view
his employer's portraits of famed Americans, or, down the street, more
crowds waiting to stand before *Niagara*, Frederick Church's seven-foot-
wide painting of the falls. Like so many of O'Sullivan's images—his
waterfalls, his deserts, and even *A Harvest of Death*—Church's *Niagara*
puts the viewer at the scene, to *experience* the great rushing cataract. It
is estimated that one hundred thousand people paid twenty-five cents
each to see Church's one-painting show. Said a witness, "This is Niag-
ara, with the roar left out!"

A capital artist

Observers of early commercial photographers in the United States noted
that, in contrast to Europeans, Americans fell quickly in love with the
daguerreotype, typically of themselves, though often of others too.
Brady's studio was a department store of portraits—first on Broadway at
Fulton Street, then in the 1850s (around when O'Sullivan would have
arrived) in a larger studio at Tenth Street. As Brady's client list grew,
he switched from making daguerreotypes to employing the newer wet
plate collodion method, a process that allowed for an infinite number
of prints to be made from the resulting glass plate. With his work—
and located where he was—Brady simultaneously cultivated fame and

fanned it, a key to so much American success then as now, and as he
did, he elevated Americans who were linked to the birth of the republic,
like John Quincy Adams and Henry Clay, while downplaying partisan-
ship and underscoring national unity—a more and more complicated
undertaking as the Civil War approached. He was inventing a hyper-
impartiality, a technology-based patriotism that claimed to be nonpar-
tisan even though that was impossible. And the increasingly famous
photographer knew how to vigorously pursue a future hit, stalking
writers outside their hotels, flattering widows of the so-called Found-
ing Fathers. Copies of his portrait of George Washington Parke Cus-
tis sold because Custis was widely admired in both the North and the
about-to-secede South: the step-grandson and adopted son of George
Washington, Custis was the father-in-law of one of the U.S. Army's
rising stars, Robert E. Lee.

And just as Americans were learning to use celebrity and mass me-
dia to gift wrap away the nation's uglinesses, so Brady's sitters appre-
ciated him for the way his camera treated their visage, as he patiently
retouched his plates to cure any imperfections. It was a reciprocal rela-
tionship, one side advertising the other, a commercial transaction that
Brady portrayed as incidental and happenstance, which foreshadowed
the celebrity reportage that is a linchpin of journalism today. *The Photo-
graphic Art Journal* described Brady's approach as impartial: "He stepped
aside to wait in silence for Nature to do her work." Brady rode waves of
patriotism and anxiety, currents of scandal and notoriety, his portraits
simultaneously taking advantage of fame and creating it. "Mr. B is a
capital artist, and deserves every encouragement," wrote Walt Whit-
man, in 1846 a newspaper editor and an aspiring poet whom Brady pho-
tographed. Daniel Webster, a senator famous for his attempts to strike
compromises on slavery, reportedly told his trusted portrait maker, "Use
me as the potter would the clay . . ."

In photos of Brady from the time, we see a thin, not very tall man
in a black coat, black doeskin trousers, black merino vest, muslin shirt,
and silk scarf. We don't see Timothy O'Sullivan. Maybe he is working a
camera, or up in the top floor of the studio, where light pouring through
the glass ceiling was used to print images on albumen paper. We might
easily imagine the Irish teenager noticing Brady as he greeted his sub-
jects in the salonlike gallery: Brady smelling of lavender water, scented

soaps, and cologne and carrying a cane, though not initially because of any physical impairment. He sported a Vandyke and glasses made of thick blue lenses. His eyesight had been poor since childhood. Toward the end of his career he was nearly blind. By cultivating his own celebrity, Brady created the idea of the Brady portrait. He became a verb and a question: "Have you been Brady-ed?"

In his so-called *Gallery of Illustrious Americans*, he Brady-ed generals and politicians on both sides of the brewing conflict over slavery, and then he moved on to Brady the war, ostensibly from the side of the Union, though at the outset the war might have been described as a war among the illustrious. He planned a multipronged photographic attack: he would gather several photographers from his own studios, including Gardner and O'Sullivan, and dispatch them behind the lines of the Union forces, taking full advantage of his connections in government and the military on the Union and the Confederate sides. He called the series *Incidents of the War*, and he marketed his photographs—of officers and civilian leaders, of soldiers, of camp scenes, of logistical maneuvers, of battlefields before and after—through such magazines as *Harper's Weekly* and *Frank Leslie's Illustrated Newspaper*. He sold the images through E. & H. T. Anthony, America's biggest publisher of mass-produced cartes de visite and stereocards. Based a few blocks from Brady's studio, Edward Anthony (who was, like Brady, a student of Samuel B. Morse) and his brother Henry sold more than eleven hundred different images or "views."

As the armies prepared to meet in Virginia, Brady's friends attempted to dissuade him from his plan to cover the conflict. His wife told him it was a bad idea, and she was correct: by the end of the war, he was bankrupt, eventually dying broke in 1896, "practically dependent," an obituary said, "upon the kindness of his friends." But at the outset of the war, Brady himself raced to the front for the first major land battle, at Bull Run, bringing along his young camera operator, Timothy O'Sullivan. "I felt I had to go," Brady wrote later. "A spirit in my feet said *go*, and I went—!"

That first expected quick and decisive victory by the Union army ended in a rout by the Confederates, the retreat of Union soldiers complicated by the fleeing spectators who had assembled to watch the federal troops win.

The Gentlemen's Agreement

It's not clear why Gardner split from Brady. I imagine that Gardner grew impatient with Brady's business practices, but in any case, O'Sullivan, by then twenty-two, followed. Brady and Gardner were a study in contrasts: Brady a socialite and a striver, Gardner an activist and a reformer, a disciple of the Welsh socialist Robert Owen, the founder of the cooperative movement. While Brady likely grew up in a rural setting, Gardner studied chemistry, botany, and astronomy as a boy in Glasgow and was eventually apprenticed to a jeweler. In 1851, at the age of thirty, he became the owner and editor of the *Glasgow Sentinel*, the principal working-class paper in the west of Scotland at the time, where he wrote editorials in support of socialism and societal reforms to benefit the working class. In an early editorial he told readers that he had purchased the paper as a means of enlightening the public on "all incidents and revelations touching the wants of the mass of the people." Slavery in America was, he said, "a stain on the escutcheon of the otherwise freest country in the world."

In a short time, Gardner made the *Sentinel* a commercial success, and with the proceeds he helped fund a cooperative in Iowa that he had visited in 1851 and planned to join later on, a plan scuttled when the cooperative, ravaged by tuberculosis, shut down. Instead, in 1856 Gardner sailed with his wife and children to New York City, where, when Brady's finances were in disarray, Gardner's technical expertise helped the famous photographer shift his business to the then-popular large-plate exposures that were printed on twenty-one-by-seventeen-inch paper—giant enlargements that became known as the Brady Imperial print, an immediate success.

After the war, in 1867, Gardner, like O'Sullivan, would take an assignment photographing in the West for the Union Pacific Railroad. He worked for the U.S. government, making photographs of tribal delegations as they visited Washington, D.C., and also photographed Lincoln on various occasions. During the time that O'Sullivan assisted him, he had a studio at the White House, and there are accounts of Gardner and his assistant (presumably O'Sullivan) photographing Lincoln's corpse at the Washington Navy Yard, though no extant photo. But when the war began, Gardner was quickly assigned to the staff of

General George McClellan as photographer of the U.S. Topographical Engineers, giving him Brady-like access to battles for his commercial project. Gardner approached the war as a partisan and social reformer, seeing slavery as the great evil over which the war was fought and, increasingly, framing Lincoln as the nation's great moral savior. And whereas Brady used portraiture to celebrate his "illustrious Americans," *Gardner's Photographic Sketch Book of the War* was a portfolio of landscape views, an illustrated travelogue of newly baptized hallowed ground.

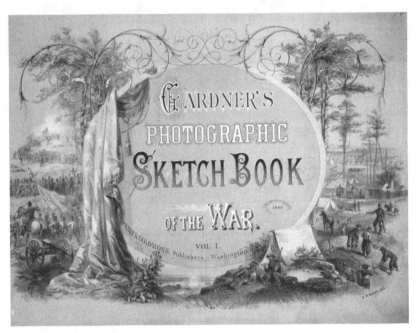

Title page, *Gardner's Photographic Sketch Book of the War*

The opening photograph is of the Marshall House in Alexandria, Virginia. It is a plate by William Pywell, O'Sullivan's future brother-in-law, and it shows the site where, Gardner reports, a Confederate flag was raised just across the Potomac River, in view of the White House during the war.

The Marshall House was famously the site of the first Union casualty—Colonel Elmer E. Ellsworth, commander of the Eleventh New York Volunteer Infantry Regiment and a close friend of Abraham Lincoln's from Illinois. In describing the incident, Gardner speaks of the

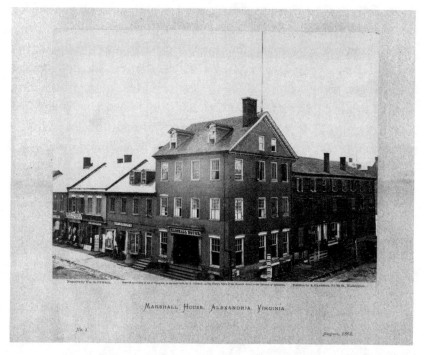

Marshall House, Alexandria, Virginia, 1862, by William Pywell

structure in the past tense, the building reconstructed: "Finally North-
ern men took possession of the building, and fitted it up for business, so
changing the interior as to be scarcely recognizable by those who visited
it in 1861." Each tour guide–esque passage of the *Sketch Book* christens
the adjacent image with a particular past and attempts to transport the
viewer back to the very moment the glass plate was exposed. The text
that Gardner wrote to accompany O'Sullivan's image of dead bodies in
the Gettysburg farmer's field was similarly romantic:

> Slowly, over the misty fields of Gettysburg—as all reluctant to
> expose their ghastly horrors to the light—came the sunless morn,
> after the retreat by Lee's broken army. Through the shadowy
> vapors, it was, indeed, a "harvest of death" that was presented;
> hundreds and thousands of torn Union and rebel soldiers—
> although many of the former were already interred—strewed
> the now quiet fighting ground, soaked by the rain, which for
> two days had drenched the country with its fitful showers.

The war's cause, the *Sketch Book* asserts, was slavery, though it is not the first but the second image in the book that says as much: a photo of a slave pen in Alexandria, Virginia, pictured hauntingly empty. The death of a white Union soldier precedes the enslavement of Black human beings in Gardner's telling, as slavery's importance in the North is, if not downplayed, then ranked second. In the 1830s, Alexandria was the capital of the American slave trade—and until 1846, when Alexandria separated from the District of Columbia, the U.S. slave trade capital *was* the U.S. capital. Slave markets also thrived in Northern and Southern states; the slave market in New York City, for example, was at the foot of Wall Street until it closed in 1762. (New York ended slavery in 1827.) And yet, in referring to slavery in his caption, Gardner emphasizes the Southern states while, in a dark elision, he hints at the terrifying sexual violence intrinsic to the system of slavery:

> In many of the Southern cities the people had erected build-
> ings of this kind for the confinement of slaves awaiting sale . . .
> Before the war, a child three years old, would sell, in Alexan-
> dria, for about fifty dollars, and an able-bodied man at from one
> thousand to eighteen hundred dollars. A woman would bring
> from five hundred to fifteen hundred dollars, according to her
> age and personal attractions.

The two volumes of the *Sketch Book* have been called "foundational" with regard to the history of photography and to the history of the United States. "They contain some of the finest photographs of the Civil War," wrote Beaumont Newhall in his 1949 history of photography. But I think of the *Sketch Book* as similar to a dark family photo album, with pictures that we go through to congratulate ourselves when in fact they damn us. Notice that the book ends not with a discussion of what it asserts the war was about—slavery—but with the work of memorializing the dead, Union and Confederate; it points toward the reconciliation that will be the national project in a few decades. Gardner sets the stage with a party of men and women at the site of the Battle of Bull Run—what Confederate troops referred to as Manassas—and a crowd of white soldiers and civilians. The penultimate photo in the *Sketch Book* is titled *McLean's House, Appomattox Court-House, Virginia, Where the*

Capitulation was Signed between Generals Grant and Lee. Gardner, who is conscientious about crediting his photographers, cites O'Sullivan for making the plate—the negative—and cites himself for making the print used in the book, the positive. But it seems to me that even the positive is a negative; it is another picture of an absence, made by O'Sullivan, for whom absence was already his photographic specialty:

> The photograph represents the house in which the terms of capitulation between Generals Grant and Lee were signed. The apple tree (about half a mile from the Court-House) under which they first met, has been entirely carried away in pieces, as mementoes, not even the roots remaining.

It is unlikely that the roots were gone when O'Sullivan made the plate; the roots were just underground. Gardner, however, makes the point that the war has come full circle, with the Union reunited, the conflict fading away. The house's owner, according to Gardner, was himself a witness to the first battle of the war, and now, in April 1865, a witness to the beginning of what is portrayed as a national healing.

Today the house is a national historic park, and in 2023, as if following Gardner's lead, the National Park Service was describing the surrender on its website as "cordial" and even quaint, with Grant "embarrassed at having to ask for the surrender from Lee." Lee's troops were deserting, but the website makes the point that in the final minutes before surrender, Lee rejected the idea of a guerrilla war proposed by E. Porter Alexander, a Confederate general who became a railroad executive after the war. Absent is the mention of Lee being indicted for treason in the state of Virginia, or of Lee losing the right to vote and living on parole while being publicly accused of whipping people he had enslaved and then pouring brine into their wounds (a charge he did not deny). "The character of both Lee and Grant was of such a high order," the website reports today, "that the surrender of the Army of Northern Virginia has been called 'The Gentlemen's Agreement.'"

It is true that Lincoln and Grant did not want to try to execute the Confederate leadership for treason, though President Andrew Johnson did. A Tennessee Democrat who supported the Union—though not the right of African Americans to vote or even be citizens—Johnson

pushed for Lee and thirty-nine other Confederates to be put on trial. But as the case against Lee and the others was being built, Johnson was impeached and Grant elected president, and the charges against the Confederate leaders dropped. (John Brown, as it happens, is one of the very few Americans who have been executed for treason.) By 1976, in time for the U.S. Bicentennial, President Gerald Ford signed a bill posthumously restoring full rights of citizenship to Lee, saying, "General Lee's character has been an example to succeeding generations, making the restoration of his citizenship an event in which every American can take pride."

Ford made his remarks at Arlington National Cemetery, the former site of Lee's plantation. In the spring of 1871, when O'Sullivan was in the West, following a U.S. Army lieutenant on a covert mining survey into Death Valley, Frederick Douglass gave a speech at Arlington. "We are sometimes asked, in the name of patriotism, to forget the merits of this fearful struggle, and to remember with equal admiration those who struck at the nation's life and those who struck to save it, those who fought for slavery and those who fought for liberty and justice," Douglass said. He rejected the argument: "We must never forget that victory to the rebellion meant death to the republic."

The mode of life of the army

Gardner's photo book—two leather-bound volumes, with albumen prints attached to printed pages—was a commercial failure, in part because it was finished months after the war had ended, or at least the part of the war that involved headline-making battles between troops. Over the years, the *Sketch Book* has suffered not from what it says about the war (or what it doesn't say), but for how it handles the details, the details concerning the death series in particular. Aside from noting that the bodies appear to have been moved between exposures, researchers have suggested that a gun was apparently used as a prop in a photo that Gardner attributes to O'Sullivan. Details such as these were first brought to light in the 1970s by William A. Frassanito, a Vietnam War veteran born in Queens, New York, who became a Gettysburg photo historian. "Gardner was not above stretching the truth in order to increase the historical value of his views," Frassanito wrote.

Frassanito's work is meticulous and captivating: after serving as a military intelligence officer in Vietnam, he moved to Gettysburg, where he spent years pacing the battlefields for geologic details, matching photos to the landscape and inspiring legions of others to do the same. His findings were so good and so conclusive that they had the unintended side effect of forever tainting O'Sullivan's Gettysburg photos as damaged goods. "Not surprisingly," wrote the critic Susan Sontag, "many of the canonical images of early war photography turn out to have been staged, or to have had their subjects tampered with."

The charge taints what Sontag calls "the moral authority" of the pictures, and it is a charge that photography in some ways set itself up for, in its early days billing itself as more accurate than painting, as if a human being weren't in charge of choosing scenes and focusing on one detail over another, as if it were life captured rather than an image that has been fashioned. But the accusations can also cause us to lose sight of Gardner's larger project and forget, too, that Gardner was not following the same rules attached to photojournalism in the twenty-first century, or what rules remain. In terms of his work in the field, to write the pictures off as fakes distracts from what the *Sketch Book* is telling us about what Americans thought of the war, especially Americans on the side of the Union. Gardner was making a more troubling gesture toward what would ultimately be a calamitous appeasement, an agreement on the postwar American racial order. He wasn't so much an individual artist staging a photo as he was a representative Northern abolitionist staging his view of the war, what it meant and what it would come to mean. More recent investigations of the photos have suggested that the bodies were as likely moved by the army's burial detail as by the photographers. But the damage has been done, especially in a controversy-driven culture that exults in the littlest slipups while missing the big picture.

In the end, the scandal diverts our attention from what Gardner's *Sketch Book* illustrates when it comes to the other bodies involved in the Civil War. Take *Breaking camp, Brandy Station, Virginia*, a photo of the deserted headquarters of General George H. Sharpe, chief of the Secret Service of the Army of the Potomac, taken by Gardner's brother James.

The passage that Gardner writes to accompany this picture flatly ignores the Black man who is the picture's focus, as if he were an object, not a man. "The photograph possesses interest only," he writes, "as an

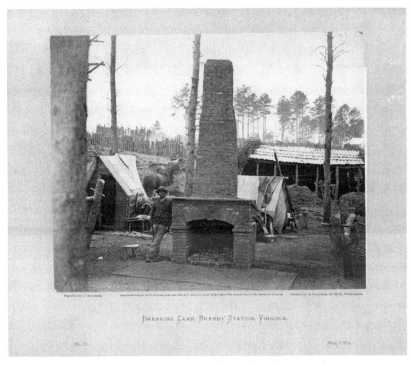

Breaking camp, Brandy Station, Virginia, 1864, by James Gardner

illustration of the mode of life of the army in winter." This is despite Black Americans' extraordinary prominence in the national conversation in the very stretch of years in which the photos were made, years when the existence of the U.S. Colored Troops was first debated and then, once established, aggressively publicized by the North—of great interest to the public, in other words. Two hundred thousand Black men served as soldiers and sailors, 10 percent of the Union army, one-third of them dying during the war, though in the *Sketch Book*, despite Gardner's avowed abolitionist aims, Black men or women appear distinctly in only six of its one hundred images. When Gardner's sketches do refer to African Americans, they are treated more like what the army called contraband, which is to say things or goods, or mere servants, and his sketches can be darkly slapstick: in one a boy serving Union generals is compared to a monkey in a tree, a gruesome pun given the lynchings that will be a centerpiece of the post-Reconstruction terrorism to come.

It's easy to write off Gardner's remarks as typical of his day, but as

early as 1863 Sojourner Truth was selling a carte de visite of her portrait to raise money for her own travels. "I sell the shadow to support the substance," she wrote. Frederick Douglass—who raised a Black army regiment that included his own son—was the most photographed person of his era and wrote passionately about photography, emphasizing its democratizing nature: "The humblest servant girl may now possess a picture of herself such as the wealth of kings could not purchase 50 years ago." Photos, Douglass argued, could be used to change society and, over the course of an individual's life, to powerfully reinvent one's own self. Meanwhile, Gardner—with the *Sketch Book*, with the plates he would make for the Union Pacific Railroad, with the portraits he would make of visiting delegations, leaders of tribal nations visiting Washington in hopes of negotiating what Washington increasingly wished to ignore—was reinventing a nation-state, raising the curtain on an America that was healed, as opposed to wounded and war-torn, the darkest forces recuperating and reorganizing, preparing to develop the West as if the war had never happened or was a setback, as if slavery had not disappeared but transformed.

There is not a reinvention of Black Americans in the *Sketch Book*, but an effort to lock in stereotypes, as seen in the one image that highlights the work of Black men, *A Burial Party, Cold Harbor, Virginia*. Taken by John Reekie, one of Gardner's contributors, it shows Black laborers working to collect soldiers' remains—boots and limbs, skulls bleached white.

It's a stark image of death, shocking and sad, and it shows us a Black man posing alongside a stretcher carrying mangled skeletons in Cold Harbor, Virginia. In his accompanying text, Gardner manages to belittle the work and thus the men. "An orderly turning over a skull upon the ground," Gardner writes, "heard something within it rattle, and searching for the supposed bullet, found a glass eye." Whether or not it was in fact discovered in the field, the glass eye most likely refers to Ralph Waldo Emerson's all-seeing eyeball, the eye that perceives all the world, an idea that was frequently mentioned whenever the Transcendentalists were spoofed (as they very often were) in the *Sketch Book*'s time. Taking it as it was meant, the Emersonian eye is all-seeing and optimistic, the soul-like symbol of Transcendentalism that plants itself like a photographer's sensitive plate in the middle of a world that's charged with a

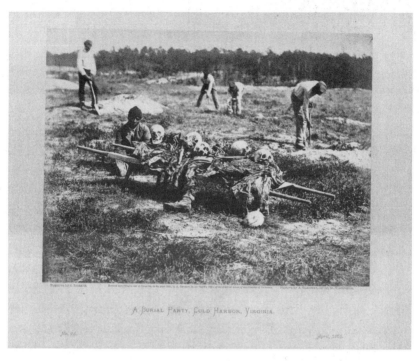

A Burial Party, Cold Harbor, Virginia, 1865 / negative by J. Reekie;
positive by A. Gardner

sacred vibrancy. But this eye comes from the death-spoiled earth. Gardner's eye is like a buried bullet, seeing not optimistic transcendence, but hell—and all concern is for the unburied Union soldiers. As Gardner uses it here, the image of the eye also manages to mark the living with the lifeless dead, one skull for each man working, one dead foot in the grave.

The Civil War did not take place

Maybe the most important thing to keep in mind if you are heading west to follow O'Sullivan as he transitions from photographing the battlefields of the Civil War to photographing the likewise contested territory between the Rockies and the Sierras is that the title of Gardner's *Sketch Book* was changed. When it was first published, it was titled *Gardner's Photographic Sketch Book of the War*. My copy is a paperback, published in 1959. It combines Gardner's two volumes and changes the

title from the 1865 original to *Gardner's Photographic Sketch Book of the Civil War*. The change from "War" to "Civil War" reflects the way the public conception of the war changed over the course of the decades, a change that, it seems to me, Gardner's book doesn't just anticipate but underscores and promotes.

Prior to the 1870s, the South primarily referred to the war as the War for Southern Independence, aligning themselves with the early American colonists. New Englanders, on the other hand, typically referred to the Rebellion or the War for the Union, but things changed quickly in the years following the war. After Lee surrendered to Grant, the violence against African Americans in the South increased to such an extent that in 1866, a moderate majority of the Republican-controlled Congress was convinced to send troops to occupy the South to protect African Americans *and* Union soldiers, Black and white. In the ten years that followed, while federal troops fought Southern guerrilla fighters, newly freed African Americans established universal male suffrage, in addition to public education that benefited poor whites as well as the formerly enslaved; state constitutions were rewritten; and African American men were elected to state and local governments in numbers that, in certain states and counties, have yet to be repeated in the twentieth or twenty-first century. Troops, including U.S. Colored Troops, were authorized by the Enforcement Acts to fight the Ku Klux Klan, who were on horses where the Union infantry was not and who thus roamed freely in the vast Southern territory outside the federal troops' garrisons—terrorists keen to abduct Black soldiers.

But then, in 1877, for numerous reasons—political scandals that embroiled Grant, economic chaos brought on by stock speculation and overinvestment in railroads, a drop in public support for Reconstruction related to nativist reactions against new Europeans, and, of course, all the biases on display in the *Sketch Book*—federal troops were withdrawn. As Northern Democrats increasingly sought support among Southern white voters, the war now came to be referred to using an agreed-upon term, and though the War Between the States remained the preferred term in the South, much of the nation soon settled on the term Civil War. By no means did this come out of the blue. Back in the days leading up to the Battle of Gettysburg, raiding Confederates kidnapped freed Black men and women in town, strapping Black children to their

horses, yet Gettysburgians described the Southern invaders as "gentle-manly," given that they took only horses and Black human beings. (They were praised further when they returned the horses.) It was in a similar spirit that as the 1800s ended, the war was now described as "civil" even though it wasn't. Gentlemen disagreed, then gentlemen forgave and moved on, building railroads and sending troops to the West or overseas.

By 1887, President Grover Cleveland gave captured battle flags back to the Confederacy. In 1897, at his inaugural address, President William McKinley said that "the North and South no longer divide on the old lines . . ." As the twentieth century arrived, nativist sentiment further united the North and South, and by the time Virginia-born Woodrow Wilson was elected president—he showed a Klan film, *The Birth of a Nation*, in the White House (the army had assisted the director, an early instance of the United States using film as propaganda) and re-segregated federal offices—"Civil War" had become the universal term. The new name dodged blame and retouched the cause of the war (the way Mathew Brady edited warts off celebrities) and erased the participation of Black Americans, the way Gardner left them out of the frame in his *Sketch Book*. As Reconstruction ended, the violence of the guerrilla war being waged against Black Americans escalated, fought not just with guns but with angry mobs and lynchings, with chain gangs and union busting and myriad forms of voter disenfranchisement. In 2002 the historian William Pencak wrote, "Would it be too much to say that the South won, not the Civil War—which did not take place—but an 'Era of Racial Violence' which extended—to be arbitrary—from 'Bleeding Kansas' in 1854 to the end of Reconstruction in 1877?"

What's the difference, you can ask, between Southerners fighting a guerrilla war for slavery in Kansas and ex-Confederates turned terrorists driving Union troops from the South? What is the difference between the Union marching troops through Georgia, terrorizing the populace, crippling its economy, and, in the 1870s, doing the same through Sioux or Nez Perce territory, albeit with less regard for that populace? What's the difference between marching through the gold-rich Black Hills and—as O'Sullivan will attempt to picture it for his military commanders and publishers alike—the jungles of Panama, where the resource to be mined was navigational, a strategic access to seas and ports? And

most important, for me, how do we see these past and not-so-past battles in the landscapes we picture today?

After 1877, the Confederacy returned to controlling its own affairs, the racial order enforced by Jim Crow and worse, and Robert E. Lee was praised as a noble figure in both the South and the North, where Woodrow Wilson called him "a model to men who would be morally great" and Eisenhower kept a portrait of him on the wall of his White House office.

When you look at what the South accomplished, you can conclude, as Pencak did: "The Civil War did not take place, and the South won it." When you look at Alexander Gardner's *Sketch Book* as a book not about freedom or rights or a victory for abolitionists, then you see that the war didn't end. The battles may have looked different and may have emerged out of a different context, but the war kept going on in one form or another, dying down and then flaring up again wherever the federal government put down rebellions of one sort or another, the definition of rebellion depending on the circumstance, often confusing the distinction between Confederate rebels and Native people "rebelling" to retain their land. You begin to see the shadowy figures at the back of the stage in O'Sullivan's *Harvest of Death* as moving to the foreground, regrouping, and coming alive to fight again in the West, the staging ground (in Missouri and Kansas and elsewhere) for the rebellion that was allegedly past. Now the West—where citizenship was disputed, where sovereignty was devalued or ignored—would become a battle site, and not just with guns but with miners and dams, with vigilantes and nativists, with ranches and land grabs made by Congress-backed corporations. When you begin surveying the North American landscape in such a way, you begin to see O'Sullivan as a photographer of a war that didn't just happen in the South. It was bleeding west and expanding with America's reach, and two years after Lee made his gentleman's agreement with Grant in the spring of 1865, O'Sullivan was packing up lenses and box cameras and glass plates to follow the war again.

Guns unlimbered and bodies unlimbed

Gardner's *Sketch Book* is better regarded today than it was at the time of its publication. Americans saw the images that Gardner made him-

self or printed, though likely they mostly saw them individually or in sets of cartes de visite and stereocards, published and republished, then collected, then lost, and now sold in antique stores and on eBay. O'Sullivan's photos for Gardner and the photos he made for Brady have merged together, and when I sit down to page through them now, each individual image works like a frame from an old motion-picture reel, O'Sullivan an accidental cinematographer, moving through the war, quickly setting up his tripod, hurrying us from site to site, from scenes of dramatic destruction to mundane pauses in the battle, pregnant with the expectation of death. See the commissary staff posing for O'Sullivan, twenty men doling out portions of coffee, tea, molasses, beef, salt pork, and potatoes, sometimes to Union soldiers, sometimes to Confederate families, sometimes to the formerly enslaved, who are finding but also making their way out of the South and into the North, another kind of survey in action. See the bombproof oyster house, thick log-and-mud construction amid continual bombardment, the door guarded by its sign: FRUIT & OYSTER HOUSE. See the priest saying Mass for the Fighting Sixty-Ninth, a famous regiment of Irish New Yorkers, a unit poised to suffer great casualties in the Battle of Bull Run: their chaplain will be chastised by his bishop for baptizing a gun.

O'Sullivan frequently traveled with the Fiftieth New York Engineer Regiment, a unit in charge of constructing and repairing bridges and fortifications. The Fiftieth were in and out of combat zones and often fired upon while fording streams. In some of O'Sullivan's photos where long rows of guns appear to be firing, men are blurred, owing to their fast movements and flight responses, twitches of self-defense or fear: each frame contains notes on the choreography of war. A photo of the bombed-out Union battlements—the dug-in barracks of the U.S. Colored Troops, the largest Black force assembled during the war, at Petersburg, in Virginia—is a flicker of the 292 days of fighting often described as a siege. As the scene impressed itself on his silver- and cotton-treated glass plates, the earth feels dry and hollowed out, its flesh gone, like a skeleton. At Petersburg, Union troops sent Pennsylvania miners underground to dig, many of them, like O'Sullivan, born in Ireland. They packed the tunnel with eight thousand pounds of explosives that, on the morning of July 30, 1864, erupted beneath Confederate lines with, as a Maine soldier reported, "earth, stones, timbers, arms, legs, guns

unlimbered and bodies unlimbed." Concerned for how the plan would play out, Ambrose Everett Burnside—a Union general who was also a railroad executive—sent a greater proportion of African American units than white soldiers into the breach at what became known as the Battle of the Crater, where Union forces ended up being shot at like fish in a barrel. Those who survived were sent into slavery or returned to it, tortured and killed, marched as prisoners through streets full of angry Confederates—one of the events historians downplayed in the gentlemen's history of the war, which moves past particular bodies.

The war that happened was, of course, all about bodies, all of them, and I consider the contrast with a photo by O'Sullivan that I return to over and over. It is a plate he made during the Second Battle of Bull Run that is a freeze-frame of an exodus. It pictures a group of formerly enslaved Black men, women, and children following a Northern Army that was at this point still reluctant to lead the way.

Fugitive Negroes, fording Rappahannock, 1862

It is a remarkable photograph, if only as a record of the movement, specifically, of a group of African Americans who are fording the Rappahannock River in Virginia in 1862, when the Emancipation Act is months away. Lincoln is wary of freeing the enslaved, hoping first to save the Union. "The North," wrote W.E.B. Du Bois in his 1935 history of Black reconstruction, "went to war without the slightest idea of freeing the slave. The great majority of Northerners from Lincoln down pledged themselves to protect slavery, and they hated and harried Abolitionists."

Ignoring the Fugitive Slave Act that Congress passed in 1850, Gen-

eral Benjamin Butler, the Union commander, decreed that his troops would consider enslaved people "contraband of war"—meaning property confiscated during battle. Under this strange schema, they were thus *objects* contained by the rules of war. But by fording the river, these men, women, and children are enacting a transformation, one that's both political and economic: they are leaving a plantation, taking with them their labor, moving between legal worlds and real ones.

This photograph begs scores of unanswerable questions—about the thoughts of the boy on horseback watching the cameramen, about the young women looking away, about the Conestoga wagon apparently filled with things, because, of course, things tells stories too. It is like a Bible story made real, the Rappahannock like the river of Jordan, though when O'Sullivan uncovers his lens while standing in the shallow river, he is picturing these families amid the battle. It is summer, a year before Gettysburg, shortly after General Robert E. Lee and Stonewall Jackson have outmaneuvered the Union forces—the war is by no means a sure thing for the North. In this and other pictures taken in the same hours, O'Sullivan sees Union general John Pope's troops retreating across the Rappahannock: a blur of cattle crossing the river just below a railroad bridge and a blur again of ambulances on their way to a battle, as well as a mistlike cloud of dust that follows troops in helter-skelter retreat.

In the 1930s, Susie Melton recalled this time, when she and her family fled north to the Union lines: in 1862, she was about as old as the boy on the horse who is looking back toward O'Sullivan. Speaking to a Federal Writers' Project interviewer, Melton recalled the night when her family prepared to leave, not caring about the plantation owner. "Didn't care nothin' about missus," she said. "Was going to the Union lines." That night everyone with her danced and sang, setting out at daybreak with blankets and clothes, with pots and pans and chickens strapped to their backs. When the sun came up over the trees, she remembered, her family thought back to the place they came from and sang, "Sun, you'll be here and I'll be gone."

In 2022, Mali Lucas-Green, an artist and a teacher from Jonesboro, Georgia, visited the Fredericksburg and Spotsylvania National Military Park, near the Rappahannock crossing, and told the ranger on duty about Moses Lucas, an enslaved man who, after being impressed into service for the Confederate army, crossed the river to the Union side,

then turned around to retrieve his wife and four children, all of whom were enslaved on a nearby farm. Two of the four children died in the river, which was swollen after rains, details Lucas-Green gleaned from the testimony Moses had dictated to his son, Lucas, who was Mali Lucas-Green's great-grandfather. When Lucas-Green told the ranger about her grandfather, the ranger showed her O'Sullivan's photograph.

What makes O'Sullivan's picture remarkable, I think, is that the bodies you are seeing move are looking back at you, and you are not moving. You are standing still, like a wagon broken down or a rock.

Detail: *Fugitive Negroes, fording Rappahannock*

The greatest crime of all the centuries

A number of years ago, on a beautiful early-spring weekend, I managed to return to Gettysburg for the first time in decades. I had gone to college there for one term, from 1981 to 1982, but my recollection of the battlefield came down to just two events—the first when I was a freshman and my parents hired a battlefield historian to sit in our station wagon with me and my five younger siblings; I've always wondered if the historian had ever experienced a warring Irish American family in such close confines. I also carried memories of a friend from that time who walked me out into the battlefields one beautiful spring day. On his encouragement, we lay down in green grass and stared at the blue sky,

a simple meditation. He was a thoughtful and gentle guy who studied philosophy and politics, and he pointed out what I had not been thinking so much about back then: the magnitude of death in the landscape, the feel of it.

When I returned, it was the spring of 2017, the United States was in the midst of relitigating the meaning of the Civil War. The city of New Orleans had very recently taken down its Confederate monuments; meanwhile, white supremacists had marched in Charlottesville to protest the removal of a Confederate statue. In light of these events, the National Military Park at Gettysburg, with its numerous monuments commemorating the Confederate States of America, could feel like a Confederate theme park. Setting aside Georgia's stated reasons for secession ("For the last ten years we have had numerous and serious causes of complaint against our non-slave-holding confederate States with reference to the subject of African slavery," Georgia wrote in 1861 as they withdrew from the United States), the monument to Georgia's Confederates says, "We sleep here in obedience to the law. When duty called we came. When country called, we died."

I knew that the commemoration of the Battle of Gettysburg had been complicated from the start. Basil Biggs, a free Black farmer and veterinarian in Gettysburg, fled with his wife and children as the battle was just beginning, eventually returning to a farm in shambles, his crops destroyed, three dozen dead Confederate soldiers hastily buried in his fields. He reburied them on his own accord and was subsequently contracted, along with ten other Black men, to exhume all the Union soldiers and rebury them in what was to be the Soldiers' National Cemetery, the neat rows of graves at which Lincoln would give his address in November 1863.

In coming years, the cemetery that Biggs built was visited by African Americans who arrived by train or bus. The "colored excursionists," as newspapers referred to them, took tours and picnicked at Gettysburg, celebrating the war as an end to slavery. On anniversaries of Emancipation Day, Baltimore's Black community made up some of the biggest groups. Families and church groups celebrated the link that Lincoln himself, in his memorial address, established between the battle and Black freedom.

But then, very quickly, with the national push toward reconciliation,

the emphasis on slavery and emancipation began to fade, creating what the historian Margaret Creighton calls "the public segregation of memory." The monuments to the Union were increasingly augmented by Confederate memorials, with former Confederates returning to christen them. In 1882 the Confederates were treated to a banquet complete with toasts from Union soldiers. (Black veterans weren't invited until the fiftieth anniversary, though when Black Philadelphians petitioned the state for battlefield monuments to African American contributions, they were denied.) In 1888, the twenty-fifth anniversary of the war, the governor of Pennsylvania said that the war had been fought over abstract ideas. "I think I speak the words of truth and soberness when I say that, so far as we were concerned, there was nothing of personal animosity or bitterness or hate involved in the contest," he said. James Longstreet, the Confederate general, compared the North and South to a bride and bridegroom, and by 1913 an Alabama congressman talked about the ways Confederate and Union troops had mingled their blood for what each side believed was right.

A few politicians protested this sort of appeasement. In 1890, Senator John Ingalls of Kansas said, "Four million human beings were held in slavery, monstrous, inconceivable in its conditions of humiliation, dishonor, and degradation, unending and unrequited toil, helpless ignorance, actions nameless and unspeakable; families separated at the auction-block, and women and children tortured with the lash.

"If we were not right," he added, "then the war for the Union was the greatest crime of all the centuries."

But by the early twentieth century, Gettysburg commemorations were whites-only events, with town restaurants and hotels no longer serving Black customers. A rare protest came in 1963, during the civil rights era, from Richard Hughes, then governor of New Jersey, speaking on the anniversary of the battle. "The Civil War was not fought to preserve the Union 'lily white' or 'Jim Crow,'" Hughes argued. "It was fought for liberty and justice for all."

The precise location of *A Harvest of Death*, where exactly O'Sullivan opened his lens, is, like O'Sullivan, a mystery, but amateur historians theorize and draw up maps and charts, many convincing, one very convincing to me. In general, those conversations—on social media pages and on blogs and in chat groups—feel sanitized of race and politics,

poisons seemingly diluted by the logistics of war, by reading places technically as mere longitudes and latitudes. The photo itself is treated like evidence in a case that is less concerned with the crime than with the crime scene.

When I returned to Gettysburg in 2017 to look for the site, I arrived late and checked in to a motel in town. The next morning, after coffee, I drove through the park, stopping to inspect monuments, read Union and Confederate markers, look at vistas. When I came to a spot that seemed to me a good candidate for where O'Sullivan made *A Harvest of Death*, nobody was around. I took some photos and then remembered my old college friend and felt compelled to again lie down on the ground. My friend had committed suicide a few years earlier, and I was shocked by how suddenly and deeply I felt a great sorrow in my body—in my jaw, my legs and gut, pulling me into the earth as I remembered our time together in this place. I closed my eyes, remaining motionless, and tried to listen, to hear what I could hear not just with my ears but with all the rest of my body. When I opened my eyes and saw nothing but the clear blue sky, vast and flat and all-encompassing, I felt as if I were afloat in an ocean, moving slowly, feeling far away.

INTO THE GREAT BASIN

I set out for the Great Basin, to follow O'Sullivan's path in his first years in the West as photographer for the Fortieth Parallel Survey, under the command of Clarence King, soon to be a world-renowned scientist.

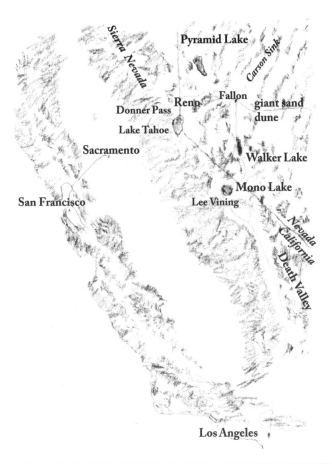

Sierra Nevada

Pyramid Lake

Carson Sink

Renō · Fallon · giant sand dune

Donner Pass

Lake Tahoe

Sacramento

Walker Lake

San Francisco

Mono Lake

Lee Vining

Nevada
California
Death Valley

Los Angeles

3

Alkali Lake, Carson Desert, Nevada, 1867

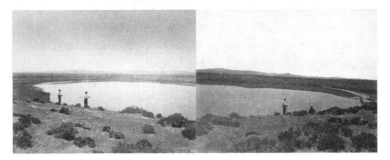

Composite of two plates

I was in Los Angeles on a job, reporting for a magazine, and instead of flying home directly, I made plans to return through Reno, Nevada, to spend some time seeing the places that O'Sullivan photographed in 1867, eventually finding my way to the fissure in Steamboat Springs but starting with the site of a photo titled *Alkali Lake, Carson Desert, Nevada,* a soda lake in the vicinity of a place that other nearby photos called Ragtown. This was about a year into my survey, which, after starting it up with great excitement in 2012—an adventure in the American West—I was forced to suddenly shut down for a time, owing to an illness that made it tough for me to get around. My trip to Nevada marked my first time back in the field. Excited and wary, I managed to finish up my work in downtown L.A. and got dropped off at a rental car place,

and toward the end of a summer afternoon, I set off for the Great Basin. This meant finding my way around the San Gabriel Mountains and skirting the edge of the Mojave Desert, driving north on Route 395, a historic American mining corridor that runs clear to the Canadian border. I didn't have a smartphone, due partly to the fact that directions from a Global Positioning System seem at odds with surveying the surveys that led to that very system. More generally, I think that being informed of your location is counterproductive when you are trying to discover where you are. Not surprisingly, I got lost on L.A.'s highways pretty quickly, but I found a gas station, bought a decent map of L.A., and got underway again. My destination that evening: Lee Vining, California, on the southwest shore of Mono Lake.

In contrast to O'Sullivan, I had limited funding, but like him, I was freelance—or *a* freelance, as I prefer to think of it—though I was significantly older, having just turned fifty and having spent a lot of time on reporting assignments in the field. O'Sullivan was twenty-seven that spring when the U.S. Army authorized him to purchase cameras and photographic equipment for a civilian scientific survey of the West. He purchased these things from E. & H. T. Anthony & Company, the nation's largest supplier of photographic equipment and the Manhattan-based publisher of Brady's and Gardner's wartime photos. O'Sullivan's parents were living on Staten Island at the time, and though the trip might have felt like turning a page, or at least a change of scenery after having spent six years photographing the dead or soon-to-be-dead in the East, it was also a paycheck.

The U.S. Geological Exploration of the Fortieth Parallel, as it was called, was unique in the history of American territorial surveys—a civilian expedition funded by the military. Army officials perhaps thought that O'Sullivan's military experience would be ideal for this assignment—he would act as intermediary between the military and civilian scientific worlds. The survey was proposed by Clarence King, an about-to-be-eminent geologist, and approved by Edwin Stanton, the late President Lincoln's secretary of war. King's men would start from San Francisco, cross the Sierras, and, from there, map what they considered largely a desert landscape, with an eye toward uncovering valuable minerals as well as the coal needed to fuel the transcontinental railroad that was only a year from completion. Among other things, King

planned to use the resulting research to present a grand geological syn-
thesis concerning the formation of the North American continent. On
their trip, the scientists would be guarded by military escorts to protect
against Native American attacks that were, in fact, more likely to be
discussed in the eastern press than to actually happen.

And so, on May 11, at New York's South Street Seaport, in the
company of a botanist, several geologists, a topographer, and a zoolo-
gist, O'Sullivan boarded the SS *Henry Chauncey*, a paddle wheeler, and
sailed out of a harbor and into a view that I imagine he recognized from
growing up on Staten Island—a panorama of sloops and ferries, oyster
boats and steamers. In an hour or two, they were past Sandy Hook, the
sliver of dunes at the mouth of New York Harbor, headed south toward
the horn at Cape Hatteras. A few days later they sailed through the
Windward Passage that connects Cuba and Haiti. *The New York Times*
announced their departure: "Among the passengers to California this
week was a party of young men on an important surveying expedition to
a section of the Rocky Mountains and the great basin westward." It was
important mostly thanks to Clarence King, who, at twenty-five, was two
years younger than O'Sullivan—so young that his appointment raised
eyebrows in the House of Representatives. King was well-connected and
aggressive. His biographers never fail to note that Henry Adams would
later refer to him as "the best and brightest man of his generation."
Though he was a political novice, he asked for and managed to receive
congressional funding for his scientific work, a bureaucratic feat that
Adams described as a "happy accident."

Like an eroding chain of mountains, King was descended from fad-
ing nobility. His once-successful merchant father, born in Newport,
Rhode Island, died on a trading trip to China. Raised by his doting
mother, King eventually attended the Sheffield Scientific School at
Yale. When he graduated, in 1862, he debated enlisting in the Union
army, counting a favorite aunt's abolitionist fervor as a defining moral
influence. But he eventually chose to study the geology of the western
mountains, insisting that the energy he might otherwise put into mili-
tary service would be used in an exploration that he considered tanta-
mount to national service. He equated mountain climbing with fighting
in a war, an equivalence that sounds defensive and was not apparent
to everyone: on a boat trip along the shore of Lake Champlain around

the time he graduated, King and his friends, rowing near the Canadian border, were briefly detained as draft dodgers. King's close friend on the trip, Daniel Dewey, was killed in action at Irish Bend, Louisiana, in 1863. As King left for California, one scholar writes, "the personal and individual violence of the Civil War may have been on King's mind."

Though they were close in age, King and O'Sullivan had lived markedly different lives. In 1863, the year that O'Sullivan photographed Gettysburg, King was headed west with Jim Gardner, a friend from college who was also a geologist. They had no jobs, only letters of introduction, though the trip seems less like the desperate search for employment that King remembered and more like a wealthy kid's jaunt. They took a train to Saint Louis, then a stagecoach to Nevada, where, when the bunkhouse they were staying in burned, they lost their luggage and money. They found work at the local mine, saving up to get to San Francisco by paddleboat on the Sacramento River. On board, they happened to meet William H. Brewer, also a Yale alum and the director of the California Geological Survey, and as soon as they arrived in San Francisco, Brewer introduced them to the California survey's director, Josiah D. Whitney, yet another Yalie. For the next few years, while the war raged, King worked for the survey as an unpaid volunteer, climbing and mapping the Sierra Nevada. It was a dream job he funded with his family's fortune, but by the time the war ended, family funding had evaporated: his stepfather had died in turn, and King suddenly found himself the sole supporter of his mother and her three children, all of them living in a mansion in Newport and running up expenses that a volunteer mountain surveyor could not afford.

"Family trouble and misfortune cannot be anticipated or prevented," he wrote to colleagues. "It comes like a shadow and darkens one's days most painfully."

And so the Fortieth Parallel Survey was both a means of advancing scientific understanding of the geology of North America and a way for King to pay the rent, or several rents, an idea he claimed came to him on one specific day a few years earlier, when he and his friend Gardner were atop a peak in the Sierra Nevada, looking east, above what would become California Route 395, my path a century and a half later in an Avis rental car. Peering down at a range of basins and mountains, King saw a vast, unsurveyed tract, a gap in the national maps. When he

returned east, he pitched the idea to Congress, not so much surprising as irritating his mentors with his characteristic audacity. "King wants to get more glory by doing something on his own hook," wrote Whitney, his California boss.

King's grand plan was twofold: to apply the latest modes of European mapping and geologic thinking to the American West and, in so doing, to appeal to the consolidated interests of science, industry, and the military. Science focused on the flora, fauna, and landscape of the region, while industry was interested in what was underground—very interested since the recent discovery of the silver deposit in Virginia City, Nevada, that had come to be known as the Comstock Lode. King would marry these two interests with an eye on profit for himself. The military wanted detailed surveys of the terrain—the roads and trails that were well-worn but not on U.S. maps—in hopes of further containing and diminishing the power of the tribal nations as well as the Spanish-speaking communities that predated the on-paper switch from Mexico to U.S. territory. Already the Pacific Railway Act offered more than two hundred million acres of Indigenous land west of the Mississippi to private corporations.

Lincoln signed the act in the summer of 1862, shortly before signing the Emancipation Proclamation on January 1, 1863, and during the same summer that he signed orders for General John Pope to suppress a Dakota Sioux rebellion in Minnesota. It was a low point for Lincoln, the army racking up defeats, public support for his policies evaporating. The Dakota, starved and mistreated after watching their territory suddenly shrink after decades of good relations with British, French, and American traders, had seen how the Confederates inflicted devastating early losses on Union troops, and they debated Southern alliances as Union troops proceeded to burn the plains and destroy Sioux food stores. ("We have," Pope wrote in a letter, "and can have troops enough to exterminate them all, if they furnish the least occasion for it.") When Lincoln sent Pope, he saw the Dakota as part of the Confederate rebellion, or one more piece of it. "Information was received . . . ," he told Congress, "that a simultaneous attack was to be made upon the white settlements by all the tribes between the Mississippi river and Rocky mountains."

King, a devotee of John Ruskin, saw himself as America's great philosopher-scientist: a geologist uniquely armed with the imagination

of an artist, who would elevate American science and, in so doing, pioneer the scientific incorporation of the West. It is a measure of his bureaucratic genius that he convinced the army to finance him instead of hiring an army officer, though when Congress finally appropriated $50,000 and President Andrew Johnson named King geologist in charge of the survey, the secretary of war took him aside, pointing out that four major generals had wanted this appointment for themselves.

"Now, Mr. King," Stanton said, "the sooner you get out of Washington, the better."

Destroyed spiritually

By late afternoon, I was through the San Gabriel Mountains and across the San Andreas Fault, the crumbling seam affixing California to the continent. By the time I reached the city of Palmdale, I was done with the hills and mountains of the coast and heading north, the Sierras rising quickly before me. The Mojave Desert was off to my right, the beginning of Death Valley ahead. The midsummer day seemed to want to go on forever, and I cut across the corner of the Mojave, my window shut tight, the rental car's air-conditioning on high. One thing I appreciated immediately about this trip was how small I felt coming into the desert. A veteran traveler, I was making my first trip alone in close to a year, and perhaps because of my tentative state, I felt a heightened sense of the terrain I was driving through, even though I had never seen it before. I was picturing O'Sullivan's glass plates waiting in the dark to be suddenly exposed, and as I drove through sparsely populated flatland, my awareness of my own sensitivity translated to a suspicion about what I was seeing with my eyes and a distrust of the road atlas I was following. It was as if, by moving farther away from L.A. and its metro area, I was more on an invisible grid than off it. For a moment I thought I saw the Great Basin the way the U.S. Army did or as did carte de visite viewers in their 1867 homes, as a dry and ulcerated space that the North and South, reunited, might—if they couldn't heal it—dig up and cut away, as if all the cracks and fissures required surgery, or something worse.

In no time at all, I drove the Aerospace Highway, passing Edwards Air Force Base, the airstrip where the Space Shuttle used to land. Suddenly I recognized the shuttle as a survey instrument, like the ba-

rometers, telescopes, and theodolites Clarence King was carrying into the Great Basin, and when I got home, I learned about Global Hawk, an unmanned aircraft that is manufactured by Northrop Grumman, the $35 billion multinational aerospace and defense corporation that operates out of Edwards today. From altitudes of sixty thousand feet, firing lasers down from the sky, the Global Hawk can survey forty thousand square miles of territory in one flight, which is about four times what Clarence King's survey covered in 1867 in that first summer in the field.

After about two hours I pulled over at a deserted scenic rest area to check in with my wife, and getting out of the car, I discovered I had no cell phone service. Now, especially since this was my first time traveling solo in a long year, I felt even more alone. The wind was strong and hot and animated, a surprise after being sealed inside my rental car; I thought I felt it moving through my body, like an X-ray. The view was red and dry and flat but cragged, like Mars with air I could breathe. Looking off from the high point of the rest area, I could see the low hills of Death Valley and maybe the Panamint Range. When I took a photo with my camera, I noticed the rental car's long shadows on the pavement of the parking lot. In a few minutes I was again driving north and east on California State Highway 395 when suddenly the Sierras appeared in the sky on my left. I'd never seen them from their east-facing side, and they seemed to jump up out of nowhere, like a steroid-swollen muscle—"a defiant wall of rock plunging abruptly down to the plain," Clarence King wrote.

About three hours into my trip I came upon Owens Lake, a now mostly dry waterbed that had been drained to supply water to Los Angeles—the Nüümü, or Paiute, and Newe, or Shoshone, who are among the five tribes with traditional ties to the area, refer to the lake as Patsiata—and then a sign pointed toward the Alabama Hills, a place famous for western movie scenes, named by local Confederate sympathizers after the Confederate warship *Alabama* that sank the Union man-of-war *Hatteras* off the coast of Texas in 1863. (Just up the road, a peak called Kearsage was named for the Union ship that sank a Confederate ship off the coast of France.) Very recently Californians have decried the name Alabama for its reference to the Confederacy, though the outrage does not extend in reference to the valley that settlers renamed for the Maryland-born Richard Owens, née Owings, namesake of what

white settlers called the Owens Valley Indian War, which, also in 1863, killed several hundred Paiute and marched more off the land to make way for mining and ranching in an area that had been, prior to white settlement, an interconnected series of irrigated living sites. In Lone Pine, I passed the Lone Pine Paiute–Shoshone Reservation. "The Tribes believe that the era of divide and conquer is over," wrote Teri Red Owl, the executive director of the Owens Valley Indian Water Commission and a citizen of the Bishop Paiute Tribe. "We're not giving up. Not only are we seeking the return of land and water. We're also fighting to save our homelands."

Despite all the place-names that referenced wars, I was startled to next come upon the Manzanar War Relocation Center, one of ten such centers where, in 1942, roughly 112,000 men and women—anyone of Japanese ancestry living on the West Coast—were forced into camps, surrounded by barbed wire, guard towers, and guns. The gates were closed by the time I stopped on the road to look in. At Manzanar, ten thousand people were placed in 504 barracks, each with eight people in a twenty-by-twenty-five-foot room surrounded by armed guards and dogs and barbed-wire fences. In 1944, a decade after Ansel Adams rescued O'Sullivan from obscurity, he photographed Manzanar and published his photos in *Born Free and Equal*, a book that was intended to protest this national injustice but was received harshly, with critics calling Adams a "Jap lover." On this early survey outing, I was having trouble seeing how Manzanar related to the King survey—though eventually I would—but when I finally read Adams's book, I saw it as a tepid protest, marred by the photographer praising the landscape's beauty as a consolation prize for the prisoners. "I believe that the acrid splendor of the desert, ringed with towering mountains, has strengthened the spirit of the people of Manzanar," Adams wrote. His caption for a photo of families being forcibly removed from their homes: "Departure on relocation is a great adventure."

In a few more hours it was dark, the stars thick in the liquid black sky. Sleepy and worried about it, I was pulling over every twenty minutes, but just after midnight I checked in to a little motel room in the town of Lee Vining, nerves frayed. Just before I went to sleep, I found a description of Manzanar written by a woman who had been confined to the camp. "The next morning," she said, "the first morning in Man-

zanar, when I woke up and saw what Manzanar looked like, I just cried. And then I saw the mountain, the high Sierra, and I just cried. That's all. I couldn't think about anything."

A perfect Babel

Clarence King was late to leave for California, boarding the *Henry Chauncey* in May 1867. Working feverishly in the survey's offices at Yale, he had collapsed from exhaustion, missing the send-off dinner that everyone on the expedition attended—everyone but O'Sullivan, it would seem. At the start of the survey, the photographer does not seem to be a full partner, likely because he was a working-class Irish immigrant. His war experience would also have set him apart from the others. King had hired James Gardner, his old Yale friend, to manage the survey, and, with King exhausted, Gardner finished the final preparations on his own. The rest of the people on board included Henry Custer, a Swiss-born topographer who had previously surveyed the North Cascade mountains in the Washington Territory; William Bailey, a whiny twenty-four-year-old botanist; Samuel "Frank" Emmons, a Boston-born, Harvard-educated geologist; and Robert Ridgway, a seventeen-year-old ornithological prodigy. For a few years, Ridgway had been writing letters about bird identification to the head of the Smithsonian, who then recommended the boy to King. Also on the boat were hundreds of soldiers, off to garrisons in the West, leaving one theater of war for another.

O'Sullivan was assigned to a compartment with Ridgway and Bailey, the two youngest surveyors, who at this point are not impressed by the camera operator. In their journals they criticized him for talking too much about the war, feverishly extolling King's reminiscences of everything *but* the war. "Truly, since Scheherazade there has been no more gifted story-teller," Bailey wrote. King told his stories as the *Chauncey* steamed past Cape Hatteras, past the Bahamas, and along the coast of Cuba, where the waters were reported to be shark-infested and a crewman fell overboard but was rescued, a passenger cheering "Hooray!"

When they landed in Panama, sharks followed their boat to the pier in the town that Spanish-speaking residents referred to as Colón, the Spanish surname of Christopher Columbus. The American population referred to the same settlement as Aspinwall, named for William

Aspinwall, the shipping magnate who had become wealthy from California gold. At the Atlantic terminus of Panama's cross-isthmus railroad, the survey team waited for a train, standing amidst thatched huts, fruit sellers, merchants. Bailey, the botanist, described it as "a most forsaken hole . . ." On the Pacific side, they met a tugboat that transferred them to a 342-foot steam-driven paddle wheeler, the *Constitution*, anchored in the Gulf of Panama and soon bound for San Francisco. As they traveled northward, the boat was visited by swarms of butterflies, dragonflies, and hummingbirds, the deck covered in canvas to block the hot sun. By night, the canvas rolled back to reveal the stars. King was the entertainment.

"For him to start a story was but a signal for a crowd to gather," a survey member said.

In the middle of the night they stopped in Acapulco. Vendors paddled alongside the boat with torches. No one commented on the U.S. troops headed to the Mexican border, war rumors in the air. No indication by any of the scientists who saw the Mexican flag that former Confederate generals had retreated behind Mexican lines. Just musings on the Pacific sights. Even the cranky Bailey was inspired: "No memories of my life thrill me more in the recollection than those of this sail on the Pacific."

It was dark and moonless when the survey finally sailed through the Golden Gate, the strait for which the bridge was later named, and I don't know what hotel O'Sullivan checked in to, but Clarence King found a room at the Occidental, a seat of the burgeoning West Coast literary scene. In the next few days, the survey geared up, buying more scientific and photographic equipment, hiring more men and mules, soon heading for Sacramento, where they set up camp at a site a half mile from the capital: two to four men to a canvas tent, each in a wooden bunk, cooking over a fire in a trench with cook pots and Dutch ovens. The men branded pack animals with the symbol of the survey—two crossed geologist's hammers—broke in the mules, and allowed the mules to break them in.

As they prepared to cross the Sierras into the Great Basin, King met an old buddy, Dick Cotter, who had just returned from laying cable across the Bering Strait to Siberia. Cotter was recovering from exposure. King described him as emotionally frayed and, on the spot, hired him as a packer. While the survey team was waiting for the snow in the Sierras'

passes to clear, they were visited by Leland Stanford, the Gold Rush merchant, former California governor, future senator, president of the Central Pacific Railroad, and ardent photography enthusiast. King and Stanford likely discussed the deposits of coal and various ores that lay to the west, and surely King just talked, too, obsessed as he was with wealth and the wealthy. June arrived, but the snows weren't melting. On July 3 the survey geared up with the mules and wagons, the tents and supplies and started out for Donner Pass, already a notorious crossing, at an altitude of 7,239 feet.

Battle Born

I was up early on my second day in California, preparing to head north to meet O'Sullivan's survey. Exhausted from the previous day and anxious about finding a lake in a town that no longer exists, I packed the car, walked around to the front of the motel, and felt the warm light reflect off the hundred-million-year-old rock face of the High Sierras. The motel was on a bluff, and I looked out toward Mono Lake, a view

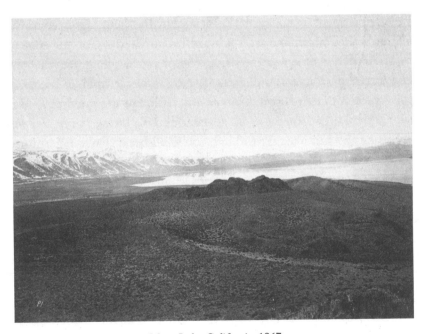

Mono Lake, California, 1867

I recognized from the photograph made by O'Sullivan on his first trip to the Great Basin. The smoothed-foil surface of the lake flattened out into an arid landscape and distant hills.

It was a gorgeous morning, and I expected to feel eager to go, but the infinite view overwhelmed me, and I soon found it difficult to set out. Moving at all felt like walking through a swimming pool. I went to the motel's café, bought a large coffee, and in a burst of impatience proceeded to spill the coffee, burning my hand. One of my hands doesn't work very well, as it happens, though you'd never know just looking at it, and being numb, it's especially bad at handling heat, all of which is to say that while I had been trying to be upbeat, losing control of the coffee immediately made me feel useless and down. Though I tried desperately not to attract attention, I apparently did—a woman kindly stepped away from her family to help me. Looking back now and remembering my intense frustration at the time makes me wonder about how, as the survey proceeded, the scientists initially reacted to the war photographer's temper, though the journals show he was eventually offered compassion, even as they refer disdainfully to his frequent reminiscences of the war. What was he feeling? What did he carry with him from that war?

Eventually I managed to summon some momentum, mostly out of embarrassment at having to be helped in the café. I gassed up the car and headed north and west, toward Fallon, Nevada, on the edge of the Carson Desert. It was the beginning of another long day, this one starting out at around 100 degrees. A veteran of car trouble, I felt like no match for a desert breakdown of any kind, but the good news was that the rental car was new, its air-conditioning strong, even if I felt zapped by the sun blasting through the windshield. I was determined to stay on roads that were relatively well traveled, even though two of the routes I was debating were minor secondary roads heading toward otherwise roadless areas and military test sites. Born and raised in the East, I hadn't been aware of the extent of the military test sites in Nevada, but now, trying to find a soda lake and a desert sand dune and looking at the map on the dashboard as I drove, the extent of military control appeared in stark relief. Assuming that I could find the soda lake, I hoped to determine the whereabouts of the giant sand dune, and as best as I could tell on my maps, it appeared to be surrounded by territories that the military used to practice waging war. In *Red Flag: Air*

Combat for the '80s, a 1984 account of anti-Soviet war games over the three million acres that comprise the Nellis Air Force Base Complex, Nevada is described from on high: "The land was cheap because it really wasn't much good for anything but gunnery practice—you could bomb it into oblivion and never notice the difference."

Nevada's state flag features the words "Battle Born," a phrase derived from the political midwifery of Lincoln, who, at the start of the war to suppress the Confederate secession, rushed the territory into statehood—first for the value of its mines, and second for votes: in 1864 the incumbent feared electoral defeat by Northerners who wanted to negotiate with the Confederates, who were then not winning but also not losing the war. During the transition from territory to state, the federal government set aside vast tracts of "unappropriated public lands," which eventually allowed the army and then the navy to carve out millions of acres of air space and bombing ranges, and then "electronic warfare zones" and, in 1951, larger nuclear test sites. Practice ranges were expanded in the early 1960s after unexpectedly high pilot and aircraft losses in Vietnam and, in the late seventies, to develop the B-1 stealth bomber. Jimmy Carter later proposed the development of the MX nuclear missile, to be carried on railroad cars that would roam a Pennsylvania-size section of the West, encompassing the dry valleys of the Great Basin in western Utah and eastern Nevada, before the program was canceled by Ronald Reagan.

In contrast to the Fortieth Parallel Survey team, which moved slowly by mule and foot, I moved quickly through each thirsty basin, each surrounded by its accompanying mountain ranges, one discreet panorama opening onto the next. Despite my speed, I kept picturing myself from outside the car, as seen from a plane, the tiniest dot moving slowly across a vast landscape. Long, thin snake-shaped clouds of dust moved slowly up and down the dry hills on either side of the car, evidence of a too-far-away-to-see pickup truck or an SUV. From time to time a slope showed off a patch of corduroy green, which I took to be a piñon-juniper forest. Mostly there were ranches and fenced-off land, but eventually I passed through the town of Hawthorne, its welcome sign decorated with implements of war. Just outside the main settlement, a U.S. Army ordnance depot covers 226 square miles of the dry basin and range, about the size of the city of El Paso, Texas.

The U.S. Navy relocated its ordnance depot to Hawthorne in 1928, two years after its principal ordnance depot, in Lake Denmark, New Jersey, was struck by lightning, destroying the arsenal, killing nineteen men, and leaving the base and the surrounding vicinity resembling, in the estimation of a base commander at the time, World War I's western front. Around the time that I drove through Hawthorne, officials at the Nevada base were investigating the death of seven marines who had been killed during a training operation when a mortar tube was accidentally loaded twice. On a recording of the radio call that went out during the incident, you can hear a marine shouting "*cas*," the military abbreviation for casualty: "*We have a mass cas! Mass cas! Mass cas!*" One of the severely wounded marines held his own airway open with his fingers as he waited for help, the nearest helicopter an hour away.

I got out of the car in Hawthorne, felt the relentless heat, and saw that I was too early to visit the Hawthorne Ordnance Museum, which, judging from the window, is a curated collection of old bombs and mortars. I bought a bottle of water at a gas station and, when I got back into the car and looked at the maps, felt newly frustrated by my lack of planning and time, but I steadied myself and drove on, my confidence turning tenuous again. Very soon I came to the edge of Walker Lake, a large, tranquil body of water laid down in the center of a dry basin. Its steel-blue wide-open expanse startled me. In a manner emblematic of the Great Basin's drainage patterns, the Walker River starts in the Sierras and ends up on the edge of the Great Basin as Walker Lake. As opposed to the major rivers of the world, which start in a high place and end up in the sea, Walker Lake is part of an endorheic basin, the term *endorheic* coming from the ancient Greek and translating to something along the lines of "the flow stays within." There are several closed-in lakes in the Great Basin, which is itself mostly self-contained: Lake Tahoe, Mono Lake, the Great Salt Lake. Something I came to understand very early on my first day is that Timothy O'Sullivan specialized in making pictures of endorheic basins—breathtaking dead ends.

A peaceful creek

I was standing on the side of the road, staring at the lake, the occasional car passing, nobody in sight, and yes, I was in a hurry, but there was

something about waking up on the other side of the Sierras and heading into the Great Basin that made me feel a little like I was in a different basin of time and space. I thought I was getting glimpses of the differences between the histories that had been imposed on the place, like the grid of a map, and the histories that seemed to emanate from it, like the heat-rippled air that was changing my view of the road before me. Here, at the outset of my survey of O'Sullivan's survey photos, I was just beginning to understand how little I knew about his photographs, despite studying them for so long, and I was just beginning to see the connections between the war against the Confederate rebellion and the war against Native nations in the West, as well as wars and military actions against other groups in the western United States. I left the lake, and after a few minutes I was driving slowly through the town of Schurz, home of the Walker River Paiute Tribe. *Agai-dicutta* means "people who eat trout" in the Paiute language, and the Agai-Dicutta Band of the Northern Paiute Nation live on the Walker River Paiute Reservation, established by President Grant in 1874. The trout still swim in Walker Lake, albeit precariously: the lake's level has fallen the equivalent of fifteen stories since water was first diverted for settlers' ranches. I took a quick detour into town, and I was surprised to discover that just a couple of miles off the main road is the grave of the Paiute spiritual leader Jack Wilson, known as Wovoka.

Wovoka was born near Walker Lake in 1856. Accounts of his origins vary, but in some he was the son of a man known as Tävibo, a disciple of Wodziwob, who, in the 1870s, had introduced the Ghost Dance, a way for tribes to revitalize themselves that would eventually unite tribes throughout the West. Various reports say that the idea of the Ghost Dance came to Wodziwob after a vision very near Walker Lake during a solar eclipse. He told his followers that if they danced, the buffalo would return, white settlers would disappear, and dead ancestors would return to a renewed landscape. In the 1880s, Wovoka began to encourage the Ghost Dance practice. "Our fathers are coming, our mothers are coming, they are coming pretty soon," Wovoka said. "You had better dance." In some instances he envisioned them coming on a train from the East.

From Walker Lake, moving all through Nevada and into California, Wovoka preached nonviolence as well as hard work, and tribal citizens throughout the West wanted to hear him speak, but groups of Indians

gathering to dance and pray made white settlers anxious, then paranoid, culminating in what U.S. history books refer to as the Ghost Dance War. In December 1890 the Ghost Dance War culminated in what is referred to as the Battle of Wounded Knee, though the term *battle* is, like the Ghost Dance War, a misnomer. It wasn't a battle; it was a massacre. Three days after the soldiers fired into the crowds of Sioux people, General Nelson A. Miles, a Massachusetts-born soldier who fought the Confederates with Grant and then transferred west to fight Native nations, surveyed the valley, counting the bodies of three hundred men and women lying there, covered by snow. Unarmed mothers killed while protecting their children were found as far as two miles away, and one baby was still alive, protected by the embrace of her mother, who while dying had stopped the soldier's bullets from reaching her child. The baby was wrapped tightly, a buckskin cap on her head. That child was taken from the survivors of her tribe, adopted by another general, whose wife raised her as Marguerite, an example of white settlers taking Native American children from their families, which was not made illegal in the United States until 1978, when Congress passed the Indian Child Welfare Act.

I learned that Marguerite worked with Buffalo Bill's Wild West show, and that the Sioux called her Zintkála Nuni, or Lost Bird. After she died, in California in 1991, her remains were interred at Wounded Knee alongside the rest of the Sioux who were buried in a mass grave in 1891. Small cherry trees were planted at the four corners of her grave. Afterward, Jim Garrett, a Cheyenne River Sioux citizen who was at the ceremony, described Wounded Knee and its surroundings. "At one time, this was a peaceful creek," he said. "No one really knew it except for the probably good hunting that was found here and the plentiful water and the plentiful shelter. But because of that fateful day in 1890 the whole world knows this creek today."

Clean the damn Indians out

Leaving Schurz, I crossed an old railroad track, wondering how a religious movement founded in this faraway-seeming town had spread so quickly across the Great Basin and the Rockies and throughout the Great Plains in the 1880s, all the way to the Sioux at Wounded Knee,

a thousand miles away. From my vantage point along Walker Lake I came to realize that part of the answer was the railroad, which, along with telegraphs and mining, was among the continent-crossing technologies on Lincoln's mind when Nevada was made a state. He said as much in his message to Congress in December 1864: "The great enterprise of connecting the Atlantic with the Pacific States by railways and telegraph lines has been entered upon with a vigor that gives me assurance of success, notwithstanding the embarrassments arising from the prevailing high prices of materials and labor."

Lincoln, a former railroad attorney, saw rail and telegraph lines in the context of filling the space between California and the Mississippi. "It is of noteworthy interest," he wrote to Congress, "that the steady expansion of population, improvement, and governmental institutions over the new and unoccupied portions of our country has scarcely been checked, much less impeded or destroyed, by our great civil war, which at first glance would seem to have absorbed almost the entire energies of the nation." And Lincoln's description of the in-between is ruthless: "The organization and admission of the State of Nevada has been completed in conformity with law, and thus our excellent system is firmly established in the mountains which once seemed barren and uninhabitable waste between the Atlantic States and those which have grown up on the coast of the Pacific Ocean."

By the time O'Sullivan was photographing the survey on its way across the Sierra Nevada—part of the "barren and inhospitable waste" between the Atlantic and Pacific—almost 60 percent of the U.S. population was redistributed onto lands occupied not just by sovereign Native nations but by Spanish-speaking communities, who were, in the eyes of U.S. nation builders, "treasonous in their apparent refusal to learn English." As old treaties were revised or broken, railroad lines disrupted hunting, access to water, and active trade routes, causing communities to relocate. The U.S. government argued that the railroad would help the Native Americans, civilizing them through employment. In his *Report of Surveys Across the Continent in 1867–68*, William Palmer, a railroad executive, engineer, and Civil War veteran, wrote, "I believe they will cease roving and stealing and take to steady work.

"Unless this country be penetrated by a railroad," he added, "it must be practically abandoned."

This analysis calls to mind what the railroads had been in the East during the previous few years—a crucial technology of war, starting with the First Battle of Manassas, when Confederate troops were railroaded in to rout Union troops. O'Sullivan took scores of photos of railroad bridges being built or protected or destroyed. General Sherman, while marching to the sea after burning Atlanta, dismantled all the Confederate train lines in his path, ripping up rails, melting them, tying them like pretzels around trees, a tactic that Sherman himself oversaw. "I attached much importance to this destruction of the railroad," he wrote, "gave it my own personal attention, and made reiterated orders to others on the subject."

When O'Sullivan's second boss, Alexander Gardner, made his trip west as a photographer around the same time as O'Sullivan, he made images, first for the Union Pacific Railroad, promoting its route, and then for the U.S. government, photographing the negotiations between Native American leaders and the United States that took place at Fort Laramie, in Wyoming, in 1868, presided over by Sherman. Very recently I read an online report published by *National Geographic* that described the negotiations Gardner photographed as "peace talks" and Gardner as a sort of accidental anthropologist. "Never before, and never again, would so many tribal leaders gather in one place, nor would anyone else have the chance to document a way of life that was so rapidly disappearing," the report said.

Yes, numerous wet plates that Gardner made at the so-called peace talks depict representatives of nations that included the Oglala, Miniconjou, Brulé, Yanktonai, and Arapaho, among others, but this statement is complicated for various reasons. Great numbers of Native people would assemble on the plains repeatedly after these talks, most recently during the Standing Rock protests. And though *National Geographic* made it sound as if the way of life of Native nations was disappearing because of something uncontrollable, like the flu, being in the way of the transcontinental railroad and the development it was designed to spur was like having your neighborhood in the path of a new interstate highway, and the Union Pacific's path had been a long time coming. It was surveyed in the 1850s by Jefferson Davis—at the time the U.S. secretary of war, who imagined a slavery-based empire that encircled

both the Gulf of Mexico and the Caribbean Sea—and funded in 1862 through the Pacific Railway Act, signed by Lincoln, a veteran, as noted, of railroad board rooms. The railroads were like sutures on the body of the continent, and the surgeons doing the suturing were speculators and railroad executives, former army officers who used the railroad to win the recent war and would next work to link the industrial economy of the North to the South's plantation system, rearranging western space to do so. "A Civil War battlefield," wrote Richard White in *Railroaded*, his history of U.S. railroad corporations, "sometimes seemed a convention of men destined for the transcontinentals."

The description of the Great Plains summit as peace talks also goes against what the military commander running the Wyoming Territory talks said they were. "This commission is a not a peace commission only," said Sherman. "It is also a war commission. The Great Father wishes us to be kind and liberal to the Indians of the plains, if they keep the peace; but if they will not hear reason, but go to war, then he commands that these roads be made safe by a war that will be different from any you have ever had before."

Three years earlier, the United States had met with representatives of all the tribes who had signed agreements with the Confederates— including the Creek, Choctaw, Chickasaw, Seminole, Cherokee, Comanche, Great Osage, and Seneca—to inform them that by fighting against the Union, they had forfeited all their previous treaty rights and were obliged to renegotiate. During the war, the Confederates had promised them land, annuities, and for those who enslaved Black people, the continuance of slavery. Now the United States wanted these tribal nations to take in freedmen and integrate them, treating them as citizens with rights equal to their own, an integration not happening in the North and only being enforced temporarily in the South. The United States also wanted railroad rights-of-way.

On the plains, the Sioux and Arapaho leaders, like their Paiute counterparts, first saw the railroad as an intruder to repel: trains disrupted traditional food pathways, and the immigrants who arrived with the railroads taxed them further: it took only a decade for non-Native hunters to destroy the great buffalo herds. Tribes initially responded with physical resistance, attacking surveyors, pulling up stakes,

removing bolts and fishplates, tearing down telegraph poles. The United States, in turn, brought in more troops. "We've got to clean the damn Indians out or give up building the Union Pacific Railroad," an Indian agent wrote.

In the Great Basin, the Paiute resisted throughout the 1850s, first by attacking the stage lines and then the forts built to support the incursion of settlers in Indian land, a period referred to as the Paiute Wars, even though the settlers (as well as the mining corporations they established and supported) were the ones doing the attacking and subsequent warring. By the time O'Sullivan and the King survey arrived, in 1867, miners had spread throughout Paiute land in the Great Basin. Meanwhile, smallpox outbreaks were killing the Paiute, and when O'Sullivan and the Fortieth Parallel Survey were entering the Great Basin, those who had survived were suffering through a famine so devastating that local authorities had uncharacteristically asked ranchers to go easy on any Paiute man accused of stealing cattle.

Close at hand

I followed the old tracks near Schurz for a while, and I came to see that while the railroad alongside Walker Lake began as a disconnection, it ended up connecting tribes throughout the Great Basin and the West, refashioned for tribal purposes, just as Sherman bent railroad lines around Southern trees. This was the first great realization that my resurvey of O'Sullivan's surveys presented: if the 1860s and '70s were decades remarkable for physical resistance by Native people against the concerted attacks on their territories, the 1880s and '90s were equally remarkable for the Native resistance that happened in the radical reimagining of the connections *between* tribes. I saw too that some of these reimaginings were made possible by the railroad, which, by the 1870s, some tribes began to embrace: the sutures were ripped out and restitched, the Great Basin's relationship to the West quietly refashioned. Sioux leaders, for example, began to negotiate for access to train routes, gaining tribal members free passage. Eventually, even the names of individual Sioux reflected their change of heart about trains: Iron Horse, Iron Wing, Iron Tail, Iron Shield, Iron Heart, and Iron Nation. Among the Shoshone Bannock in the north of the Great Basin, tribal leaders negotiated to ride

in the coaches, while the rest of the tribe was permitted to ride on freight trains.

In the Great Basin, the Paiute managed to secure free rail passes and rode in the cars or sometimes on top. Paiute citizens would travel en masse to do seasonal agricultural work, to meet alongside railway stations, to talk and socialize. Wovoka himself was known to travel by rail throughout Nevada and California, and when he had his visions, when he began to prophesize and teach the Ghost Dance, the leaders of tribal nations throughout the West rode the trains to visit him at his home near Walker Lake. Some Indian agents began to deny people permission to visit Wovoka, though the movements of Native people were generally restricted; by 1890, U.S. courts described Native people as "little better than prisoners of war." Some agents allowed visits, not understanding that they were aiding the spread of the Ghost Dance. "I would recommend that all the Indians be permitted to visit . . . ," wrote John Mayhugh, a former Indian agent, to the commissioner of Indian affairs, "as I am satisfied they will only send delegations from each tribe for the purpose of ascertaining the truth of the Prophesy . . . The Indians of Nevada expect delegations from most of the tribes north and northeast—and Sitting Bull is expected."

Until the massacre at Wounded Knee, dozens of tribal leaders came along the tracks I was following to visit Schurz, riding the Carson and Colorado Railroad. There were delegations of Ute, Shoshone, Cheyenne, Arapaho, Lakota, Bannock, Mojave, Kiowa, Navajo, and Nez Perce coming from around the Great Basin and the Great Plains and the Columbia Basin, all to meet with Wovoka. At Pyramid Lake, on the Union Pacific line, the Indian agent reported that more that thirty-four Indians from different nations traveled through the area during the spring of 1890. The railroad that ran through Schurz had been transformed from something that separated the tribes to something that connected them and encouraged resistance.

Not that I knew this as I drove along the road trying to find a soda lake somewhere an hour or so ahead; I would figure it out when I got home. On that morning in my rented Ford, I was half amazed and half overwhelmed by the enormity of the Great Basin, and after passing through Schurz, I was trying to remember all I had heard about the Ghost Dance, a communal dance that, it occurred to me, contrasted with

my isolated voyage locked inside an air-conditioned car. In the 1900s, Ella Deloria, a Sioux anthropologist, spoke with a Sioux man who had experienced the Ghost Dance as a boy, and when I read her interview with the man today, I am struck by the fact that railroad locomotives led to a remembrance that is so tangible, so palpable—and, in comparison with my experience of the road past Walker Lake, so un-lonely. It's a recollection through which I can almost feel the group dancing at the time, the whirlwind of heavy breath and bodies spinning, the wondrous emotions sweeping like a tide rising in a landscape of uneasiness:

> The people, wearing the sacred shirts and feathers, now formed a ring. We were in it. All joined hands. Everyone was respectful and quiet, expecting something wonderful to happen. It was not a glad time, though. All walked cautiously and in awe, feeling their dead were close at hand. The leaders beat time and sang as the people danced, going round to the left in a sideways step. They danced without rest, on and on, and they got out of breath but still they kept going as long as possible. Occasionally some-one thoroughly exhausted and dizzy fell unconscious into the center and lay there "dead." Quickly those on each side of him closed the gap and went right on. After a while, many lay about in that condition. They were now "dead" and seeing their dear ones. As each one came to, she, or he, slowly sat up and looked about, bewildered, and then began wailing inconsolably.

Vociferous and sweary

On July 9, 1867, Clarence King's Fortieth Parallel Survey at last crossed Donner Pass, the snowbound crease in the Sierras through which wagon trains entered California precariously from the East and then, after California was settled and mined, through which mining inves-tors would enter the resource-rich Great Basin from the West. William Bailey, the survey's botanist, wrote in his diary: "O'Sullivan's photo-graphic eye was tickled at this really splendid view [of Donner Lake], and he and I leaving our horses, climbed a little eminence in order to enjoy it fully." When O'Sullivan set up his tripod, the infamous gap had already been named for the Donner Party, a family of eastern settlers

who in the winter of 1847 notoriously died in the pass. When he opened his lens that summer day, crews were at work on the last segment of the transcontinental railroad crossing. His brass lens pictured the long wooden railroad sheds, designed to protect trains from forty-foot-high snows, here almost camouflaged in the collodion plate's translation of the ancient volcanic rock they crossed. What is not pictured is the work: construction crews used shovels to remove the granite that had been blasted by the nitroglycerin explosive called dynamite that Alfred Nobel had invented the year before. Just five months later, when the work at Donner Pass was done, the *Sacramento Daily Union* would write, "The track of that road reached the summit of the Sierra Nevada on November 30th and solved the question whether steam communication between the Atlantic and the Pacific is possible." Like telegraph wires or a nervous system, the West was, from the point of view of federal mapmakers, now in conversation with the East. The *Daily Union* exulted: "The mountains have been reconciled with the plain, and the soft lip of the sea has been made to kiss the rough brow of the Sierra."

Donner Lake, 1867

In his journal, Bailey shows us, first, how prissy he and the other scientists could be ("The language of these drivers is vociferous and sweary," he wrote) and, second, the tremendous work required to dig through the pass, work done mostly by men who had emigrated from China. "I went into the new tunnels and saw the Chinamen at work," he wrote. And yet the workers are invisible in O'Sullivan's pictures for Clarence King, especially the Chinese. Even the company engineers were reluctant to hire them. Leland Stanford was persuaded by the money that could be saved: Chinese workers earned the same as white workers but, in contrast, were not given food and shelter. Charles Crocker, the Central Pacific's head engineer, wrote a rare note of support: "I wish to call to your minds that the early completion of this railroad we have built has been in large measure due to that poor, despised class of laborers called the Chinese, to the fidelity and industry they have shown."

O'Sullivan wasn't the only photographer not picturing Chinese workers in the West, but making such a plate was like picturing a crowded stadium as empty. Sailors from Asia had known the Pacific coast of North America long before the 1840s, but when the Gold Rush began, large numbers of Chinese people landed in the Bay Area in hopes of finding gold—many from the Pearl River Delta region in Guangdong province, many of them peasants fleeing corruption and poverty in the unstable political aftermath of Britain's Opium Wars. By the mid-1850s, thousands were arriving annually, a West Coast version of what had been happening on the East Coast when the Irish arrived there in droves, also a result of British colonial policies. If Lincoln, in the era that capitalism had managed to extensively infiltrate world markets, was concerned about the labor cost of pursuing U.S. territorial expansion, the British Empire helped keep down the cost of labor.

By 1870, sixty-three thousand Chinese were living in America, 75 percent of them in California, many hoping to return home with money for their families. Just as nativist parties formed against the Irish in the East, anti-immigrant political parties formed in California, often led by the newly settled Irish. By the 1850s, in a move intended to restrict Chinese and Mexican settlement and limit Native American claims, the U.S. government limited naturalization in California to white citizens. Recently settled white Californian immigrants greeted newer Chinese immigrants with the Foreign Miner's Tax (later amended to

target Chinese miners specifically), followed by a law against wearing hair in a braid. The Workingmen's Party, the West Coast equivalent of the East Coast's Know-Nothings, inflamed anti-Chinese rhetoric, rioting in San Francisco's Chinatown. In 1870, in what was then the small town of Los Angeles, a white gang wiped out the city's Chinatown. Independent Chinese miners gave up on gold and went with labor contractors who assigned them to large-scale agricultural jobs and railroad construction.

By the time the Fortieth Parallel Survey arrived at Donner Pass, 90 percent of the railroad's workers were Chinese, eight thousand tunneling, three thousand laying track. The westward-bound Union Pacific Railroad employed predominantly Irish laborers, the relationship between the two immigrant groups complicated by the fact that Chinese workers often worked for less pay and were derided as inferior by most of the Irish, the quality of their work to the contrary.

"How did you find them to compare in that heavy work on the Sierra Nevada tunnels, deep cuts and rock-works, with the white labor you had?" James Strobridge, the superintendent of the eastward-bound Central Pacific Railroad, was asked.

"They were equal to the white men," he replied.

Riots broke out all along the West Coast and up into Washington and Canada, a bloody trail that followed the new lines of the railroads. The Chinese workers were killed by mobs, their shanties burned. Men who died were buried hastily, few records kept on the dead, though wealthier workers arranged for their remains to be sent to China. In 1870 the *Sacramento Reporter* informed its readers that twenty thousand pounds of bones had been dug up from shallow graves and shipped away to China.

They cross the pass at night

Beyond the tunnels, the U.S. Geological Exploration of the Fortieth Parallel moved through Donner Pass at night, when the frozen snow made the route crossable for the mules and packers but still frustrating for O'Sullivan, his ambulance heavy with chemicals and fragile plates of glass, and as my rental car closed in on the alkali lake near where the team began their surveying—their first base camp—I was imagin-

ing O'Sullivan's arrival in the Great Basin, picturing the photographer in a state of frustration, perspiring in the cold. On that dangerous, icy nighttime crossing, he was, diaries tell us, aggravated by all aspects of the logistics—according to a companion, "in a perpetual state of profanity"—a comment that reminded me of the last time I'd gone off on a trip alone, more than a year before my own survey. I was with a war photographer who, having just returned from a difficult assignment in the Middle East, was sent to photograph a story I'd been assigned in a disaster zone outside the United States—this was just before I got laid up and had to put my own travels on hold for the better part of a year. This photographer was an excellent work partner, and I liked him straightaway. He could talk to people and moved smoothly through complicated situations, with careful attention, though in a couple of days I noticed that he could boil up easily, especially in the face of what I'd call small injustices, people in charge treating bystanders poorly. Nonetheless, his photos were warm and patient, and I thought of this contrast in temperaments as a matter of him being a too-sensitive plate, who, given his experiences, was moved intensely by the violence that the rest of us took a while to see. I thought of him often that day while following O'Sullivan's trail, thinking about the ways a war photographer carries memories of war like images on memory cards or exposed rolls of film.

My experiences traveling with photographers also led me to imagine that O'Sullivan was consumed by his work, taking in views, anticipating logistics, shepherding supplies. Interstate 80 runs through Donner Pass today, offering travelers a rest stop with fourteen truck parking spaces and a pet area, the historic markers noting not so much the petroglyphs along the rocks or the thousands of Chinese workers who died while dynamiting through them, instead pushing one western past over all others. The cabins that the Donner Party holed up in in 1846 were being preserved and memorialized when the Fortieth Parallel Survey came through two decades later, even though the Donners were by no means the first eastern overland settlers to colonize California.

In May 1844—very likely when Timothy O'Sullivan's family had just arrived in the United States from Ireland—the Stephens-Townsend-Murphy Party left Council Bluffs, Iowa, with a group of Oregon-bound, largely Irish settlers. Those ten families tried a shortcut across the Carson Desert. Things went badly. The party split up; a woman gave birth in a

snowbound camp in the mountains, and an eighteen-year-old boy was left behind to guard the wagons, spending the winter alone in a cabin. But unlike the Donners, the Stephens-Townsend-Murphy Party survived. Two years later the Donner Party would spend the winter in a cabin the earlier party had built. In the Alder Creek meadow, twenty-two men, women, and children ate boiled animal hides, charred bone, wild mice, and their dogs. Then, after half the party had died, they ate their dead, on or about Christmas Day. "A woman sat by the . . . body of her husband, who had just died, cutting out his tongue," exclaimed a California newspaper. This was, the reporter noted, even as the last survivors were being rescued. "The heart she had already taken out, broiled and eat [sic]."

A survivor published an account of his ordeal in 1849. By 1876, Bret Harte, a friend and an editor of Clarence King's, published a fictionalized account of the Donner Party's cannibalism in a novel called *Gabriel Conroy*, some details of which James Joyce, in 1914, used in "The Dead." But unlike the deaths and murders of thousands of Chinese workers and the state-sponsored genocide of Native nations, the Donner Party's misfortune was publicly mourned, most especially by the easterners who had moved to the West to coordinate its development. In 1981 the Native Sons of the Golden West dedicated a monument to the Donner Party—"in commemoration of the pioneers who crossed the plains to settle in California." The Native Sons were leaders in the campaign to exclude Japanese Americans during World War II. Richard Nixon was a member, as was Chief Justice Earl Warren and California governor Edmund Brown, and in 1920 the Native Sons' president described the group's purpose: "California was given by God to a white people, and with God's strength we want to keep it as He gave it to us."

The *actual* Native people in and around Donner Pass are invisible when the Native Sons' version of the Donner Party is told, but in 2001, Julie Schablitsky, an archaeologist doing research on the Donner site, approached the Washoe Tribe of Nevada and California, whose homeland includes Donner Pass. "Until now the Native American perspective has been left out of the telling of the Donner tragedy, not because the *wel mei ti* [Northern Washoe] did not remember the pioneers," Schablitsky wrote, "but because they were never asked, or perhaps were not ready

to share." In honor of their ancestors, two Washoe elders shared stories in which the Washoe recount how the small group of travelers was easy to notice—for trying to cross so late in the year with large wagons, for camping in a spot unsuitable for the season, for seeming unable to make use of the resources that were (to the Washoe) in plain sight. In one story, the Washoe pity the Donners and bring rabbit and wild potatoes to the campsite. In another, the carcass of a deer is carried to the site of the stranded settlers, who proceed to shoot at the Washoe. "The migrants at Alder Creek," Schablitsky wrote years later, "were not surviving in the mountains alone—the northern Washoe were there, and they had tried to help."

The size of Rhode Island

As I groped my way north and west, I was closing in on the soda lake that O'Sullivan had pictured, my first destination, but mostly I was beginning to understand the Great Basin as a place of various silences, some peaceful and vast, many violent, a residue of centuries of nation-building that—in the words of Ned Blackhawk, the Western Shoshone scholar whose family has lived in the area for generations—"predated and became intrinsic to the American experience." "Violence and American nationhood, in short, progressed hand in hand," Blackhawk wrote.

In the closed-in compartment of my rental car, these thoughts mixed with the road's white noise. I could see the Wassuk Range, the Agai Pah Hills, and then a lonely mesa on the edge of the Terrill Mountains, beautiful, arid folds laid on the infinite landscape, backed by a watercolorist's wash of gray sky. Everything seemed so vast, and the more I drove, the more I felt like a tiny bird, flitting and gliding and skittering but unable to soar through the vastness and also somehow unable to land.

A few miles outside of Fallon, the desert suddenly turned into the preternatural green that marks irrigated land. My tentative plan had been to drive through Fallon and head west, on State Route 50, which is the old Lincoln Highway, an early cross-country automobile route that often follows the nineteenth-century overland settlers' wagon trails. I was hoping to find the soda lake, and then, if I still had the nerve, I would drive more hours toward what I thought was the Carson Sink,

taking what on my road atlas was a dicey-looking back road. In the Carson Sink I would find the giant sand dune that O'Sullivan photographed around the same time—among his most discussed western images in the small circles that discuss him. I had it in my head that finding the soda lake and then the giant dune came down to choosing the right turn and, likewise, that the wrong turn would be a four-hour, faraway mistake.

Second thoughts turned to muttering, and then an exclamation to no one as I realized there was a fork in the road that I had just missed. Amid a blur of profanities, I somehow knew to pull over quickly, back up, and take the turn. A passing car honked, the driver illustrating with feverish gesticulations his feelings regarding the last-minute decisions I'd made to drive in reverse as I swore profusely at a fork in a state highway.

Now, as I look back, I see this turnaround as my single best decision, a quick shift that changed everything, despite the haze of angry frustration. Fallon is the seat of Churchill County, which is itself about five thousand square miles, the size of Connecticut. In retrospect, if I hadn't taken the bypass, I probably would have gone off looking for a pile of sand in a sandy area the size of Rhode Island. I landed in Fallon, made a few inquiries, and in fifteen minutes was pulling up to the edge of the soda lake on the outskirts of what was once known as Ragtown. I parked the car on the side of the road and walked a few yards up a short steep incline to look out on the kind of sand-lipped lake that geologists refer to as a maar. A wide, shallow crater, a maar is evidence of a volcanic explosion, a place where the earth broke through its own skin. This maar was the size of a couple of Olympic swimming pools, a volcano cone filled with water, and the longer I looked down into it, staring hard in hopes of seeing its bottom, the more I felt as if I were under hypnosis, frozen in the clear dark liquid staring back at me.

I stood there for a while, waiting and watching for the earth to slowly boil up, or for an image to develop, but even with a light breeze the hundred-degree heat was harsh. Looking around, I could see Virginia Peak, a nearby mountaintop, and the cut in the Sierras in the vicinity of Donner Pass, and when I laid my printouts of O'Sullivan's pictures on the hot earth, I marveled at the ways the view matched O'Sullivan's panorama—the distant peaks of the Sierra Nevada aligned;

even the vegetation, or the lack thereof, looked similar—and I thought about the meaning of the men with guns who are posed in his picture. They were, it seemed from my new vantage, standing on a hilltop, as if in guard towers or the crow's nest on a ship. Now I looked out at the landscape myself, seeing a wide-open rangeland on one side, a residential neighborhood on the other. I heard a dog bark, making me feel watched too.

It's still called Soda Lake, and it wasn't until much later that I learned about the soda works that were hidden under its surface along with a well-preserved cottonwood grove. Sodium carbonate, it turns out, was required for mining Virginia City's Comstock Lode, about fifty miles southwest, and they mined it from what was a shore of the old lake. In the delicate desert, the lake level rose, a side effect of the giant government water project that backed up the local rivers and eventually gave the farm fields in Fallon that bright green. Or, as a local historian wrote, "Irrigation water from the massive aqueduct system, which brought water to the desert valley from the Carson and Truckee rivers, percolated into the groundwater and caused the lake level to rise." When I compared the old and new photos, I realized that Soda Lake had risen since O'Sullivan photographed it. After I left the site, I came to see his photograph as two things at once: a photo of a lake that was under control, armed men patrolling the volcanic-rim hills that are its shore, but also a picture of a breach or a rupture. In the rush to map and control the area, this oversize pond was a casualty, a body of water rising as though boiling over.

4

Desert Sand Hills near Sink of Carson, Nevada, 1867

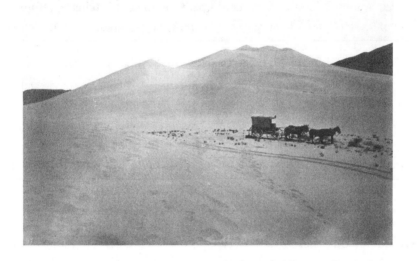

It strikes me now as strange that so much is described in terms of desert in the Great Basin. When I think back on my search for the giant dune that O'Sullivan photographed, I think of it less as a trip in a car and more as a search at sea or out on an ocean. I was sailing through places but also through the past, or various pasts, looking for clues as if they were buoys attached to something deep. Downtown Fallon was just a few miles from the soda lake, and it felt like a protected cove or a safe harbor, even more so as I look back. It was there I discovered the site where O'Sullivan made his photograph of the dune, *Desert Sand Hills.*

I discovered the site on a handmade, pool table–size raised relief map of Churchill County hanging just inside the Churchill County

Museum and Archives, and the find—momentous for me in terms of time-saving logistics—was the result of another spur-of-the-moment rerouting. After seeing the museum from the road in the corner of my eye, I turned the car suddenly, again irritating more unsuspecting drivers. When I think back on this particular trip, it's a wonder I wasn't escorted from the state, or worse, given how agitated I seemed to be, so scared yet ready to explode. Suddenly, as I stumbled into the air-conditioned embrace of the local museum, the fear of driving long hours the wrong way into a desert that was most likely part of or adjacent to a military bombing range vanished. The museum's collection of preserved automobiles and farm equipment, of ancient kitchen equipment and old bottles, felt encouraging somehow, or even like a rescue—I had the sensation of coming upon life vests thrown overboard. Looking at the map, I was back in elementary school, drunk on tactile pleasures: I pressed plastic buttons on a handmade wooden console and watched corresponding indicators light up on the wall before me, directing my gaze to particular hills and bodies of water, to old highways and ghost towns and (I was pretty sure) a stretch of white that was the giant sand dune. Seeing Fallonites moving in and out of back rooms, I felt confident that someone could point me toward the place where O'Sullivan had parked his ambulance and made his picture.

On the giant wall map, I saw the Truckee and the Trinity Range mountains that the Fortieth Parallel Survey team surveyed and photographed in that first season. I saw the nearby U.S. Naval Air Station and the reservation of the Fallon Paiute-Shoshone Tribe, and I saw the old wagon trails that converged in the area, including the Truckee branch of the overland trail to California, which eventually became the first transcontinental railroad and then Interstate 80. I saw the Pony Express route of the 1860s that became the Lincoln Highway of the early 1900s that became today's State Route 50. I saw roads to a mining town called Fairview that, like the nearby town of Wonder, no longer exists. When gold was discovered in California, in 1849, twenty-five thousand people traveled through the basins and around the ranges and across the county that would be named for Sylvester Churchill, the Vermont-born newspaper publisher who made his name in 1847 in what is referred to in Mexico as the *intervención estadounidense*, or the U.S. intervention. For decades, Churchill County was a way station for settlers; Ragtown was

named for the rags that littered the trees and sagebrush, hung to dry or discarded by the California-bound travelers.

By the time O'Sullivan and the Fortieth Parallel Survey team arrived in Ragtown, the Carson Sink was a celebrity desert—notorious on the East and West coasts as the biggest obstacle to incoming settlers between Salt Lake City and Donner Pass—the Forty Mile Desert. Ragtown was an 1867 version of a busy interstate highway service area, most of the traffic, in contrast to the survey team, arriving from the East. In Ragtown, the Fortieth Parallel surveyors might have overheard California-bound settlers discussing the deep sand of the desert they had just traversed, its prickly pear cacti, the small, beautiful plants and grasses, including Indian paintbrush, sand lily, and apricot mallow. More animated discussions might have concerned the rattlesnakes, the scorpions, and the dry hot winds that made dust devils of sand and dirt. Particularly strong winds could overturn wagons.

The fact that there was no water on the crossing was a frequent topic in journals and newspapers, with special attention paid to water that was a mirage and water that, if you drank it, killed you, due to alkali poisoning. Reports noted that when rain came at last, the sand was transformed into an impassable ooze. George Willis Read, who crossed the Forty Mile Desert in 1850, described every vessel on his wagon as being hopefully filled with water at the outset and then, close to the end, desperately empty. The passage was, through his eyes, miserable. "Deep sand which continued for 14 miles," Read wrote. "I saw 200 wagons in ½ mile and dead animals so thick you could step from one to another." People spotted pistols, dishes, boots, and clothing, all discarded along the desert route, as well as hastily buried relatives. An 1850 survey detailed 1,061 dead mules along the trail, as well as 5,000 dead horses, 3,750 dead cattle, and 953 human graves.

In contrast, Ragtown was comparatively lush, a greenish node that marked the desert's end. Beginning in the 1850s, it also marked the return of commerce, in the person of Asa Kenyon, a transplanted New Yorker who ran a supply station where he charged the kind of exorbitant prices that today are charged in airports. ("Humanitarian or Opportunist?" a history column in *The Fallon Post* asked recently.) Reports described him hiring local Paiute men to scare off or steal travelers' livestock, after which Kenyon acted as a negotiator between the

Paiute and the settlers, taking a fee from the people passing through. Above all, the Paiute were repeatedly ridiculed by desert crossers. Mark Twain championed the rights of Chinese immigrants and African Americans throughout his life and railed against corruption and injustice everywhere, but when it came to the Paiute, Twain was harsh, even for him. In *Roughing It*, his account of arriving in the Great Basin, he wrote, "These Goshoots . . . who produce nothing at all, and have no villages, and no gatherings . . . a people whose only shelter is a rag cast on a bush to keep off a portion of the snow, and yet who inhabit one of the most rocky, wintry, repulsive wastes that our county or any other can exhibit."

It was as if white settlers who were moving in to colonize Paiute land blamed the Paiute for the harsh climate and its terrain, which could be harsh, certainly, but also bountiful, depending on how you lived. All these stories were based on the idea that these dry flats and waterless valleys were wasteland, as devoid of value as the people who lived there.

A lively scene

See the Fortieth Parallel Survey moving their mules down the rutted slopes of the Sierras on that June morning. See them making their way east, into the land depicted on the giant raised-relief wall map that was then centered on Ragtown and is now the city of Fallon, population approximately eighty-four hundred. See O'Sullivan's converted war ambulance and hear it slosh with chemicals as it bounces alongside the Truckee River into the wide-open area outside of what is today the city of Reno's office towers, sprawling suburbs, and casinos. Picture plumes of dust as the teamsters struggle to control their heavily laden mules, eventually setting up camp at Hunter's Station, a stagecoach stop just east of Ragtown. On the evening that the survey team arrived, three stagecoaches pulled in, all coming from the East. Close to one hundred passengers milled about, waiting as thirty-six fresh horses were harnessed. "It was a lively scene," wrote Bailey, the survey's botanist.

At this point Clarence King and his team were making their very first surveys, the geologists chipping away at rocks in the vicinity of Hunter's Station, the botanist and ornithologist collecting samples, white rim lichen and an ash-throated flycatcher. O'Sullivan was hauling his gear from his converted ambulance, packing up a mule with

his camera, portable darkroom, and just enough chemicals to make wet plate pictures of the survey's encampment and the hills beyond the campsite. The team moved on the next day to Glendale, even closer to what is today Reno, where a small party headed a few miles north to the peak of Peavine Peak.

This was the practical King, the King whose schematics would determine the way the continent would subsequently be mapped and detailed—by 1879, Clarence King would become the founding director of the U.S. Geological Survey, the nation's first civilian government science agency. And this is how the West was mapped, how it was sized up by the East and for the East—or, more accurately, for its government-backed investors. As they would over and over, the surveyors triangulated, starting with the major peaks, moving to a series of smaller triangles within the swath of the survey, views from the tops of the hills. They measured elevations with their cistern barometers, which were long, mercury-filled glass tubes. They set up barometric base stations and, via the just-completed telegraph, compared astronomical readings in the basin with longitude data back east, then combined their notes with those made by earlier railroad surveys.

You can drive to the top of Peavine today, and you can look east back to the Sierras and west into the Fortieth Parallel Survey territory. You can see where bachelor Basque sheepherders carved their names into the trunks of trees, arborglyphs that date to the 1860s, when Basque men first migrated to the region. You can see the Reno area's TV transmitters and a modern weather station. King put James Gardner in charge of mapping, and you can imagine the already harried geologist on Peavine Peak, looking east toward Ragtown, about seventy-five miles away. You can imagine how, a few days after Gardner climbs the hill, the Fortieth Parallel Survey team breaks camp and presses east to a settlement called Wadsworth, within striking distance of Ragtown.

To stimulate conversation

I was feeling better about striking out for the giant sand dune somewhere in the Great Basin, but I still didn't know its precise location. More than that, I felt somewhat at ease in the Churchill County Museum and did not want to leave—I was just fine with being stranded forever in a way

station. Like an old stagecoach stop, it too was a lively scene, as well as an oasis from the heat that was wearing me down. When I walked into a room devoted to photographs of Paiute people that were made in the 1960s by a local resident named Margaret Wheat, I became transfixed by the photos as well as by the transcriptions of interviews with Paiute elders living at that time—descriptions of the way willows made cradle-boards for babies, or the way willow and tule made homes or boats, or the ways duck decoys were made with cattail or tule, as they still are. The photos celebrated a particular Paiute band known as the "Si-Te-Cah" or Saiduka, which translates as "tule-eaters." These are the Paiute who were, among other things, pushed to become farmers as settlers arrived in the 1840s, when the ubiquitous cattail, or tule, was instead cut for animal grazing. "Making cordage nets and deadfall animal traps in the manner of the old ones," said one caption.

When I realized I had lost track of time, I quickly made my way to the museum's front desk to see if anybody knew the whereabouts of the dune. I approached a young receptionist, bearing my copies of Timothy O'Sullivan's images. She told me that I should show the photos to Bunny.

"When anybody on the staff has a question, we don't ask the internet, we ask Bunny," she said.

I didn't completely follow, but that sounded good to me, and I said so. At issue was whether Bunny was around. The receptionist suggested that I not get my hopes up, it being Bunny's day off. But in a few minutes Bunny Corkill came bounding out of a back room like a teenager, despite being in her seventies, and when she spoke to me, she did so as if she had known me forever. She nodded back at the young woman, smiling slyly. "She's only worked here a few years," Bunny said, winking. "I've got twenty-seven. I'm trying to teach her how to bite people at the heels. She's learning!" A few years after my visit, when Bunny retired, the museum's director wrote: "If we had a dollar for every time there was a question for which the first answer was 'Ask Bunny' the museum would have a multimillion-dollar endowment."

Looking at me, Bunny clapped her hands together and asked what I needed. I began trying to explain myself and, in so doing, began to overexplain and in no time was flustered, incapable of stating what I was looking for. To my defense, it had been close to six months since I had spent much time in public settings. Eventually Bunny gently cut me off.

"You want to see the O'Sullivan photographs," she said. I hadn't even mentioned the photographer's name.

Bunny marched me to a small back room full of file drawers. "A volunteer built this for us, and they're a little bit Fred Flintstone, but they work," she said. I nodded, not exactly sure what she meant, and she showed me a drawer filled with large note cards, each with a small photocopy of an O'Sullivan photo attached, each annotated by a museum worker who had gone to the National Archives to research the images: it was as if Fallon had kept a scrapbook of where images of their landscapes had been, places the images had seen. Unfortunately, the annotations didn't say precisely where O'Sullivan had made each photo, but looking at them while in Fallon, I felt their proximity like a breeze in the room.

I packed up carefully and found Bunny regaling a group of young people. She spotted me and told me how lucky I was that she had come in that day. She said it with such positivity that I began to feel first lucky, then really lucky. When I managed to flat out ask her the location of the dune, she told me to just drive west on State Route 50. Because I had limited time, and for various other reasons, I pleaded for more guidance, but she waved me off, diminishing my feeling of luckiness. "You can't miss it!" she said.

I protested. She was shaking her head. "You can't miss it," she said again.

It turned out I could miss it, but in missing it the way I did, I was closer than I would have ever been had I not met Bunny. Before I drove away, I went back one more time to look at the photographs made by Margaret Wheat.

The once-great mother lake

In 1967, when Margaret Wheat published *Survival Arts of the Primitive Paiutes*, a few white scholars were slowly coming around to the idea that the people of the Great Basin nations were not scavengers, but sophisticated environmental stewards. Obviously this was not news to the Paiute, but it marked a crack in the prisonlike fortress of history in which the Paiute had been incarcerated, as well as a glimpse of how that violence might be undone. In a 1969 review of *Survival Arts*, a curator at the Natural History Museum of Los Angeles County wrote that Wheat

described "a 'web of nature' relationship of the Paiutes to animal and
plant life"—a relationship that would today be described as ecologi-
cally balanced or sustainable, in contrast to Anglo-American relation-
ships that centered on dams or logging or mining. That the reviewer
of Wheat's book was authorized to critique Native culture by virtue of
his position as a curator of a museum of natural history—as if the Paiute
were flora or fauna from the past—indicates that to some people it was
news that the Paiute had survived and were still surviving.

It occurred to me, in reading Wheat's work, that she had thought
deeply about the Great Basin's military history, starting with the work
of John C. Frémont, the military commander who surveyed the thirty-
eighth parallel for the War Department in 1849, when he coined the
term Great Basin. Wheat saw the term as an example of his many mis-
conceptions: he might better have called the region the Many Great
Basins. As Wheat came to understand, the basins were a series of uplifts,
valleys that face mountains that are raised steeply on one side, sloping
gently on the other. Each basin is a self-contained world. Frémont had
searched for a railroad route across the Rockies, hoping to find the fabled
Buenaventura, a river said to flow from the Rockies to the Pacific. "In-
stead," Wheat wrote, "he found only small thirsty streams that vanished
in dusty flatlands."

Consider the contrast between the way Margaret Wheat saw the
landscape in 1967, when *Survival Arts of the Primitive Paiutes* was pub-
lished, and the way Colonel John Frémont saw it around 1847, when
he published his survey report, *The Exploring Expedition to the Rocky
Mountains, Oregon and California: To Which Is Added a Description of the
Physical Geography of California, with Recent Notices of the Gold Region
from the Latest and Most Authentic Sources*. As the colonel and his survey-
ors came upon each new stream, each was a fresh disappointment: his
topographers mapped and wrote each basin away, ultimately declaring
the region to be broken, a wasteland—"believed," he said, "to be filled
with rivers and lakes which have no communication with the sea." Like
Lewis and Clark, Frémont was looking for a line through, a path for
the expanding American empire; he was not inclined to dwell on the
connections between basins, much less the inhabitants who understood
and lived with and depended on these connections. It is true that during
the Pleistocene era, the Great Basin appears to have once contained one

great lake. But today (as in Frémont's time) two smaller lakes remain, Pyramid and Walker. "Both are briny, containing the concentrate of the once great mother lake," Wheat wrote.

Written a century after Frémont, Wheat's book was the culmination of a life spent living and working in the Great Basin. *Desert* is a word born in European notions of abandonment, land left or forsaken, lacking investment or any possibility of wealth accrual, and though Frémont saw the ancient lake's disappearance as an end, Wheat came to see it as just another beautiful beginning. For her, the accretions of concentrated salts and minerals are akin to artworks, what she describes as "weirdly shaped castles and caverns of coral-like tufa." As the lakes receded, people entered the basins: the beginning of the ice melt marks the beginning of human habitation, a beginning of time. They walked the shorelines, leaving spears and tools. They took shelter in caves and cached food. They built fires, buried their dead in the caves. Camels, shrub-oxen, bison, and horses were likely game. Wheat wrote:

> Following the slow retreat of the shore line down the mountain slopes, generation after generation of Indians developed new skills and abandoned old ones. By the time the valley bottoms were dry and the once magnificent inland sea was reduced to reed-choked marshes and briny, treeless lakes, the Indians had learned to weave watertight baskets and had discarded the atlatl for the bow and arrow. Most importantly, they learned to survive in an inhospitable land where short, green springs were followed by long, brown summers and clear, cold winters.

Visitors—surveyors, explorers, trappers, guys in rental cars, or, prior to the rental car era, people who were crossing the Great Basin in covered wagons: these visitors did not so much learn to survive the Great Basin as endure in it or adapt it to their way of life.

I began to sense in Wheat's writing the appreciation of someone who, against prevailing currents, cultivated a patience for the landscape that perhaps led her to look again at the Great Basin people whom surveyors and writers and politicians not only wrote off, but rounded up, the people who were her neighbors. Wheat's work in the 1970s—in archaeology and conservation and in documenting the Paiute culture around

her in collaboration with Paiute elders—is so rich and formidable that it makes me wonder if she were working to atone in some way for her family's past: when Wheat was two, her father moved to the West to direct the Newlands reclamation project, the water program that, beginning in 1902, diverted the Carson and Truckee rivers. Beginning in the 1940s, until her death, in 1988, Wheat was devoted to recording the arts and beliefs of the northern Nevada Paiute tribes, working most often with her friend Wuzzie George, a Stillwater Paiute tribal elder. Wuzzie is the Anglo version of her actual name, transliterated as Wiziʔi. She was born around 1882 in the mountains near Fallon, while her family was on a pine nut–gathering expedition in the fall. Her father worked on a ranch, and her mother washed dishes at a hotel in Stillwater, often leaving Wuzzie with her grandmother, who taught her traditional skills. When Wuzzie George died, in 1984, she was thought to be 104. Catherine Fowler is today a professor emeritus at the University of Nevada, but as a student, she got to know Wuzzie George at Peg Wheat's home. "Peg, Wuzzie, and I visited the many places Wuzzie remembered from her youth; gathered food and medicinal plants; wandered the marshes looking at waterfowl; and generally talked and laughed," Fowler wrote in 1990. "Peg and Wuzzie were both exceptional women." In materials organized by the Nevada Women's History Project, I read this sentence: "To stimulate conversation, Peg sometimes drove around the state with one of her Paiute acquaintances, recorder in hand, letting geographic features stir memory and association."

Targets

My guess as to the whereabouts of the dune that O'Sullivan photographed—the guess that I flew to L.A. with and was betting on and probably would have gone with had I not accidentally stumbled upon the Churchill County Museum—turned out to be way off. It was not down the lonely, barely marked dirt road that led an hour north into the Carson Sink and its various off-limits military reservations, a desert where I feared I would break down and, with a body that was not in its best shape, die. The dune was only a half hour out of town, right off Route 50, a stretch of road nicknamed "The Loneliest Road in the World," though not that lonely compared with the roads that ran off it

into ranches or bombing ranges or sacred lands, or combinations of all three. The dune was even marked as a recreation area, a park unto itself. The single biggest reason I shouldn't have missed it is that the dune is huge, about six hundred feet tall, half the height of the Empire State Building and nearly two miles long. And yet, about twenty minutes after driving out of Fallon, I managed to pass it right by.

My precise route to missing the dune began in downtown Fallon, where I stopped for a quick sandwich at a café. Looking around, I realized that the walls were decorated with photos of pilots wearing Ray-Ban sunglasses. The pilots were all standing alongside fighter jets, all flown out of the nearby Fallon Naval Air Station, home to four bombing ranges, an electronic warfare range, and the longest runway in the navy, fourteen thousand feet—though, as I learned when I got home, the navy was planning to triple the size of the base at the time, closing off public lands that were formerly Paiute and Shoshone territory, rerouting state highways, and expanding the training area for Navy SEALS. The reason for the expansion had to do with the growing needs of the military in the Battle Born State, due to what the military considered its increasing demands in the world. Where once the navy jets flew missions at about ten thousand feet and approached targets from about four to five miles out, today they fly at thirty thousand feet, firing from twelve miles out, and newer bombs require larger blast zones. Most of the Carson Sink is a target, it turns out, or numerous targets, and the area in which I had mistakenly thought O'Sullivan made his sand dune picture is full of replicas of human constructions designed as targets: a target transmission station, a target industrial site, a target submarine. In defending the expansion, the navy said, "Achieving this proposed modernization of Navy training will help keep our nation safe now, and in the future."

Len George, a U.S. Army veteran who was the chairman of the Fallon Paiute-Shoshone Tribe for two decades, beginning in 2002, is the great-grandson of Wuzzie George, and in 2020 he wrote an op-ed opposing the expansion. "When non-Native settlers arrived on our lands, the United States government allowed us to keep only tiny Reservations that we did not choose. Consequently, we continue to utilize our ceded ancestral lands—presently public lands—for religious and cultural activities such as gathering, hunting, ceremonies and burials. The proposed expansion of NAS Fallon would destroy our way of life because it

would allow the Navy to bomb our burials and other important cultural sites, and deny us access to those areas. Congress would never allow Arlington National Cemetery to be bombed for training exercises or ban the public from going there to pay their respects; our sites deserve the same protection." Already, the bombing had destroyed Fox Peak, a sacred site.

By 2022, Nevada legislators joined together to triple the size of the bombing range, and when I read the news, I recalled a conversation I'd had shortly after first visiting Fallon, when I spoke with Donna Cossette, a member of the Paiute-Shoshone Tribe, who told me that at the various public meetings on the expansion, she suggested to the military commanders of the air base that they would do well to remember her face, given that, if they expanded the base, she was not staying off what was her land. "I told them they'd be seeing it again and again," she said. "I will be the one you will be arresting from our sacred places because that is how important it is to me." She also mentioned that the sand dune I was looking for was itself a powerful point in the Paiute landscape, and she asked me if I had felt it.

A change in the means of locomotion

When I left the little café in Fallon, I thought of O'Sullivan heading out to the dune, as reported in *Harper's New Monthly Magazine* a few years later. "For this trip an ambulance drawn by a team of four mules was used instead of the pack mule," wrote the correspondent, "a change in the means of locomotion that enhanced the comfort of the artist, and enabled him to transport a sufficient quantity of water to make the variety of views that he proposed to add to his already magnificent and valuable collection." I drove east on Route 50, past the Paiute-Shoshone Reservation, on the edge of the Stillwater National Wildlife Refuge. I read in the refuge's informational material, "These tremendously rich and diverse wetlands attract more than a quarter million waterfowl, as well as over 20,000 other water birds, including American white pelicans, Double-crested cormorants, White-faced ibis, and several species of egrets, herons, gulls, and terns." As I looked out from the car, the refuge revealed a multiplicity of greens, as opposed to the monochromatic irrigation-green of the fields I'd passed, though very soon the scene

outside the car switched to a salty gray, then a salty almost-white. The huge open space felt pregnant with the place-names from my old USGS maps, names that marked things still there, things that had disappeared, as well as things that were invisible: Old River, Stillwater River, Eight-mile Flat, Fourmile Flat, Winter Sheep Camp, Navy Bombing Target Area No. 17, U.S. Navy Electronic Warfare Training Area, and Lucky Boy Spring. On maps after the 1950s, the mountains that were to the right of my car are listed as the Bunejug Mountains, named, I learned, by Margaret Wheat, who used her grandson's pronunciation of *junebug*.

In a few minutes, the road turned south, to steer around the south-ern corner of the low but muscular Lahontan Mountains, the range that bordered the basin I'd just come through. I rolled the window down, and hot air rushed in as if from a blow-dryer, relentless, aloof, bored. The car moved down the two-lane gray road through more fields of salty whites and grays. At numerous possible turnoffs onto roads toward infinity—all roads I might have taken, I kept thinking—the signs re-peated their mantra: KEEP OUT. I passed maybe two or three cars headed back west to Fallon and pressed on into a horizon of gray.

I was moments from comprehending that O'Sullivan's dune—"the great mounds of shifting sand," as the *Harper's* correspondent wrote in 1869—sits on the southern edge of the Carson Sink between two peaks of the Sand Springs Range, one 5,340 feet high, the other 6,035, the space between them a dune-filled dozen miles. I would also soon see that today the dune is the centerpiece of the Sand Mountain Recreation Area, its 4,795 acres managed by the Bureau of Land Management and used by dune buggy and ATV riders, hikers, and sandboarders, a wildly popular place—and embarrassingly well marked.

But as mentioned, I would see all that only after I missed the dune—after I drove right by it.

"Is that it?" I asked no one, just as it began to dawn on me that I had passed the dune.

"That can't be it," I responded, more desperately, again getting angry at myself, profanity rising like steam from a volcanic fissure.

It's harder than I would have guessed to turn around safely on a des-ert highway, and when I realized I needed to reverse course, it happened that I was in the midst of a five-minute-long blind turn, a starkly scenic bend around the edge of an otherworldly mountain that looked like an

actor in a luxury car commercial, if you can call car commercial scenery actors, which I believe you can. In my defense, I can only say that the size of Sand Mountain was confounding in this particular desert view: a pure, sandy white hill, as though a single white dune had been plucked from the dune-filled Sahara or swept up in all its whiteness and left in the corner of a flat gray room.

Sand Mountain

Yes, of course, everything you see of the physical earth is changing—eroding or evaporating, expanding or contracting, sinking or rising invisibly, or, for the most part, transforming in ways that are often beyond our perceptive capabilities. Change is intrinsic in the atmosphere's aerosols, in the currents of the oceans and seas, in the unimaginable pressure floating the tectonic plates across the surface of the earth. The way I see it, Sand Mountain is a collection of change, a rest stop for geologic time as it passes through the basin like the sand in an hourglass. The particularities of Sand Mountain tell us that it is the concentrated accumulation of thousands of years of work by wind and rivers, initiated by ice in the Sierras, by glaciers that slowly scratched tiny flakes from the mountains' granite. Streams washed those flakes out into the Walker River's delta. Then, over the course of a few million years—after the glaciers melted and the giant prehistoric lake receded—the prevailing northeast winds carried those individual flakes for thirty miles. One by one, the grains of sand landed in this natural trap, a crook in the hills between the Sand Springs Range and the Stillwater mountains.

In other words, despite its name, Sand Mountain is not a single sand mountain, but a two-mile-long series of sand dunes connected by creamy drifts of sand as well as the orange spikes that mark the paths where dune buggies are permitted. In contrast to when O'Sullivan pulled his ambulance up the dune in 1867, there are now rules for driving there. Some of the rules are for the human population's safety; dune buggies must be equipped with tall fluorescent flags so that drivers don't collide with other drivers in the creases and whipped cream–like folds of the dunes. Some of the rules are for the safety of the Sand Mountain blue, a small Lycaenid butterfly, known to exist only on this one dune in the Carson Desert, where it is dependent on one plant, Kearney buckwheat,

a plant threatened by dune buggies. Research in the Great Basin and the Mojave Desert has shown that many of the insects and plants live nowhere but in the area of their respective dunes. The Sand Mountain blue butterfly lives for a week, never leaving a football field–size patch of white glacial sand.

Sand Mountain is, in the words of Michael Branch, a writer living in Reno, "still being born." The sands are still shifting, and the way in which they shift makes Sand Mountain one of a small number of dunes in the world that are known to make a sound. You can say that the mountain is audible or you can say that it sings, depending on how you think about singing dunes and depending on how you think about the world. Theories vary about how exactly a singing dune produces sound; some scientists believe that sound is a result of the friction between grains of sand, others that it is caused by air moving between the crystals as parts of the whole mass of sand shift and settle.

The sound of Sand Mountain is sometimes said to be like humming or a long intonation. Paiute stories refer to the sound as emanating from a giant snake. The Paiute dictionary includes the word *panitogogwa*, defined as "the giant mythological rattlesnake forming [the] crest of Sand Mountain dune," and it records the name of Sand Mountain as Kwazi. "Note the term also refers to a mythological snake said to have inhabited this mountain," the dictionary says. "The back of the snake forms its crest and the 'singing' sands are the noise the snake made."

While reading the Paiute dictionary, I noticed that Wuzzie George was listed as a primary consultant. Peg Wheat made several tape recordings of Wuzzie George, at festivals, at George's home. I listened to some of them, and when Wheat asked about Sand Mountain, she used the past tense, but George replied in the present.

"What did they call Sand Mountain?"

"We call him Kwazi."

As you are going along up there

Wuzzie George was known in her community as a healer or an interpreter, a person who, as she was described by a linguist who studied her prayers, "translates the special language of a person under the influence of power to the more general audience."

Wuzzie George's husband, Jimmy George, was a medicine man. She met him while working at a restaurant owned by a settler from China, and she worked alongside George until he reportedly lost his medicinal power, around 1955. Wuzzie George shared her prayers with the community, and when you listen to the tapes and read the transcripts, you feel her attempting to translate the particularities of the joys and sadnesses associated with places and things. Every year until her death in 1987, for example, she celebrated the pine nut harvest at the Walker River reservation. She prayed for the pine nuts, and, more regularly, she prayed in the morning to the sun. She prayed at meals for friends and family. "In content, her prayers always petition for good health and well-being," wrote Catherine Fowler. "In style, they feature a rhythm developed through repeating words and especially phrases that may bear some relationship to song."

In addition to working with Catherine Fowler, Wuzzie George collaborated on the Bannock-Paiute dictionary with two Swedish linguists, Astrid and Sven Liljeblad, colleagues of Fowler's. Wuzzie George loved the Liljeblads, and enjoyed teasing Sven, who was the only *taibo* (white person) she knew who could speak her language fluently. She called him *pakwi'oho*, "fish bone" in Paiute. Once, when Sven got sick, she prayed for him. She prayed at midday, when the sun was overhead, and the first lines of the prayer refer to the way the sun could take an illness away with it on its journey across the sky to the sea. It was, from what I can understand, almost chanted. There seems to have been a rhythm to the prayer, and when translated, it is a beautiful address to her ill friend but also to the sun:

> *As you are going along up there, there into this place you enter, you will be with his fever. You take it along with you into the ocean as you go. You should, where you go down, wash it away in a cool place. Tomorrow morning you should rise good and healthy on top of it.*

Moot

I had come a long way, driven the better part of two days, and was wiped out at this point, just about out of power, locomotive and other kinds, but at last I turned in to the Bureau of Land Management's Sand Moun-

tain Recreation Area. I didn't know precisely what was wrong with me, but I knew I needed to check in to a motel soon, to lie down for a while, my nerves buzzing. I pulled into the dune's parking lot, which surprised me with its very existence. On the one hand, the dune looked like a giant movie prop manufactured to resemble a huge desert sand dune, white and creamy and unbelievably fluid. It seemed like a freak of nature, though a soothing one; visiting it was like being drawn to someone you thought you maybe knew, a familiar presence. On the other hand, it was more than your eyes could see. I stepped out of the air-conditioned car and examined my copy of O'Sullivan's photo of the dune to compare it with the dune itself. By this time, the sun felt even hotter than an hour before, maybe because of the dune or the parking lot, or some debilitating combination of the two.

For photography scholars and critics, a common criticism of O'Sullivan's photograph of the dune centers on the dune's proximity then as now to a road. In this criticism, the road is a marker of civilization, and excluding it from the photo is tantamount to tricking the viewer into believing the dune is far away. I suppose that if you feel the photograph is meant to represent a far-off scene, then this proximity makes his picture a cheat or a lie—as with O'Sullivan's photographs of Gettysburg, a particular standard of accuracy is used to measure his work. I had considered this criticism significant while studying it at home over the years, but now, in the presence of the dune and the road, it struck me as completely irrelevant.

First, I now understood the dune not as a singular mound, but as an accumulation: a collection of eroded rocks from all around the Great Basin, a collective of actions. The way O'Sullivan photographed the giant sand dune also struck me as saying less about the place and more about the photographer, his situation, and, more important, his situation in relation to the dune. What is most significant when you experience the dune in person is how it feels to stand before it, to be in its presence, or what feels a little like its gravity. When you walk toward it, whether because of its vastness or because of the sun almost vibrating off its surface, it consumes and envelops you, swallowing you into itself, even at a distance. Years later I talked to a woman who is from the area, and she told me that I wasn't the only person to feel this way, by a long shot. The accuracy in O'Sullivan's plate is in the way it illustrates

how the dune crashes like a wave over the viewer, the way it holds a person as if they were afloat in a creamy white sea. As I stood at the foot of it, I looked up into Sand Mountain, following the many lines of its velvety folds and peaks. Standing very still, I could feel its pull, and I had the sensation that it was offering me assistance or reaching out. It's not hard for me to imagine an ambulance dropping its occupant off at the dune, as if it were a hospital, or a place to heal.

Worse than cannibals

By this time, I almost needed help. I could feel the heat's intensity, as I looked up the slopes of the dune and squinted into the bright hazy sky. I stood in the hot sun for a long while, not wanting to climb the dune, feeling no urge to do so, and not wanting to push myself too hard. Eventually I turned around to leave, looking to take shelter in my air-conditioned car. But just as I did, I spotted a historical marker that asked, "What are those rocks out there?"

The marker was referring to a ruin a short distance away—the remains of a Pony Express station discovered in 1975 by bureau personnel, a basalt block building covered by drifting sand. It turned out that the station was built in 1860. A description of it when it was active, written by Sir Richard Burton, a British explorer, was quoted on the marker, and it still gives a good feel for the site as it exists today:

> The water near this vile hole was thick and stale with sulphury salts: it blistered even the hands. The station-house was no unfit object in such a scene, roofless and chairless, filthy and squalid, with a smoky fire in one corner, and a table in the centre of an impure floor, the walls open to every wind and the interior full of dust . . . Of the *employés*, all loitered and sauntered about *désœuvrés* as cretins, except one, who lay on the ground crippled and apparently dying by the fall of a horse upon his breast-bone.

I don't know if Clarence King or any of the other members of the Fortieth Parallel Survey team were with O'Sullivan when he made this wet plate at the dune; I have a feeling he was off on his own, or with

only a packer to assist him. But I imagine that King, who fancied him-
self a literary man, had read Sir Richard Burton, who in the 1860s be-
came one of the most widely read travel writers in the world. (He also
translated the Kama Sutra, also a daring adventure in Victorian En-
gland.) Burton traveled the world extensively, spending three months in
the United States in 1860 and three weeks in Salt Lake City. In his six-
hundred-page account of his North American adventures, *The City of the
Saints, and Across the Rocky Mountains to California*, Burton compared
different landscapes in North America to different European colonial
outposts. The Great Basin's terrain was akin to the basins and ranges of
Central Equatorial Africa, for instance, its climate similar to what he
called the "Tartar plains of High Asia."

Like King and so many Americans, Burton described the Indige-
nous people as "savages" and complimented the Americans for treating
them, as the British did with the people of India, "as though they were
civilized people," but he also noted that the United States was wrong
to lump all Native American cultures together in the 1853 reservation
system. He saw no place for Indigenous nations below the forty-eighth
parallel, the line in the grid just below the northern U.S. border. But
while Burton's sentiments about Native Americans were shared by
many, they were by no means universal. Two years before Burton wrote
his travelogue, Friedrich Gerstäcker, a German travel writer, wrote
Narrative of a Journey Round the World. His itinerary had some over-
lap with Burton's, but in his account, Gerstäcker charged Americans
with mistreatment of the Indigenous people in California: "The whites
behaved worse than cannibals toward the poor, inoffensive creatures,
whom they had robbed of nearly every means of subsistence and now
sought to trample underfoot."

Thundered

The marker was a short hike from the ruins themselves, maybe a thou-
sand feet, but in the ovenlike temperatures, it seemed farther. I was
wary of the tremendous heat, but against my instincts I decided to make
the walk. Nobody was around, and just a few cars were parked in the
Sand Mountain parking lot, the drivers off, I figured, with their ATVs.

Particularly susceptible to heat, I made my way over, limping at this point, one leg losing power in the energy-sucking weather. I felt like a tired horse, desperate to arrive at the Pony Express station.

It seemed as if the quiet was audible. The silence of the vast salt flats surrounding the dune was almost loud, and I had the sensation that I was under a magnifying glass, being observed or maybe even being intentionally heated somehow, in the way that kids used to burn ants with a magnifying glass, the not quite blue sky acting as the giant lens. Even sounds seemed magnified: my shoe's crunch on the rocky path, my breathing, the blood pulsing through me. It was the soundtrack of a walk alone on the moon, of an astronaut inside a space suit, senses heightened.

But I made it to the ruins, then, standing as still as I could, I listened and heard my heart beat, louder and louder. I closed my eyes and felt slightly faint, or thought I did, then opened them and turned slowly to look back at the dune, which somehow seemed to be taking me in.

For whatever reason, I could not hear the dune sing, though when I think back on the day, I wonder if I missed the singing. As things had unfolded, my senses felt overwhelmed—in the quiet, I began to hear many sounds.

And then I became aware of what I assumed was a fighter jet thundering through the sky from somewhere I could not see. It was low and loud, at first a faraway background noise, but then it was very loud, rumbling through me. I thought for certain the plane would suddenly appear in the sky, racing across the top of the dune, but it did not. It was crossing another basin somewhere nearby, or hidden behind the low stratus clouds. I stood still, the sound increasing to the point of menace, vibrating through me, pulsing in my chest, finally fading away.

PART III

MINING

More explorations in the Great Basin, mostly in Nevada, where O'Sullivan's work deep in the world's most lucrative mine is examined, along with the life of the celebrated geologist who is the photographer's commander in his first years in the West and, later, lives a second, secret life in New York.

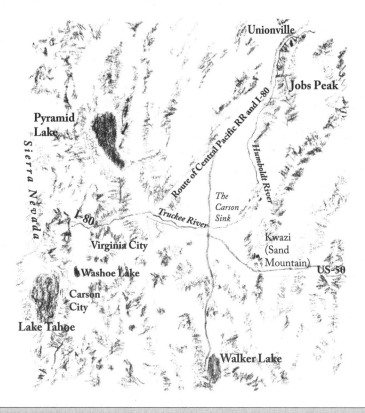

5

The Pyramid and Domes, Pyramid Lake, Nevada, 1867

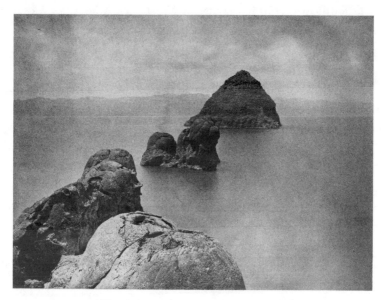

(Smithsonian American Art Museum)

Of all the photographs O'Sullivan made during the Fortieth Parallel Survey, this is among the most frequently reproduced, for good reason: it's a captivating and curious projection of tiny islands running off into the distance, the chain like a question mark, coaxing you to keep looking, beckoning toward a place you do not know, an edge of the world, or maybe another world. With its creamy water and otherworldly rocks, with a horizon that's like a veil, it says, "You are now stepping onto these crazed rocks, out onto these fungal islands, landforms that appear as if—wait, are they alive?" When *Harper's New Monthly Magazine* published a report on the Fortieth Parallel Survey, the trip to Pyramid Lake was described as an adventure, a treacherous one, in fact, just as the nineteenth-century surveys of the West are today typically

described as adventures, even though they weren't, or even though they were something else, somewhere between reconnaissance and shopping. The islands themselves are formations of tufa, the porous, calcium carbonate–formed rock commonly found around the Great Basin's mineral springs. In books and museums and on web pages around the internet, I've seen various interpretations of this image, mostly scholarly, mostly seeing the images as part of the larger project of government surveys, scientists peering into unsettled wildness, and along those lines, O'Sullivan certainly makes the West seem like a faraway place, a frontier to be tamed, as in Lincoln's description to Congress: "barren and inhospitable waste." When the photograph was first published, as an engraving in *Harper's* accompanying a dispatch describing the survey's trip, what O'Sullivan portrays as the lake's flat waters were drawn by the engraver as violent, frothed by storms. The illustration is the scene of an impending shipwreck on a South Pacific island, a scene of adventure.

I used to think of both the photo and the *Harper's* reproduction along those lines, as a call to take and tame the West or as a national advertisement for first adventure and next development. Then I visited the lake, to see not only that it was not like an ocean tossing ships in its waves, but the farthest thing from it. The lake felt serene, at least on the gorgeous blue-sky day I visited, and it was a short drive from Reno on a road that went through ranches and farms, the halfway mark a series of strip malls, each chain store a measure of just how tame things had become. What I found most striking when I arrived was how difficult it was to spot the islands, at least from where I entered the basin. The islands are big and remarkable, but the lake is bigger; when you are on-site, the lake is the thing. Since looking more closely at the history of the lake and its environs, I've come to see this photograph not as a picture of the West, but of something intensely familiar, an image that includes the viewer or even incorporates them, the pun here on *incorporate* and its root word *corpus*, or body, specifically yours. What was especially notable to me as I surveyed the Fortieth Parallel Survey's progress through the area was that O'Sullivan made this glass plate image at almost precisely the point on the expedition when the surveyors themselves began to break down, owing to illness and various other issues.

Also significant is the story surrounding the circumstances under which O'Sullivan arrived at the lake to make the image. The vast majority of everything that's ever been written about Timothy O'Sullivan—from encyclopedia entries to the handful of photo books—is based primarily on one account of his experiences in the West, an account that isn't just wrong but is wrong in a way that, when you examine it, shows us how stories and pictures and histories of the West are almost like photographic negatives, what's dark confused for what's light.

Without further mishap

First, allow me to offer some details about the making of this picture that match with the record of the survey, with the diaries and accounts and notes of the participants. We know that at the time when Timothy O'Sullivan made this plate, the surveyors were based at Wadsworth, a small settlement at the Big Bend of the Truckee River that was, in 1867, another stop along the stagecoach route to Salt Lake City. It was just west of what was then Ragtown and today is Fallon, near exit 46 on I-80, where, when I visited, there was a giant Love♥s Travel Stop. Today, if you walk into the Love♥s, you see a coffee station, showers, lots of fast-food snacks, and a large selection of U-shaped neck pillows. If you had walked into the survey's camp in July 1867, you would have seen tents filled with wooden writing tables and canvas folding chairs, as well as tents with sleeping cots. When they went off on smaller excursions—to map, to botanize, to examine rocks or photograph away from the main camp—the surveyors packed bedrolls on their mules and slept on blankets on the ground in the rainless high desert.

At Wadsworth, O'Sullivan was characteristically busy, mixing chemicals, preparing plates, lugging them, searching for viewpoints and angles. "O'Sullivan took several fine stereographic views," a survey member noted around that time. Clarence King was waiting for a shipment of gold to arrive from the army; some reports note that up to this point, he had used his own money to pay for supplies. James Gardner, as the survey's managing director, was coordinating the group of men who, as he saw it, had little if anything in common, due to their differing social status. "Fifteen men from all grades of society," wrote Gardner to his

mother, "from all parts of the Union; of every age and disposition; are not easily made into a homogeneous party at first. But I think we make a splendid advance."

The advance that so pleased Gardner might have made for a blurring of social standings during the day, but they were still evident when it came time to eat. When Gardner took meals in camp with King, the highest grades of men dressed formally. The teamsters apparently ate separately. The scientists were served by James Marryatt, who at King's bidding also dressed to serve them. Marryatt had joined the survey in Cisco, a small town on the California side of the Sierra just below Donner Pass, where he sold the survey meat and fowl. King hired him on and employed him as a valet, though when King put in his expenses with the army, he was told that the army didn't pay for valets.

The survey's flag flew just outside Clarence King's tent, and Sereno Watson would have seen it on the day he arrived in camp—covered in dust, his boots hung over his shoulder, his feet bare. Unknown and unannounced, after having walked alone across the Sierras, Watson, forty-one, was a botanist and, like King, a recent graduate of the Yale Scientific School. He was from what Gardner might describe as one of the higher grades of society, or perceived as such; he carried a letter of introduction from a Yale professor and said little. "He was by nature excessively diffident, retiring, reticent, and silent," another geologist wrote. "He possessed keen powers of observation, a love of nature and nature study, combined with an excellent physique."

King was immediately taken by Watson. "He impressed me as a man of work, grimly and conscientiously in earnest," King wrote, adding, "He smiled only as a forced concession to humor." On the spot, Watson was offered room and board and volunteer work with the topographers. The addition of a second botanist—one with "an excellent physique"— was complicated for numerous reasons, starting with how it would have felt to William Bailey, the survey's official botanist, who had already begun to disappoint King and Gardner, mostly because his own physique was beginning to fail him.

It was in these same first weeks that O'Sullivan walked out of camp at Wadsworth to find a boat for a short trip north on the Truckee River to Pyramid Lake. According to survey records, the actual story of what happened to O'Sullivan goes like this: Accompanied by Robert Ridgway,

the teenage ornithologist, O'Sullivan backtracked, walking west on the road from Wadsworth to Glendale, where he arranged to use a small sloop, the *Nettie*, borrowed from the Indian Supervisor of Nevada, H. G. Parker, who accompanied the two surveyors on the boat trip back to Wadsworth, along the Truckee. On the way, Ridgway, O'Sullivan, and Parker ran into trouble. The boat, according to Ridgeway's letters home to his parents, "ran slap broadside against a fallen cottonwood, through the middle of which ran about a 5 mile current." Parker jumped into the water to keep the boat from capsizing, while O'Sullivan and Ridgway bailed water. They made it back to camp without further mishap. It was a minor incident that King would later turn into a major one, as I shall explain.

The other group that arrived in camp was the Eighth Cavalry Regiment, twenty men from nearby Fort Churchill, a military base built along the Pony Express route, ostensibly to guard against the Paiute, even though the Paiute were suffering through a famine and dealing with the devastation wrought by settlers and miners and soldiers, including soldiers in the Eighth Cavalry. King frequently made the point that Indians were dangerous, and he often recounted an incident from his own life, in 1865, when he and Gardner were working for the California Geological Survey and walking from Los Angeles to Arizona. King claimed to have been surrounded along the way by fifty Apache warriors intent on torturing the geologists with hot coals. In his telling, King distracted the Apache with a sorcerer-like demonstration of his survey equipment—just long enough for the cavalry to arrive. It was a brush with death with a people whom King—recounting the incident in *The Atlantic Monthly* in his review of the five-volume *The Native Races of the Pacific States of North America*—described as evil. "The Apache differs in no wise from the astonishing devil whose lodge is to-day decked with the bloody scalps of last year's pioneers," he wrote.

Among the many issues complicating King's story is the fact that the people King describes as attacking him in that part of the Colorado basin (if they ever were attacking him) were most likely not Apache, but Hualapai, a community whose territory, in 1865, had been steadily encroached upon by gold miners. But here as always King used his stories like his maps and reports—to impress leaders of Congress. A story he told to underscore his strength as a leader—robust and cunning, able to

corral Gardner's "discordant elements"—concerned a soldier from the Eighth Cavalry who had gone AWOL. One day, the story went, a soldier ran off, taking a mule and supplies, and King (according to King) chased the man one hundred miles into the desert, a relentless pursuit. King made a point of describing how he physically restrained the soldier once he caught up to him, then marched him off to jail in nearby Austin. "I captured him in a hand to hand struggle in which I nearly lost my life, and only saved myself by dodging his shot and cramming my pistol in his ear in the nick of time," King wrote. "I lodged him in Austin jail, and the fact of his capture forever reduced the soldiers and the working men of the survey to obedience."

Who is John Samson?

I mention King's mostly made-up stories because upwards of 90 percent of everything ever written about Timothy O'Sullivan is based on the article "Photographs from the High Rockies," published in *Harper's New Monthly Magazine* in September 1869, and it is just the kind of story that was frequently made up by Clarence King. In this case it is attributed not to King, but to a correspondent by the name of John Samson, and it opens by detailing the movements of the King survey and by describing the team itself: "Early in the summer of 1867 a surveying party of about forty persons left California to proceed eastward directly across the different ranges of the Rocky Mountains as far as the Great Salt Lake, and traveled most of the distance in the vicinity of the proposed route of the Central Pacific Railroad." Samson continues: "The company comprised scientific gentlemen and other civilians, such as cooks and packers, to the number of seventeen." The military guard is described as "a force quite adequate to guard against any danger from the Piutes and other tribes of mountain Indians, who might be attracted by the stock, rations, or *hair* of the party"—a pun on scalping that is darkly ironic given that the state of California had been paying cash to white settlers for Indigenous people's scalps since its incorporation. Samson mentions in passing recent and horrific mining disasters—"the direst calamities that ever befell the inhabitants of the mining regions of our country," he writes, describing the Virginia City fires that burned eighty stories belowground—and then shifts abruptly to the photographer who is not quite at the center

of the piece, describing him making underground photos, with (of all things) a magnesium flare, a terrifying juxtaposition given that the recent calamities were believed to have been caused by a lantern. Shortly thereafter, the piece announces itself for what it is not: ". . . but as this is not an article relating to gold mining . . ."

What the story is, according to itself, is a tale of the outdoors, a trip to a lake where there is fishing, "not precisely the speckled beauties of the Lake Superior region," but fish that would be recognizable to Izaak Walton, the fabled European angler. The lake is described as strange, its rock formations "peculiar," and the pyramid-shaped island infested with snakes. The trip to the Humboldt Sink is an opportunity to wonder about settlers from the eastern states, who, Samson suggests, settled where they settled after being robbed by the Paiute. The atmosphere in the peaks is described as strange, a reason birds do not fly there, or so he suggests, but the expedition enjoys the lakes of meltwater in Nevada's snow-covered peaks. "The cañons in the Ruby Range were among the most interesting places met with during the entire trip."

The star of the story is the photographer, who is introduced not by name, but as someone well-known for his pictures of the war. The story describes him as a bold adventurer, risking his life for battle scenes, going where even artillerymen dared not venture, and, in a detail so fine-grained that it feels firsthand, enduring sand from a bomb blast on a beach in Charleston Harbor, a blast so close as to contaminate his plates when he made photographs near South Carolina's Fort Sumter. The story is so firsthand as to seem autobiographical, or to imply that it is merely transcribing the words of the photographer: "Many of the best photographs of events that occurred during the war were made by the adventurous artist who now furnishes pictures of scenes among the High Rockies, and narrates the adventures incident of the long journey during which the photographs were made."

And yet the photographer never takes control of the sentences that are nearly, but not quite, attributed to him; he is only ever pictured. And when the photographer's moves are described, they are imagined or—to put it generously—exaggerated beyond recognition. While O'Sullivan's boat trip with Ridgway is described in the survey records as uneventful, Samson describes it in *Harper's* as a wild, near-death disaster, a cross between an amazing feat of survival and a humiliating loss, a loss that is

comic—or comic, at least, in the narrator's hands, the narrator not being who he says he is.

Who is John Samson? In 1966, James Horan, the first and for a long time only biographer of Timothy O'Sullivan, did not so much question Samson's identity as find it strange that O'Sullivan was not named in a story that is—as is obvious from even the slightest details of the King survey—very clearly about O'Sullivan. "Curiously," Horan writes, "although the article is about O'Sullivan, it does not mention him by name." Still, Horan took the story as fact, a report on the trip itself. Since then, different historians have had different ideas about who Samson is. "John Samson appears to be a pen name," wrote a later O'Sullivan scholar. "The writer was probably a member of the Fortieth Parallel survey group." Some scholars say that Samson was O'Sullivan, and even state it definitively. An example: "The author's name is John Samson, a pen name for Timothy O'Sullivan, who was the official photographer for the King survey." This same scholar cites the details of the piece as accurate though misremembered: "Memory also affected O'Sullivan's reconstruction, as he later greatly exaggerated his role in the adventure."

As for me, I don't believe that O'Sullivan wrote the article. As I see it, he was consumed with preparing photographs and lugging around equipment—first making hundreds of plates in the field and then printing them back east, printing them being the only chance he had to make more money on the expedition. It all added up to, according to King's records, a phenomenal workload, as any photographer who has worked with wet plates will attest. It was likely all he could do to scratch the plates with numbers and notes. William Henry Jackson was a contemporary of O'Sullivan's who photographed for government and railroad surveys and to sell photos for his own profit. When he was in his eighties and retired, he wrote an autobiography, detailing all the complications involved in making plates rapid-fire, working outdoors while negotiating the nuances of a delicate chemical process—work so complicated that Jackson's own journals from his busiest seasons are sparse. As mentioned, there is almost no extant writing by O'Sullivan—no long letters or memoirs—and one letter to him that does survive is from a friend who remarks on how he has not heard from the photographer during the survey period, all of which makes it unlikely that he wrote a long

travel piece for *Harper's New Monthly Magazine*. If he had written it, it would have been his first and last try at publishing a travelogue.

As for tone and technique, the style of the *Harper's* report is nothing like that of Ridgway, the ornithologist, whose dispatches home read like letters from an excited teenager, which is what he was. "Little did I dream of *ever* seeing such a scene," he wrote to his parents early on. Meanwhile, Samuel Emmons and Arnold Hague, the geologists, are working feverishly to complete the first volume of the survey's work that King is madly pushing them to finish within the first year. Designed for the mining industry, the opening salvo of King's scientific report is crucial for the survey's financial and political survival, as well as King's own. It was King who considered himself above all else a writer and a literary artist, and despite his own tremendous workload, he managed to find time to see his extracurricular writing published on numerous occasions over the course of his career, even during the years of the Fortieth Parallel Survey. His own accounts of his climbing adventures were published in *The Atlantic Monthly*, and when he wrote about a trip he took outside the bounds of the survey, he published an account in his friend Bret Harte's new West Coast magazine, *Overland Monthly*. King's climbing stories were later combined in a book, *Mountaineering in the Sierra Nevada*, still considered a classic by climbers and naturalists. What's thrilling about *Mountaineering* is its dramatic descriptions of scenery. What's bad is bad in precisely the way the *Harper's* report by John Samson is bad: overreaching metaphors, long runs of sexual innuendo, and denigrating puns. One essay, "The Newty's of Pike," is an example of the trendy (then, as today) excoriation of what King deemed lower-class California emigrants—"melancholy examples of beings who have forever lost the conservatism of home and the power of improvement." Will Stapp, the photography historian who produced the most thorough documentation of O'Sullivan's frustratingly meager biography for the Smithsonian Institution, said of the Samson piece, "The writing stinks of King!"

Substitutions

In King-most-likely-writing-as-Samson's account, the boat ride to Pyramid Lake is portrayed as a feat, a first-ever trip on a river that, of

course, would have been traveled for as long as Paiute and Shoshone people had lived in the region, not to mention white settlers colonizing the area. (The first photographs ever made in a mine are downplayed.) In contrast with King's adventurous account in *Harper's*, Ridgway wrote a letter home to his parents. He mentions no boat mishap, though he does describe the trip as "sufficiently difficult, not to say risky, in places." King-as-Samson transforms "risk" into "terror" and conjures up volcanoes in an exotic adventure at a "great rapids" that was just as likely a powerful riffle:

> Presently the great rapids are reached; the stream is wider and shallower. Danger is near. The location of the rock, that is hidden beneath the rushing water, is discovered by the whirling eddy. In some places the foaming torrent dashes against a projecting spur of rock that breaks the current in showers of spray, of which the larger drops fall in the form of tiny crystal spheres that dance and sparkle for an instant ere they disappear below in the swift stream that has, in places, worn its course through, and exposed to view singular rock formations that tell of volcanic action.

If you travel the Truckee River today, or take a drive alongside it, from Reno up to Pyramid Lake, you encounter a beautiful valley, with soft hills and sediments that redden as dusk comes. The river has been tamed by the reclamation projects that captured water for irrigation and, in so doing, killed off the indigenous trout, which exist today primarily thanks to the Pyramid Lake Paiute Tribe's work to restore the cutthroat trout stock and fight for water rights that were first defined, then taken from them—the hydrological legal story of the West. You see wild horses in one stretch of the drive, captured and penned by the Bureau of Land Management, and you follow a river running considerably lower than it would have been before the watershed was dammed and diverted beginning in the 1920s. I'd driven through a few years earlier but still remember a feeling that was dramatic but lovely. And yet dread and fear alone are the themes in King-as-Samson's adventure as it continues along the Truckee River.

A tree trunk sinks into rapids—"a landmark for the Piutes." It

splinters, and the boat is smashed in the current, slammed against debris, the oars swept away. All is lost, until the photographer takes charge. By now the narrator has dropped the pretense that the photographer is the narrator of this particular story. "Our photographic friend, being a swimmer of no ordinary power, succeeded in reaching the shore," writes King-as-Samson. In managing the rescue, the camera operator's clothes are torn and mostly gone, his body bruised. It's almost as if King has beaten him up, and in a sense he has. Next, a strange thing happens: the others on the boat (society's upper grades) throw the photographer his pocketbook. When they do, the pocketbook sinks in the river, 320 gold pieces, lost.

At this point King-as-Sampson is all puns and innuendos and subversive quips. The photographer swims against the current in the riverbed, scours the river for his pay, and then heaves the boat to safety. "That was rough," the photographer is quoted as saying—echoing one of the rubes in "The Newty's of Pike," King's comic portrait of a poor family—"for I never found that 'dust' again, though I prospected a long time, barefooted, for it." In the *Harper's* piece, O'Sullivan is the rube, and given the photographer's experience in military settings and in the logistics of photographic documentation, not to mention the expertise that the plates from the survey attest to, it's hard not to put on a psychoanalyst's hat, to ask if King isn't acting out his own insecurities, showing off a tendency to knock out the competition even if the competition might have been one-sided. Another way to look at it is to see a member of one class inclined to demean a member of a class deemed lower. (In the *Harper's* piece, the author alludes to "a man reared on the rugged coasts of New England" but doesn't say who, though we know King himself was reared in Rhode Island.)

The more I reread "Photographs from the High Rockies," the more I think of King as cowardly and mean. It's as if he wanted to kick the idea of O'Sullivan around, strip him of clothing, money, and sense. It's a one-sided boxing match, with the photographer unable to throw a punch, fought through a fiction that's pretending to be a detailed account of actual fact. In the midst of the boat's crashing, a bag of gold goes overboard, and yes, I am speculating wildly now, but by sending his photographer searching underwater for lost gold, is King alluding to the nature of photography? To the way liquid silver is fixed by light and

bathed in water, the image brought up from below to develop into *views*, though in this case merely a comic view of the camera operator? Is he referencing O'Sullivan's inability to profit for himself on the photos of the mines, the world's first, that the government will not, in the end, allow King or O'Sullivan to release publicly? Is he alluding to the state of miners in the West by 1867, men who had gone to California and then Nevada to strike it rich but were instead forced into underground sweatshops where they scratched away at rock for little pay?

When I first read "Photographs from the High Rockies," it felt like an adventure story. Now it feels like one small example of the myriad false histories that add up to a giant sand dune's worth of damage in America's conception of the West—and it contrasts with what really happened after the surveyors left Pyramid Lake. After they returned their boat and proceeded to make their way across the desperately hot Carson Sink in the middle of summer, the surveyors, including King, got desperately ill, all of them devastated by a raging malarial fever. The only two people reported as healthy were O'Sullivan and James Marryatt, the Black man whom King insisted should dress like a butler to serve dinner.

Paralyzed with fright

In the various plates O'Sullivan made at the lake, the *Nettie* is unscuffed and safe on the shore, flying the survey's flag. After they landed, Robert Ridgway, the teenage ornithologist, set to work looking for birds and small mammals while Emmons and Hague, the geologists, set out to crack and map rocks, presumably with King, who had brought along a landscape painter. They were all getting to know one another, and at this point in the trip it was becoming clear that some surveyors would stay, some would go.

Bailey, who, even before the fevers, was complaining more and more about his health, would leave by the end of winter, replaced by Sereno Watson, the newly arrived stoic who gets along well with the team, especially his admiring boss. But as his health failed and his responsibilities were taken away, Bailey, previously a constant critic, had a change of heart about his companions. He grew especially close to O'Sullivan, whom he no longer referred to as a braggart going on too much about

the war. Bailey had been born at West Point, the son of an instructor. When he was nine, a steamer on the Hudson River caught fire, and his mother and only sister drowned. "He suffered greatly from the shock which weakened his constitution consequently affecting his health for the rest of his life," a biographer wrote. As opposed to King or Gardner, Bailey himself had attempted to serve in the Civil War but, when his health broke down, quickly returned home. It is impressive, given his history, that he tried to work on the survey at all.

In reading through the survey's record, it is easy to be charmed by Robert Ridgway, whose enthusiasm for birds takes the boy places he can't imagine. Ridgway grew up in Terre Haute, Indiana, and at a very young age he also had tried and failed to enlist in the Civil War. As a consolation, he played drums with a cousin who played the fife, and together they marched men off to battle. When Ridgway was in his seventies, many of his favorite anecdotes concerned hunting as a boy with his father in the Wabash River Valley and his work on the King survey. When he remembered Pyramid Lake, he recounted the day a peregrine falcon landed on the peak of a tufa dome, four hundred feet above the level of the lake. Ridgway was afraid of climbing but consumed with a desire to see the nest. As he ascended one of the tufa pyramids, his fear of heights caused his whole body to clench. At the top, the view immobilized him. To me, his stories at Pyramid Lake give us an idea of the ways the men—and in this case, boys—reacted when they were there as participants in what was, whether they understood it clearly or not, a fight for the lands surrounding them, battles everywhere. "I finally reached the summit, and when I did I was all but paralyzed with fright, so much so in fact that I was sure I should never get down without falling the whole distance," Ridgway remembered. "We were so high above the water that all around we could see submerged rocks, the water elsewhere being a deep, dark blue owing to its depth. If I remember correctly we took soundings of 500 feet between the Pyramid and the Tufa Domes."

He didn't make it to the falcon's nest, but he brought home a rock that he kept for the rest of his life, a tactile note or memory in stone: "On the very top I found a pebble of agatized chalcedony which I still possess as a memento of the occasion."

The only trouble

Underneath John Samson's artificial adventure, beyond what is described as "that profitable hole in the ground," there is a war going on, or maybe several, and I contend that the surveyors were bringing home bits or pieces of that war as they were exposed to it, more mementos of place that they carried home, wittingly or not. Of course the West isn't *the* West, but a lot of different wests, where the U.S. government was fighting to control different groups with varying degrees of success, and when the King survey was at Pyramid Lake in 1867, the biggest danger in the Great Basin was that of white settlers and U.S. soldiers. As an old man, Ridgway remembered the terror of Indians that King and others described in their stories as a kind of joke. "During the years when the Fortieth Parallel Survey was in the field there was, or at least was supposed to be, more or less danger of the party coming in contact with hostile Indians," Ridgway would write. "Consequently a company of United States regular cavalry was detailed by the War Department to accompany us . . . This 'escort' was of use chiefly in looking after the animals of our outfit. As to protection from Indians they caused the only trouble we had with the latter during the three years they were with us."

Rather than harm him, Ridgway believed the Paiute had saved his life at Pyramid Lake—specifically when he returned to the reservation that spring to investigate a group of pelicans. At the time, the roughly six hundred Paiute living at the lake were starving: their piñon forest, a major source of food, had been claimed by the federal government, and the most fertile growing lands along the Truckee had been taken by the railroad and by white settlers. The settlers were living under the so-called Humboldt Code, which was (as defined by the *Humboldt Register* in 1866) to "kill and lay waste everything pertaining to the tribes, whenever found—no trials, but at arms; no prisoners; no red tape." At various times, settlers raided Paiute territory, accusing people of crimes and, without evidence or trial, killing scores.

At one point in the survey, while exploring Pyramid Lake, Ridgway was out in a skiff when he heard shouting from the riverbank. "Looking in the direction of the noise we saw three Indians riding full speed toward us, each beckoning for us to come ashore," Ridgway wrote. "They reached the bank as soon as we, and no time was lost in explaining the

trouble, which was that the 'wild Injuns' had made a raid on the reservation and were going to kill everybody along the river." Ridgway later described the "wild Injuns" as "a band of outlaws from several tribes," but these descriptions aren't clear, and in the Great Basin "wild Injuns" could include raiders from either Mexico—or territory they considered Mexico—or members of other tribes, and very often the most deadly raiding parties were led by non-Native raiders, including U.S. Army officers. In its own record of battles fought during the Civil War, the U.S. Army lists the Battle of Mud Lake, in the Nevada Territory very near Pyramid Lake and waged a month before Robert E. Lee surrendered at Appomattox. The Union army, ostensibly on the lookout for Confederates attempting to capture gold being mined in Virginia City, sent a cavalry detachment led by Captain A. B. Wells, who, at sunrise, encircled the camp and fired into it. There are competing versions of how the attack transpired, but in the end two dozen Paiute men, women, and children died. One person escaped.

When the raiding party arrived at Pyramid Lake during the spring that the King survey was there, the three Paiute whisked Ridgway and his companions back to the reservation house, where other Paiute had hidden their children and were prepared to defend themselves. "They were so excited they could hardly talk," Ridgway recalled. For three days they waited for reinforcements from Fort Churchill. The Paiute individuals whom Ridgway considered to have saved his life included Natchez Overton, the Paiute leader, and his sister, Sarah Winnemucca. Years later, when Ridgway was a curator at the Smithsonian, Winnemucca herself would recount the Battle of Mud Lake, in her autobiography, and her account is not an adventure, but a dispatch from what is also known as the Mud Lake Massacre:

> The soldiers rode up to their encampment and fired into it, and killed almost all the people that were there. Oh, it is a fearful thing to tell, but it must be told. Yes, it must be told by me. It was all old men, women and children that were killed; for my father had all young men with him, at the sink of Carson on a hunting excursion, or they would have been killed too. After the soldiers had killed all but some little children and babies still tied up in their baskets, the soldiers took them also, and set the

camp on fire and threw them into the flames to see them burn alive. I had one baby brother killed there. My sister jumped on father's best horse and ran away. As she ran, the soldiers ran after her; but, thanks be to the Good Father in the Spirit-land, my dear sister got away. This almost killed my poor papa. Yet my people kept peaceful.

He would not give them up so easily

If a decade ago I looked at O'Sullivan's photos of Pyramid Lake and imagined him setting up his tripod in a distant place at the end of the world, like an Apollo astronaut making a picture on the surface of the moon, today I see a lake at the center of a region under siege. It is another war photo, taken in a time of violence that is hidden in the survey account but recounted in full by Sarah Winnemucca, the most renowned Paiute leader in the United States at the time. "The Piute Princess was a remarkable woman," said the notice of her death, in 1891, on the front pages of newspapers around the United States. The assessment was an understatement, yet Winnemucca is not mentioned in any book about the King survey that I know of. Clarence King doesn't mention that she and her brother saved the life of a survey member, nor do any contemporaneous newspaper accounts I can find. King only denigrates the Paiute and the neighboring Shoshone, like his contemporary Mark Twain, who in many ways establishes disparaging what he calls "Digger Indians"—a derogatory term used by California miners—as profitable fun.

When I think of Sarah Winnemucca saving Ridgway, I think first of her grandfather, who was a pioneer in pioneer-assisting. The Paiute leader known as Truckee guided John Frémont and fought alongside the United States in its war against Mexico. Winnemucca was born in 1844 and learned English as a child, hearing her grandfather and later her father frequently in consultation with white leaders. After working in the home of a U.S. military commander, she eventually became a translator for the United States in negotiations with various Paiute communities in the region. In 1860 she was away in San Francisco when war broke out near Pyramid Lake. Vigilantes raided the reservation. She returned to learn that members of her family had been killed.

In 1884, Sarah Winnemucca published *Life Among the Piutes: Their*

Wrongs and Claims. It is considered the first autobiography written by a Native American woman, but it is also a manifesto, the result of nearly three years of speaking out for Native rights while barnstorming in the East. "I was a very small child when the first white man came into our country," went her opening lines. "They came like a lion, yes, like a roaring lion, and have continued so ever since . . ." She begins the book with her grandfather's recollection of the first white visitors and then describes her own childhood, complicated by the increasing presence of soldiers and settlers. She goes on to recount escaping death as a child. When white settlers came to slaughter them, she and her siblings were buried alive in the Carson Desert, hidden by their parents. "Oh, can anyone in this world ever imagine what were my feelings when I was dug up by my poor mother and father?" she asks.

Life Among the Piutes includes recollections of the sexual violence committed by settlers upon the women in her family, an early published protest against what continues today, when four out of five Native American women have experienced violence, and one out of two sexual violence, and when the United States and Canada ignore missing and murdered Indigenous women—like the unmentioned Winnemucca, invisible in the news. "The men whom my grandpa called his brothers would come into our camp and ask my mother to give our sister to them," Winnemucca wrote. "They would come in at night and we would all scream and cry; but that would not stop them." The rape of the land by the settlers, in other words, was matched by sexual violence. "My uncles and brothers would not dare say a word for fear they would be shot down," she said. Instead, she and her sisters regularly left their camp at dusk, to hide during the night.

When I read these accounts, I found the rescue of young Ridgway more startling: in the face of so much violence, Winnemucca and her brother take great risks to save the teenager who was part of a U.S. government surveillance and development project that would likely make a bad situation in their homelands worse. But then I began to wonder about the ways in which empathy is a strength or a power less easily analyzed than the reports of guns. In *Life Among the Piutes*, Winnemucca recounts the actions of Truckee, her grandfather, in reaction to the arrival of the first white settlers, a cataclysmic event in retrospect, the dawn of an apocalypse, as the settlers entered a region distinguished by

its almost sublime communal orchestration of scarce resources. When I
read her account of her ancestor, I hear her describing a method of sur-
veying and reconnaissance that relied not on barometers and theodolites
or GPS and drones, but on the perception of physical expressions:

> He immediately gathered some of his leading men, and went
> to the place where the party had gone into camp. Arriving near
> them, he was commanded to halt in a manner that was readily
> understood without an interpreter. Grandpa at once made signs
> of friendship by throwing down his robe and throwing up his
> arms to show them he had no weapons; but in vain,—they kept
> him at a distance.

I find myself wondering: Was it at all evident to Truckee that this
moment was a threshold, a turning point in his life and the life of his
people—that his world on the other side of this moment will be dramat-
ically different? And how did his perception of this moment contrib-
ute ultimately to the resilience of his daughter and his Northern Paiute
community? Winnemucca reports that her grandfather had premoni-
tions. After being stopped by the white interlopers—"they kept him at
a distance"—he makes what I think of as a gesture toward a physical
realignment, an acting out of empathy: he traveled beside the men, as if
putting his body in the same or a parallel position. She writes:

> But he would not give them up so easily. He took some of his
> most trustworthy men and followed them day after day, camping
> near them at night, and travelling in sight of them by day, hoping
> in this way to gain their confidence. But he was disappointed,
> poor dear old soul!

Barnum's Photographic Arm

At this point we can ask what's at stake in O'Sullivan's photo of Pyra-
mid Lake. What's going on, if not a portrait of another distant lake
with an emphasis on the distance and the emptiness and the faraway? In
our obsession with land, do we miss what the ancient lake tells us and
focus instead on the islands? In considering these and other questions,

I find that the best way to think about O'Sullivan's Pyramid Lake photographs is not in terms of faraway places or colonial outposts, but in relation to his work with Mathew Brady, in particular Brady's photos of people with unusual bodies. To explain this I would note, first, that while the word *pyramid* adds to the lake's exoticness in Anglo terms, the Paiute do not associate Pyramid Lake with Egypt; they refer to the waterbody today using the word *kuyuuibaa*, which refers to the kuyui, or cui-ui, cui-ui being the large plankton-eating fish that live in the desert lake, and the pyramid-shaped island is to them shaped like a basket, or *wono* in Paiute. When U.S. surveyors wrote Pyramid Lake on a map, they were referring to Colonel John Frémont, the surveyor-cum-politician who, in 1846, massacred a Wintu community at what is today Redding, surrounding men, women, and children on three sides, their backs to the Sacramento River—considered the beginning of the California genocides. It was Frémont who saw the tufa domes as akin to the Egyptian pyramids, even though Frémont had never been to Egypt and the island is not technically a pyramid. (The closest the lake ever got to being in Egypt was in 1965, during the filming of *The Greatest Story Ever Told*, when it stood in for the Sea of Galilee.) The tufa domes formed between 26,000 and 13,000 years ago, when the water level of Pyramid Lake was not just higher, but much higher, and part of the larger, long-ago-evaporated Utah-size lake that was named Lahontan, after a French aristocrat who fought in North America for France in the late 1600s. In his *Harper's New Monthly Magazine* report, Clarence King recognized the origins of the waterbody and its islands but focused on its peculiarities, calling it "a curious lake."

"The peculiar rock formations, from which this lake derives its name, are remarkable even among the 'Rockies,'" he wrote.

In King's account, the rocks are creaturelike and seem to be breathing. "From every crevice there seemed to come a hiss," he said.

After seeing the islands for myself, this sentient imagery is what I found most compelling about King's description and what I think is most applicable to what O'Sullivan was up to: the way King described the domes in *Harper's* not so much as inanimate rocks, but as living organisms. "Close scrutiny," King-as-Samson notes, "shows portions of its sides to consist of a volcanic tufa, which greatly resembles a vegetable

growth of vast size." And then, in O'Sullivan's photos, the islands are like appendages, reaching out to the shore or to the viewer, or both. The image is thrilling, and making a photograph viscerally thrilling was an important and underrated part of his training. O'Sullivan had the particular skills that resulted from being in the photographic workshop of the person who made not just his name but the better part of his income photographing the stars of what were referred to at the time as freak shows. Although Brady is remembered as "Mr. Lincoln's cameraman," he might better have been nicknamed P. T. Barnum's Photographic Arm.

The so-called freak photos were made in association with P. T. Barnum's wildly popular American Museum, part natural science and history museum, part zoo, part theater and lecture hall, located just down the street from Brady's studio. Working with Barnum, Brady posed Captain Bates and Anna Swan, the so-called married giants, as well as two men born conjoined in Thailand (then referred to in the United States as Siam); Chang and Eng Bunker were known around the world as "the original Siamese twins." And it seems likely that O'Sullivan would have known Brady's photos of unusual bodies as the only photos that ever made Brady any money. With the help of O'Sullivan and his other camera-operating assistants, Brady sold scores of these images: other-bodied men and women, people who were unusually tall or short as well as conjoined twins. As opposed to his war scenes or his photos of the American elite—politicians and generals and those whom Emerson referred to as "representative men"—Brady's freak show work kept him financially afloat beginning in the 1840s, when he first photographed General Tom Thumb, the stage name of Charles Sherwood Stratton, Barnum's distant cousin. We don't typically see images like these alongside Brady's illustrious Americans, even though General Tom Thumb was just as illustrious as Daniel Webster in the eyes of the public, or really more so: the national penchant for celebrity and notoriety runs deep. In February 1863, just a few months before the Battle of Gettysburg and the draft riots in New York City, Barnum sold tickets for Tom Thumb's wedding to Lavinia Warren, the two-foot, eight-inch-tall woman who was known as the most photographed woman in the world. Tiffany & Co. designed their miniature horse-drawn carriage, and in the midst of establishing troop conscription, Abraham Lincoln invited the couple to the White House.

Cannibals

During the Confederate states' rebellion, and then during the years that O'Sullivan headed west, Barnum's celebrity increased. By 1872 he had moved uptown from his Broadway gallery to a building that held two performance rings and seated two thousand people. In the same year, he advertised a show in *The New York Times* that featured the bearded girl, the California dwarf, the no-armed man, and the Circassian ladies as well as what Barnum advertised as "Digger Indians," using the dehumanizing term for Great Basin nations. There were also purported cannibals from the Fiji Islands, cannibalism being a practice that had died out by 1870, when the Fiji cannibals were hired to perform at Barnum's museum, and the photo of the Fijians is a good example of what Brady's success would have taught O'Sullivan. For Barnum, cannibals were a big draw, and more than one historian has noted that in the United

Fiji cannibals, c. 1860–70, by Mathew Brady (Smithsonian American Art Museum / Frederick Hill Meserve Collection)

States, cannibalism was simultaneously described and decried at the very moment the country was expanding as a world power, devouring more territories overseas while consolidating territory in the West, consuming the world. An early instance of the word *cannibal* as applied to North America is in the journals of Christopher Columbus, who, arriving in Hispaniola, intended to pay the Indigenous workers for their work until he was told that they resisted Christianity and ate humans, at which point he enslaved them. Exaggerated or fabricated talk of cannibals in novels and popular entertainment worked like the feint of a boxer or the handkerchief flourish of a magician, or a comic rendition of a ragged Civil War photographer traipsing through western mountains: they were distractions from imperial claims to territory overseas and, in the case of Pyramid Lake, just over the Sierra Nevada.

What was truly horrifying for Victorian Americans when they saw Mathew Brady's wet plate collodion images of the Fiji cannibals was this: except for the spears and clothing, the cannibals looked—terrifyingly— like Americans. The photos themselves were spectacles, politically mischievous and titillating, notes on unspeakable carnal desires, a too-close view of the unapproachable exotic. But the pose of the cannibal was drastically different from the pose of one of Brady's illustrious Americans. When posed, the faces of the illustrious mostly looked to one side, at a classical and hoped-for noble angle. Backdrops were classical scenes or painted vistas. In this picture, the allegedly flesh-hungry cannibals are presented against a blank canvas in a place that isn't determinable; it could be a South Sea island, could be Brooklyn. And they look straight into the viewer's eyes. They stare. They are armed. They are cannibals looking at you as you debate taking a trip uptown to see them in a show, and as you debate, they appear to be taking you in.

Fiji Cannibals is a photograph that is part of a conversation about bodies, the Fijians as well as yours. I think of it as a national subliminal conversation, one for the nation's psychiatrist to parse out, if only the nation had one: an embodiment of pent-up desires, territorial and otherwise. Working for Brady, O'Sullivan learned to infuse his images with primal references, but he also learned to make photos that, whether Brady would have said so or not, questioned the kind of cultural assumptions that capitalism was making—about who was beautiful, who was dangerous, which desires were acted on, which weren't. While other western

survey photographers made images of industrial productivity—a seam of coal, a newly built railroad track, a view of a wannabe bustling new settlement—O'Sullivan made so many pictures in which the land appears like a body, or parts of one, and when I look at them, I see questions about who is devouring whom, or what. In *Geyser Pool, Ruby Valley, Nevada*, one of the Great Basin's boiling sulfuric pools feels intimate, almost a pun on ore and oracle, or even orifice. The half-hidden surveyor's body is either just about to be sucked in or just expelled.

Geyser Pool, Ruby Valley, Nevada, 1868

What I am saying here is that I get the same feelings looking at O'Sullivan's photos of Pyramid Lake. We see an alluring chain of islands that lead off into infinity, one appendage after the next, familiar somehow and floating in a primordial soup—the land as liquid as the lake. Through survey photos, the appetites of Americans were whetted with views of the extraordinary, nature's freak shows—the rushing falls, the steaming and explosive geysers, the plains that appear as vast oceans. In O'Sullivan's photos, they are places to devour but also, tantalizingly, places that will perhaps devour you.

A sharpshooter

Can I say with certainty that O'Sullivan made his picture of Pyramid Lake with Barnum's style in mind? Can I say that this is made by a confidence man, or speculate that it is a work of conscience, thoughts submerged but only just below the surface? Can I prove that he was looking for commercial success or saying things about the rise of American imperialism and the corporate push to devour the West? We all live more like practitioners than theorists, and I have to imagine that the photographer just worked to do what King might not even have known he wanted and what Brady and Barnum were so good at—luring in the viewer, creating an audience. I can show, however, that O'Sullivan knew how to make the viewer a kind of participant in the view, and I can point to an earlier example, made in May 1864, when he climbed up into the spire of a church in Massaponax, Virginia, to photograph Ulysses Grant in a council of war.

Set up in a high window as Union commanders sat on long wooden benches under the shade of two courtyard trees, O'Sullivan made a few photographic plates in quick succession. In the first plate (pictured on the facing page), Grant stands in the far-left foreground, leaning over the shoulder of General Meade: Grant studies a map, or perhaps a copy of a map photographed then printed by the unit's photographer. One man—to the right on the bench and smoking a pipe—has nearly turned around to look back and up at the spire where O'Sullivan has positioned himself. He's looking up at the camera operator almost warily, and this wary glance adds to the picture's tension, exposes it as covert. At this precise moment, O'Sullivan opens his lens, light touching the mixture of liquids on his plate—they are exposed.

In a second image (not pictured), Grant is seated, composing a dispatch, or appearing to. His legs are crossed, and he is looking down at the pen and paper as he writes, appearing absorbed. The man who was looking up warily now chats with the commanders behind him, as if his question about O'Sullivan has been answered.

Then, in the next plate (pictured), Grant appears to wait patiently. The officers' horses are tied up in the background. Wind blows the leaves of the trees, and the movement—of men, of animals, of what appears to be a passing carriage of some kind—makes watery streaks

and blurs around the council of war, a ghostly halo that appears in the middle of the Overland Campaign, a series of battles that end in carnage. But in the middle of all this activity, Grant is in focus, not talking, holding still, preternaturally calm. His head is pictured precisely in the V-shaped intersection of the two tall trees, as if the camera were a rifle and the trees the cross in the shooter's gunsight. The photo is now, as it must have been then, riveting in terms of access not just to the actions of an illustrious American, but to what almost appear to be his thoughts. We see him, not frozen in time, but alive, as time is pictured proceeding, the blur of bodies like crashing waves. It is also engaging in a way that is maybe less shocking today than it was to a viewer in 1864, when the Union army was plagued by Confederate marksmen.

By 1864 both the Union and Confederate forces had begun to employ sharpshooters, so named because of a large-bore single-shot rifle manufactured by the Sharps Rifle Company. Sharpshooters were terrifying to soldiers; their presence changed warfare, almost invisibly increasing the size of the battlefield, expanding the area considered dangerous into what was previously safe, behind the lines. General John Fulton Reynolds was the highest-ranking general to die at Gettysburg, and though the precise cause of his death is disputed, in numerous popular accounts it was attributed to a sharpshooter hiding high in a tree. Both Mathew Brady and Alexander Gardner made photos of the field where General Reynolds was thought to have been killed.

When you think about sharpshooters, O'Sullivan's photo starts to feel like a calm, ruthless depiction of the calculation of a kill, and for me, it emphasizes the ways we all participate in the violence of war, even by looking on, even if we have been schooled to believe there is no war, as in the scenes at Pyramid Lake. Taken together, the three plates made from the spire at Massaponax are like evidence in a murder trial, implicating the sharpshooter-like camera operator and the viewer at the same time.

A desperate situation

Turning back to the progress of the Fortieth Parallel Survey in that summer of 1867, we see that after a few days of the surveyors exploring the shore of Pyramid Lake and its islands, the Paiute living at the

lake helped them arrange for mules. As the scientists started out toward
the east, Ridgway's mule insisted on racing off into the desert ahead
of the party, a good thing, because the boy, sick with fever, got off his
mule and passed out in the desert sink, his team catching up to rescue
him. "I never knew when they picked me up and placed me in the am-
bulance, nor was I conscious at all until camp was reached," Ridgway
recalled. The ambulance that picked him up was O'Sullivan's traveling
darkroom.

Ridgway's health improved in a few days, but then the health of every-
one around him began to fail. For the remainder of the survey, Gardner
managed to climb the peaks that he used to plan out the work, arranging
a stack of rocks to mark each point for topographical triangulation. (One
such peak was Virginia Peak, in the Pah Rah Range, north of Reno,
where today the National Weather Service keeps a weather surveillance
station.) With many getting sicker, the party entered the alkali des-
erts near the Carson Sink, the desert stretch so abhorred by the white
settlers, and proceeded to the Osobb Valley, at that time just renamed
Dixie Valley by white settlers, mostly Confederate sympathizers.

In the wet plate images O'Sullivan made in these days, he high-
lighted the mounding that occurred as calcium deposits built up slowly
around these fissures, and in these images—of the vast, sage-dotted
sink, its long stretches of salt baked and flattened—the hot springs look
like wounds. "It was the most uncomfortable camp in all my experi-
ence," Ridgway wrote. "The water used for drinking and cooking was so
charged with sulfur that it smelt like ancient eggs, the air was redolent

Sou Hot Springs, Osobb Valley, Nevada, 1867

of the stench of rotting tules, and at night we suffered the torment of millions of blood-thirsty mosquitoes. The reader's imagination will not be taxed in visualizing the desperate situation of the fever-ridden young explorer under these inhospitable conditions."

They headed north along the old Humboldt River road and camped just beyond a settlement on the edge of the Humboldt Sink. The mosquitoes got worse. Following the tactic of local miners, they sat between piles of dried cow dung set on fire, but mosquito swarms repeatedly extinguished their candles. At some point King himself got sick, passing out from heatstroke, unconscious in a cave, blind (he said) for a few days after. When he recovered, he decided to move the group up the slopes of the Humboldt Range, to camp in a place called Wright Canyon, in the Star Peak Range. Things kept going wrong. It was less and less an adventure, more and more a nightmare. Shortly after arriving at the new camp, the cook got sick, seeming very close to death. James Marryatt took over the cooking duties, and now King grew more and more concerned that the United States' first major scientific survey was poised to fail. To make matters worse, the survey instruments King used to gauge altitude were indicating that the weather was about to change: "The barometer indicated the approach of a great storm," he wrote.

King moved everyone again, to a place that was higher and more populated. The sick men and their mules crossed from the mountain's west-facing slope to the east-facing slope, to a town called Unionville, which, like the Dixie Valley, was also named for the war between the Union and Confederate armies, this one chosen by Union supporters. The survey set up in a small hotel. By this point they had surveyed to the 117th meridian. They were short of their goal for the season, the 115th, yet King wrote to his military commander to claim success in terrible terrain—"in every way," he wrote, "the most difficult and dangerous country to campaign in I know of on the continent."

King deemed one topographer healthy enough to survey and, with him, headed off into the mountains to work, leaving behind the other two healthy members, O'Sullivan and Marryatt, to manage the rest of the party. We can only guess why King hired O'Sullivan in the first place. I have my doubts that O'Sullivan was King's first choice as survey photographer, if he had a choice. For various reasons, I suspect that he might have wanted Carleton Watkins, who was better-known and

more widely acclaimed. O'Sullivan was most likely on the survey be-
cause General Andrew Humphreys, the commander of the Army Corps
of Engineers to whom King reported, knew O'Sullivan from the war
and put him there. Maybe O'Sullivan's long-standing relationship with
Humphreys explains King's next decision, or maybe it was King's re-
lationship with O'Sullivan, of which little record exists. For whatever
reason, King put the U.S. Geological Exploration of the Fortieth Paral-
lel, now based in Unionville, Nevada, under the command of Timothy
O'Sullivan. James Marryatt was appointed second-in-command.

High Street

When Mark Twain arrived in Unionville—in a blizzard, in the winter
of 1861—eleven cabins and a liberty pole marked the seat of the Union-
ville Mining District. Originally named Buena Vista, Confederate
sympathizers who had also fought against Mexico in 1847 renamed it
Dixie, until 1861, when enough Union sympathizers arrived to change
the name again. Like so many white settlements in the Great Basin,
Unionville was an investment more than a community, given that the
Great Basin was akin to a twenty-first-century tech stock: everybody
wanted to buy in, especially since investment in Paiute and Shoshone
lands was backed by government guns. And along with investors from
New York City, a miner named John Fall bought up the mining claims
in the Unionville area with his partner, David Temple, a New Jerseyan.
Fall hired not just Chinese but Hispanic and Native American miners.
It was an unusual act in a state where the press referred to Chinese
miners as baboons, though a few months after the survey left that fall,
mining fell off and white miners, referring to themselves as members
of the Anti-Chinese League, drove the Chinese workers out at gun-
point. When the Central Pacific Railroad was completed that spring
just over the mountain, most of the rest of the town would leave on its
own accord.

After King departed Unionville—leaving in charge an Irish immi-
grant and a Black man likely from Jamaica—O'Sullivan set to work.
In this beautiful green-tinged mountain valley late that summer, the
photographer jury-rigged a makeshift studio. Americans loved their
traveling photographers, and the small population probably welcomed

what they might have referred to as a "likeness-maker" or a "philosophi-
cal alchemist," or even just a cameraman. O'Sullivan would have been
conserving his large glass plates for official survey work and, for his cus-
tomers, making what were called tintypes or ferrotypes—images printed
not on glass but metal, often iron sheets referred to as tin. Thus, while
Clarence King's scientists were woozy with fever, O'Sullivan was killing
time and bringing in some cash. The "photographic laborer," as King
had described him, set about capturing the likenesses of miners, a few
mine owners, and the workers who could scrape together maybe ten
cents for two images made during a sitting with a stereo camera. After
developing the stereo image, O'Sullivan could snip the tin in half. In-
stead of setting up his big box camera on the top of a mountain or the
edge of a lake, he set up in a ruin, an abandoned and roofless building.
The address was 3 High Street, and outside he hung a sign:

MR SULLIVAN'S PHOTOGRAPHIC GALLERY

6

Cars coming out of shaft, Comstock Mine,
Virginia City, Nev., Winter 1867 to 1868

Since Clarence King skipped over the Comstock Lode in his dramatic account of the survey for *Harper's New Monthly Magazine*; since he all but ignored what was a singular (albeit risky) technical achievement by our photographer, let's now go down into the world's largest silver mine—the world's largest silver mine in 1867, when O'Sullivan went down, and the most profitable in American history: no silver strike was ever bigger or more lucrative. Let's line up with the miners topside, some of them coming up into the cold winter air from a shift below, some waiting to be lowered down into the hot and humid and fetid candlelit darkness—these miners can be seen in this photograph, *Cars coming out of shaft, Comstock Mine, Virginia City, Nev.,* which O'Sullivan made in the winter of 1867 or 1868 when the survey made camp near the Comstock

Lode to study it extensively. Let's step in line behind O'Sullivan, who has arrived in Virginia City with the rest of the surveyors, some of the team setting up in Virginia City proper (in the case of Clarence King) and some, like O'Sullivan, put up in a boardinghouse in Carson City, about fifteen miles away. If you are arriving in Virginia City for the first time, you might be confused—this legendarily deep place is up high, teetering on a mountaintop—until you realize that the giant, city-size hunk of silver that makes up the Comstock Lode was gouged out of the interior of what the first white settlers called the Virginia Range. Looking across the panorama of the Virginia Range, on a clear, windy day, you see actual peaks and hills (or the sort that O'Sullivan descended into), but you also see hills that aren't hills at all, but hill-size dunes of debris, the earth dug out from under the mountains, the remains of mining, some still blowing away today as if they were born of natural processes, like scree on a glacier.

As we ride the elevator down, the planks rattle, the cables tense then (suddenly) ease, the cameraman's equipment—the lenses and plates, bottles and tripods—trembling as they jolt and descend. The bottles hold water and collodion as well as the liquid silver that O'Sullivan is (as surely it has occurred to him) about to use to photograph the men attacking the sparkling walls of silver, as if these wet plate collodion images of silver mining were a double exposure, a photographic pun. If there is some concern about how the photographs will turn out, that is because these will be the first known underground mining photographs. Only the year before, Charles Waldack, a Cincinnati photographer, managed to make wet plate images in Kentucky's Mammoth Cave, a first, then published as forty-two stereocards by E. & H. T. Anthony of New York, a publisher of many of O'Sullivan's earlier war images.

And so we proceed, descending into what is one of many shafts dug through the giant seam of valuable ore that had, of course, been discovered at various times in human history—humans have dug for ore in the Southwest since humans first lived in the area—but it was discovered again at the very end of the California Gold Rush, in 1859, when Anglo miners arrived looking for gold but found mostly silver. Note that various dubious stories attach the origin of Virginia City's name to one early miner, James Finney, whose nickname was "Old Virginny." Peter O'Reilly and Patrick McLaughlin, two more Irish immigrants, are reported to have first claimed the Comstock Lode itself. Henry "Pancake"

Comstock convinced them that he had a previous claim to the site—
a lie, most likely, that would eventually result in $145 million worth of
silver dug out over the next ten years. In 1882, McLaughlin killed
himself with a revolver. Henry Comstock sold his share and moved to
Montana, where, after running through his money, he killed himself
too. The old *WPA Guide to Montana* reported that a pine board marked
Comstock's grave in a cemetery outside of Bozeman until grazing cattle
chewed it away.

Perhaps, as we descend, you are alongside another miner, squeezed
into what barely amounts to a basket. Perhaps he is from New York or
Ohio; perhaps he speaks Mandarin or Cantonese, or you hear words
from the Celtic language spoken by English miners from Cornwall.
You've already noticed that these are not miners hoping to strike it rich,
but men who are working to stay alive, and thus you are becoming aware
of the fact that Virginia City was settled at the very end of the last poor
man's gold rush. During the California Gold Rush that had begun in
1848, people from all over the Americas and the world rushed to take
advantage of a moment when getting a one-way ticket on a boat to Cali-
fornia was not just an affordable risk, but, at the outset, a potential win,
and this kept up at least until the first large groups of miners arrived to
mine in Virginia City. By the time of the 1870 census, Virginia City
wasn't only Nevada's biggest town; it was its most international: Nevada
had more foreign-born residents than any other U.S. state. But by that
time, things had changed from the early days, when one or two men
mined a site in the Sierras, taking the typically meager profits for them-
selves. By the time O'Sullivan was headed down this shaft, the people
who were living comfortably on top of the mine in the newly built man-
sions and hotels were making more and more money by paying more
men less and putting them deeper and deeper underground.

The mine pictured at the start of this chapter was possibly first staked
on July 4, 1859, by Leonard Coates Savage and his second cousin, Abra-
ham O. Savage, as well as their associates. They had come from the
Sierras, where they had staked a previous claim. As you ride deeper, you
are completing your descent through the mine's second shaft, and the
entrance to that shaft is where the miners wait, as pictured by O'Sulli-
van: it was one of the largest mines in the territory when it was sunk in
1864. By 1868 it had produced approximately $2,543,868 in bullion and

$1,184,000 in dividends. The mine was named for Leonard and thus known as the Savage Mine.

And on that winter day in 1868, as you step out of the elevators and walk into the underground rooms, you first hear the cracks of picks on rock, shovels scraping and digging, and then you feel the steamy heat leaking from the walls and from pools of near-boiling water warmed by the internal heat of the earth. The heat was a concern for mining companies in terms of the rate of production. The plaque that today marks the site of one shaft in Virginia City reads "Another problem was the stifling heat of 130 degrees due to geothermal forces that often doubled over miners with stomach cramps."

As you move deeper or farther into the mine and your senses acclimate, or try to, you see the skittering shadows of rats. You smell not just rodent but human urine and excrement. If you were entering the mine after dynamite had broken out a new vein of silver, you would smell an odor like that of bananas. And you would see very little at the bottom of the mine at first, though eventually you might make out a miner breaking rock off the wall, tossing it into a narrow wheelbarrow, a picture O'Sullivan would make. You might notice something sparkling: "Throughout the mass of the ore in many places," wrote Dan De Quille, the pseudonym of William Wright, a writer for the *Virginia City Territorial Enterprise*, "the walls of the silver caverns glitter as though studded with diamonds." You might also, even in the dark, sense the presence of a miner nearby, a miner you could not yet see, a perspiring body surrounded by other perspiring bodies, a gang of rock breakers slugging it out with the walls in the warm bowels of the earth.

More like brutes than humans

To repeat: mining silver in Virginia City looks nothing like the placer mining in 1847, or the romantic picture of such—a camp in the mountains, pans skimming a clear mountain stream, canvas tents, coffee pot on a wood fire, the stuff of Hollywood westerns. Not that placer mining was a bucolic endeavor either. Louise Amelia Knapp Smith Clappe grew up in Amherst, Massachusetts, and, in 1849, went to the California Sierras with her husband, a physician. In a series of letters to eastern newspapers, she described the mining camps they lived in. "Nearly

every person on the river received the same step-mother's treatment from Dame Nature, in this her mountain workshop," she wrote. "Of course the whole world (*our* world) was, to use a phrase much in vogue here, dead broke."

As late as 1850, a few independent prospectors in Virginia City had managed to yank a large chunk of gold from the earth, but even then, miners were teaming resources to build the required dams and sluices, with larger financial interests moving in to manage operations. The idea of men leaving the East to strike it rich with gold and silver in the West persisted well beyond the chances of anything like that actually happening, as did the parallel project of not nation-building, but nation-claiming. Toward this end, miners in small groups or miners as investors in corporations didn't just figuratively claim land that God had, as they saw it, deemed American; they claimed it, literally, with ink and paper, then with the shovels and picks used to work that claim. In an 1860 address on the history of California given in San Francisco, Edmund Randolph, a Virginia-born lawyer and judge, extolled the western miner, specifically the white miner who was creating a new Rome in a savage wilderness: "However silent, however humble and unseen, or on what bestowed, it is Labor which has created California." California had taken control of the land, Randolph said, from the Indian—"a despicable type of man, in petty groups, [who] wandered through these valleys, of which the bear was more Lord than he."

"California," Randolph went on, "is in full possession of the white man, and embraced within the mighty area of his civilization! . . . We see in our great movement hitherward in 1849 a likeness to the times when our ancestors . . . poured forth by nations and in never-ending columns from the German forests, and went to seek new pastures and to found a new kingdom in the ruined provinces of the Roman Empire."

Within just a few years of the initial gold rush in California and the subsequent silver rush next door in Nevada—in what Clarence King described as a wasteland, "an American Sahara," valuable only for the value that could be mined from it—the new kingdom was dominated by more and more distant and incorporated investors and administered locally by politicians who were, on the one hand, wary of control from Washington, D.C., while content to accept its support in taking control of the territory. (The historian Patricia Nelson Limerick argues that

white westerners "centralized their resentments much more efficiently than the federal government centralized its powers.") The miners who subsequently worked for those companies were no longer nugget searchers staking claims on a mountainside; they were wage laborers. They were employed, in the words of the historian Daniel Cornford, "by heavily capitalized hydraulic and quartz mining concerns in working conditions very much akin to those experienced by eastern workers in mid-nineteenth-century American factories." "We all live more like brutes than humans," a miner wrote to his sister in 1850. Starting at $20 a day in 1848, wages declined to $10 in 1850, then to $3 by the late 1850s. Engineering became more complicated, necessitating greater investment in infrastructure, less in men. Quartz mining grew, attracting European investment. By the time Clarence King's Fortieth Parallel Survey rode into Virginia City, most miners were propertyless. "No longer living in camps, hoping to strike it rich," wrote the historian Ralph Mann, "they now dwelt in embryonic industrial slums, hoping for a living wage."

Which means that the mine into which you have just entered in the company of Timothy O'Sullivan and his cameras is not so much a mine as a giant underground factory, a hidden-from-view industrial slum. It is another negative image, a place to picture almost backward: the *inside* of a mountain, as opposed to popular pictures made by the likes of Carleton Watkins, which tended to show workers topside, as if working an unruly farm. The Savage Mine is a hill hollowed out. From the surface of Virginia City in 1867 or 1868, while looking out toward such peaks as Mount Davidson and Mount Bullion, to name a few, you only see what the mine exhales, or did: exhausted men; pumped-up water, like bilge from a buried and sinking ship; and the dug-out earth deemed not valuable—spoils that remain (as mentioned) in the vista today. Note the ways those newer hills, soft pyramids of pulverized rock, also affected the community. In the 1860s, local boys scavenged the bits of wood and metal at the base of these hills, and Washoe and Paiute residents of the area reportedly made camps alongside them in space that distanced the Indigenous adapters from white settlers' homes while simultaneously allowing access to in-town employment.

The old hills, meanwhile, were losing their tree cover as the piñon forests in and around the Virginia Range—a life source that provided its Indigenous inhabitants with seasonal food harvests for millennia—

were cut in the frenzy of extraction, the lumber used to prop up bigger and bigger spaces for mining. If the mines exhaled spoils, they also inhaled trees, so that when O'Sullivan arrived, the mines were a vast and connected series of ever-expanding ballroom-size chambers. As a tree's roots invisibly mirror its canopy, so the size of each dark abscess was in proportion to the resources poured in. As California bankers increased their investments, the chambers grew. As overseas investment poured in, the mines expanded further, like a tumor or an infected wound, polluting the water table, destroying streams. Eventually the chambers were constructed according to the patented designs of Philip Deidesheimer, an alumnus of Germany's renowned Freiberg School of Mines, an engineer who came to Virginia City in 1860 and (reportedly inspired by seeing a beehive) invented his Lincoln Logs–like system: six-foot interconnecting wood-framed cubes that reminded investors of underground cathedrals and, for miners, called to mind what they'd heard of hell. As Deidesheimer's impact expanded, the piñon forests above disappeared. "Deidesheimer's square-set system," writes one archaeologist of the mines, "sounded the death knell for thousands of acres of Sierra forest."

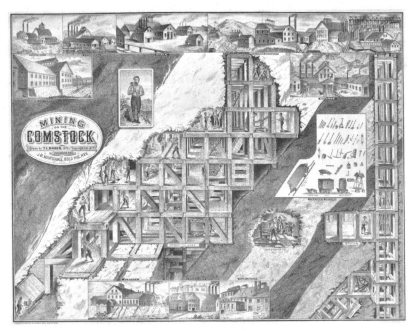

Mining on the Comstock, drawn by T. L. Dawes, published in 1876

Fire underground

Walking with Timothy O'Sullivan, you are moving through a deep, dark bank vault that is being emptied out, nobody precisely sure, at the time, how long the funds will last. This is the silver lode that encouraged Lincoln to rush Nevada to statehood—as opposed to various other western territories, where the federal government took its time relinquishing its jurisdictional powers to fledgling state governments. As such, the Comstock Lode is both a key strategic site for the Union and, coveted by the Confederacy, a two-and-a-half-mile-deep deposit of high-grade ore that produced nearly $400,000,000 in silver and gold. In addition to birthing Nevada, the Comstock Lode made San Francisco boom, and it is the mine that funded the Union army. It was the first of what would be a long history of extractions in a state that today leads the United States in the production of gold, silver, barite, lithium, and mercury, as well as the production of geothermal power. Investors have to thank ancient volcanic actions and sediments and, in the case of lithium, brine in pools beneath salt flats, not to mention Indigenous lands—federal sovereignty invaded Native sovereignty the way pollutants from a mine invade the water table. In 1858, the year Lincoln became president, the 150,000-square-mile territory called Washoe was put under federal administration, the Comstock mine declared a national asset. A branch of the federal mint was quickly organized in Carson City, minting silver coins with Virginia City ore, the mint protected by soldiers at nearby Fort Churchill, the same soldiers who protected members of the King survey—but, then again, didn't. In 1862, *The Bankers' Magazine and Statistical Register* estimated that the Nevada Territory supported 140 mining operations. In 1863 and '64, the Gould and Curry mine reported a profit of $2,908,800 on its portion of what was becoming the greatest haul of ore in the world.

If—while tentatively exploring the dimly lit, hellishly hot mine— you are tempted to think that the West was free from the violence of the Civil War, that the North and the South confined their fights to land east of the Mississippi, recall that Jefferson Davis had long viewed the West in terms of a Southern empire. As they worked to build a treasury at the war's outset, the Confederate states looked to hijack shipments of ore in the New Mexico Territory and California, especially in what is now Arizona, the scene of a Confederate invasion in 1861.

With a contingent of just 258 Texans, Colonel John Baylor defeated Union forces in New Mexico and declared control of a Confederate Arizona, a swath of land south of the thirty-fourth parallel, which included southern portions of what are today the states of New Mexico and Arizona. (In Las Cruces, New Mexico, a plaque marking the site of Baylor's victory was put in place by the Sons of Confederate Veterans, an active neo-Confederate group.) Baylor praised the territory's "vast mineral resources" and its oceanic access ("affording an outlet to the Pacific") and looked to recruit reinforcements from a California full of, if not slave owners, then supporters of slavery, with Arizona, for example, considered by the South to be more pro-slavery and secessionist than the Northern states. He expected to draw recruits from its substantial pro-Confederate population. "California is on the eve of a revolution," Baylor reported to the Confederate president that fall. "There are many Southern men there who would cheerfully join us if they could get to us."

Meanwhile, so much silver was mined in the West that it made the political establishment in the East nervous. When the silver kings moved their wealth into San Francisco—much of it monopolized by William Chapman Ralston's Bank of California—eastern plutocrats sent out agents to investigate. Clarence King's genius was to work anxious investors on both sides of the aisle, with contacts in New York and Washington, D.C., and with more in California, where he had surveyed during the war. While living in Virginia City, King took frequent trips to San Francisco by stagecoach, then via the newly completed train line. He pitched his survey to California bankers and railroad investors as a way to use science to map a united financial future based on lucrative ore, to make straight lines of the mess made by the miners themselves hammering away at the rocks.

Doubtless, King would have been keen to have photographs made in a mine—the first-ever mine photos. It would be a spectacle to be credited to the King survey, or better yet to an unknown photographer whose camera lens was aimed by none other than King! Which is perhaps part of the reason why O'Sullivan would risk the ire and possibly fury and even terror of miners to light a strip of magnesium in a mine where explosions were not only regular but frequent occurrences. While the miners hold still, the strip will spark and hiss, as if impersonating the beginnings of a deadly flare-up, and thus it will be a lot to ask a group

of miners to stand still for a moment like this. Fire underground carried huge risks, exacerbated by the use of candles in order to see. Fires had broken out in the mines not too long before this picture was made; and a little over a year after the photo was taken, the worst mining disaster in Nevada history would start with a fire, at the eight-hundred-foot level of the Yellow Jacket Mine: toxic smoke filled the chambers, burning timbers crashed, shafts collapsed. Thirty-seven miners died, bodies burned and crushed, some never recovered, and sections of the shafts would stay sealed off for years. Despite what it meant to pose the miners before a small fire, despite the images being the first ever made in a mine, and despite all the technical complications and logistical triumphs, O'Sullivan's mining photos were never circulated. Aside from a few officials in the War Department, some members of the survey team, and perhaps some of the various mining officials King associated with in Nevada that winter, they were rarely if ever seen.

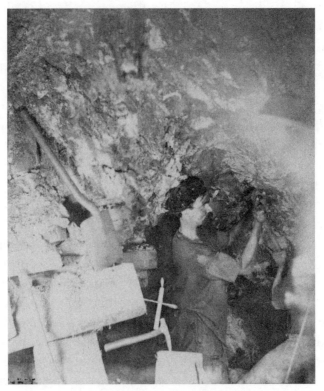

Miner working inside the Comstock Mine, Virginia City, Nev., 1867–68

The appearance of idling

If you had been spending time with Clarence King, either when he too descended into the mines to make his scientific inspections, or afterward, when he regaled bankers in San Francisco or senators in Washington, D.C., or financiers in New York with his western adventure stories, you would recognize him as a storyteller and raconteur, as someone who understood the drama inherent in the portrayal of miners, of men breaking away at the fabric of the planet, scraping and chiseling and hammering almost at time itself, in tactile contact with the primordial. But as a scientist with plans to write the greatest work of scientific literature of all time—a costly endeavor that required a few more years of expensive fieldwork and a few more synthesizing the observations in offices back east—King knew it was crucial that he not offend his congressional backers, especially so early into what he envisioned as several years of survey work. Congress, and the various representatives associated with the extraction of western resources, was loath to portray the kind of brutal, desperate work involved in mining silver.

We can assume, however, that O'Sullivan's hard-made plates were originally intended to illustrate Clarence King's *Report of the Geological Exploration of the Fortieth Parallel*, a multivolume report that King would release in sections. The first section to be published was specifically designed to gain support from Congress for King's intensive western survey work and, crucially, from Congress's mining and railroad interests. The serialization would eventually culminate in the 1878 release of King's magnum opus, *Systematic Geology*, his decade-in-the-making encyclopedic description of western U.S. geology, which he hoped would be his great contribution to the natural sciences. The finished report would feature works painted by the renowned artists who visited the survey sites (Albert Bierstadt and Gilbert Munger) as well as lithographs made from O'Sullivan's prints. (The actual prints were distributed to Congress and interested parties as an accompanying portfolio.) King hoped the report would do for North America what the great scientific writings of Europe had done for the Alps and that his cutting edge geologic maps would put America—and him—on the scientific map at a time when mostly European geologists were celebrated.

But in the short term, he used his scientific team to pinpoint any

and all minerals of worth in the vicinity of the nearly complete transcontinental railroad, making this otherwise bland scientific work catnip to financiers and their congressional allies by using graphics that were nothing short of thrilling: they condensed the earthy facts of Comstock mining—abysmal working conditions that generated millions of dollars of ore—into lines and colors, a pleasing graphic compression of violence, like sweat labor administered, in today's terms, through an app. Thus, the first volume published was volume three: a 647-page description of the Comstock Lode, *Mining Industry*. It made straight-lined graphic sense of what was underneath, data of what was being mined.

A chart from *Mining Industry, by James D. Hague, with Geological Contributions by Clarence King* (David Rumsey Historical Map Collection, David Rumsey Map Center, Stanford Libraries)

Clarence King would pour everything he had into his survey—and the report that he published in pieces—with an intensity that could also lead to great distraction, sending him away from the survey on what could seem like a whim. When the survey set out for Virginia City after the crew's dismal fever-wracked fall, King was still away, up north in Oregon on an unplanned side trip to investigate a recent discovery

of dinosaur bones (by an old friend from Yale), details of which he of
course squeezed into his magnum opus. He had sent word to O'Sulli-
van, who was still in charge of the recovering scientists, ordering him
to move the survey back west to Glendale. At this point, as opposed to
suffering in the malarial heat, the surveyors were dressed warmly, and
in O'Sullivan's plates they are pictured now in hats and coats, some with
walking sticks, some sitting on the ground in between the sagebrush.
The now long-gone smelter that they visited is behind them, the wind
blowing the black smoke and white steam fast toward the mountains.
On the cold march back, they slept in a barn. After great trouble finding
fuel for a fire, they managed to gather enough greasewood to boil tea
and cook the little bit of meat they had. "The night was so cold—that we
all slept in the corral in the hay," Bailey noted. "O'Sullivan and I slept
together for the sake of the additional blankets—and for such animal
heat that each might impart to the other."

Oreana, Nev., 1867

Of course, the Great Basin *was* a different place on the cusp of winter
and in cool weather. In cool weather it took only two long days for the
survey to cross the forty-mile desert: they battled monotony instead of

mosquitoes, pulling more quickly through the deep sand. In his letters, Bailey describes the joy that came from seeing trees along the banks of the Truckee River at last. Cottonwood groves nourished by a Sierra-born stream meant that the surveyors, Bailey wrote, "wouldn't have to drink any longer the disgusting alkali of the desert."

In what is today Reno, the surveyors rented a house, made a fire, slept in beds, ate heartily, began to ship notebooks with thousands of meteorological observations and crates of geologic samples to their offices back east. It was snowing by Thanksgiving Day, at which point Emmons and Gardner arrived in Glendale, where they had turkey as well as cider from Oregon. King arrived a few days later and moved himself, the geologists, and James Marryatt (back from being second-in-command to being King's valet) into a luxurious hotel in Virginia City. O'Sullivan and the rest of the survey group rented a flood-prone house down the hill in Carson City.

Personnel problems persisted. Bailey, the botanist, was now often too ill to work, so Jim Gardner took along Sereno Watson to work in the heavy snow. Gardner was now praising Watson for his physical strength ("In spite of cold and wind he had stood his ground on a mountain and closed up the last gap in our topographical work") and ready to fire Bailey, who privately felt trapped by the way others saw his infirmity. "I hate to give the appearance of idling," he wrote, "especially as Gardner, the second in command, hates me, and would do anything he could to remove me." And yet Bailey also comes to value Watson: "He is a man, however, that I greatly admire and respect." Bailey manages this impressive magnanimity as his own body continues to fail that winter, a physical deterioration through which he finds his own words misinterpreted. "The mean slights and misunderstanding of my words and actions have almost made me desperate of what I say or do—" he wrote, "so that where I believe I would have achieved a good reputation for cheerfulness and kindness at first, I am naturally looked on now as peevish."

If you had followed O'Sullivan into the mines, following his wagon through Carson City, you would have noticed that contrasts abound in the survey crews' accommodations. In Carson City, one group of surveyors complained of having to ford the winter streams that began to flood the area surrounding their boardinghouse. "We settled down to the prospect of swimming for our meals," Bailey wrote. King and Gard-

ner, meanwhile, extolled their comfort in Virginia City, where it cost twice as much to rent a room, the men enjoying the company of their colleagues. "We five young bachelors made merry round our board and rejoiced in our comfortable home," Gardner wrote to his mother, "and the storm raged furiously outside and I felt very thankful to be at rest. That night I slept in Clare's arms on luxurious mattresses and between snowy sheets; instead of rolling myself in a blanket on the ground."

El sistema

The ways that what you see today aboveground in Virginia City contrasts with what you would have seen in 1867, either before or after you went down with O'Sullivan, should also be noted as we continue to descend. When I visited the mountaintop town not too long ago, I saw an old-timey miner, bearded and overalled, dressed as if he'd just come from panning gold on a stream that still runs—though mostly in the collective American imagination of the West. He was greeting tourists, dodging kids' ice-cream cones, and looking like a mascot for a movie about gold mining, with mules and pots of coffee and pans and streams, and if your view of nineteenth-century western mining is influenced by mainstream American films, school textbooks, or American culture in general, then the lives of the men in O'Sullivan's mine photos are maybe not the mining lives you would imagine. In Virginia City's Mexican Mine, as the Maldonado brothers' claim was known, Spanish was spoken; the miners had come from Mexico or what had very recently been Mexico but was now deemed either California or part of Nevada, Utah, Arizona, New Mexico, and Colorado. As opposed to the English- or Irish- or Welsh- or Norwegian- or Chinese-speaking miners imported by corporations, miners who spoke Spanish were more likely to be married: the 1870 census reported that 14 percent of Spanish speakers were women, a figure five times larger than in other groups. "Spanish-speaking settlers and their children were the first to establish a substantial family-based society in the region," wrote Ronald James, a historian who worked on several archaeological digs, beginning in 1993, when the Comstock Historic District Commission's archaeology program teamed up with the University of Nevada to dig, first in a saloon and then at various home sites in Virginia City.

The Spanish-speaking miners brought with them traditional mining techniques, and while Clarence King and the investing industrialists emphasized expensive, steam-driven engineering, the archaeologists digging in Virginia City discovered that Mexican miners used an ancient mining system developed first by the Phoenicians, then perfected in Spain. *El sistema*, as the method was known, carefully followed a vein of ore as it proceeded underground, as opposed to blowing out swaths of earth, with or without ore, a tactic that would lead to what is today referred to as mountaintop removal. There was another way to mine, in other words, a less devastating alternative. White miners nevertheless referred to *el sistema* disparagingly, as rathole mining—ironic, given that the white mine owners packed increasing numbers of men deeper and deeper into grimy shafts, like the rats that scurried around them. In fact, the little mountaintop settlement was packed with people from around the world, so that at Yeong Wo Mercantile, archaeologists dug up Chinese porcelain, a Euro-American clay pipe for tobacco, a Kan'ei Tsūhō coin minted in Japan, as well as a glass gaming piece, a single die, and an opium tin, its lid stamped DUTY PAID. "Two blocks east of here once stood a Chinese community of almost 2,000 people," says a plaque standing today on C Street, Virginia City's main street.

Yet despite what residents did to connect with one another, Virginia City itself was as much a community as an anti-community, a colony organized by class and ethnicity, each group paid differently from the next, imported for profit, then divided. Around the West, mining companies drew in people from around the world, only to try to separate them, and if miners complained, mine owners found more miners—at one point importing Scandinavian workers to Nevada, though when a Boston company managed to get them all the way to Michigan in 1863, Union army recruiters lured them away with bounties. "The Cornish considered the Chinese more despicable than even the Irish," wrote James. "And for the Irish even the Cornish were preferable to the Chinese." The name of the store catering to Chinese miners can be translated as "Masculine Harmony Company," and it was part of an organization that facilitated immigration and offered miners such services as burial benefits and payment to their widows.

In the Boston Saloon, archaeologists discovered a clay pipe that, according to DNA testing, had been initially smoked by a woman,

which surprised many historians. Recent scholarship has shown that there were more women than previously imagined in Virginia City, employed as servants and prostitutes as well as needleworkers and spiritualists. The Paiute, in the meantime, came to incorporate Virginia City into their seasonal economic cycle, Paiute women living in the settlement to work as seamstresses. As opposed to white settlers who were slow to adapt to change, Paiute people showed great flexibility in adapting to an environment that changed drastically in a few years—a common theme, it seems to me, in Indigenous communities in the Great Basin and elsewhere in North America. Projectile points were carved from broken bottle glass instead of stone. Shelters once covered with pine boughs and woven grass or tule were covered with flattened kerosene cans. Traditional garments were fashioned with western fabrics— all examples not of the dying cultures described by white politicians and businessmen, but of adaptability and cultural survival under great duress.

In the past few decades, digging by archaeologists also determined that the Boston Saloon served better cuts of meat than a bar serving Irish residents, though another saloon had better-tasting water, using a state-of-the-art charcoal filter from London. The owner of the Boston Saloon, the bar referred to by the *Territorial Enterprise* as "the popular resort of many of the colored population," was William A. G. Brown, a Black man who was born free in Massachusetts in 1833 and arrived in Virginia City in 1863. If western history tends to paint mining towns as white-only enterprises, sifting through the remnants of the Boston Saloon also helped shift perspectives: among the numerous Black businessmen in the town, one Black man was a physician for a decade, another ran for mayor. William Brown first worked shining shoes in Virginia City's streets, opening a bar in 1864 on B Street, then opening the Boston Saloon sometime before the King survey arrived in town in 1867. It was the red-light district but also the site of the town's opera house. Kelly J. Dixon, one of the archaeologists who has worked in Virginia City, wrote, "Although Hollywood's popular depictions forge a common, monotonous misperception of saloons that ignore their diversity, historical and archaeological records demonstrate the variety of these leisure institutions, including saloons that served as 'popular resorts' for people of color living in mining communities."

When I read the archaeological reports from Virginia City, I begin to think of archaeology as akin to geology, human objects linking to other human objects, signaling connections through distance and time. Discoveries in the Virginia City archaeological digs connected miners not just to places beyond Nevada but also to settlements across the Pacific, to places on the other side of the Atlantic or along the Caribbean: the Gulf Coast, while less well-known as a portal in and out of the West, was as connected to the mining capitals as New York or San Francisco. One day in 2002, on the site of the Bucket of Blood Saloon, the young son of one of the archaeologists discovered a shard of glass that led to the discovery of twenty-one more shards, which were reassembled into a 130-year-old bottle. This bottle was eventually traced to its source, the McIlhenny Tabasco company, on what was the McIlhenny family plantation in Avery Island, Louisiana. Identified by its shoulder and embossing, the jar came from a time when the sauce was just beginning to be sold and marketed outside of New Orleans, around 1870. The hot sauce was itself a symbol of a forced migration: when enslaved Africans arrived in the United States, they used indigenous chili to re-create the spices West Africans used to season their food; the bottle was a symbol of the connections that went beyond the route of the cross-continental railroad. It connected Virginia City to the Gulf of Mexico and its port cities, specifically to African Americans in New Orleans—New Orleans, I would remind the reader, being the place where, as it happened, Timothy O'Sullivan appears to have arrived from Ireland as a small boy, the place where he grew up.

When I try to imagine the miners O'Sullivan might have met while heading underground, and when I picture him in the creaking elevators. rubbing shoulders with miners or mine owners or even Clarence King, I end up picturing miners like Timothy Francis McCarthy. A blacksmith who had left Ireland in 1853, McCarthy, like O'Sullivan, lived on the U.S. East Coast until 1866, then worked for a short time in Butte, Montana, arriving in Virginia City in 1872, where he found employment at the Savage Mine. Around the time O'Sullivan was there, one-third of the population of Virginia City was Irish-born, constituting a plurality. "I have been down in the Savage shaft on this day to the 100 foot level," McCarthy wrote on July 29, 1872. He had two children, and his wife became ill while pregnant with their third. On September 15,

1872, he wrote, "No mass this day . . . Mary have been very sick . . ."
Mary died on October 6, their third child was stillborn, and McCarthy
sent his children off to a convent in California. In 1875 his nephew Riob-
árd wrote to him from Ireland, careful handwriting on the back of a
carte de visite image of himself. Though it is likely that many people in
Nevada spoke Irish, given the number of Irish-born miners, the note is
said to be the oldest-known record of Irish being used in Nevada. It's a
stark and simple communication:

> A dhearbhrathair dilis rna mhathar ionmhaina, Taidhg; is me mac
> do dhearfear—Riobard.

> To Taidhg [Timothy], the dear brother of my beloved mother; I
> am the son of your sister—Riobard [Robert].

McCarthy's Virginia City house was in the center of the Irish American
district, and in the crawl space of his home, archaeologists found an iron
press used to produce wafers for Holy Communion. It was designed to
imprint the letters IHS into each wafer, the Greek letters that for Catho-
lics represent the name Jesus. McCarthy appears to have forged the
press for the local Sisters of Charity.

Stone of Destiny

As I gear up to travel down into the Savage Mine myself, or as I imag-
ine myself catching up with O'Sullivan while he hurriedly and care-
fully produces his plates in the depths of the nearby Gould and Curry
Mine—at a depth of nine hundred feet, three-quarters as deep as the
Empire State Building is high—I picture him meeting the owners of
the mine, introduced by Clarence King perhaps, or by James Gardner,
for all intents and purposes the manager of the survey. I imagine the
photographer meeting miners who, like O'Sullivan, are Irish-born. Did
they speak? Were they inclined to? Were they allowed? Did the miners
merely shuffle their tired bones in place? Surely O'Sullivan's years with
soldiers prepared him for working with reticent laborers, but did they
treat the visiting camera operator as an annoyance or perhaps as cause
for a brief paid break from hourly work? Thinking about such things

is like trying to find a path in the dark, but through my own digging in books and old western mining towns, I imagine possible correspondences. I learn, for example, that a great percentage of the Irish who went to Virginia City went, first, to Cork City, in Ireland, and then on to Butte, Montana, following in the footsteps of emigrants before them. A little more than half the Irish who settled Butte came from County Cork's four parishes. Of the five great peninsulas that make up the southwest coast of Ireland, the Beara Peninsula, partly located in County Cork, was the capital of hard-rock mining—a site of extraction that, following colonial procedures, saw the copper shipped to Swansea, in Wales, the supplies imported from England, the miner paid little and living in "eye-revolting poverty," a visitor reported. The miners of the Beara Peninsula were experienced hard-rock miners, some of whom were eventually lured by mine operators to mine silver in Virginia City.

Of course the Irish weren't the only hard-rock miners in Virginia City. In 1868 half the miners in the West were from the British Isles, and only half of those were Irish. Cornish miners, prized by mining bosses for their skills, had a reputation for being fiercely independent, and at the time O'Sullivan made his pictures, they were agitating to improve their working conditions as mine owners pushed them to adopt new techniques. Traditionally, they worked in pairs—"double-handed," one man with a hammer, the other holding and turning the drill bit. Owners derided double-handing as wasteful; the miners saw it as efficient and safe. Cornish miners also resisted using the new, more explosive dynamite that owners hoped to employ in Virginia City, preferring a more precise and thus safer explosive. Again, mine owners protested, threatening to hire Chinese workers to work as single men *and* use the more dangerous explosive. In 1869 the Cornish miners went on strike, forging alliances with other miners throughout the Sierras in Nevada and California—another constant in western mining at the time: despite how diligently mining companies worked to keep miners apart and against each other, they found ways to organize. In this case, they vowed not to go underground for less than three dollars a day. Mine owners tried and failed to hire scabs and then capitulated. The success of the miners' unions in Virginia City helped kick off decades of labor militancy among hard-rock miners throughout the American West. It was arguably the spark that ignited a surge of union activism that ran up to World

War I, at which point union organizers were jailed in great numbers, framed as traitors and spies working against the U.S. government. The right to organize in the United States would not become law until 1935.

The connections between miners crossed borders and oceans, as if rocks were fluid, which in geologic time they are. The miners who followed the Cornish on strike were miners from Wales, as well as from Peru and Mexico, and the Irish miners on the Beara Peninsula were fighting mine owners in Ireland too. In the late 1860s, Ireland had three copper mines, and the miners at Hungry Hill, in a coastal parish called Allihies, were protesting wages and conditions, an action that the miners in Virginia City knew about from its coverage in newspapers. "The lately revealed miseries of the Berehaven Miners excited the indignant feelings of Irishmen away in California and in the shores of the Canadian Lakes," *The Cork Examiner* reported in the spring of 1868. These Irish miners' miseries were being revealed to their North American comrades at the same time the Fortieth Parallel Survey was describing the mines and eventually *not* publishing O'Sullivan's photographs of their sorry working conditions.

If at last I imagine climbing onto another set of rickety elevators with O'Sullivan, I begin to understand that in the winter that straddled 1867 and 1868, Virginia City was not in fact a world away from the Beara Peninsula in County Cork. The world is ocean-connected and close, or can be, even while being vast, and what I find most tantalizing to consider is the notion that O'Sullivan might have been in communication—verbal or otherwise—with people he knew, or knew of, or had a connection to in ways beyond his own work with the silver on his plates. In small ways, over the course of my survey of this photographer's work, I think I have experienced some of these connections myself. The name O'Sullivan, as it happens, is one of the most popular names in Ireland but is especially prevalent in County Cork, and in a nineteenth-century survey the surname Sullivan was the most prevalent in the mining district of the Beara Peninsula. Once, when I asked an Irish historian about the Beara Peninsula, he said, "That's Sullivan country." (The *O* is a version of the Irish prefix Ó, meaning "a descendant of," and was often dropped on arrival in the United States, sometimes by immigration officials.) Another time, I was in San Francisco, assigned to interview a tech company executive who, when I looked him up, was worth more than the millions that the Comstock Lode

produced in 1869 (albeit not adjusting for inflation). From the point of view of mining, Silicon Valley is a continuation of the gold, then silver, boom, with technology digging up more from the mines and then mining data itself. I checked into a very nice hotel where the company I was working for had set me up, and I was about to board the elevator to my room when the manager, who was working at the front desk and had noticed my name, asked me if my family had come from County Cork, as his family had. I did a double take. Signing in while jet-lagged, I'd vaguely registered an Irish brogue, and now I read his name as he pointed to his name tag: Sullivan.

If you examine the history of the Allihies mine itself, you see that the owners built a mansion next to the ruins of a castle built by O'Sullivan Beara, the ancient ruler of the region. The family of O'Sullivan Beara described themselves as descendants of the Milesians, conquerors of Ireland. They are the people who, in old Irish stories, went into the earth to mine Lia Fáil, or the Stone of Destiny. They mined it in what is today Spain—in the council chambers in the Spanish coastal town of A Coroña, carvings depict the miners mining—and then transported it to Ireland, where it sits today on the Hill of Tara. In those old stories, Lia Fáil is a sacred stone that isn't just a stone. It's animate. It's a stone that sings and sometimes even cries out in joy.

The very diabolism of photography

The last thing I want to point out—as O'Sullivan lugs his camera toward one more miner, as he coats the glass with the liquids that will capture scenes of brutal underground work impressed upon them—is that photographs, especially when made on glass plates, could have been seen as something more than just pictures. In the years when O'Sullivan was riding through the Great Basin in a military ambulance, people tended to believe that glass could itself could be transformed by its surroundings, in ways associated with traumatic circumstances. Grace Greenwood, the first woman to report for *The New York Times*, described what she called "specters" or "ghost faces," images in glass that began to appear in windows throughout San Francisco in 1872. "The first spectr [sic] of this kind," wrote Greenwood, "was discovered in the front window of a very respectable house occupied by a widow who, it

is said, recognized it as the apparition of her dead husband." The widow had sold the windows by the time Greenwood arrived on scene, but throughout the city the correspondent managed to see similar images that she couldn't explain, but described as being not *on* the glass but *in* it. "They are the very diabolism of photography," she said.

Not coincidentally, if you ask me, reports of this "image on glass" phenomenon mostly disappeared from newspapers after George Eastman's flexible plastic Kodak film became widespread in the early 1890s. Up to this point, people around the United States still described seeing images in other glassy places, particularly in the retinas of the eyes of the dead. In most of these stories, there was the idea that glass—or even the glassy surface of the human eye—is receptive, that glass remembers and is capable, under certain circumstances, of capturing things otherwise not spoken or said.

I keep this in mind as I watch O'Sullivan down in the mine—as I watch him point his lens, carefully treat his glass plate, then light his magnesium flash, a quick flash of light that imitates a fire in the hole, if smaller and theoretically more controlled. It is bright enough to illuminate a miner who, as I look at him now, appears almost trapped in the remnants of a cave-in that had occurred at the Gould and Curry Mine shortly before O'Sullivan visited. Three years earlier, the mine had been entirely destroyed by fire. Two years before O'Sullivan's visit, a tremendous cave-in happened at night, while the 220 miners were on break; a vast ceiling of rock collapsed. "They were much frightened and bewildered, all their lights being at once blown out," one report said. The caved-in portion of the mine was a hundred feet long, sixty feet wide, and three hundred feet deep. The newspaper explained that no miners were injured, which is difficult to believe, and rather than a disaster, the reporter described the destruction as a boon: "The result was more an advantage than otherwise, as old chambers that had been worked out, were filled without expense to the company. Rich ore was exposed from the chambers above, and the hole on the hill caused by the 'cave-in' is about an acre in extent, and large enough to entomb an army."

The Irish photographer's glass plate is a close-in shot of the cave-in itself, the remains of the disaster, and, given the framing, what almost appears to be the remains of the still-living miner. As a spectacle, the photo takes its cue again from the collaboration of P. T. Barnum and

Mathew Brady: in this image of former forest crammed into a carved-out mountain, the same light that alchemizes the photographer's careful mixture of silver and guncotton exposes the hidden work of the miner, and exposes the viewer. You *feel* the miner that you can't really see, as if he were you, or part of you. It's extraction and displacement made visible, even palpable, and in the finished picture we see only a foot, a knee, and a portion of the miner's calf, the rest of him presumably alive though terrifyingly invisible.

Cave-In at Comstock Mine, Virginia City, Nevada, 1868
(Amon Carter Museum of American Art, Fort Worth, Texas)

It takes some studying, but eventually you see that the miner's pick appears to be out of reach, stuck in the side of the piñon forest's remains, now framing the abstract chaos of fallen timbers and earth. We know that the light comes from a magnesium strip O'Sullivan has lit with a match, but I am struck by the way it is the light itself that appears most important, or even most valuable, in this photo of a silver mine. When you look at that light—or, more precisely, when you look at what the light left behind on O'Sullivan's plate—you see that it appears to emanate not from silver or gold, but from outside the frame of the photo, from the very place where the miner's body is trapped like a casualty.

7

Limestone Cañon, East Humboldt Mountains, 1868

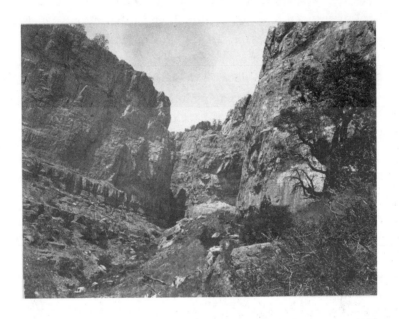

At this point in our survey of Timothy O'Sullivan's western survey pho-
tos we briefly stop time. We pause in the survey's itinerary and move to
examine more closely the work of Clarence King, the leader of the For-
tieth Parallel Survey, who, as we've already noted, is the author of the
only published in-person account of O'Sullivan's work in the field, that
piece appearing in *Harper's New Monthly Magazine*, wherein (as dis-
cussed) King doesn't so much offer the photographer backhanded com-
pliments as deliver difficult-to-decipher insults. There's a good chance,
as mentioned, that Clarence King wanted a more celebrated photog-
rapher assigned to the Fortieth Parallel Survey. Carleton Watkins had
exhibited photographs of Yosemite to great renown in the San Francisco
galleries that King loved to visit, and King and Watkins would indeed

eventually work together, as we shall see. But O'Sullivan, assigned by the army command, managed to make himself useful to King early on, or so it seems, working quickly with a sparseness and practical elegance that make his Great Basin plates more than run-of-the-mill geologic illustrations. Was it the acclaim that the O'Sullivan photos brought to King back east that made him hire the Irishman again and again? Or just the terms of his army funding? Either way, this image of limestone folds, holding together and falling apart, is simultaneously violent and delicate, an abstract depiction of tumult and mayhem, just what King would have been looking for. To me, the images say as much about O'Sullivan's thinking as they do about King's, which, at this point in his scientific career, has to do with the notion of "deep time," a principle posited by Ibn Sīnā, a Persian philosopher and scientist, then popularized in Europe eight hundred years later by the Scottish farmer and doctor James Hutton. It's the starting point of geological theory today. In his 1785 paper "The Theory of the Earth," Hutton wrote that in looking at geologic processes, "we find no vestige of a beginning, no prospect of an end." The earth doesn't stop, in other words, and geology charts its progress with a timeline of infinite length.

And when I chart the timeline of Clarence King, I note the complications that developed in the geologist's life during the survey and the increasing darkness of those complications as they interact with the darkest complications of American society. The winter he spent in the vicinity of Virginia City marks the beginning of a tremendous tension in his life, a nearly invisible seam or fold, though I think of it as foreshadowed by a strange moment late in the summer of 1867, when the survey team had been convalescing in the Buena Vista Valley and King was struck by lightning.

King was at a place he called Jobs Peak, marking sights for his maps, aligning far-off peaks and landmarks in his view, and surely, despite being sick with fever, in a kind of heaven-on-earth for a geologist who loved the outdoors and devoted himself to the study of the western landscape. He was using a metal theodolite, a precision instrument used to measure the angle between distant points, a version of which is used by surveyors to this day. As he worked, a storm was building in the distance. King and his topographer could feel the atmosphere charging, hairs tin-

gling on their necks. The air seemed to sizzle. Then an explosion cracked, like the bang of a gun. Suddenly King was on the ground, the theodolite thrown a distance away. In a letter he would write that winter, he described the way an "electrical flash came through the instrument, striking my right arm and side." For many days, his nerves raged—tingling, as he described it, burning, surging—and for years after, he would complain of problems he considered related to the powerful jolt of electricity that flowed through him and into the earth. "I was staggered," he wrote, "and my brains and nerves severely shocked."

When he managed to get back to Unionville, where his men were ailing, he told the story of being hit by lightning while on Jobs Peak, pain not blunting his need to be the entertaining raconteur. And when he told the story, King described the way his physical appearance had been dramatically changed. According to him, for a short time—and it's not clear what he meant by a short time, much less if his story has even the hint of truth—he was severely discolored, "a coffee color." King was, as he described it, white on one side of his body, black on the other.

I don't trust him, but even if it's just a story, his condition works as a metaphor for King's life and his life's work. If you think of him as the founding father of modern American maps, then he is an architect of a way of seeing U.S. landscape that separates resources from their environments, that sees one kind of community as worth taking note of and not another. And when you look again, you discover a hidden private life. In Virginia City, shortly after O'Sullivan photographed the mines and the miners, King's public and private identities found themselves at odds. It was the beginning of a split in the soon-to-be-eminent geologist's life. King's twenty-sixth birthday that January in Virginia City was like a marker in the rocks, the point at which his life seemed to shift into high gear and then very quickly crash. Although we can't know much about O'Sullivan, we can know something about the people he worked for, and if O'Sullivan exposed things that were underground while working in Virginia City, King increasingly worked in the opposite way, beginning a decades-long struggle to conceal one part of his life from another, to live half his life underground. By the time he died—penniless in a run-down hotel in Phoenix, Arizona, a few days short of his sixtieth birthday—the eminent scientist was living two separate lives.

Kingy

In that very first winter of the survey, starting in 1867, King fell in love with Virginia City itself, a boomtown that seemed designed to match his tastes—for geology and climbing and the outdoors, for offerings of so-called culture in opulent rooms and fancy halls in a rough-and-tumble place. It was the perfect base for an East Coast scientist with literary aspirations—convenient to San Francisco but far from his obligations in the East, where he was struggling to support his twice-widowed mother and her children through her second marriage at their home in Newport, Rhode Island. In this small but powerful capital of lucrative extraction in the Sierra foothills, he could conveniently position himself as an adventurer, even if his adventures were less about actual adventuring and more about how he was perceived as the artistic gatekeeper to the lucrative mysteries of the region, an alchemist of sorts, with, it turns out, many of the occupational hazards associated with alchemy. After setting up the geologists, topographers, and O'Sullivan in Carson City, King and James Gardner moved to the Ophir House, the luxurious home of a mining superintendent. King was euphoric, as Gardner wrote to his mother. "Clare and I are having a lovely time together in our little house," he said.

Aboveground, Virginia City was part industrial squalor, part mountaintop marvel of opulence, the wealth from below managed from a little less than an acre. There was Shakespeare at the theater, as well as classically trained singers and performances by the likes of John Philip Sousa: bass drums and cymbals on a stage, a hundred stories above sections of miners banging picks, clanging shovels. The local paper, the *Daily Territorial Enterprise*, was the most exciting in the new territory, a roaring broadsheet of news and storytelling and combinations thereof, and a hotel on C Street had the first elevator west of the Mississippi. Clarence King attended plays, concerts, and certainly the finest saloons as well as the ones considered the least fine. King loved to slum, to use the term of the day, thinking of himself as someone uniquely attuned to what was considered fine as well as coarse. And everywhere he went, he dressed as a mountain dandy, or something along those lines. "He wore tight-fitting trousers of light-colored doe-skin with a stripe down the side," wrote Thurman Wilkins, one of King's earliest biographers. "The tone

of his vest was more subdued, but a gold watch flashed across it; his coat was darker still, but against it pale violet or lemon-colored gloves made a jaunty contrast." He carried a cane and wore a wide-brimmed hat. His colleagues calling him Kingy.

Early that winter, King met a schoolteacher named Ellen Dean. At the same time, Gardner began courting Dean's friend, the daughter of a mining superintendent. Together the two couples attended shows, toured the area, went bathing in the warm springs. Samuel Emmons, the survey's other geologist, noted in his journal that when evening came, King and Gardner were often "out calling." By April, when they were about to leave Virginia City and resume survey work back in the Humboldt Range, King and Gardner were both engaged to be married.

From the Ophir House, King took quick trips to San Francisco, not much more than a day by stage and the new railway extension, where his friend Bret Harte was about to publish the very first issue of *Overland Monthly*, the proud California title that intended to compete with East Coast journals. King would eventually contribute a signed piece on Shoshone Falls, as western travelogues and travelogues in general were all the rage. Mark Twain, a recently relocated Virginia City celebrity, was just setting out on a trip around the world to write up humorous travelogues for a San Francisco newspaper, *Alta California*, and publishers everywhere were still clamoring for stories about the West.

Throughout the winter, King wrote and surveyed and made frequent quick trips to San Francisco, seeming euphoric, until suddenly something went wrong. All at once he fell into a deep despair.

A frightful glimpse

It's not clear why this happened or how, precisely, and I wonder if the lightning strike had something to do with his depression, often cited as a symptom of such a jolt if the person survives. In any case, at some point King's engagement to Ellen Dean, the Virginia City schoolteacher, was all at once off. In August 1868 he had written a note to Jim Gardner, who was set to wed Josie Rogers, the mining superintendent's daughter, congratulating his friend on his upcoming marriage and noting that he was about to do the same: "I can bid you Godspeed in this move with more thankfulness and more hearty good will than I once could, for one

of the best of God's own girls has promised bye and bye to crown my life with the same blessing yours is about to receive." But on the day that Gardner, his dearest, oldest friend, married Rogers in Virginia City, King didn't appear. It was a strange absence. Instead, King was with O'Sullivan, who was out in the Humboldt Range, in northeast Nevada, making photographs of the limestone folds and looking for evidence of glacial ice.

King was constantly on the watch for glaciers. A year later he would be the first person to publish a scientific account of glaciers in the United States, describing the glaciers of Mount Shasta after climbing the California volcano on September 11, 1870. That report would bring him his first round of national fame; it was followed months later by a travelogue recounting his adventures as a climber, *Mountaineering in the Sierra Nevada*. But at this point in his survey he was in the Humboldt Range, noticing the telltale signs of glaciation: the trailings of scree that geologists associated with a glacial deposit known as a moraine, as well as carvings and half-open, steep-sided hollows. He would have seen the moraine's edges trimmed by the sun-bleached wood of wind-gnarled junipers that still overlook the blue-sky edges of those mountains today. In the Humboldt Range, King saw the ways the Pleistocene glaciers had worked like sculptors, carving sharp peaks from the uplifted five-hundred-million-year-old sediments, smoothing out canyon walls, and, in high, close valleys, sculpting out little jewel-like lakes called cirques. Today, as the climate of North America has rapidly warmed, glacial ice has mostly left this part of Nevada, and what little remains is hidden underground.

As King wrapped up the 1868 season, he pushed the survey team north, out of the Great Basin, taking O'Sullivan and a team of topographers to the roaring Snake River cataract, where O'Sullivan would make his first photos of Shoshone Falls. (Before leaving the West, O'Sullivan himself would visit the falls twice.) The vast Snake River cataracts were north of where King's survey work had been approved by Congress, and King had to justify the trip to his supervisors. He pitched the falls as a commercial development opportunity for railroads, although, when he published his description of the falls in the *Overland Monthly* (not hiding his authorial identity, apparently not worried about upsetting his army commander by this point), it was maybe unintentionally less a work of

boosterism than a reflection of dread—the intense dread that, in those days, King's friends were so shocked to see in him. "Dead barrenness is the whole sentiment of the scene," he wrote.

Had the geologic cataclysms he was searching for somehow seeped into his life? "You ride upon a waste—the pale earth stretched in desolation," he continued. "Suddenly you stand upon a brink. As if the earth had yawned, black walls flank the abyss. Deep in the bed a great river fights its way through the labyrinth of blackened ruins, and plunges in foaming whiteness over a cliff of lava. You turn from the brink as from a frightful glimpse of the Inferno, and when you have gone a mile the earth seems to have closed again."

By December 1868, when the survey had disbanded for the season and King and the scientists were back in the East, King's depression was even more obvious to his friends. When Samuel Emmons visited Gardner and his new wife in Washington, D.C., he told friends about the happy couple. But when Emmons visited King in his apartment, it was a different story. "At room, find King very despondent," Emmons noted.

Up to now—in the records of the survey and in the accounts in general—King was the gregarious storyteller. Something had changed. One account says that King had taken Ellen Dean to Newport to meet his mother, and that after the meeting the engagement was over. The reasons are not clear, though a letter from Gardner indicates that it had something to do with his mother's reception of Dean. (King had asked Gardner not to mention his fiancée's name in Newport.) Subsequently, cryptic notes appeared in King's journal. "The idea of mother and God triumphs over passion," he wrote at one point. In another entry he suggested an image for a novel he might one day write: "Novel note—after the breaking of the engagement he dreams he sees her drown and only her hands above water and her cry then wakes on the gray hills."

Primitive manhood

When you are examining a photo that O'Sullivan made for King, keep in mind that race and class were intrinsic to the way King saw the landscape, as it often is for the organizations making maps today—on paper or in the digital realm—whether obvious or not. *Mountaineering in the Sierras* is a book that's still read by climbers climbing in Yosemite, by

people who appreciate the work for its descriptions of the physical environment. But in addition to exciting climbing stories and descriptive prose, King relates the mountains and their rocks to race—specifically, what he sees as the inherent difference between the white settlers and the Indigenous nations they are evicting. Case in point is his description of what he believed to be the first ascent by a white man—i.e., himself—or the first ascent of what he *thinks* is Mount Whitney: a reader of *The Atlantic*, where King's essay was first printed, wrote in to point out that King was one mountain off. When King received the letter from *The Atlantic*, he was in the midst of the Fortieth Parallel Survey, but he dropped everything to climb the correct peak.

In King's account of his Mount Whitney ascent, the view from the peak is viscerally thrilling, at once lyrical and scientifically up to date. The scientist-climber riffs on the latest findings of John Tyndall, an Irish scientist who first articulated what we would today call fluid dynamics, the behavior of the gases and particles that make up the atmosphere. (Tyndall's late-nineteenth-century work to describe the atmosphere as a collection of fluids will lead directly to the analysis of climate change in the late twentieth century.) "Now it was like an opal world," King wrote, "submerged in a sea of dreamy light, down through whose motionless, transparent depths I became conscious of sunken ranges, great hollows of undiscernible depth, reefs of pearly granite as clear and delicate as the coral banks in a tropical ocean." He then descends the Sierras and, at rest on his back on the valley floor, looks up again; in so doing, he remembers, as if in a dream, a Native American—"the gaunt, gray old Indian who came slowly toward me . . ."

The Native American whom King allegedly sees is less like a human, more like an animal ("his hawk eye upon the peak") and is doomed, doomed precisely for his inability to adapt. For King and other social Darwinists, Charles Darwin's theory of evolution is not so much about competition as it is about adaptation. An organism adapts to the pressures of its environment such as floods or volcanoes, and adaptation has less to do with ancestry, more to do with Emersonian self-reliance, or more properly a misreading of Emerson, since crucial to Emerson's concept of self-reliance was the notion that an individual was part of a community. As King sees it, Native Americans lack the ability to adapt, though naturally King's analysis obscures the view of sovereign tribal

nations suffering attacks by corporations, white militias, and military powers, not to mention any picture of the ways they then successfully adapt, repeatedly in King's time and even to this day, when tribal communities are currently under threat of lithium mining in Oregon and Idaho, on the edge of King's survey. In 2014, when white nationalists took over the Malheur National Wildlife Refuge (federal land on Burns Paiute territory) by force, with guns—a rebellion against federal authority that ignored local Native nations, just as King did—the militants were later cleared of charges in a subsequent federal trial. In King's writings, Indigenous people are like flourishes or watermarks, decorative details in his narrative. The Native American lacked what King calls "divine unrest" and so is the end of a racial line.

The Native person is listless, a lost cause fading into an ancient world, and thus for this adventurer and surveyor—and, increasingly, mining investor on the side—Native nations are erasable, merely a good story from the past. If the sight of an Indigenous man in the midst of the western landscape was useful to King the self-styled scientific pioneer, it was only as something to be imitated or mimicked for the sake of personal renewal: "the unperishing germ of primitive manhood which is buried within us all under so much culture and science."

And this appropriation would be a theme not just in King's nature writing and his geologic reports, but in his life, where he portrayed himself as being suffocated under contemporary culture and science, charged and enlivened only by what he describes as "savage." He is a geologist who mines communities, who extracts a culture's resources for the benefit of his own work, and though *Systematic Geology* is largely forgotten, we shouldn't forget that King managed to establish its point of view as that of the nation vis-à-vis the West. He codified the way we see, using what he called "primitive" merely to see more clearly what was there for the taking, a western landscape that had been cleansed of its romantic Indian past and was pure science, the art of which was decipherable by King and his scientific class.

"My mood vanished with the savage," King wrote at the end of his Mount Whitney essay, "and I saw the great peak only as it really is, a splendid mass of granite 14,887 feet high, ice-chiselled and storm-tinted; a great monolith left standing amid the ruins of a bygone geological empire."

Thanks to God and Clarence King

Early in the summer of 1872—and just a year after he published his acclaimed account of what he (wrongly) thought was a first ascent of Mount Whitney—King became an international star. His notoriety came suddenly, while he was in the midst of the Fortieth Parallel Survey. O'Sullivan, for his part, was snowbound along the Green River in Wyoming, photographing for King at the very northeastern boundary of the Great Basin. Meanwhile, King's surveyors were on a train when one of them happened to overhear a geologist talking about a diamond discovery. It was a moment when American investors, after a gold rush in the Sierras and a silver bonanza in Nevada, were abuzz with rumors of diamonds. Playing on the investors' eagerness, two con artists had conspicuously deposited a bag of diamonds in the Bank of California, hoping to attract the interest of investors. The con artists then convinced Henry Janin, a respected mining engineer, to visit what they described as a diamond field. Like King, Janin had studied at Yale, as well as at mining schools in Germany and France. The men allowed Janin to inspect their site, blindfolding him on the long train ride, and after Janin's approval, banks and wealthy investors from both U.S. coasts were poised to take the bait, everyone from the Tiffanys and the Rothschilds to Horace Greeley and the famed Union general George McClellan. The location of the diamond field was a secret known only to the investors—until Janin happened to ride his train across the Great Basin within earshot of Samuel Emmons, one of Clarence King's geologists.

Emmons reported the gossip to King, who interviewed Janin, and after collating the details (the length of Janin's blindfolded trip, his description of the diamond field's terrain), King, without alerting his military sponsors, quickly organized a team to secretly investigate. King, Emmons, and a topographer took trains to Northwestern Colorado, a train ride from Salt Lake City, each disguised, each speaking in code along the way: notice that King was increasingly more obsessed with secrecy in every aspect of his life. In short order, they found the diamond field and even more quickly determined that the gems had been planted, or salted, in miner's terms. The diamond field was a hoax. Again in secret, King proceeded to San Francisco, where he called a meeting of bankers and financiers, alerting them to the swindle. You

can see him in the meetings, the nattily dressed geologist-raconteur saving the wealthy investors from doom. After their audience with King, the investors pulled out their money just in time, avoiding a loss that newspapers in the United States and abroad went on to suggest would have caused a financial crash.

"We have escaped, thanks to God and Clarence King, a great financial calamity," wrote the *San Francisco Chronicle.*

Suddenly the civilian scientist who had been feverishly trudging through the Great Basin was being lauded in European capitals. The *San Francisco Bulletin* called him a "cool-headed man of scientific education."

All this fame seemed to take King's mind off his ill-fated engagement to Ellen Dean. By July, members of the Fortieth Parallel Survey team were camped in Parley's Park, a beautiful high-mountain meadow near what is today Park City. They ate fresh trout, waterfowl, venison. "King, always a delightful companion, was especially so in camp," wrote one surveyor. He supervised paintings of the Wasatch Range by Gilbert Munger, a landscape painter attached to the survey that season;

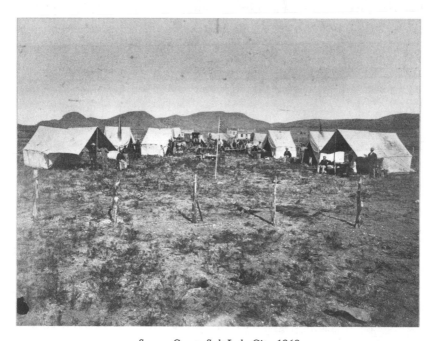

Survey Camp, Salt Lake City, 1868

and around this time O'Sullivan made several panoramic sets of plates, wide views of the Wasatch Range, in the vicinity of Salt Lake City. On July 19, O'Sullivan photographed the entire survey team, and then smaller groups, "men sitting in each other's laps," notes said.

Though the survey will continue for three more years, this moment, in retrospect, feels as if it is an ending, especially since, despite his fame, King's congressional funding for the next year is up in the air. In October, as the geologists headed east for the winter and maybe longer, the survey sold off all its equipment in Salt Lake City.

Back east, in offices in Washington, D.C., Newport, and New Haven, King worked furiously with Emmons and Hague, his two other geologists, to complete *Mining Industry*, the survey's first report. After being rushed to publication, it was a hit for the now world-renowned scientist. The government printed three times as many copies as planned, and as a how-to guide for mining investors, it helped speed up what was, as I think of it, a compression of the West, a collapse of time and space hastened by the railroads and telegraphs and intensified by more and more corporations making claims on western space: in 1872, four years after King's team left Virginia City, President Grant signed a mining law declaring that "all valuable mineral deposits in lands belonging to the United States, both surveyed and unsurveyed, shall be free and open to exploration and purchase . . . by citizens of the United States and those who have declared their intention to become such." Floodgates opened for government-sponsored miners and mining, and in the process, Indigenous land rights were trampled, treaties ripped up or ignored. With its appetite whetted for more information on the whereabouts of ore, Congress reauthorized King's survey, General Humphreys alerting King to quickly prepare to head west.

The order took King by surprise. Hard at work on his reports, he resisted immediately returning to the West, but Humphreys insisted, and King hastily assembled a skeleton team that did not include O'Sullivan. Given that it was late in the year, O'Sullivan had already been assigned to another survey, as we shall see. King headed to the peaks in the Cascade Range, where, on Mount Shasta in California (and subsequently on Mount Hood in Oregon and Mount Rainier in Washington State), his surveyors became the first white scientists to describe glaciers in America. "On the Discovery of Actual Glaciers on the Mountains of

the Pacific Slope" was published to acclaim in the *American Journal of Science and Arts* in 1871.

As King's fame increased, he was asked to lecture on America's glaciers and to write for more magazines. He hobnobbed with renowned scientists and the literary elite. In Cambridge, he was introduced to Ralph Waldo Emerson and Henry Wadsworth Longfellow, as well as a rising *Atlantic* editor, William Dean Howells, who, on meeting King, said, "I regarded the brilliant and beaming creature before me simply as a promise of more and more literature of the vivid and graphic kind." People were enamored of the geologist-writer who had saved the world from financial collapse, who had seen "savages" on mountaintops never before seen by other white people, even if he confused those mountaintops, as well as who or what was savage. But for all his promise, King faced repeated financial setbacks, in a way that seemed to have upset his friends as much as him. "A touch of avarice would have made him a Vanderbilt," said his friend John Hay, Abraham Lincoln's secretary of state.

Distinctly catastrophic

King faced intellectual setbacks too, even if he was less aware of them. He wouldn't publish the final volume of *Systematic Geology* until 1878, and even as he worked on it with his team, one geologic worldview was coming to replace another—in the end, making the decade he spent on the survey's final reports irrelevant. Despite the painstaking care with which it was produced and illustrated, *Systematic Geology* is rarely cited or studied or even mentioned by geologists today. When King was in college, the predominant geologic doctrine in the United States was catastrophism. It held that the earth was the site of repeated and large-scale catastrophes, like explosions and floods—the disaster movie version of the world's creation, starring events like Noah's flood. But by the time O'Sullivan was photographing the bending and breaking of metamorphic rocks in the Great Basin, European geologists were gradually adopting a new conceptual framework.

Uniformitarianism held that the world's physical history was long-term and gradual, that the cataclysms were cataclysmic but small in the scope of the world's nearly infinite time span. For many American

scientists, the debate had religious complications: catastrophism fit neatly with the Bible's flood narrative, and to reject it was to reject religious teaching, something King was loath to do. He worked to resolve the conflict between uniformitarianism and catastrophism by splitting the difference, which rarely works, in either scientific theory or life. In a speech King gave at Yale in 1877, "Catastrophism and Evolution," he argued that the world was created gradually *and* with catastrophes, making an analogy to the different kinds of people in the world, some catastrophists, some levelheaded. "You may," he said, "divide the human race into imaginative people who believe in all sorts of impending crises,—physical, social, political,—and others who anchor their very souls in status quo."

King would come to think of his own work as radical, even though it was based on preserving that status quo. Given that British scientists leaned toward uniformitarianism, King thought that its rejection—or adaptation, really, since he didn't reject it outright—would be another American Revolution, this time scientific; as a synthesis of all that his survey team had seen during the Fortieth Parallel Survey, *Systematic Geology* would be a scientific Declaration of Independence. The problem was that King had learned to practice science with a broad view that was worked out in the field and written up in the library, a practice that was by then considered passé. The "cool-headed man of scientific education" looking out at the Great Basin from a Sierra Nevada mountaintop was being replaced by specialists in the lab inspecting rocks beneath microscopes.

Plate tectonics is the theory that charges geologic thinking today, the idea that rigid plates float atop the earth's mantle. Seen through a modern lens, the older Appalachian Mountains are descending and the Sierras are uplifting as the pressure of the earth's colliding plates forces the younger western mountains ever higher. But until his death, in 1901, King pictured the Sierras as descending, decaying in the wake of the cataclysms that formed them. He also believed that cataclysms had happened more recently in the West than in eastern North America and that the formation of the Sierras and the Rockies (and the Great Basin in between) had involved tremendous, fast-moving forces from not *that* long ago. He was talking about even more action-movie stuff, on top of the Great Flood, examples that included, King said, "peaks rising in a

single sweep thirty-thousand feet from their bases" and "precipices lift-ing bold, solid fronts ten thousand feet into the air."

The West, for King, was "distinctly catastrophic." When he looked out from Jobs Peak just before he was struck by lightning, or when he paused at Donner Pass, King saw an America that, in its post–Civil War search for a new kind of nation and a forward-looking culture, needed to reorient itself. This is what he wanted O'Sullivan to capture: the dynamism, the violence, the change in the landscape that marks the trail toward a new America. If he preached poetry, his work reads like accretions of failure. Of his demise, no friend will be more disappointed than the man King will count among his very best, Henry Adams. When they met, in 1874, King and Adams connected immediately. Adams was a first-year Harvard professor on a tour of the West, precisely the sort of tourist King normally despised. Lost after wandering from a camp near Estes Park, Colorado, Adams and his mule found their way to King's survey camp, where the two men shared a bed that evening, talking away. In fact, if King is remembered at all today, it is due largely to Henry Adams, who in his writing described the geologist as a near-perfect American. "His wit and humor," Adams wrote, "his bubbling energy which swept everyone into the current of his interest; his personal charm of youth and manners; his faculty of giving and taking, profusely, lavishly, whether in thought or money as though he were Nature herself, marked him almost alone among Americans."

Thick and numbing

Adams wrote these lines of praise in *The Education of Henry Adams*, his own magnum opus, and they served as an elegy to King, who had died six years earlier, in 1901, penniless and broken. King had saved the country from the economic recession that the diamond hoax theoretically might have caused—not that San Francisco's Gilded Age railroad and mining barons didn't do other damage to turn-of-the-century American society with their crazed speculations. But King himself became a financial calamity, a fate that his friends, given what they saw as his intelligence and his skills, ultimately chalked up to a combination of repeated bad luck and the severity of the Panic of 1893. "In 1871," Adams said, writing in the third person, "he had thought King's education

ideal, and his personal fitness unrivaled. No other young American approached him for the combination of chances—physical energy, social standing, mental scope and training, wit, geniality, and science, that seemed superlatively American and irresistibly strong."

King started a bank in Texas, staked claims in Mexico and Cuba, prospected for silver and gold, quartz and phosphates, urged his friends to back him. Over and over, his friends steered him toward investments that inevitably failed. Even when he partnered with the head of the Union Pacific Railroad—he was promised commissions related to coal—his vision of an investment to retire on crashed with the stock market, in 1890, yet he continued to match financial failure with spectacular profligacy. His friends recognized that he was supporting his mother and her children in Newport while dining at the Century Club and living in upscale hotels, though in fact they didn't know the half of it. For a time, it was as if he put all his mental acumen into *Systematic Geology*, which is both visually groundbreaking—the charts and illustrations are magnificent—and, as mentioned, scientifically anachronistic. Expiration dates are always a fear for anyone involved in a long, all-consuming project.

In 1879, the year after *Systematic Geology* was published and long after King had left the field—at a time when O'Sullivan was done photographing in the West or, as far as anyone knows, anywhere at all—King was appointed director of the newly formed U.S. Geological Survey, in Washington, D.C., a position that played to his two great strengths: large-scale analysis and delegating. As an administrator, he designed the USGS's methods of exploration and mapping, and he set to work, first, mapping mining deposits west of the 100th meridian, where precious metals abounded, and in the East, where deposits of copper, oil, and coal were mined. He was working too under John Wesley Powell's proposition: for the United States to develop the West, it had to develop vast irrigation projects and organize the land accordingly. As a socializer, his life was centered around the lives of two couples, Henry and Marian Adams and John and Clara Hay. Together with King, they referred to themselves as the Five of Hearts.

King quit the USGS in 1881 and was succeeded by Powell, the renowned soldier, geologist, and Colorado River explorer, whom King had suggested for the position. Freed from his desk job, King made his

first trip to Europe, taking the grand tour, peddling shares in west-
ern mines while enjoying the sights. With a flair for the dramatic that
was beginning to be perceived less as artistic than as odd, he searched
for and wore a barber's basin like the one worn by Don Quixote, Cer-
vantes's fictional antihero, an appropriate choice to emulate given King's
grandiose view of his own increasingly desperate circumstances. While
in Europe he traveled with his cousin, Henry James, who wrote:

> the genial King, who is lodged below me here & who convokes
> us sometimes (Hay & me—with others) to the most gorgeous
> feasts—when he is not buying old silk tapestries, or the pet-
> ticoats of Mme de Pompadour, to cover New York chairs, or
> selling silver mines to the Banque de Paris, or philandering with
> Ferdinand Rothschild, who appears unable to live without him.

James noted that King also spent time in working-class bars, mimicking
the dialogue he overheard, amusing barmaids, slumming, and appreci-
ating, as James disgustedly described it, the vile and primitive.

King had moved to New York by 1885, when Marian Hooper Ad-
ams, Henry's wife, died, but I have a hunch that it affected him deeply,
given her closeness to him, given her closeness to those he was closest
to. After she died, King's life swerved more wildly. Clover, as her friends
knew her, was the lively center of the Five of Hearts. The four intimate
friends spoke of Clover as "our first heart." Among other things, she
was curious about the West. She encouraged King's Great Basin sto-
ries, and King brought her souvenirs—antlers, a Paiute basket, and on
at least one occasion a glass photographic plate. More than anything,
Clover loved photography, and King, who had spent years traveling with
O'Sullivan and a few other photographers, encouraged her interest in
making pictures. She photographed her friends, as well as landscapes
and seascapes. This was at a time before photography became simple and
automatic: the wet plate process still required great meticulousness, and
she took pleasure in the details of her exposures, watching the images
magically appear in the wash of dangerous chemicals. "My wife does
nothing except take photographs," Adams told a friend.

When biographers consider the reasons why Clover Adams killed
herself, they point to her father's death five months earlier and the ways

Umbrella tree at Smith's Point (Photograph by Marian Hooper Adams, 1883, Massachusetts Historical Society)

Oak grove, White Mountains, Sierra Blanca, Arizona, tree, 1873 (O'Sullivan)

it seemed to send her into a deep depression. They also note her discouragement with her husband, who was arrogant and pretentious, like his dear friend King, and who, some biographers suggest, understood that in his wife's complex emotional landscape he was lost. To the outside observer Henry Adams came off small in the presence of his wife's profundity, a notion that seems to have terrified him, even after Clover died, and that haunts his magnum opus. *The Education of Henry Adams* was published in 1919, a year after Henry Adams's death, and it is in some ways a radical work of reconsideration. This was consistent with his previous work, *History of the United States of America* (*1801–1817*), a book that stands out in its time for framing U.S. history off-center, the stage featuring more players from around the world: It reassesses the course of U.S. history not from the vantage point of Europe, but of the Caribbean and the Americas. Thus, Toussaint L'Ouverture, the leader of the 1801 Haitian slave revolt, is as important as Washington and Jefferson. Tecumseh, the Shawnee leader who brought together numerous Great Lakes–area nations under a confederacy to stand against U.S. territorial incursions, is portrayed not as a savage, but as an individual who affected the course of U.S. history from the outside—outsiders, of course, are anathema to the story of Manifest Destiny, a story that, even when disguised in a fashionable progressiveness, is enduringly marketable to this day.

The Education of Henry Adams was published posthumously, and for me, the book is profound for what its seemingly impersonal structure hides. While the book, written in the third person and moving through a neat chronology of American events, reads on one level as an intellectual autobiography of the author, it does not mention the author's wife, nor their marriage in 1872, much less her death—the sudden end of a dozen years of marriage. Their life together and the loss that devastated him, a loss that perhaps injected a kind of dark cynicism into the tone of the writing, is incorporated into the book's structure, or disincorporated, occurring in what is presented as a twenty-year gap that covers the space of the couple's life together, from the summer of 1872 to the winter of 1885. It's as if Clover's death—"the disaster which has broken my life into pieces," he will write fourteen years after—is too unbearable even to mention. "What one did—or did not do—with one's education," Adams writes when the chronology starts up again, "need

trouble the inquirer in no way; it is a personal matter only which would confuse him." But understanding Adams's unspeakable loss and examining the borders he draws in his life and his work helps us understand the *Education*, and as I think of it, the author created a space in the work, a pointed absence—which brings us again to Timothy O'Sullivan's photos. Sometimes O'Sullivan is criticized for what he has cut out of a landscape view, as if the trick is in the editing. But the trick, as I see it, is in seeing all that's left, the fullness of space that might seem empty, even when (or maybe especially when) that space has a dark power, a gravitational pull. Like his photo of the limestone canyon that begins this chapter, the landscape—and in this case the whirl of uplift and erosion, millions of years compressed in stone—holds things aside from the silver or gold or oil or water that's about to be claimed. It contains a sense of time that is easier to feel than it is to see, that must be very carefully exposed.

When I read Clover Adams's letters, I am struck by the ways in which the world she thrilled to capture on her photographic plates has begun to seem dead and lifeless as she moves deeper into depression. You are struck by her complaint of feeling physically disconnected from the world, as if she has not only lost touch with it but also lost the ability to feel specific things, and then to feel anything at all. "Ellen, I'm not real," she wrote to her sister during one of her battles with depression. "Oh make me real—you are all of you real!"

"The ice formed itself around her, thick and numbing," the writer Vivian Gornick wrote of Clover Adams. The liquid world was increasingly solid. "Nothing could burn through that numbness, certainly not pain."

Clover killed herself by drinking potassium cyanide, the chemical she also used to develop her photographs, and the remaining Four Hearts were distraught at the death of their friend. She had been the geodesic marker in their lives, their centerpiece. After Clover died, they went silent in various ways. Three years later, King was married—in secret, and, at the time, even the remaining Hearts did not know about his relationship, though one theory has it that it had been revealed on the day in 1893 when King was reported to have broken down in public. The day after this incident, a headline in *The New York Sun* asked, "Is Clarence King Insane?"

Composite

That King had to be committed made Adams sad. "It's miserable to think that one might never see him again as he delightfully was," he wrote. "In truth, I never thought there was no madness at all in his sanity—and feel indeed as if there may be some sanity in his madness." King had plenty of reasons to break down, starting with the state of his finances, which were terrible to begin with and made worse by the Panic of 1893, a severe recession brought on by the rapid expansion of railroads. His first biographers focused on money to explain his break-down. A more recent biography factored in the psychological stress entailed in concealing another life. In this other life, he was married to an African American woman, living with their five children in what were then predominantly Black neighborhoods, first in Brooklyn, then in Queens. He was also living under an assumed name, James Todd. In assessing King's mental state at that moment in 1893 when he broke down (or was reported to) at the Central Park Zoo, Martha Sandweiss, a historian of western photography who has studied King, wondered if the African American butler who is mentioned in news accounts of King's collapse might have recognized King, the white geologist, as Jim Todd, the man King pretended to be when he pretended he was Black. "I think it's entirely possible," Sandweiss speculates, "that a black man who recognized him ran into him at the zoo and said something—'Hey Todd,' 'Hey James,' 'Hey Jim'—and losing it was a way better alternative for him than facing up to the fact that he had two names."

It's not precisely clear when King met his wife, but sometime in 1888, in an apartment on East Eighty-Sixth Street in Manhattan, he married Ada Copeland, a Black woman living in Manhattan who had been born into slavery in Georgia. A Methodist minister presided. They subsequently moved to the Vinegar Hill section of Brooklyn, near the Brooklyn Navy Yard. King appears to have told his wife that he worked as a Pullman porter, a job that required travel for weeks at a time, and a West that was increasingly incorporated by the railroad would have allowed him to have one life in New York and others elsewhere, prospecting in the West. More and more, his white friends began to suspect something was going on, something, they further suspected, untoward.

When King was in the asylum, Henry Adams thought he recognized a subtext, writing in a letter to Hay that "something remains untold."

"I don't care to ask," Adams added. It's a remark that speaks again to those absences that surround Adams's life and work, and the work of his friends—absences that are built-in and hidden or built-in and intentionally ignored.

All King's friends had noticed odd complications in his schedule. One day King's secretary said he was in the West, then Hay ran into him at lunch in New York or Washington, D.C. And the complications increased as King's secret family grew. A son was born after 1889, a boy he named Leroy.

From what is written down and from what Ada would testify in court years after King died, it appears that James Todd told his wife that he was born in the West Indies and had come to New York more recently from Baltimore. Even with these very few particulars, it is not hard to imagine King mining the details of his life as a light-skinned Black man from relationships in his past—for example, his years on the western survey with James Marryatt, whom King knew as Jim and who, various reports have it, was reportedly from the West Indies. (Recall that Marryatt had briefly served as second-in-command of the survey, under O'Sullivan, but for the most part he dressed formally to serve King dinner, on King's insistence, the army admonishing King for describing him as his personal "servant.") At Yale, a few years behind King, another James Todd was a rising geologist, soon to work at the USGS. King had often told his friends that he had a novel in him, lamenting that he would write novels if only he hadn't so many mouths to feed. But it seems as if this other persona was his novelized other life—as a Black man, a true-life fiction.

By claiming West Indian birth, King managed to make himself into a particular kind of Black man living in New York City, his light skin carrying a different set of complicated racial implications, like his fabricated Caribbean Island upbringing. As James Todd, King had prestige as a Pullman porter in the United States, a well-paying position open only to Black men, often formerly enslaved. After the Civil War, the experience of riding on a Pullman train was marketed to middle-income whites in the South and the North as akin to the upper-class experience of being attended to by Black servants, but in the 1950s,

Pullman porters would organize into the first Black union, helping lead the way into the modern civil rights era. If it seems remarkable that so light-skinned a man could pass as Black, remember that in the 1880s, one drop of blood could mark a person's whereabouts with respect to the color line. Sandweiss writes: "And that he could cross the color line from the other direction—despite his own light-skinned appearance— illuminates the extraordinary arbitrariness of racial categorization at the end of the nineteenth century. At the very moment that laws sought to make racial categories fixed and unchanging, King showed just how fluid they could be." At the same time, the laws that hurt you as a Black man living under the myriad penalties of racial segregation helped you live a life as a white man pretending to be Black.

Marriage between two people deemed to be of different races was illegal in the United States in 1888; as recently as 2022, eight states, ranging from Connecticut to Alabama, required a couple to identify their race to get a marriage license.* The illegality of King's marriage, in other words, might have been another reason he panicked at being recognized at the zoo. King's friends would have recognized that his writings at the time took relatively radical stances for a white American—referring to interracial marriages as "the hope of the white race," for instance, though what he meant by "hope" had to do with differences being melted away, racial essences dissolved. King used the terminology of metallurgy, speaking of smelters melting constituent parts into one new compound. In 1885, critiquing the design of the new memorial to Ulysses Grant (now known as Grant's Tomb) for *The North American*

* Virginia's policy, enacted in 1924, was part of the Virginia Racial Integrity Act, originally referred to as "an act to preserve the integrity of the White Race," and, until 2019, when a federal judge deemed Virginia's requirement that couples choose a race identity in order to receive a marriage license as unconstitutional, couples chose from a list of "approved races," including "Aryan," "Octoroon," "Quadroon," and "Mulatto." The legislation was written by Walter Plecker, the physician, eugenicist, and white supremacist who headed Virginia's Bureau of Vital Statistics from 1912 to 1946; he described it as "the most perfect expression of the white ideal, and the most important eugenical effort that has been made in the past 4,000 years." "The act," *The Washington Post* reported in 2015, "didn't just make blacks in Virginia second-class citizens—it also erased any acknowledgment of Indians, whom Plecker claimed no longer truly existed in the commonwealth. With a stroke of a pen, Virginia was on a path to eliminating the identity of the Pamunkey, the Mattaponi, the Chickahominy, the Monacan, the Rappahannock, the Nansemond and the rest of Virginia's tribes."

Review, King argued that until all races were combined, there would be no pure American style: "In later periods, when the composite elements of American populations are melted down into one race alloy, when there are no more Irish or Germans, Negroes and English, but only Americans, belonging to one defined American race, that race will become conscious of its own ideals and aspirations, its own sentiments and emotions, and, as all other great races have done before it, will find its own fit means of expression."

I find it hard to believe that his friends didn't know more. To me, their shock seems defensive, like the shrugs of a neighbor who claims never to have noticed the serial criminal living next door. Before King's public breakdown, his obsessive erotic interest in women of color was well-known, though to say that he seemed to see them as objects and not as women is an understatement. "Women, I am ashamed to say, I like best in the primitive state," he wrote to John Hay. "Paradise, for me, is still a garden and a primaeval woman."

Masquerade

There must have been a kind of joy in the moments when the glass plates were being exposed, when King directed O'Sullivan with his camera into the cool hills, when the climbing was comfortable, not too far from roads and trains, when surveying was like adventure tourism financed by the army. But when I look at the photos O'Sullivan made while working alongside Clarence King—at the limestone canyon in the Humboldt Range and all through the Great Basin—I see the violence and turmoil in various geologic processes, and I see the anxiety and shame that, at the end of King's two-lives-at-once, subsumed him, the way the earth's continental plates are subsumed in the thousands-of-miles-long trenches, the great engines of plate tectonics. I also see lies: the lies that King lived and the lies he forced his secret family to endure even after he died, lies built on the racial tensions that are, like a geologic substructure, the mantle of life in the United States, even after the Civil War, and maybe more so.

As Ada Todd continued to have children with her husband, James—four in four years—Clarence King continued to travel the country, desperate and failing over and over to make money. "I fear he will die

without doing anything," John Hay wrote, "except to be a great scientist, a delightful writer, and the sweetest natured creature the Lord ever made." King continued to dine at the Century Club and kept a collection of art on Tenth Street—a small fortune, he seemed to think, though in the end not really. Ada continued to live on Hudson Avenue in Vinegar Hill, a Black and also Irish neighborhood that the city described as "substandard." A municipal report noted, "Garbage and refuse choke the gutters and decaying animal and vegetable matter lies till it rots to nothing."

Throughout this time King was still supporting his mother in her house in Newport, as well as her staff of servants. Around 1891, his son Leroy died while King was away. "My darling, I know all your feelings," he wrote to Ada. "I know just how you love me and how you miss me and how you long for the days and nights to come again when we can lie together and let our love flow out to each other and full hearts have their way."

After his stay at the asylum in Manhattan in 1893, King returned to his peripatetic public life, investigating mines, testifying for mining companies, doing geologic work around the country, staying afloat by borrowing money from his friend John Hay. In his life as a Black man, James Todd moved the family from Vinegar Hill, with its stench of slaughterhouses, to Bedford-Stuyvesant, an African American neighborhood established in the early 1830s by free Black people. Meanwhile, in his life as a white man, he traveled with Henry Adams to Cuba in 1894. King's public politics leaned toward that of his friend's; they might be called anti-imperialist, at least more so than American foreign policy. "Why not fling overboard Spain and give Cuba the aid which she needs?" King wrote. "Which cause is morally right?—which is manly?—which is American?" But in his personal life he continued to see people he referred to as "savages" and continued to believe that they were in touch with a romantic past that does not exist. "Within ten days he knew all the old negroes in the district and began to go off at night to their dances," wrote Adams from Havana.

Close to 1896, Ada moved the family to Flushing, in Queens, where the children attended segregated schools and where Ada had her fifth child. On January 1, 1900, the local Black newspaper announced a party, which her husband might well have attended. It was a costume party, and

Mrs. Todd asked everyone invited to wear a mask. "On Tuesday evening a masquerade party was given at the residence of Mrs. Ada Todd on Prince Street," the paper reported. "A goodly number gathered and many varieties of costumes were represented."

In August 1900, while returning from another long trip to Alaska, King learned that race riots had broken out in New York City. Newspapers compared them to 1863's draft riots, when white mobs roamed New York's streets, murdering and lynching. The city's Black population had begun to increase for the first time since the Civil War, as African Americans fled the race war waged against them in the South, moving north for jobs. A Black neighborhood had grown up in Manhattan's West Fifties, the Tenderloin District, an area that had previously been predominantly Irish. One night, a Black man stabbed a police officer during a fight. Subsequently, white people pulled Black riders off Ninth Avenue trolley cars, to beat them. The police clubbed Black men—in the street, in precinct houses, though the attacks were billed not as a race riot by whites against Blacks but as a spontaneous anarchy sponsored by the disorderly elements in society, a group that in this case did not mean white New Yorkers. "For four hours last night Eighth Avenue, from Thirtieth to Forty-second Street," *The New York Times* reported, "was a scene of the wildest disorder this city has witnessed in years."

At the end of 1901, the founding director of the USGS and the man who saved the American economy from crashing in 1872—the scientist whom Henry Adams said stood apart from the rest of his countrymen for his wit and humor and "his bubbling energy"—wrote to Ada and, for safety, implored her to leave the United States and move to Toronto, which she did. By the fall, King was in the Southwest, trying to recover from tuberculosis, living alone in a cheap hotel in Phoenix, his lungs weakening. Around Christmas, growing desperate, he again wrote to Ada, suddenly revealing his real name, giving her directions on how to take it as her own, directions that must have been confusing, to say the least. At some point he told her that he had set up a trust fund. "I have left $80,000 with Mr. Gardner. You need never worry." This is what she will remember him writing. In December, a doctor telephoned to Toronto to tell Ada King that Clarence King was dead.

Ada moved her children back to Flushing and, on her dead husband's advice, put a letter in a paper, advertising for a meeting with

James Gardner, King's old friend. When the meeting happened, Gardner arranged for monthly payments, which she received until 1933, when she, as *The New York Amsterdam News* wrote, "fought the group of wealthy white society folk to regain the trust fund." The headline in the *Daily News* describing her battle read "Old Negress, Suing Estate, Reveals Love."

But the trust fund was another fiction; the payments that she assumed were coming from the account her husband had set up were secretly coming from the man who was Abraham Lincoln's private secretary and both William McKinley and Theodore Roosevelt's secretary of state—John Hay, the architect of the imperialist policies Adams had questioned. When Ada sued, Hay cut off the payments. She would die in 1964, at the age of 103, living in the house that John Hay had bought for her. In court, she had fought only for what she had been told was hers. According to accounts in the *Amsterdam News*, a girl who was six in 1888—the only guest at the wedding who was still alive—described in court the icing on Ada's wedding cake, which was served in a tenement, and Ada described what her late husband had told her about his oil wealth and his valuable art collection. They had five servants who worked in their Flushing home, from which James Todd was frequently absent, but, as Ada testified, he was always attentive to the children when home. From the witness stand, Ada read her husband's love letters in a failed effort to prove a common-law marriage. "My dearest, I cannot tell you how delighted I was to see your handwriting again," King wrote in one. "To see something you had touched was almost like feeling the warmth of your hand."

PART IV

TO THE GREAT SALT LAKE

The King survey begins to wind down, and at last, I manage to step
out into the Great Salt Lake, or on it, in this case, despite my own
persistent logistical complications.

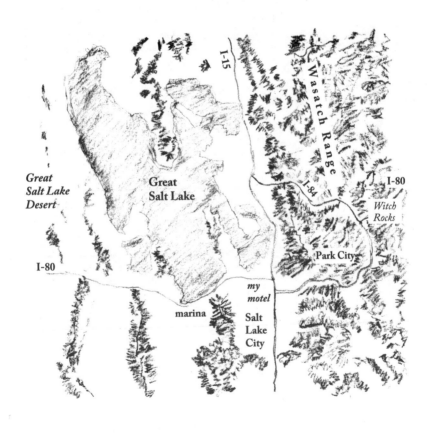

8

Salt Lake Desert, 1869

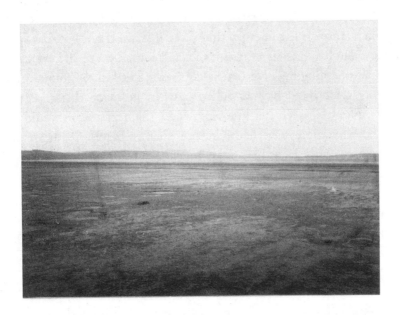

At some point in my own explorations of O'Sullivan's photos, I came to understand more clearly some of the ways in which adventures are complicated. Like most of the western surveyors, Clarence King not only sold his survey as an adventure but, for a time, sold himself as an adventurer too, a strategy that, in the end, rather than bringing him riches and fame, brought him the opposite. In my own life as a free-lance writer, I've written up a lot of adventures and on many occasions found myself encouraged to frame things as adventurous, or vaguely so, when they were in retrospect predictable, foreseeable bores. By the time I got to Salt Lake, or by the time I got there with a copy of O'Sullivan's photograph in my hand, various things had happened that made me not only tired of adventures but also convinced that adventures—in the

American West, especially—were like poisons polluting the stream of time and all the stories it contains. Surveying O'Sullivan's work had become a matter of not just painstakingly developing my understanding of the surveys and of western geography but of un-developing some understandings, too.

Over the years, I have returned repeatedly to the photograph O'Sullivan made of the Great Salt Lake Desert, the salt flats adjacent to the Great Salt Lake, a picture I have returned to more than almost any of his others. It seems to describe a liquid intelligence that asks questions and offers answers—and every time I see it, I am taken by what seems simple about it and what seems infinite and complex. When I eventually set about planning my own trip to the Great Salt Lake, I found myself thinking a lot about how O'Sullivan, when he made this glass plate image, might have felt not knowing where the next season would take him, how he might have felt at such a juncture, given all the seasons behind him in the West and in his previous assignment at war. At this giant evaporating lake bed, all that he had photographed during the war and then in the Great Basin was behind him, but his future was blank, like an empty glass plate. As it happened, I had planned a trip to the Great Salt Lake long before I finally arrived there, but then, as things worked out, I didn't end up going. Why didn't I go? A long story. Some setbacks, I'll say, or a crash, in terms of my physical condition. I'd been laid up again—as mentioned, just after I'd begun my O'Sullivan survey—and I managed to get a little better, then got sick again. It had to do with what I think of as my body's wiring, the various connections to the brain. Terms that medical professionals use to describe what I was experiencing included *relapsing* and *remitting*, words that, in their Latin roots, allude to problems—*relapse* connected to ancient ideas surrounding a return to heresy or wrongdoing, and *remit* to something being sent back for fixing or repair.

At the time, I liked to wax poetic about the prognosis, to distract myself from what could only be guessed at, but my neurologist had no moral note in her diagnosis, and I tended to think of the various issues the medical situation entailed as akin to mines and ambushes planted in the field before me, or buried just out of sight or just past where I thought I could see. The point I want to make here is that at the time I had no idea how I was going to get to Utah or when I would ever travel

on my own, and I was of the opinion that my trips to the soda lake and Sand Mountain in Paiute-Shoshone territory were my last trips for a long time; the excursions had wiped me out and sent me back to the doctor. Now I was just trying to keep myself together, to keep moving and do what work I could, confusingly difficult in those days in ways that are hard to describe. What I mostly remember, from the vantage point of years later, was that all I wanted was to find a rhythm or a current that I could settle into, a flow in which I could find a way forward again.

Then one day, out of the blue, after I had been feeling pretty good for a couple of weeks, I lucked out. I got a call to do a job in Salt Lake City, an assignment that involved two short interviews, which I thought were doable—like a puppy, I tired easily, and lost my train of thought. It was an assignment I'd won, I assumed, by virtue of me doing my best to hide the fact that I was any different from before, everything being so difficult to explain. Suffice it to say that very soon, on a dreary fall day, I was on a plane that began to circle, then descend, and, as we made a slow, sweeping turn, finally touched down in the northern reaches of the Great Basin. From my window I could see the Wasatch Range and the Great Salt Lake in the distance, a blur of jagged ridges and salt that looked like frozen fields, a sight that made me both excited and, for some of the above reasons, very scared.

I had rented a car, and as I arrived at the rental counter in the airport, the agent did a double take when he saw that under the last name Sullivan there were several rentals, a serendipity that he, at least, took as a good sign. "It *must* be," he insisted. I was at pains to not see any signs at all.

Then I drove to Park City, where I had an interview scheduled. The job would take a couple of hours just before noon, and then I was free, work done, motel paid for. It was overcast when I got off the plane, but for a few hours the sun broke through. Having landed early, I was able to take my time on the way to the interview, driving unhurriedly into the Wasatch Range, seeing the peaks O'Sullivan saw, picturing him picturing the hills while coaxing his mules, lugging plates and lenses, his heavy water bottles and chemicals—comparatively pleasant excursions, or so it seemed a century and some later. I'd circled the places he photographed on the map I'd carried from home, and I managed to be

on time for the interview and still spot several peaks and a meadow that O'Sullivan photographed or maybe even just admired: muscle-clenched basalt formations surveyed from afar by angled, weathered spires. People go to Park City for films and skiing, but the attractions playing out in the hills are beyond what IMAX can offer. "The Park City area is at the heart of one of the most diverse, well-exposed and accessible geological repositories on Earth," wrote a geologist at Brigham Young University. "Features of nearly every geological event that shaped the face of western North America are represented." And the writing in the landscape seemed obvious: I could see epochs folded into rock layers, far-traveled plates eroded, the sublime violence and terrifying patience of the elements.

I stopped near the top of a pass at what appeared to be a newly constructed strip mall. It seemed to pop up out of nowhere, constructed in what would have once likely been a meadow. I bought a snack and two disposable film cameras at a new-seeming grocery store. Then I got back into the car, every once in a while getting out to take photos, each time moving in a circle like a French New Wave cinematographer, hoping that when I developed the snapshots of the panorama, they would help me remember not so much what I saw that day—I am not a very good photographer—as what I experienced, if that's even possible. Today when I look at them, I see a panorama from which I am absent, and I get the feeling that I was neither steady nor planted. I remember feeling as if something had been lost or stolen from me, though I was struggling for details.

I hoped to stop in Park City for just a minute, but finding a parking spot in the tourist-packed city was like panning for gold in a stream crowded with miners. When I finally found one, I walked a block or so and then felt overwhelmed with the weight of what years earlier would have seemed like a straightforward assignment. I hurried back to the car, heading early to my appointment on the outskirts of town, then sat in the car and worried until it was time for the interview to begin.

My interview finished on time and went well, or seemed to. Like a photographer, I had to wait for my piece to develop, or in this case appear typed on a screen: as O'Sullivan would have known, anxiety is built into the freelance life, and, really, who ever knows? Still, under a flat white sky I was getting things done, a big deal for me back then.

At the same time, I knew I was different. I didn't really look all that different, except to my wife and the neurologist. I felt different, though, and felt it keenly.

My flight home didn't leave till the next morning, so I had the rest of the afternoon free. I dug O'Sullivan's photo of the Great Salt Lake and vicinity out of my bag and put it on the car's passenger seat. How many times have I gone back to this photo, to study it or just to stare! It was always the same photo, but it always had more to say. I recall now that at the time I was taking this trip, I had become certain that the Great Salt Lake contained something untranslatable, something I was desperate to find but still couldn't see.

Bagged for our collection

As I drove, I had little visions of the 1869 survey crew as they might have been when they camped in the area. I could see Clarence King reflecting on his broken engagement; Jim Gardner, whose new wife had suddenly become sick and was dying at the time, writing long, beautiful letters home. And I wondered: Did O'Sullivan think of his soon-to-be wife? Laura Pywell was the brother of William Pywell, another photographer who worked for Mathew Brady and Alexander Gardner during the Civil War. In 1873, Pywell would be assigned to photograph the Yellowstone Expedition, a survey not so much meant to extol the natural wonders of what is today Yellowstone National Park (though stereocards of the exploration were of course marketed as home entertainment), but to determine the route of the Northern Pacific Railway. In 1864, Congress had awarded the Northern Pacific a New England–size swath of land in the West, the largest ever offered to a railroad corporation. It was land that, then as now, belonged to the Blackfoot and Crow, the Sioux and Nez Perce, though according to Congress, not anymore.

What I know about the whereabouts of Timothy O'Sullivan and the rest of Clarence King's survey team at the time this picture was made is that O'Sullivan arrived in the Salt Lake area in 1869, toward the end of his third year exploring the West. Instead of taking steamers via Panama, he arrived direct from Washington, D.C., on the just-completed transcontinental railroad, a trip of weeks now turned into a matter of days: west of the Mississippi, time and distance had collapsed, affecting

everything from the flow of information to the value of land, which increased like vacant lots at an interstate exit. In contrast to the first season the survey spent in the Great Basin—trips into furnacelike sinks and alkali flats that ran toward the miragelike mountains in the distance—this trip in the spring of 1869 was mostly an alpine heaven. Working in the muscular Wasatch Range, the surveyors camped in beautiful high-elevation meadows that surrounded Salt Lake City. O'Sullivan accompanied Emmons, the geologist, and Gilbert Munger, the landscape painter now attached to the survey, and he began the season by moving his camera slowly toward what is today Park City, Utah, circling the area. Eventually he set up his wooden box camera and brass lens to look straight into the flatness surrounding one of the largest terminal lakes in the world—thus creating a picture of an entrance or a portal, a place that echoes and resonates. Beyond the hills that are in the background of the plate, or to the north by the compass, rain runs into the Snake and Columbia rivers and then on to the Pacific. In the hills and canyons to the south—where, after wrapping up with King, O'Sullivan will work on his next western survey—all the water flows to the Pacific via the Colorado River. But in the Great Salt Lake, rain that falls into the bed of this ancient Grand Canyon–size depression stays and vaporizes and moves again into the sky.

What I know about photography around the Great Salt Lake in 1869 is that Utah was a photographic hot spot, and Salt Lake City and its environs the very epicenter. William Henry Jackson, the twenty-six-year-old photographer who was about to photograph Yellowstone with Ferdinand V. Hayden's government-sponsored survey, was among the photographers hired by the Union Pacific Railroad to photograph the driving of the Golden Spike in 1869 at Promontory Point, north of Salt Lake. (He also photographed for railroad corporations in Mexico, New Zealand, Siberia, and India.) He would continue to photograph Promontory Point for the next decade. It was a bankable picture—"for," as Jackson wrote, "although a stretch of empty rail is in itself a dull subject[,] this particular one had instantly established itself as a popular choice." In the memoir he wrote when he was in his nineties, Jackson rattled off the other Utah sites he photographed, either for the railroads, for government surveys, or to sell them on his own. It reads like a salesman's list of wares: Devil's Gate, Devil's Slide, Pulpit Rock, Death

Rock, Monument Rock, Hanging Rock, Castle Rocks, and Needle Rocks—"a few of the wonders we visited and bagged for our collection."

For the federal government, the business of taking control of a territory was complicated in different ways around the West; in the 1850s the United States sent troops to suppress Mormons who hoped to create their own territory in the land that the U.S. had taken forcibly from Mexico the decade before. The Mormons' rebellion, as federal authorities might depict it, coincided with the rebellion of Indigenous communities struggling against incursion by railroads and white settlers, as well as by the Mormons themselves. In part because of the conflicts within conflicts, the territories were good business for commercial photographers, who raced to photograph the West, or to photograph it over and over again—all for publishers working to feed the public's insatiable curiosity about the progress of western development as well the not-unrelated interest in Indians, Mormons, and cannibals. If mining companies and government-sponsored geologists were akin to dance partners in the race to incorporate the western territories, then a photographer working for a survey had one eye on the orders of his survey boss and another on trying to make a buck for himself, selling images to photo-hungry publishers back east. If O'Sullivan represents the contracted government surveyor blessed with a per diem, then Charles Roscoe Savage represents the pure freelance, though nobody had a problem switching sides. Savage, thirty-seven at the time, was the Mathew Brady of Salt Lake and environs, a self-made western photographic impresario, and around the time O'Sullivan made his own plate of the Great Salt Lake, he spent time photographing alongside Savage, checking in, no doubt, with somebody who knew the region's views and vistas inside and out. Eight years older than O'Sullivan, Savage was born in England. As a young man, he converted to Mormonism. He served as a missionary in Switzerland, then left England to study in New York City, taking lessons in the Broadway photographic galleries that, at the time, employed the teenage O'Sullivan. By 1866, Savage's *Views of the Great West*, a series of stereographic views that included landscapes from California to Oregon and New Orleans, was sold by western railroad companies, winning him free passage around the West with his box camera.

Like O'Sullivan, Savage traveled in a wagon converted into a photo studio. When Savage and O'Sullivan went photographing together up

into the hills around Salt Lake City in the spring of 1869, Savage had
just returned from photographing Shoshone Falls, the Snake River cata-
ract widely known as "the Niagara of the West." A photograph of Sho-
shone Falls was a surefire sale to New York publishers, certainly part of
the reason that Clarence King had ordered O'Sullivan to photograph
the site just the year before, and surely also part of the reason O'Sullivan
would visit again in his last summer as a western surveyor—the end, as
far as anyone knows, of what you could call his career. The year before
he went out with O'Sullivan, Savage was among several photographers
chosen by the railroads to photograph the Golden Spike, William Henry
Jackson among them. As a carte de visite, the Golden Spike photo sold
very well, a hit, what you needed to survive as a self-employed photog-
rapher, as O'Sullivan surely noticed. Taking place about ten miles from
the northern shore of the Great Salt Lake, the driving of the Golden
Spike was an event highly choreographed by the business and financial
interests involved, an entertainment spectacle that rivaled the wedding
of Tom Thumb and later the moon landing. On the day of the event,
three gold spikes and one of silver were gently hammered into a cere-
monial railroad tie made of laurel. These were quickly replaced by iron
spikes hammered into a standard pine tie. One of the iron spikes was
attached to a telegraph wire that, when struck with an also-wired ham-
mer, transmitted the completed connection for the coasts to hear.

The temptation

In analyses of O'Sullivan's work, the point is often made by critics that
he didn't have to worry about selling his photos. In other words, by
paying him a per diem, the army offered him a kind of artistic free-
dom. This theory seems to me true up to a point, though certainly
King wanted plates that would create interest in the survey's geological
work—as would O'Sullivan's next commander—or at least create in-
terest in the aspects of the survey that they preferred the public to be
interested in. But just as it's hard to imagine that he worked in any kind
of an artistic vacuum, so it is difficult to imagine that he wouldn't have
been thinking about how to make money *after* his assignment was up, in
order not just to prosper, but to survive. Overall, it strikes me as a theory

made by someone who has a job, or at least hasn't spent the majority of their time working freelance, a job description I once heard defined as "free to starve."

But the flat directness of O'Sullivan's photo of the Great Salt Lake Desert makes it difficult to characterize in terms of any intention or requirements. It's not much like a survey photo and not much like a photo that would appeal to publishers back east selling western views, but then again it could be either, given that it has an almost defiant drama that forces the viewer to inspect what is nearly an infinity, a combination of salt and horizon and maybe water, or what's left of it. For me, it pushes the boundaries of both job requirements; it's a survey photo of the unsurveyable or an entertaining view into something you can't see. It's almost as though O'Sullivan was trying to avoid what everyone else was doing. "Many opportunities for making picturesque views presented themselves to O'Sullivan, but he resisted the temptation to make inviting pictures," wrote Joel Snyder, the photographer and critic, in the introduction to a book of photos by O'Sullivan published in 1981. In the same year, in a review of a show of O'Sullivan's photographs at the Philadelphia Museum of Art, Andy Grundberg, the *New York Times* photography critic, wrote, "O'Sullivan presents the contradiction of an artist in service to, and constrained by, the society of which he is a part. O'Sullivan's more problematic position is also more modern. Is it too much to suggest that for this reason, too, his pictures have more to say to us today?"

When I try to imagine O'Sullivan's thoughts as he pictured the Great Salt Lake and vicinity on that day in 1869, with the war now more than four years behind him, I dwell on the notion that he apparently didn't know whether he would be hired for the next season. In other words, he doesn't know where he's headed, not that he necessarily ever knew, though the question of the future might have inspired him to look back toward where he'd been, all the various theaters of war. He had just begun to court Laura Pywell in Washington, D.C., presumably a positive turn of events in his life, but, like an increasingly vast number of Americans living in the economic disarray that followed the war, he had no idea where his income would come from, or if it would come at all. As it happened, the following year, the survey continued

without him. For various reasons, King instead hired Carleton Watkins, the West Coast's photographic superstar at that time and for a long time after. Born in upstate New York, Watkins moved west in 1851, looking for gold, and then went to Yosemite during the Civil War, working, like King, for the California Geological Survey, making the photographs that are often cited as having induced Congress to name Yosemite a national park. A decade older than O'Sullivan, Watkin won various awards for his work. In 1868, while O'Sullivan was photographing with King in the Great Basin, Watkins was awarded first place at the Paris International Exposition for his California landscape photography. Did O'Sullivan worry about the competition? Did O'Sullivan worry about his own professional prospects? Doesn't, at some point or for some reason, everybody?

As King would likely have observed, Watkins and O'Sullivan are starkly different photographers. O'Sullivan's pictures of miners (albeit mostly unpublished at the time) depict mining as violent and desperate, an assembly line where men hack away at rock as rock seems to hack away at men. Watkins's plates can make mining appear no more desperate than work at a sawmill or a farm, the labor safe and organized. Watkins made pictures that were, from the point of view of investors and mining-interested legislators, more likable than those of O'Sullivan, whose pictures are not unlikable but something else entirely. Rick Dingus, a photographer and writer who has studied O'Sullivan, imagines that O'Sullivan's work methods, though likely good enough to satisfy the army's high command, might have come across as slapdash to King, the artistic geologist. "His sometimes mottled photographs probably seemed to his contemporaries a bit coarse and lacking in the craftsmanship, polish and refinements of taste required of an artist," Dingus writes, "but it is precisely the forceful and straightforward quality of his vision that seems so honest and expressive to us today, because it avoids the trappings of artistic conventions."

Plundered

The Great Salt Lake is as big as it sounds, seventeen hundred square miles, about eight times the size of New York City, a place where water

goes to change its molecular state, three or so billion gallons evaporating on average every day, more as the climate warms and as we warm the climate. At one point in my life, calculating where O'Sullivan made the image would have felt daunting, but by the time I got to Utah, I had gained a good deal of perspective on where and how he worked. I had also spent days poring over maps. It seemed likely that he made his picture from the road, as he often did, being always on the move, hurrying through assignments, and the road along the lake was still there, shadowed by the adjacent interstate highway. My exploratory options were limited, anyway, by the fact that my flight was early the next day. They were limited as well by my fear in those days of going off too far alone. To reiterate, I was not looking for any kind of adventure, for many reasons, though I subsequently marveled again at how many endeavors are fashioned into adventures in America, even if the ones endeavoring may not want them to be. I really just wanted to see the lake.

In the years that had passed since I first set out in the Great Basin looking for the giant sand dune in the Carson Sink, I had, I thought, tried hard to get past all the things that kept getting in the way of my long-planned Salt Lake trip—paralysis, physical and otherwise, the things that, at this point in my survey, I am loath to describe—and sometimes trying to get past these things felt impossible, like breaking through rock. But as I say, I was much improved at this point, which was why I was more than a little dispirited when, as I got into the car and began to head toward the lake, I suddenly felt everything crashing down on me once again, like an invisible cave-in. And now, as if on cue, the sky was getting gray, as if I were stuck in another adventure, not what I'd hoped for. But how do you get out of an adventure, anyway? There was nothing in the least exciting or thrilling about what I was feeling. To the contrary, the trip to the lake had become like a job I suddenly decided I didn't want to do, even though I was locked in. I remember how I felt that day, and as I remember those sensations, I can almost feel them again as I type—forward movement stalled by a moat of dread.

Time was what terrified me most back in those days: time ahead of me, time behind, time I couldn't get my hands on, so that time seemed to pass too quickly, and a given day or week or even month could seem to sit still. O'Sullivan had coated his plates with his silver and guncotton

in preparation for exposure; and at that moment, reluctantly heading out of Park City, I felt coated with dread, afraid to move or explore, haunted by any close examination of exactly how much time I had lost, on work and on life, with my wife, my family, the friends who could stand to deal with me as I was, sharp and frustrated, angry and flustered. Pills, doctors, tests, therapies, and despite or sometimes because of all these things, I could feel frozen, locked up, and robbed of the ability to press onward. I had often felt like a ship stripped of sails and oars, a craft still floating but plundered.

Even now I am afraid to think about these things, wary of paging through old notes and journals. When I do, I see myself groping and flailing, half composing long, strange sentences over and over on pages that more than anything are trying to find a way to get started, but can't. I look back to see a musician who can't turn the page of the score. I recognize now, of course, that these sentences were mostly made while I was terrified.

Now, approaching the lake, what I thought I saw in O'Sullivan's plate of the Salt Lake's landscape were things I didn't want to see, the depth of them. In other words, the view that I saw in his picture scared me partly because it seemed to contain things I knew I needed to see, that I had to understand to find a way back or forward or out, or anywhere. Henry David Thoreau always disappointed Ralph Waldo Emerson when he used opposites in his descriptions, but it is a strategy that makes sense to me, specifically in the case of O'Sullivan's point of view. To me, his photograph is packed solid with emptiness. Like an X-ray, it shows you what you can't visualize. It shows you only what you can feel.

A difficult and potentially dangerous maneuver

I decided to head for my hotel, a Hampton Inn on the eastern outskirts of Salt Lake City. I checked in and watched TV, tried to relax and failed. After an hour or so, I gathered up my maps and set out for the lake again. As I drove, I tried to distract myself by thinking about O'Sullivan's gradual approach. Before and after this particular plate-making, he photographed the meadows, canyons, and mountains

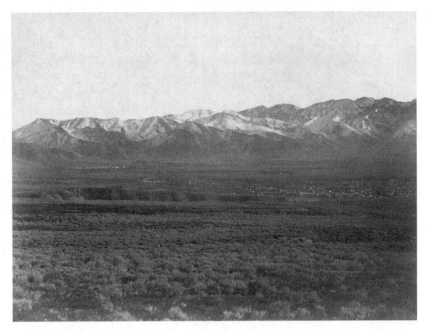

Salt Lake City and Wahsatch Mountains, 1869

of northern Utah, views from peaks. From a wide-open field he made a panorama of Salt Lake City, at that time a small settlement tucked almost invisibly beneath the quiet mountains that were themselves the remnants of an ancient seafloor, compressed and uplifted, then wrestled upward by the Wasatch Fault.

As I got on the interstate, I also pictured O'Sullivan photographing the survey team itself, on the outskirts of what is now Park City, where he posed them, all assembled, wagons circled, as well as individually, bathing, working, horsing around, with humorous captions likely written by King. It is a reminder that the scientists thought of the surveys as fraternal organizations, as going to war without the war, or without a war directed at them. When the surveys were over and the scientists returned to work in the cities, they often had trouble fitting back into a not so fraternal society and the less expansive Victorian boundaries of friendship. In this picture, made in camp, the shadow of O'Sullivan and his camera reaches into the picture from below, making him part of the team but then again not.

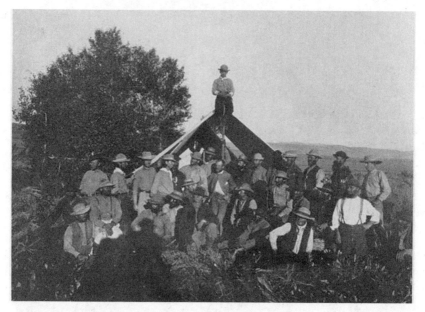

The immortal few who were not born to die

He photographed James Gardner and Clarence King, King's mood by then brightened in the presence of the newly married Gardner. King's old friend was about to take a job with a rival government survey, which King considered competition, so they are months from becoming ex-friends. "Rex ipse Jimque," reads the caption of one photo, written before the men split: "King himself and Jim." Gardner, whose new wife will soon die, wrote to her at the end of the survey's time in the Salt Lake area, remembering the landscape with her in mind, seeing in the meadows the absence of her:

> Oh darling I am camping at Tuilla, on the same spot where we spent that delightful day and evening. The same waving corn fields and in the foreground the same green and yellow meadows stretched beyond to the purple lake shores and the placid blue water shading to a landless horizon in the distance between mountain islands that stand so sharp and dark against the amber sky.

We have no surviving letters between O'Sullivan and anyone, much less Laura Pywell, who is the sister of the Yellowstone survey

photographer, a camera operator O'Sullivan would have known during the Civil War. According to a note Laura wrote on the back of a carte de visite that was a portrait of O'Sullivan, they had begun courting the previous fall. After he finishes another tour of the West, she and O'Sullivan will marry. We do, though, have O'Sullivan's photographs, and a site he photographed repeatedly around this time was Witch Rocks, a well-known rock formation in Utah, today about forty minutes southwest of Ogden by car. It is a formation of coarse conglomerate, pebbles, stones, and even some boulders that, as visitors to the area often note, seem to change before you in the light. From the journal of Albert Tracy, an army captain, in 1858:

> They jut upwards through the smooth surface of a rounded hill, and form a cluster, so singularly like figures in kirtles and steeple-hats, or bonnets that they have received the appellation stated. At moonlight, and with their lengthened shadows stretching above the hill, their appearance is exceeding[ly] weird and witch-like.

Witch Rocks was an easy sale when O'Sullivan photographed it in 1869, a formation that all the western photographers photographed. Andrew Russell, another western photographer of O'Sullivan's time, featured Witch Rocks in *Across the Continent, West from Omaha*, an illuminated lantern show of images, which toured in and around New York City, often shown at churches and meeting halls. Today you pass Witch Rocks along I-84. It's on the left if you are heading toward Salt Lake, and I vividly remember passing it late one winter day in 1990, when my wife and I happened to be moving west, looking, as it happened, for a better freelance life. I was driving a U-Haul truck, my wife and our six-month-old son up ahead in the car. We could see the Wasatch Range turn from deep red to nearly black, still feeling huge when you could barely tell it was there.

Rick Dingus, a photographer and writer, analyzed O'Sullivan's photos of Witch Rocks by visiting the site, some of which has eroded since O'Sullivan's visit. (One formation fell in a storm in the 1990s.) "Standing close to Witches Rocks is an awesome experience," Dingus wrote. At the site, he considered O'Sullivan's tactics, concluding that the photographer

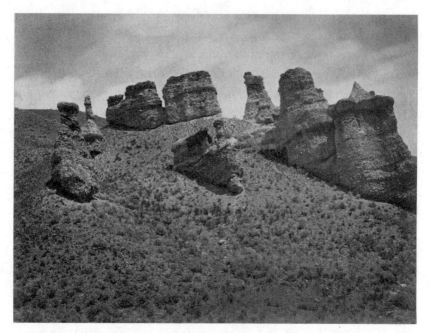

Witches Rocks, Utah Territory, 1869

circled the jumble of wind-carved conglomerate as he made his plates—hard work. "By matching the lighting in O'Sullivan's views, it was easy to see that his pattern described a spiraling traverse around the small amphitheater, gently changing altitude on steep slope," Dingus wrote. "Learning the hard way, I found that moving across abruptly from the first position to the last without making the gentle traverse was a difficult and potentially dangerous maneuver."

Dingus also noticed that for O'Sullivan, as he moved around the site, one column became something like the middle point of a compass rose. "This column may be described as the center of O'Sullivan's ever-widening circle," Dingus said. "Clearly, he took a delight in the aesthetics of perception, but his photographs were not limited by formal concerns. He remained true to his subject matter." As opposed to the way Carleton Watkins and his other contemporaries most often approached a place—looking for the one iconic and often commercially profitable image—O'Sullivan repeatedly rejected the best general view. He kept looking.

At the lake

How to approach the Great Salt Lake, a lake that includes a desert and is almost a region in itself? How to approach it as O'Sullivan might have? How to approach it as anybody? On this trip, I was driving from the east, along I-80, and I had as my destination a point on the lake's southern edge, the Great Salt Lake Marina. I was trying to take my time; there were still plenty of hours in the day, but I didn't want to screw up something that seemed simple, my specialty at that time in my life. As I drove past the outskirts of downtown, I could quickly see the way the long, flat valley ahead would become the lake and, beyond that, the desert, so called. As I rode parallel to the mountains, the Wasatch Range seemed to shadow me. The midafternoon sky was full of stratus clouds, a low ceiling that worked to make things not dark, just not light. When I rolled down the car windows, I felt a chill in the autumn afternoon air.

Just a few minutes away from the edge of Salt Lake City, the interstate picked up salt-white edges, and then the shoulder of the road seemed to have turned entirely to salt. I saw a smokestack ahead, behind some hills, which turned out to be at the northern end of the Oquirrh Mountains, which end where the giant lake begins and are prickled with TV and FM transmission towers. Mined voraciously for gold, silver, and copper, the Oquirrhs are the site of the Bingham Canyon Mine, begun in 1848 and today one of the largest open-pit mines in the world. In a few more minutes I noticed that the fringe of salt on the edge of the road had turned into fields of white and now a lake: the Great Salt Lake!

It seemed like a long shot, seeing precisely the view that O'Sullivan had seen when he made his picture—though it was, I realized now, just up the road. Once again I was winging it, to a great extent. But incredibly, the closer I got to the lake, the more certain I was that I was in a place not too far from where O'Sullivan stood in 1869. Then again, I had come to understand that precision wasn't the point. As my own survey project continued to unfold, the faithfulness, as I began to perceive it, was in my own negotiation of the experience of the photograph of the lake and its environs—what could a place and time tell me? And at this point, just looking out the window of the car, I felt as if I were

aligning with O'Sullivan in 1869, as well as aligning with other things of my own.

I pulled off the highway onto a service road that appeared to skirt the lip of the lake, slowly passing a creepy-looking old resort. A dance hall frequented by Mormons and designed originally as the Coney Island of the West, the hall and adjoining amusement park had burned down several times over the years before being rebuilt and moved and rebuilt again, the final iteration in 1981, just as the Great Salt Lake was about to rise, which it did, flooding the building. By the time I pulled up, it was operating as a seasonal music hall on a lakefront that, according to archaeologists, had evidence of human presence dating back twelve thousand years. At that moment it looked empty and a little haunted. The shoreline had pulled away too, especially since I'd last been there, in the late 1990s. The lake that had been rising when I was a kid, in the 1970s, now was emptying, fading away—the Great Salt Lake drying into the Great Salt Lake Desert adjacent, becoming desert itself, as if O'Sullivan had made a preview of the future. In 1993 I was flying across the United States from Oregon to New York when a pilot turned our attention out the windows to *Spiral Jetty*, the giant sculpture that Robert Smithson built in the lake, the pilot saying that the work had recently reappeared after having been completely submerged for years. Today *Spiral Jetty* appears to have been left stranded as the Salt Lake City area draws more water for agriculture and industry and for an increasing number of homes. And the disaster isn't only a matter of the lake's aesthetics or the loss of snowpack in the mountains that the tourist economy depends on (less water in the lake means less lake-effect snow). As the lake evaporates and the lake bed is exposed, so is the residuum of centuries of mining: heavy metals that turn to dust—mercury and selenium—as well as a natural amount of arsenic that, harmless in the lake, becomes toxic in the air.

I drove toward the marina that was just next door, though there were no boats and, as I would soon see, no water: the lake had withdrawn half a mile or so. I got out of the car in front of the marina, but no one was around. Something about the spot felt wrong, such that I quickly decided to drive back to the old resort, where I saw another car parked. This car didn't seem abandoned, but there was nobody in it. I stepped outside and stood still on the edge of the Western Hemi-

sphere's largest body of salt water without an outlet to the sea—the once 2,600-square-mile (in 1986) and now roughly 1,000-square-mile collection of briny water, formed in the lake bed by the Bear, Weber, and Jordan rivers, each surrendering its current in the Great Salt Lake and, through evaporation, becoming part of the sky.

I'd made it this far, but now I looked at my copy of O'Sullivan's photo, and I was frozen and didn't know what to do. I debated going out onto the lake or getting back in the car. It's frustrating even now to remember the way that it felt like a tremendous choice in that moment, one that overwhelmed me. Part of me wanted to just drive away, be done, so what. But in a minute, the part of me that was amazed by the feeling of the place prevailed and pushed me out toward the lake.

Gray

I climbed over a small embankment on the property of the abandoned dance hall and stepped tentatively out onto the dried-up shore, a salty flat that reminded me of a dead coral reef, a gray moonscape. The sensation was something like walking on hardened snow a few freezing days after a snowfall, though the temperature at the lake on that early fall day was comfortable, maybe sixty degrees. The air had the salt smell of the ocean despite the absence of ocean. I squatted down to examine the salt closely, to touch it. First, I absentmindedly used a hand that doesn't work as well as the other hand—the one that is numb and dead-feeling owing to my aforementioned neurological complications; it is as if I am wearing a thick glove, or a bandage. Realizing my mistake, I used my good hand to touch the lake. The salt felt thick, like sugar left out during a long, humid summer.

All at once I heard the faint sounds of four or five faraway people—friends, I quickly guessed, judging from distant, muffled laughter—and I began to put it together that they had probably arrived via the other car I had seen in the parking lot. While I couldn't make out individual words, I could hear their tone, which was spirited and friendly: it was as if I had slipped into a current of sound, a breeze of voices. The people I could hear were farther out on the waterless lake, just visible but blurry presences in a haze that was like a thin veil, and as I continued to crouch, I suddenly had the sensation that I was very alone. I remained crouched

and collapsed, or tucked in, like a ball, while listening and looking and trying to just encounter the place, not think about it, not worry—not think at all. As I did, I was struck by the sense that time had completely stopped, that in this salt and cloud-gray landscape I was like the whaler who looks out on the vast open water in *Moby-Dick*, lost in an infinite view of the ocean, what Melville calls "a sublime uneventfulness."

I looked to the north, or northwest, I'm not exactly certain: in the bright gray haze, directions were indiscernible and beside the point. I could have been in Utah or on the shore of the Dead Sea. The sun was maybe an hour from setting, and it was now just about to slip below the ceiling of clouds near the horizon, shards of light beginning to break through the soft, foglike aura. It was the particular time of day that photographers refer to as the golden hour, for the sun's softer light, though that phrase is also used in medicine, to describe the hour after a traumatic injury, during which the odds are best that medical treatment will prevent death. In the Library of Congress, O'Sullivan's photo is titled (presumably) by Clarence King, *Salt Lake Desert*, and the lake seemed like a desert that day, albeit a strange one. In the way that a desert exposes a person, allows them nowhere to hide, I felt exposed and at the same time sheltered—enclosed within the gray and white sameness of the sky and the haze and the infinity of crumpled salt. It seemed as if the briny surface were emanating something I couldn't see, but could feel, in concert with the mist and the clouds. I tried to discern where the lake's liquid surface began, but the salty shore went ahead of me into an impossible-to-measure distance and then, just beyond that, became the gray and silvery sky. In the farthest distance were the shadows of more mountains, like ghosts watching from bleacher seats.

I remained still for a long time. I said nothing. I looked ahead to where the small miragelike puddles of briny water maybe became lake, maybe didn't—it was never clear. Slowly, the gray-white sky began to break open, allowing in drifts of blue, like a watercolorist's wash. I could still hear the occasional far-off sounds of the friends' laughter, a hushed mumble when they spoke and, when they laughed, a muted, distant joy. The vast, empty lake of salt seemed to drag in every sound within hundreds of miles, gathering them into a soft blur. It made for a rush that you could not hear, but could feel and then not feel. To be there was to experience an absence—of people, of time and place and noise and

view—but an absence palpable and dense. It was a white noise that all my senses seemed to understand not as a noise, but as a sound, a sensation that I could move through, that almost felt just thick enough for swimming. As the light shifted, I felt as if I was on the wet plate of a photographer, my own self, and by experiencing the light and the mist and the lake itself, I was being exposed, as if what was precious and destructive in me, my silver and guncotton, was being touched and changed, as if the world was moving into me while something inside me escaped.

BETWEEN OCEANS

The photographer, at the midpoint of his life in the West, makes a brief excursion to Panama for an interoceanic survey with the Marine Corps, entering a peninsula that has often confused invaders and colonizers over what's up and what's down.

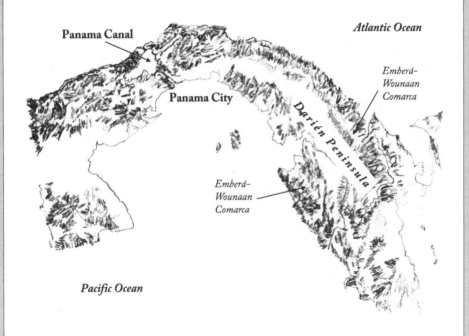

9

Forest, Isthmus of Darién, 1870

(The New York Public Library)

In the fall of 1869, at the very midpoint of the eight years Timothy O'Sullivan spent photographing west of the Rocky Mountains, he got on a train in the Great Basin and headed back to Washington, D.C., from where, instead of heading west again, he made his way to the Brooklyn Navy Yard, boarded a navy ship, and sailed for Panama with the Marine Corps. For a long time, I couldn't make much sense of this trip, and nothing I could find written about it helped or answered my questions. Why was he suddenly sent by the War Department to a mountainous rainforest four thousand miles away, this time accompanying a unit of marines? And what exactly did Panama have to do with the West, anyway? Books that feature his photographs rarely include any of the plates he made in Panama, and in the popular versions of what

the U.S. Army Corps of Engineers to this day refers to as the "Great Surveys of the American West"—the surveys by Clarence King, George Wheeler, Ferdinand V. Hayden, and John Wesley Powell made in U.S. territory west of the Mississippi, in the Colorado Plateau, Yellowstone, and the Grand Canyon—the emphasis is on science, adventure, and scenic wonders in the United States' new backyard, an adventure undertaken, as one account puts it, "through Flood, Mud, Snow, and Forest." O'Sullivan is a piece of a puzzle that connects the Civil War and the conquest of the territory west of the Mississippi with equatorial jungles outside U.S. borders—and, by way of the ocean-connecting possibilities of Panama, the world.

But if what seems like a side trip to Panama confounded me, I was not the only one. A few years ago, scholars determined that some of the photos thought to have been taken by O'Sullivan were taken instead by John Moran, a Philadelphia-based photographer. Moran—the brother of Thomas Moran, the artist who traveled with Ferdinand V. Hayden's government survey of the Grand Canyon—was an early proponent of the idea that photographs could be art. O'Sullivan was with the marines for one part of the Panama expedition, Moran for the other. For many years, a self-portrait of O'Sullivan was thought to be a rare image of the obscure photographer, but later research revealed that it wasn't him at all. In a similar way, I came to see that the trip to Panama that I thought an interlude was in no way different from the western surveys, but the same—set in a faraway jungle but, by means of force, bringing the distant closer, or trying to.

The plates that O'Sullivan did manage to make are mostly discounted by photo historians ("a set of pictorially undistinguished stereo cards," wrote one), though sometimes I wonder if critics aren't thinking about the pictures from the vantage point of the military and its congressional backers. Yes, they fail as illustrations of the real estate being surveyed. But some of the pictures, accidentally or not, manage to tell the story of the survey, which, according to the navy's final reports, is a tale of white people pushing through a dark jungle, wary of Native unrest but in the end triumphant, even in failure. "The Indians seem to have made the best impression on the explorers, and are said to be a less savage race than others of their kind," wrote the *Daily Alta California*, reporting on

the survey. If nothing else, the stereograph pictured at the start of this chapter conveys something about the experience of the peninsula itself: a dense forest, thick with vines and rain, described over and over by scientists and marines as "impenetrable," meaning, by the strictest definitions of the word, that there was no easy way to pierce it, and that if you did manage to get inside, then rather than you breaking through it, the forest would surround you. Feeling surrounded is something O'Sullivan makes me feel with his Panama pictures, and many others.

In terms of what the U.S. military and its congressional backers intended when they sponsored an interocean survey on the narrow but mountainous peninsula, this expedition was meant to end another frontier of sorts. The United States had been unable to chart a path across the peninsula; the terrain had thwarted a previous expedition of marines. In terms of the chronology of Timothy O'Sullivan's life, his trip to Panama lasted for a period of just six months—from January to July 1870. It was a trip to what was then a part of Colombia, in the Darién Peninsula. His orders came on January 11, 1870, and a little less than a week later he shipped out with a team of marines as a member of the Darién Surveying Expedition. Thus, in January 1870, instead of spending the winter in Washington, D.C., where he was still courting Laura Pywell, O'Sullivan made his way to the USS *Guard*, a ship that was, like him, a veteran of the Civil War. In February, after making landfall, the expedition set out into the peninsula's hills. Its mission: to find a route through the mountains, a possible quick connection between the Atlantic and Pacific oceans.

In a few weeks, machetes were slashing through dense, tropical forests in thick, humid air and relentless rain. Flooding trails, oozing mud, and a hundred marines alternatively trusting villagers for guidance or threatening them with oblivion, all in search of a path up and over a mountain that, a decade earlier, had killed dozens of marines. To the American military, the mountains O'Sullivan was about to cross were a thirty-mile-wide strip of failure, a gap separating two oceans, and mere mortality (or the threat of it) seemed to briefly constrain the land-hungry machine of U.S. territorial expansion—at least until the Civil War distracted the machine's attention. Now, in 1870, the marines were back, starting up and into the jungle forests; one day early in the

weeks-long climb, as O'Sullivan and his colleagues struggled to move through the center of the intestinal tract–shaped peninsula that is today crossed by a canal, a midshipman stopped to look at his hands, swollen and pricked, surrounded by mosquito clouds. He counted 108 bites on one, about the same on the other.

Corpse-white

Even today, given ever-extending road systems and vast dam-controlled irrigation or hydroelectric projects or the growth of industrial agriculture or deforestation and region-despoiling mining—the Darién is out of sync with the world. On the nineteen-thousand-mile Pan-American Highway that runs from the southern tip of Argentina to Alaska's Prudhoe Bay, what is known today as the Darién Gap is the one and only break—a gap that, in 1976, President Richard Nixon wanted paved through in time for the U.S. Bicentennial, though opposition prevailed. "It will bring environmental changes to an area that has been almost totally cut off from the effects of technology, and it will bring social changes to Indian tribes who have until now lived as they have for centuries," a 1973 news dispatch from Panama said.

The failure of Nixon's road is just another example of the Darién's long history of confounding outsiders, especially its would-be colonizers. Various European monarchs eyed the isthmus as a point of transit for the gold shipped from one side of South America to Europe. In 1698 the Scottish established a settlement at Darién—New Edinburgh— hoping to charge a transit fee, but the scheme failed miserably: nearly 2,000 of the 2,800 colonists died, and the tax on the Scottish economy is remembered today as a turning point in Scottish history.

The U.S. interest in a passage through the peninsula was another marker in its transition from colony to colonizer. Ben Franklin plotted seventeen different paths for a canal, and after gold was discovered in California, the United States sponsored railroads and then, encouraged by mine-interested Europeans, pushed for a canal. In early 1849, Edward Cullen, an Irish physician, claimed to have climbed to the top of a tall tree along the eastern shore of the Darién and seen both oceans—but he hadn't, a detail that, in 1854, U.S. Navy lieutenant Isaac Strain might have benefited from. When Strain sailed off on his survey of the Darién

Peninsula, along with a contingent of marines, he took only ten days of food into the tropical forest, and he accidentally marched in circles. Weeks later, when he finally made his way out—"skeletal, corpse-white" and weighing seventy-five pounds—he was infected with parasites, and six of his men were dead. The Strain survey reads like a poke in the eye of Manifest Destiny, taunting the United States.

After the Civil War, the North took up where the South had left off. Jefferson Davis and like-minded Southerners (and the Northerners who supported them) had mapped out a pro-slavery Caribbean empire while making various attempts to colonize the portion of Mexico that the United States had not taken during the Mexican War. In 1857 the Tennessean William Walker occupied Nicaragua, naming himself president after previously naming himself president in Sonora in 1854, where he founded a slaveholding colony, or tried to, as he had in Baja, California, the year before that. Northerners sympathized; Pennsylvania-born James Buchanan tried to buy Cuba for the United States, seeing the island, like Southern pro-slavers, as a potential slave territory that could balance the power of a slavery-free North.

The Darién survey the War Department hired O'Sullivan to photograph was the first post–Civil War military survey aimed at establishing U.S. dominance in the Caribbean and beyond. It was, as I think of it, a western survey confined to less territory—dozens of miles as opposed to thousands—with guns and technology aimed at extending the geophysical reach of the United States, all while treating the Indigenous population like pests or dangerous animals. If the resources being extracted in the Great Basin were mostly mineral, then the resource Darién offered was its location, a place from which to control not just land but the oceans that bracketed it.

Clearing away of all doubts

Sailing with a hundred marines, O'Sullivan stored his cameras and tripods, his glass plates and chemicals in the holds of the USS *Guard* alongside engineer's transits, compasses, aneroid barometers, mercury-based mountain barometers, spirit levels, rubber blankets, whiskey, quinine, guns, ammunition, and a hundred miles of telegraph wire. As they approached from the Atlantic, the wire would be used to send a signal

at the moment when the Pacific came in view. Orders from the navy secretary were "to ascertain the point at which to cut a canal from the Atlantic to the Pacific Ocean." As usual, O'Sullivan's particular motivations for taking the assignment are not known, but given that the King survey had not yet been reauthorized by Congress, I'm betting he took the survey because he needed the work. He had just gotten married, as noted, and now his new wife, back in Washington, D.C., was pregnant. He was being paid $5 a day in port, $7 in the field (a raise from his time with King), and he was to "conform to all rules of Naval discipline."

He was on assignment with Thomas Oliver Selfridge, who had commanded gunboats during the Civil War—in 1862, when a Confederate ship attacked the USS *Cumberland* in Virginia waters, he was one of the few to survive the first attack of an ironclad ship—and Selfridge's second-in-command, Captain E. P. Lull. Before setting out, Commander Selfridge ordered Lull to contact the "headman of the Indians and advise him the chief of the expedition would be on hand shortly." "Sufficient is it to add that advantageous as an interoceanic canal would be to the commercial welfare of the whole world, it is doubly so for the necessities of American interests," Selfridge wrote to the secretary of the navy. "The Pacific is naturally our domain."

Selfridge worried about the Indigenous settlements. "I fear I may have trouble with them," he said. But in the face of what he perceived as threats from the people on whose land he was about to trespass, he confirmed his resolve to his commanders: "But if they compel me to hostilities by an armed opposition, I shall not cease till every cocoanut tree between Caledonia Bay and San Blas is destroyed."

Selfridge hoped to find a path through what the Scots had long before named the Caledonia Gap, a gap that appeared to be of low elevation but wasn't. Selfridge did order the men to respect local property and threatened to punish any men who committed "outrage of their women," which causes a reader of Selfridge's survey reports to speculate on what was committed on previous surveys, or on this one when he wasn't looking. On the beach at Caledonia Bay, Selfridge met with a local leader, using the same grade-school diction that U.S. Indian agents used in recounting conversations with Paiute leaders in the Great Basin or Navajo leaders on the Colorado Plateau. "I am sent here by my great

chief with orders to pass through the country and I must obey," he said. "I shall cross to the Pacific, peaceably if possible, but if not I have ample force at my command."

By the middle of February the Darién survey began to move, and O'Sullivan set out with his cameras and supplies into the interior of the Panamanian isthmus, traveling with the first reconnaissance team, every fifth man with a hatchet to hack away at vines. Selfridge later wrote to the naval secretary to say that the unusually large military force traveling with the surveyors was meant to, in his words, "produce a beneficial effect upon the Indians." Though he wrote repeatedly of how unconcerned he was about the local people, his actions suggest that he was very concerned: the marines and surveyors were ordered not to sing or make any noise at night.

To protect themselves from the environment, the men wore large straw hats, blue flannel shirts, and duck trousers, along with shoes and canvas leggings. The day began with a tablespoon of whiskey and two grains of quinine, to fight malaria. They climbed the cordillera and moved slowly through sheets of rain. Nothing was dry. It rained continuously in the mountains, the muddy trail a few feet wide on the edge of great tropical gorges in which men heard "the roaring of wild animals." "After a while, the men had to throw away everything but their provisions," Selfridge wrote.

David McCullough, a historian who would write a book and narrate a 1987 PBS documentary on the Panama Canal, described the Darién expedition, noting, "Some of the older men, veterans of the Civil War, said they had never experienced anything to equal the march." O'Sullivan, one of those veterans, carried his equipment across fast-moving waist-deep streams, one man in a human water-crossing chain, unspooling telegraph line behind them. He proceeded to make his photographs in a forest so thick and humid, so rain-soaked and disorienting that treating a glass plate with chemicals wasn't just more complicated than in a desert (where it was complicated enough) but nearly impossible. The tropical humidity would make the coating and drying of photographic plates dismally complex, if not frequently out of the question. For the most part, O'Sullivan's views and angles—so wide-open in the Great Basin and often panoramic in the Wasatch Range—come across on the

Darién survey as cramped and constricted, even run-of-the-mill. "The project proved frustrating," wrote Joel Snyder, a photographer and writer who has studied O'Sullivan's plates, "because of the dense tropical foliage that obscured the very features of the landscape that O'Sullivan was assigned to photograph."

It took about five weeks to climb the mountain that looked from one ocean to the next. By the end of March, the chief telegrapher sent a message to the crew of the *Guard*, reporting that the surveyors stood on the top of the mountain that overlooks Caledonia Bay, a cove on the Atlantic side of the peninsula, and the Pacific, a view of two oceans at once, although there appear to be no photographs of that moment. A message was telegraphed from the top, where the crew sang an old minstrel song:

> The entire column of the Surveying and Telegraphic Corps unite in sending you and all friends on board, a greeting from the summit of the dividing ridge. Looking to the westward we see the long-looked-for slope of the Pacific stretching far away, seemingly all an impenetrable forest; to the northeast Caledonia Bay and the Guard is plainly visible; immediately around me I see Lieutenant Schulze, Mr. J. A. Sullivan, Ensigns Collins and Eaton of the Guard, Messrs. H. L. Merinden, J. P. Carson, T. H. O'Sullivan and Calvin McDowell, and as I telegraph this message they are singing "Jordan is a hard road to travel."

The expedition explored a few more routes, with O'Sullivan photographing, and then, after O'Sullivan departed, with Moran, the photographer from Philadelphia. Years later, Selfridge would go on to survey the Amazon River, and, when comparing that effort to the Darién Gap survey, he would call it "child's play." In a letter to *The New York Times* the fall after O'Sullivan returned to Brooklyn, Selfridge managed to characterize his failure to find an easy route as a victory: "The expedition returned to New-York in July, and though not successful in finding a proper route, have reaped a full reward for their labors in the clearing away of all doubts from three separate routes, and their elimination in the future from the field of research."

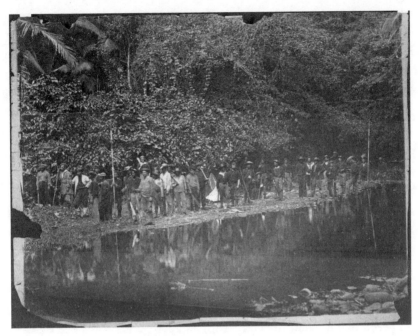

Return of Commander Selfridge and his Reconnaissance Party from an Expedition in the Interior of Darien, 1870 (The Metropolitan Museum of Art)

Green hell

After the mountain forests that O'Sullivan photographed were abandoned as a canal site, the Darién's reputation among outsiders was colored by the logistical difficulties outsiders had experienced there—a place defined by what it lacked, whose inhabitants were defined as lacking. Lieutenant Isaac Strain, whose men died while failing to cross the Darién, had described it as "the territory of these intractable savages." Selfridge, O'Sullivan's commander, echoed Strain and linked the character of the Native people to territorial gains in the western United States: "They have the usual characteristics of the copper-colored race, but are much lower in stature than the North American Indians, being rarely met with over five feet six inches in height." Notice that as Selfridge completed his survey reports, the U.S. Congress was passing laws to reframe its relationship to Indigenous people living *within* U.S. boundary lines: as of 1871, no longer would the federal government

recognize any tribe as an independent nation, even though they were. "As a whole," wrote Selfridge of the people he met in the Darién, "this tribe are cowardly, but treacherous, and, though they are to be feared only by small parties, become dangerous in work like ours, from their knowledge of the country." By "work like ours" he meant surveying, of course. When he talks about Native people's "knowledge of the country," he speaks of it as if it were a strategic resource, which it is, or can be. When describing the population of the area, the people he saw weren't people, but an impediment. "The whole of the Isthmus of Darien, except a small portion of the valley of the Tuyra, comprising the towns of Chipogana, Pinogana, Yavisa, and Santa Maria, and a few scattering inhabitants on the Bayamo near its mouth, is uninhabited except by the San Blas or Darien Indians," Selfridge went on. "It is on account of their jealous exclusion of foreigners that so little is known of the country."

"Its malignant historical reputation," a 1997 account went, "remains justified to some extent: it's the nearest thing left in Central America to the 'green hell' that swallowed Strain and company."

Hell is in the eye of the beholder, and from the standpoint of ecological productivity, the forests there are referred to as the lungs of Central America. The district that encompasses them—the Emberá-Wounaan Comarca—is also home to more than thirty-five thousand people living primarily in eight territories that are home to the Kuna, Emberá, and Wounaan peoples. In resisting mining and logging, citizens of the Emberá-Wounaan Comarca face the battles that Indigenous people around the world face in their relations with the nations that look to claim their territory: it is estimated that Indigenous peoples occupy 20 percent of all the world's land, when the vast majority of nations recognize neither their rights nor their existence. (They make up 6 percent of the world's population, but live in areas home to 80 percent of the world's biodiversity.)

In 1983 activists created the Emberá-Wounaan Comarca as a self-governing Indigenous district that has territorial land rights under Panamanian law, and in 2000 the Wargandí Comarca was recognized by the Panamanian state, though nearby Indigenous communities on more than a million acres of land have *not* been recognized. The pressure to take the land is parallel to the pressure to survey it—and in 2015, while the Panamanian government encouraged non-Indigenous communities to move

into unmapped Indigenous territories, Panama's environment minister estimated that 96 percent of all timber was leaving the Darién illegally. People living in the Emberá-Wounaan Comarca associate the forests and the landscape with their culture and the loss of the forest with cultural extinction. "Knowledge is lost, because, with the loss of the forest, the daily practices of botany, architecture, art are also lost," a human rights campaigner said. Protests by these Indigenous groups are met with violence. One journalist who reported on forest loss in the Darién was Ligia Arreaga. "When I presented the evidence that [Indigenous] lands were really being sold, they hired assassins to kill me and make me disappear," she told an interviewer. One day, a Catholic priest showed up at Arreaga's home. He said nothing but quietly coaxed her into a car, driving her miles away, then telling her that a man had just confessed to him that he'd been hired to kill her. With support from an Irish nongovernmental agency, Arreaga left the country for a short time. "Forests are being defended with life," she said. "That is our reality."

Who's producing the maps?

In the fall of 2019 my wife and I were packing up to move from New York to Philadelphia. I was taking a last walk in our neighborhood when I happened to notice that I was on the street where Clarence King first lived with Ada Copeland, once a neighborhood of poor Black and Irish New Yorkers, now gentrifying rapidly—and adjacent to the navy yard from which O'Sullivan sailed to the Darién. I also happened to notice that the United Nations General Assembly was in session and that a young Darién activist named Carlos Doviaza was in New York, part of a group of Indigenous activists sharing the ways they used mapping and photography to monitor and protect their own forests. When the group presented at the U.N., an activist from the Maya Biosphere Reserve discussed the fight to preserve a rainforest threatened by drug cartels and logging. A representative of an Amazonian Indigenous organization described helping young people work with elders in his community to map local landscapes, creating what he described as a digital database. A teenager from the island of Borneo, in West Kalimantan, described the struggles of staying on land when Western colonists had decried his ancestors as cannibals. Michael McGarrell, a citizen of the Patamona

Nation that is within the boundaries of Guyana, described miners loot-
ing diamonds and gold in the former English colony, as well as the cost
to human lives of resource extraction. "We want to see our leaders stop
being criminalized, stop being assassinated, stop being murdered," he
said. "Because all we are doing is trying to protect our earth." It felt like
a meeting of the Darién Peninsulas of the world, the gaps in the global
economic architecture, each being attacked from outside.

Doviaza had traveled to New York City from his home in the Darién's
Emberá-Wounaan Comarca. "I am Embará, from the Darién," he told
the audience. He was there to discuss his use of drones to photograph and
map Embará territory, as well as the territory of other Indigenous groups
in the Darién. Whereas the U.S. military uses drones to survey territory
in wars, he was putting drones to a different use. Speaking through a
translator, he said, "We are a group of young Indigenous people who are
able to use technology to protect territory in this initiative we are calling
Geo Indígena."

He continued: "We work with all seven Indigenous peoples in Panama
in order to advance their rights and monitor their territories. We started
our work in the Darién, which is known for the Darién Gap, the one place
in the inter-American highway that does not have a road, the one road-
less area between way up north in Alaska and the Tierra del Fuego, in
Argentina. This initiative shows that Indigenous young people are able to
manage technology as well as if not better than the government."

The moderator asked Doviaza a question: "You mentioned that you
are producing your own maps and geographic data—can you tell us
how you have interacted with the state, the authorities, with that data,
and can you tell us how that data has changed the relationship with
authorities?"

"To begin with," he replied, "governments don't include Indigenous
people at their roundtable, because they don't think that Indigenous peo-
ple have the technical ability to be there. And that was somewhat true
until five years ago, when people were beginning to have these capaci-
ties. And so we began training ourselves to use technologies, to be able
to learn from these technologies and use them to generate our own in-
formation. Up until five years ago, you couldn't imagine that the seven
Indigenous peoples in Panama would be able to use drones or GPS
equipment, but for the past five years we have been able to learn to use

these tools. Today we are—and this is important not only in terms of using the technology but also in terms of defending our culture and enriching our culture. And it has been important because we've *always* been monitoring our territory. Now we're just using new technology to do it."

Doviaza described the ways in which his community managed the maps and information that came from this work in its negotiations with the Panamanian government around not just land rights but basic human rights. Like the United States, and often with its military support, Panama has a long history of banning Indigenous languages and cultural practices in the Darién. "We have created this success—in terms of being a counterpart and generating our own information, which then gets fed into these dialogues."

The audience included other Indigenous activists, and before he finished presenting, Doviaza encouraged all the attendees at the conference in New York City to consider a question: "So in your countries, who is it who is producing the maps? Who's controlling the data?"

Before he left New York, Doviaza spent some time walking around, at one point posing for a picture on the Brooklyn Bridge, standing over the harbor. Lower Manhattan was behind him, the Brooklyn Navy Yard before him, the very inlet from which O'Sullivan set off for the Darién in January 1870, and where, six months later, he returned to depart by train for Indigenous lands in the western United States—if you set aside time, it is as if O'Sullivan and Doviaza switched places. The way Doviaza described traveling through the very city that O'Sullivan's Darién survey had departed from reminded me of the way the Darién survey described the Darién, and I marveled that with Doviaza's trip to New York Harbor, to the island of Manhattan, he was staking a claim not in Manhattan real estate, but in its opposite: a world organized for the sake of community, forests considered not as resources but as beings themselves, alive. It was as though O'Sullivan's survey had been flipped on its head.

"[This] cement jungle," Doviaza wrote of New York, "is one of the largest that I have had the opportunity to walk without a guide, going deeper and deeper in and through many unknown things, discovering differences between the green forest and the concrete one. In the end, they all come and go—they live to survive."

PART VI

EXPLORATIONS

In which we follow O'Sullivan as he returns to the West to begin his second and final series of surveys—crossing Death Valley when it shouldn't have been crossed and then rowing against the current on the Colorado River when he might have rowed with it, both adventures riveting, deadly, and, from the standpoint of a military survey, pointless. In examining these photos and the sites where they were made, we begin to see O'Sullivan's photographs as tools with which we can look again at North America's landscape.

10

Death Valley, 1871

As I set out to explore the second of Timothy O'Sullivan's two western surveys, I found myself more and more interested in trying to un-survey the surveys, to run them backward or unravel them, the way you might pull a thread from an intricate embroidery or reuse an old glass photographic plate, scraping away the silver and collodion. Un-picturing things seemed especially appropriate given the nature of the second survey, which appeared to be one thing but was something else altogether, beginning in Death Valley, then proceeding up the Colorado River to the Colorado Plateau—south of where the King survey operated. The Colorado Plateau is a 150,580-square-mile red rock high desert that is cut with canyons and dusted with forests, all west of the Rockies and south of Wyoming's basins and peaks; it is cut across by the river that

gives it its name. In the spring of 1871, a few weeks after returning from Panama, the thirty-one-year-old cameraman stepped off at Halleck Station, a train stop just west of Salt Lake City that was barely two years old. He was still in familiar territory but with a new boss, Lieutenant George Wheeler, commander of what he called the United States Geographical and Geological Explorations and Surveys West of the One Hundredth Meridian. If western survey work was familiar to O'Sullivan, it was also coming to an end, though he did not know exactly when. By this time the western surveys themselves were about to be disbanded; Congress was frustrated by numerous teams of surveyors surveying places repeatedly, squabbling over territory: the United States was so hungry to consolidate western lands that there was a traffic jam of survey teams.

When I look at O'Sullivan's photographs from this period, I see pictures that are less interested in illustrating the eccentric geological theories of his commander (as they were under King) and more focused on illustrating his commander's survey work, or a version of it. In measuring them, I weigh heavily the fact that this was Lieutenant Wheeler's first survey, and in contrast with King, who had come from a scientific background and a once-patrician family with a penchant for art, Wheeler was all military, twenty-nine (two years older than O'Sullivan), and an engineer with the army's Department of California. Like many of the government and military leaders orchestrating the incorporation of the West after the Civil War, Wheeler was born in the East, in Grafton, Massachusetts, a mill town, where his family traced its lineage back to the 1600s. He had secured a spot at West Point not with the help of his locally influential family but thanks to the support of a mining-interested congressman from Colorado.

I consider too that while Congress paid for the survey and the army organized it, it was administered out of the West by territorial commanders who were, in the absence of states with governors and representative assemblies, all-powerful. Graduating in 1866, the year after Lee surrendered to Grant, Wheeler landed his first assignment in San Francisco under the supervision of General E.O.C. Ord, commander of the Military Department of California—which referred to U.S. territory west of the Rocky Mountains and south of Oregon. Wheeler claimed to have learned mapmaking from Ord, but he learned more than that. As far as transforming a West that was not quite yet officially

the United States, Ord's résumé reflected the one-two punch that characterized Western incorporation: extinguishing insurrections against federal power and enabling extractive industries. He had fought against numerous Native nations—the Seminole in Florida, the Spokane in Washington State, and the Rogue River in Oregon—and had begun his career in San Francisco in 1847, at the start of the Gold Rush. In California, on the recommendation of his army superiors, who advised freelance work for mining companies to make up for the army's poor pay, he worked part-time as a surveyor for land speculators and mining operations. Ord surveyed Los Angeles and San Francisco shortly after California had been wrested from Mexico, and at the end of the Civil War he commanded the Army of the James. During the rebellion of the Confederate states, Ord forced the march that led to Robert E. Lee's surrender, after which he returned to the West. Immediately after the war he led the army's Department of Arkansas and the Indian Territory and later made friends with Texas legislators by sponsoring raids across the murky U.S. southern border against Apache and Mexicans, raids that were so fierce as to be criticized by General Sherman, the notoriously brutal commander, who cited Ord's "eccentricities." The historian Robert Utley, in his analysis of western military commanders, described those like Wheeler—who had not served in the West before the Civil War—as thinking of the landscape as "a romantic land of adventure," while those who had served saw it as "a hard land of beauty and sterility."

When O'Sullivan packed up his cameras at Halleck Station to report for duty with Lieutenant Wheeler, the Department of Arizona had just been carved out of California, and one way to look at the trip he was preparing to take is to understand O'Sullivan as a camera-wielding cog in the national war machine—a machine that was forcing the growing legal and corporate strength of the United States onto a newly militarized western map and, in so doing, facing down rebellions of all kinds in a place that had been part of the country for only a few decades. When O'Sullivan was born in Ireland, in 1840, the map of the West didn't include Texas (which was independent) or anything west of the Rocky Mountains. The designated Indian Territory was bigger than the original thirteen colonies. Even more than the King exploration, riding its mules under a banner of scientific exploration, the Wheeler survey, while also claiming to be scientific and generating the requisite scientific

reports, was a more explicit continuation of O'Sullivan's work following the Army of the Potomac through the watersheds of the Appalachian Mountains in the East. It was an instrument of a war that, today, we struggle to label. Richard Maxwell Brown, a historian of the western United States, describes the period from 1850 to 1920 as the "Western Civil War of Incorporation." This Civil War, he writes, "coincided with a trend from 1865 to 1900 in which wealthy and powerful individuals, companies, and corporations sought either to force settlers off the land or to overcharge them for their occupancy."

"It was a land-enclosing movement," Brown continues, "which in the West engendered instability and discontent comparable to that caused by the land-enclosure movements in England from the Middle Ages to the eighteenth century."

If O'Sullivan's most widely seen photos are of the Civil War, the photos he made for Wheeler are the ones most likely to show up in art museums—the photos he made in the Navajo Nation at Canyon de Chelly and along the Colorado River in a river canyon that was subsequently submerged by a dam—and though, when we stop to look at them on a gallery wall, we think of them as made *after* a great war, I read them more and more as evidence of the continuation of a war, dispatches from a new front. If the federal forces were battling a Confederate rebellion in 1863, they were now battling rebellions enacted not only by Native nations (who were coming under renewed attack as settlers, ranches, and railroads invaded) but also by the settlers, who wanted increased local control of the land that the government had—with laws and troops—enabled them to settle. In this case, Death Valley was like the Shenandoah Valley, the ancient geologic basin that was the setting for the Battle of Gettysburg—here infiltrated with miners and surrounded by newly settled towns, all of which encroached on Shoshone and Paiute and Chemehuevi territory. Brigadier General Andrew Humphreys had worked closely from 1853 to 1857 with Jefferson Davis, the secretary of war, in surveying the route of the Pacific railways, and it was an association that hurt Humphreys at the outset of the Civil War, when he was considered possibly too Confederate. But by the war's end, after promotions at Fredericksburg and Gettysburg, he'd become chief of staff of the Army of the Potomac, giving Wheeler his orders in the West, which were expansive:

... obtain correct topographical knowledge of ... everything re-
lating to the physical features of the country, the numbers, hab-
its, and dispositions of the Indians who may live in this section,
the selection of such sites as may be of use for future military
operation or occupation, and the facilities offered for making
rail or common roads ... the mineral resources that may be dis-
covered ... the influence of climate, the geological formations,
character and kinds of vegetation, its probable value for agricul-
tural and grazing purposes, relative proportions of woodland,
water, and other qualities which affect its value ...

When he was finally done, three years later, Wheeler would describe
his completed survey area to a meeting of the American Geographical
Society as "the mighty domain that is our inheritance as a government,
the States and Territories of the United States of America."

As for Wheeler's own résumé, though this 1871 trip with O'Sullivan
was the young lieutenant's first official survey, it was his second assign-
ment in the resource-rich territories of the Sierras. In 1869, when he was
twenty-seven years old, the army sent the cocky commander out from
San Francisco with thirty-six soldiers, forty-eight mules, and thirty-one
horses, to inspect mining areas. On that trip, he was like a chef touring a
market or a bank robber casing a bank. From the standpoint of military
logistics, that 1869 trip did not end well. His second-in-command got
lost with a large party and ran out of food. But it highlighted Wheeler's
two main interests: an ambition for fame as an explorer and the covert
acquisition of mining rights. For his 1871 expedition, leaving Halleck
Station and heading for Death Valley, he printed up stationery, leaving
out the words *geographical* and *geological* and characterizing it more gen-
erally as "Explorations West of the 100th Meridian."

The first and last chance

Halleck Station was near a fort that was built first to protect settlers
on the Overland Trail, then to protect railroad workers, and always as
a station for soldiers attacking and controlling Paiute and Shoshone
settlements. In O'Sullivan's pictures of the place, long, lonely barracks
stand guard over a dusty parade ground and a military observatory that

looked more like an outhouse than a place to calculate the motion of the stars. Wheeler commanded four topographers, an assistant surveyor, an astronomical observer, a geologist, a meteorologist, two natural history collectors, and O'Sullivan, along with guides, packers, general laborers, and soldiers. There were horses, a forty-mule packtrain, and carts for instruments. Given the tightness of the canyons, O'Sullivan seems to have switched out his converted ambulance and strapped his equipment to mules. To make time, Wheeler divided the team into two groups and assigned unusual leadership duties to both O'Sullivan and the geologist, Grove Karl Gilbert—unusual in that the geologist and photographer were not technically military personnel, though perhaps Wheeler thought of O'Sullivan as a soldier of some standing. He conferred them what he called "co-equal powers of authority over field parties."

In the first month in Nevada, Gilbert was sent by Wheeler into various mining towns with a questionnaire. The questions were not about geology but about mines, and thus frustrating to Gilbert, a passionate scientist hoping to immerse himself in the region's geology. Toiyabe City, an early stop, was already a ghost town, its silver mine depleted and its former population of several hundred down to five inhabitants, four of them French. Very soon, while Wheeler spoke of the trip as a survey, Gilbert began to refer to the work in his own notes as a reconnaissance, one of the geologist's many small private criticisms of his boss. Gilbert was also concerned about Wheeler's severity. Only a few days in, the survey team was read aloud Articles 60 and 90 of the *Rules and Articles of War*, reminding all assembled that they would be held to military standards and punished accordingly. Wheeler told the team that the rules would be "severely enforced." By June 24 the first contingent of his surveyors had worked their way down to California and were camped on the edge of Death Valley.

For a large group, it was an exceedingly dangerous place to travel, then as now. Springs are everywhere in Death Valley, hundreds of them, but the distance between them is significant, and at the time of the Wheeler survey it was not unusual for people unfamiliar with the trails to perish while looking for them. This remains the case today; a twenty-first-century doctor performing an autopsy on a man who died during a twenty-mile hike described the body as half the size of a normal adult, all moisture gone from the mummified corpse. "This person had baked

out here, like in a Dutch oven," the doctor said. A person loses three quarts of moisture every hour in a Death Valley summer, and without enough water—this hiker brought only three gallons—the hiker's legs would have quickly begun to cramp. Headache and nausea would have overtaken him, his core temperature shooting up. When the hiker was found, no scavengers had touched the corpse. "What was interesting to me," the doctor added, "was that there was no sign of any predator activity—the ravens hadn't poked his eyes out, the coyotes hadn't been out there. Those animals know better than to be out there."

As Wheeler set off into a cauldron the size of Connecticut, white settlers living on the edges of Death Valley or in the mining camps near springs seemed to excitedly anticipate Wheeler's arrival, possibly looking forward to some sort of federal investment in the area, judging from the reporting in the local press wherein the words *scientific* and *business* feel almost interchangeable. "The Expedition of Lieut. Wheeler's promises to be one of the most important of the coming Summer," wrote one newspaper, "and its progress and results will be awaited with anxious interest, not only in our own country, but throughout the scientific world."

But things quickly went very badly. For starters, Wheeler's timing was off, to put it mildly. Still today, and especially in July, Death Valley is the hottest place in the Western Hemisphere, often in the world. The modern record was set on July 10, 1913, at Furnace Creek, when rangers measured 134 degrees. "I remember the day very distinctly," said a ranger at the time, "as a man by the name of Busch perished in the valley north of the ranch that day on account of the heat. I do not know in which direction the wind was blowing on that day, but it was blowing very hard from either the north or the south." The wind, rather than cooling, can make a person think their skin is burning.

Wheeler, in other words, could not have picked a worse time to survey Death Valley. On that day in 1871 when the expedition got underway, O'Sullivan took a photo of a general store on the edge of the valley, its sign reading THE FIRST AND LAST CHANCE.

Devils Hole

If I am un-surveying, then the photograph of Death Valley at the opening of this chapter has less to do with an individual photographer

picturing the place that the United States was slowly incorporating, and more to do with the Death Valley that his commander wanted to see—a wildly deadly place, a desert that would challenge even a military unit, and that, once crossed, could be described as defeated, encompassed, contained—"a romantic land of adventure," in this case a particularly dangerous one. What this photograph doesn't show is the way this desert is what even the word *desert* doesn't allow: a place lush with interconnections, an ecosystem that speaks, through aquifers and evaporation, with its neighboring deserts in and throughout the basin and ranges that run across the continent.

On modern U.S. maps, Death Valley is one of four valleys that make up what is the largest national park in the contiguous United States. Owens Valley, Panamint Valley, and Amargosa Valley are the other three. Each of the valleys runs northwest to southeast, one of the many series of basins and ranges that repeat down into Mexico, looking like a piece of corduroy when seen from space. With the tectonic stretch of the earth's plates, the mountains rise on each side while the valley floor itself sinks, a process that has made Death Valley the lowest point in North America, 282 feet below sea level at Badwater Basin and still descending. The lowest point in the contiguous United States is adjacent to the highest point, the Sierra mountains' 14,505-foot-high Mount Whitney—about ninety miles apart as the crow flies—and this juxtaposition of very highness with very lowness causes Death Valley to work like a convection oven: heat rises on the walls of the valleys and, in the process, cools slightly but not much, then falls, warming the canyon floors. Ground temperatures are about 50 percent higher than air temperatures and can reach 200 degrees, and if you drive into Death Valley from the south—driving through the Mojave Desert, for instance, coming out of L.A.—you can see the clouds that come in from the Pacific and then, after rain falls over the Sierras, appear to run out of water: the gray streaks that survive evaporate before making it to the ground.

Yet despite its parched surface, Death Valley sits atop an enormous aquifer, the forty-thousand-square-mile remnant of the ancient glacial lakes that once covered the area, still today fed by subterranean streams following always-shifting underground creases and faults. Every minute, ten thousand gallons of water gush up in a tiny oasis in the Amargosa Valley, on the small Nevada-bounded portion of Death Valley National

Park, and a water-filled cavern there is estimated to be five hundred feet deep. Called Devils Hole, it's a tiny lens into the region's hidden and watery underworld, though its bottom has not been determined, despite numerous deep dives. (In the 1960s, two men died swimming into the hole, their bodies never recovered.) Devils Hole's source was determined in 2010. Scientists, writing in the *Journal of Hydrology*, described a crack in the Great Basin that, as it is being stretched apart, slowly funnels water to Devils Hole from the Nevada Test Site, which the U.S. Department of Energy refers to as a "reservation" and is about sixty miles north of Las Vegas; from 1951 to 1992, 1,021 nuclear weapons were tested there, and 921 of these tests were underground. Water from the test site travels about forty miles south and west through ground infused with radionuclides.

The basin and ranges that make up Death Valley are thought to have been named by gold miners in the area, in the 1840s, as they noted the skeletons of miners who beat them there, but it is a misnomer in that Death Valley is alive—with seeds waiting for rain, with microbial life in the encrusted salts, with the green piñon and juniper you can just make out on the tops of the Panamint Range. Water flows through Death Valley all year, and its name is another example of America's largely backward view of the territory it has colonized. The Devils Hole pupfish, a remnant of the valley's glacial era that still lives in the Amargosa's underground water, is theorized to have been isolated for ten thousand to twenty thousand years. Of the six mostly endangered pupfish in Death Valley, this inch-long iridescent blue killifish was one of the first species protected by what became the Endangered Species Act, in 1967. Drilling by private water companies threatened its existence. The pupfish that survive live in 92-degree water that is at an extremely high salinity. They forage algae and diatoms and spawn on a shallow rock shelf near the surface of the aquifer, itself connecting to innumerable underground waters that haunt the surface of the planet. In March 2012, a 7.4 magnitude earthquake was centered in San Juan Cacahuatepec, a city in Oaxaca, Mexico, two thousand miles to the southeast. At that moment, biologists monitoring the fish population in Devils Hole watched the water in the cavern suddenly recede, like water down a drain. Then, just as suddenly, the water in the hole rose and overflowed, quickly submerging the metal walkways that cross the hole. It was an

underground tsunami effect, waves in Devils Hole generated by plate movement two thousand miles away.

Grave doubts

As the hottest part of the summer arrived, Wheeler's men entered Death Valley from the north, and their commander initiated his practice of breaking the eighty men into two groups. Lieutenant D. A. Lyle, an artillery officer, commanded one group, while Wheeler took the rest of the men the long way into Death Valley, heading south and west toward the Pahranagat Range, then into the Amargosa Valley, a three-hundred-mile trip. Lyle came down through new mining camps to the north, toward Camp Independence, on the western slope of the Sierras—a camp where the soldiers stationed there took time vacationing and prospecting, given the sleepiness of the outpost in the years after 1863, when the First Cavalry had removed close to a thousand Owens Valley residents—Northern Paiute, Western Shoshone, and Eastern Mono people—to the Fort Tejon reservation in the San Joaquin Valley, where they were encouraged to farm land unsuitable for farming. Lyle's party marched down what today is Route 395, the long north-south road along the base of the Sierras, through Independence and Lone Pine: the road passes the great tracts of land that would later be taken over by the Los Angeles Department of Water and Power for a diversion project that would drain Owens Valley dry. When Lyle's party arrived in Independence on July 18, they were ahead of schedule. Impatiently, Lyle decided to head east again, to meet Wheeler and guide him across Death Valley. At this point, Charles C.F.R. Hahn, Lyle's civilian guide, disappeared.

Crossing the Inyo Mountains, Lyle had been headed toward a place called Saline Valley. Hahn was experienced in crossing Death Valley; he had successfully led a cavalry unit through the region in 1867. Somewhere en route to Grapevine Springs, their next planned stop, he'd gone ahead to scout for water and grass for the party and its animals. He was accompanied by a man referred to as Sam, identified as a Native American, as well as a white man called John Koehler, referred to by Wheeler and his officers as a naturalist. If you study the oldest government maps, you see little springs in the foothills of the Last Chance Range, the

spring toward which Hahn appeared to be headed—until, that is, the night they made camp, when Hahn up and walked away. According to Lyle, he was never seen again. "He . . . turned and left without saying a word . . ." Lyle reported. Lyle later suggested that he had always doubted the guide, though in saying so, he sounded disingenuous. "From several previous interviews I had held with him in regard to this country, I had grave doubts as to whether he knew the country or not," he wrote. "These doubts were now painfully confirmed."

In the space of just a few weeks, things had gone very badly for Wheeler's survey—a confused team broken in two, racing for no good reason across a dangerous desert valley landscape after having already lost a man—and they were getting worse. The next day, Lyle's group learned from two miners on the trail that Wheeler was ahead and desperate for food and water. Lyle blamed all the distress on Hahn, who, Lyle now insisted, had deserted. The *Inyo Independent* was immediately skeptical of Lyle's claim, reporting that friends of Hahn had found his saddle, blanket, shirt, letters and papers, and the buckle of his army belt at Gold Mountain, near the head of Death Valley. The *Inyo Independent* interviewed an "attaché" of Lyle's party who said that Koehler, the survey's naturalist, had threatened to kill Hahn if he failed to find water, at which point Hahn took off. "The belief was general in the county at the time," the *Independent* wrote, "that [Hahn] had been basely deserted by the company—equivalent to murder, in that region in midsummer."

Lyle and Wheeler kept to their story, but speculation continued. In 1875 a resident of Independence claimed to have run into Hahn in Colorado, where Hahn said he had run from Koehler out of fear. He had abandoned his saddle, he told his old neighbor, in hopes of creating the effect of his death, and had ridden bareback through the desert to Arizona. Years after that, a pair of field glasses assumed to be Hahn's were discovered on a trail between Sand Spring and Grapevine Springs. People said the glasses still worked, though no matter where you were, if you looked through them, you only saw desert.

Human nature good & bad

The two sections of Wheeler's survey eventually connected, Lyle's men, who nearly died of thirst themselves, bringing water to Wheeler's, who

were on the brink of dehydration. Then, after just a few days of rest, the survey pressed on, though water was all anyone could think about. "Water was of course hoarded most carefully," Gilbert, the geologist, wrote. He described an almost waterless camp, dehydrated animals tied up, offered only barley, only half of them eating due to thirst. It all sounds terrible: no water for washing dishes, for washing hands, everyone huddled in tents to hide from the sun—it should be noted that tuberculosis was beginning to kill survey members and would eventually kill O'Sullivan years later, the bacterial infection spreading through shared air in close quarters. When I read Gilbert's journals, the voice I hear is of a man hired for a job that he maybe wishes he hadn't taken; he's in the midst of something he just has to make it through, and I wonder if O'Sullivan felt similarly, or more so, since water was required to make his photographic plates—as usual, his image contains in its making an aspect of its subject. "The little remaining of the kegful after making tea for supper & bkfst.," Gilbert wrote, "was poured into the most reduced canteens."

Things only got more desperate as the expedition worked to cross the valley, the adventure already a nightmare, a desperate siege, the survey team against the scorching and waterless terrain. "Our dry camp last night illustrated some phases of human nature good & bad," Gilbert wrote. "There was no conversion of character, but merely a development. Those who customarily exhibited sense remained cool. The feeble-minded were panic stricken. The generous, the selfish, the sanguine, the timid did not change their characters." When they moved on to the next spring, they were again disappointed. "The water in these holes but half satisfies the thirst of our brutes," Gilbert wrote. They could convince their pack animals to drink, but they were too thirsty to eat. Gilbert was worried, but he tried to do his work, which was to describe the geology: "Death Valley has a characteristic look to the North—steep sided, hazy, deep, repellant."

The expedition was falling apart, a situation Wheeler would avoid describing in his final reports. In a few days, a topographer, Louis Nell, who had been off working alone, failed to return to the group. He was found two days later, collapsed, out on a trail—"senseless & lying on his face with his mouth half full of sand," wrote Gilbert, who, with A. R. Marvine, the astronomer, attended to Nell. His body was numb,

the *Inyo Independent* reported, its editors increasingly unimpressed with Wheeler's progress. "With this party but one mule was lost; but Mr. Nell, topographer[,] came near losing his life, being found, however, after two days exposure, all sense but that of sight being gone."

In his journals, Gilbert sounds increasingly unimpressed, especially when A. H. Cochrane, the military surgeon attached to the expedition, chastises Nell in his absence. "Dr. Cochrane has the atrocious taste to continually abuse Nell (absent) for stupidity in getting sick & getting lost," Gilbert writes. What is missing in Gilbert's account is any mention of the loss of yet another man. It's a strange omission because on the same day that Gilbert writes of his irritation with the doctor, a military council was ordered convened at camp to, the report said, "dispose of the effects of the late Egan, citizen guide, attached to Lieut. Wheeler's Expdn."

In Cerro Gordo, site of a hugely successful silver operation, William Egan was described by locals as reserved and "scholarly." He had joined up with Lyle in Swansea, a town on the western side of Death Valley. From the west, Wheeler had been directing the main party toward Telescope Peak, an eleven-thousand-foot mountain in the Panamint Range. Once again, the plan was for Lyle's party to meet with Wheeler's, which would arrive from the north after a reconnaissance of Cottonwood Canyon. By the time the two parties met up, they would have, in Wheeler's official estimation, crossed Death Valley. Now Lyle was ordered to await a rendezvous with Wheeler. Impatiently, after a few days of waiting, Lyle sent William Egan ahead to meet up with Wheeler, ordering O'Sullivan and a packer to accompany him.

There are various accounts as to exactly why Lyle suddenly sent the party out that way. One says that Lyle wanted O'Sullivan to take photographs. Mostly it appears that speed was of the essence for this survey team. It was a speed that nobody outside the leadership understood the reasons for, and speed obviously added to the danger of Death Valley. With O'Sullivan following, Egan was to find a way to Furnace Creek, across the Panamint Range, trudging from one Dutch oven–like valley to the next. The three men left on August 19, camping the first night at Emigrant Spring. The weather was now unbearably hot, as opposed to desperately hot. All the animals were ready to collapse by evening, with the exception of Egan's mule.

The next morning, they started out, but O'Sullivan and the packer immediately realized that they couldn't keep up. One version of what happened has the three men designating Egan to ride ahead to mark the trail. In this version, they agreed that O'Sullivan would turn back by eleven o'clock in the morning if he did not see Egan or Cottonwood Canyon, the midway cutoff to Furnace Creek, where Wheeler was waiting. Thus, at eleven, with no sign of Egan or the canyon, O'Sullivan and the packer turned back, as—allegedly—agreed. Two days later, Wheeler arrived at Wildrose, and in the official accounts (written long after the fact) Lyle was not surprised that Egan was not there. Wheeler had left some men behind in Cottonwood Canyon, and it was presumed that Egan would meet up with them there, or that he had already. By this point the focus was on the achievement of Wheeler's great yet inconsequential goal—the crossing of Death Valley.

When you look through Wheeler's old scrapbooks, you see that he kept the newspaper clippings that extolled the successful trip, not mentioning the lost guide. "Death Valley Was Crossed," says one headline in the *San Francisco Chronicle*. The extensive newspaper coverage exists partly because Wheeler had hired a young Boston writer to publicize the survey's arduous achievement, even though the trip was less spectacular— and, frankly, stupid—to people who lived in the vicinity of the hottest valley on the planet. (The young writer was likely the "attaché" mentioned in newspaper accounts.) It was only when Wheeler's men all assembled to move out of Death Valley that they realized Egan had not caught up with the main party. Wheeler wrote to Captain Harry Egbert, the commander of Camp Independence: "I'm afraid we have lost another guide."

Untamed

Lyle's final report reads as if it were written by a spoiled child, and in the twentieth century, one historian will note: "The report gives very little information such as Lyle was sent out to get; it is principally devoted to his hardships."* By the time Wheeler lost William Egan, the local press was outraged.

* From the survey's final reports: "The route lay for more than 39 miles in light, white, drifting sand, which was traversed between 5 a.m. and 6 p.m., the center of the desert

"Wheeler and his Guides—Where's Eagan?" asked a headline, referencing one of the lost guides.

In no time, the papers went on attack, first questioning Lyle's age and experience—the twenty-six-year-old Ohioan had just transferred from Alaska, then a four-year-old U.S. territory, after beginning his military duty on Alcatraz in 1869—then attacking him as overbearing and overzealous and imperious toward civilians, a jerk. They questioned Wheeler's character, too—his treatment of the civilian employees who were being court-martialed and even his treatment of the Shoshone citizens who lived in the area. The *Inyo Independent* reported that when a mule went missing earlier in the summer, Wheeler ordered his soldiers to torture the first Native person they encountered, whereupon a boy was tied up by his thumbs and dangled from a wagon. Above all, the papers defended the local guides, reporting that Lyle had threatened to shoot Hahn, the first guide who went missing. "Lyle gave our [correspondent] information to understand that Hahn deserted," the *Independent* wrote, "and that, had he time he would have returned to hunt and shoot him. But it is far more probable that Hahn was disabled while out of camp and left to perish, for it was his pride to escort a company, and could have no motive in abandoning it."

In contrast, Egan (like Hahn) was described by the papers as "a universally esteemed gentleman, well known throughout Nevada and this country." They recounted the story of O'Sullivan and the packer, both off to "meet Wheeler and take photographic views of a certain canyon." The *Independent* didn't blame O'Sullivan; it took his word, after, it appears, interviewing him. It blamed Wheeler and indicated that

being reached about meridian. The stifling heat, great radiation, and constant glare from the sand were almost overpowering, and two of the command succumbed near nightfall, rendering it necessary to pack one man on the back of a mule to the first divide on the route, where a grass sward was reached at the end of a long, sandy stretch, while the second, an old and tried mountaineer, became unconscious for more than an hour in nearly the same locality. This happened, fortunately, near 6 p.m., when the sandy waste was mostly behind us. With water from the canteens the men were restored to consciousness, and the march resumed by moonlight, without trail or guide. A living stream was reached between 3 and 4 a.m. at the eastern base of the Inyo Range, after a continuous march of over twenty-three hours. Other marches of this trip, but not in quite such desert sections, have extended from 50 to 60 and even 80 hours, with scarcely a single halt."

something might have happened between Wheeler and the guide. "Sullivan said that 'They came back, but Egan went on,'" the *Independent* reported. "Wheeler came in the next day and Monto says that Egan never did return, and *no inquiries were ever made concerning him*." Monto was Peter Monto, a resident of Inyo County who had been hired on as a blacksmith to Lyle, and his report that no inquiries were ever made was emphasized by the *Independent* because such a statement would have concerned anyone living on the edge of Death Valley.

The *Independent* also reported more of what might be called war crimes, given that Wheeler was conducting the survey under the rules of war. At the point when Wheeler was camped at Ash Meadows, an oasis of water on the eastern edge of Death Valley, Wheeler wanted a Native person (probably a Shoshone man) to take a note to Wheeler's brother, who was working for the survey in Stump Springs, seventy miles away. "The Indians had been very friendly, trading, etc.," said the *Independent*, "and Wheeler tried to get one of them to take the note. For this the Indian wanted a shirt, pair of pants and $5." Wheeler refused. The next morning, when the man returned to camp with several other Shoshone men, Wheeler ordered them tied to the ground. One man managed to untie himself and was gunned down as he fled. After that, the rest of the men started out with the note, a corporal and a private going along to guide the group. An hour later, the two soldiers returned to say that the Native men had escaped. Wheeler got on his horse and started out to deliver the note himself, but along the way he was, the account says, "surrounded and placed completely in the power of twelve Indians." Thanks to the negotiations of another Native man, he was allowed to proceed.

This loss of a second guide sent the local papers over the top (in contrast to the killing of a Shoshone man, which reads in the papers as less concerning). "The Wheeler Exploring party, of which we have heard so much the past six months, seems to have been composed of brutes, if not worse," wrote one editor. "Two guides taken from the Owens River Region have never since been heard from, and the *Inyo Independent* broadly hints that they were murdered by members of the party."

Collusion

The *Inyo Independent* was most enraged by one member of the survey in particular, the man one editorial called "that Boston flunky," a writer named F. W. Loring whom Wheeler had hired as his literary attaché—if he were working today, we might call Fred Loring Wheeler's public information officer or publicist. Born in Boston, the scion of a wealthy family, Loring, upon his graduation from Harvard, was hailed in Boston as "the most promising of all young American authors." At a time when writers and artists could make their name as the United States impressed itself on the land west of the Mississippi, Loring took the job with Wheeler to publicize the survey in the eastern press. Nominally on assignment for *Appleton's Journal of Literature, Science and Art* and the *New York Tribune*, his job was to write Wheeler's dispatches. When the guides began to disappear, he defended against the attacks and accusations leveled at the survey, usually with counterattacks. Loring, among the last people to see Egan alive, remembered Egan as an ignorant windbag. "Our guide left today with [O'Sullivan]," Loring wrote in his own diary, "to try some of the cañons on the west side of the Death Valley for water, so that we can cross over easily to Furnace Creek; and for a short time we have respite from bear-stories." Bear stories was a reference to Egan, whom Loring vigorously derided. "An objectionable pioneer, mountaineer, miner, forty-niner, bear-hunter, and squatter," Loring wrote. "I do not like the class."

The diary entry, which Loring apparently offered to the press in his own defense, goes on about Egan: "He was a fraud—such a fraud as only an old mountaineer who pretends to know the country can be. After leading them fairly into the Death Valley, he left them, as they found he had lost his way. He did not come back again, and he never will come back."

The *Independent* called Loring's account "brazenly flagrant and outrageously false" and once again defended Egan as a civilized and cultured man. They seemed to understand that Loring was hired to dramatize the trip, but they thought he had gone too far. "Egan was a gentleman in education, bearing and by birth," the *Independent* wrote, "unassuming and commanding the friendship and respect of almost every citizen of Inyo county."

The Inyo County editors struggled to understand Loring's increasingly far-fetched accusations. Then Peter Monto, the local blacksmith doing work for the survey, introduced the notion that Wheeler might not be surveying the area just for information about the flora and fauna and the geology. Monto told the *Independent* that Wheeler and Egan seemed to be in some kind of "collusion," and hinted that John Koehler, the survey's naturalist who had never seemed like a naturalist, was in fact a miner.

A short time later, the remains of a mummified body were found along a trail by a miner who had heard about a lead deposit from Wheeler. The body was not identified, but now the newspaper editors were fuming. Something was going on, and what that was would remain a secret mostly for a hundred years, though the *Inyo Independent* was on the right track.

"Did the Government," the paper asked, "fit out a private prospecting expedition?"

The actual condition of affairs

Fred Loring wrote prose and poetry, and just before leaving Boston to work for Wheeler, he wrote what is sometimes referred to as the first gay novel by an American, *Two College Friends*, the story of a romantic friendship between two students and their professor, published at the moment Loring arrived in the West and dedicated with a zinger: "Indignation at my dedicating this book to you will be useless, since I am at present three thousand miles out of your reach." As Wheeler's publicist, the twenty-two-year-old Loring used all the familiar western tropes to disparage the local citizenry, especially the local Shoshone population. In a story he wrote for *Appleton's*, Loring described a council of war with a band of the Shoshone, and even when you consider racist stereotypes of the time (or any time), it's not so much funny as caustic, an easterner's description of a West that the East was in the midst of systematically destroying. The chief is as "an artistic barbarian, with an eye for color," Loring wrote.

The punch line has to do with the Shoshone fearing violence, a fear incited by the invasion of Wheeler's military survey, an operation that was making even the white settlers anxious. The Shoshone were concerned

that the survey meant, in Loring's words, "the massacre of all Indians in the state of Nevada." He jokes that their fears are unwarranted, foolishly inspired, he claims, by an entomologist, or a surveyor Loring *says* is an entomologist—"a supposition which had its foundation in the frantic behavior of our bug-collector, who scoured the mountains around us in search of prey." Loring jokes about the Shoshone's fears in the very same year that Paiute and Shoshone families in nearby northern Nevada are burying their children alive in desperate hope that they will survive murderous white Nevadans. The Shoshone are most certainly not foolish. Better than anyone, they know what's going on.

Loring was writing primarily for eastern readers, and aside from downplaying the violence raging against Native people, he criticized the many white Americans who were at the time speaking out in favor of Native people's rights. "There are those who, through a sickly sentimentality or a love of notoriety, prate about the wrongs of the noble savage, who is, generally speaking, a filthy and degraded brute," Loring wrote. "This country is too valuable to humanity to be given up to grasshopper-hunting." He also absolves settlers who, in taking Native land, massacre Native people: "The conduct of our settlers is not perfect, but it does not deserve opprobrious reproach." He conceded that there were "harmless" Native people, but they were beside the point. "There are others who are blood-thirsty, untamed, and pitiless, and these are objects of attack, which is right."

Loring complained that "certain would-be orators, who utter much meaningless stuff about the condition of the Indian in the East, which few people there attend to or care about, are raising a bitter feeling in the extreme West, and may produce disastrous results in the future." Loring's reference to "would-be orators" was a jab at Vincent Colyer, a New York–born artist and Civil War veteran who toured the Southwest advocating for humane treatment of Native Americans. Following the New England lecture tours of Sarah Winnemucca and Standing Bear of the Poncas, who lectured in Boston, in 1879, non-Native activists in the Northeast took up the cause of the western Native nations, or tried to, with varying degrees of paternalism. Colyer was one of them, and as a member of the U.S. Board of Indian Commissioners, Colyer drew the ire of miners and cattlemen in particular in defending the establishment of Indian reservations.

"This report shows plainly that, according to the records of the Indian Department, the Apache Indians were the friends of the Americans when they first knew them," Colyer wrote to the Indian commissioners. Colyer, a Quaker, argued that unless they could cultivate land, Indigenous nations would continue to wage war against white men; it was more cost-effective, he insisted, to give the Apache land and aid, setting aside reservations. When he returned home from the survey that fall, Loring planned a speaking tour to rebut Colyer, and an eastern paper previewed Loring's lecture: "[Loring], a native of New-England, declares that, of all the outrages ever perpetrated upon any community within the limits of our national domain, that in which Vincent Colyer has just figured in Arizona is the most flagrant. [Loring] says that the people of New-England have no idea of the actual condition of affairs here, or of the untamable character and insatiable rapacity of the Apache Indian, and that to his personal experience in the Territory for the past few months is he, himself, indebted for the true knowledge which he has gathered up his subject."

Loring never made it back for the debate. He had just started for Boston when he was gunned down in a stagecoach, along with five others, near Wickenburg, Arizona. A woman and her male partner, Mollie Sheppard and William Kruger, survived. Kruger wrote a letter to *The New York Times* detailing the crime. He described the cry of the driver (*"Apaches!"*) as well as Loring's fall from the stage; the gunshots through his right temple, left eye, and lung; and his final breaths as five others lay dead around him, Loring still barely alive. Kruger insisted that he had to flee to save his own life and to carry away Miss Sheppard, but he was certain of one thing: "There is not a particle of doubt in my mind that the attacking party were Indians."

The papers predicted that the killing of Loring by a group of Apache would turn the public against the tribe. "The murder of young Loring and his companions will do more towards enlightening the public mind in regard to the true policy of dealing with these treacherous Apaches than the five hundred similar murders together previously committed by them has done," one paper editorialized. And it did. "There is a marked change in the tone of the Eastern press upon the Indian question," wrote the *Daily Alta California*, citing Loring's murder. And yet as months passed, it became less clear that Apache had killed Loring.

A subsequent military investigation drew a more complicated situation: that the attacking party was not a group of Apache men, but most likely a group of Mexican men hired by William Kruger himself in cooperation with Mollie Sheppard, a successful sex worker who had sold her home in Prescott immediately before, both suspected of searching the mail on the stage for valuables rather than fleeing the scene. Letters had been opened and resealed.

Back in the East, Colyer's plans to support Native people on reservations were subsequently ridiculed. The *Times* facetiously referred to the Apache as "Colyer's 'lambs'"—"burning and murdering and scalping with renewed ardor." While touring Arizona that year, Colyer had learned that most Arizonians—"the hardy frontiersmen, the miner, the poor laboring-men of the border," he wrote—were in favor of sending Yavapai and Apache citizens to reservations. The interests opposed were the better-financed interests: "traders, army contractors, barrooms, and gambling-saloon proprietors," as Colyer described them, this group supported by the *Arizona Miner* and the *Arizona Citizen*, the papers that touted the continued militarization of the territory, preferring that the army chase the tribes without quite exterminating them. By November, the army's regional commander ordered the Apache to go on reservations or be exterminated, and so military expenditures kept flowing, then as now. From 2001 to 2021, the Pentagon spent a little more than $14 trillion from the beginning to the end of the war in Afghanistan, one-third to one-half of that amount going to military contractors, and always in what has been referred to by the army—in 1871, in 1971, and into 2001, at the start of the wars in Afghanistan and Iraq—as "Indian Country."*

* In the congressional war crime hearings after the 1971 My Lai massacre, an army captain said, "We used the term 'Indian Country.' . . . It is like there are savages out there, there are gooks out there. In the same way we slaughtered the Indian's buffalo, we would slaughter the water buffalo in Vietnam." Said a soldier in Iraq, in 2003, "We refer to our base as 'Fort Apache' because it's right in the middle of Indian country." In 2006, James Woolsey, the director of the CIA from 1993 to 1995, told a reporter for *Vanity Fair*: "Without the trained Iraqis, it was like the Seventh Cavalry going into the heart of Apache country in Arizona in the 1870s with no scouts. No Apache scouts. I mean, hello?" In 2008, Stephen Silliman, an anthropologist at the University of Massachusetts, Boston, noted, "However, the Seventh Cavalry never engaged the Apaches, instead having been the cavalry units who fought at Little Bighorn in 1876 and participated in the disastrous massacre at Wounded Knee in 1890."

A reservation was real estate lost, land that might otherwise be mined or irrigated, cleared and cleansed.

A hidden agenda

It wasn't until the 1970s that a historian pieced together the disparate records of the Wheeler expedition and finally got a glimpse of what Wheeler was up to, first in Death Valley and then in the remainder of his western surveys. Her name is Doris Ostrander Dawdy, the puzzle she put together had its pieces strewn across western archives, and solving it required shoe leather and thousands of odometer miles. When I discovered the book she wrote on the Wheeler expedition—a small, obscure book that I found difficult to track down—I was amazed at what she had achieved after spending years traveling the Great Basin, like a miner, mining reference libraries and newspaper clipping files, sorting through old histories. To get a view into the surveys' day-to-day work, this meant piecing together Wheeler's files but also looking at the notes and journals made before the final reports to Congress. She came to see Wheeler's final report as a document designed to deflect. Taken in total, the Wheeler Survey was a grand obfuscation by a young officer who had what Dawdy called a "hidden agenda."

Dawdy was the ideal person to discover this agenda. An art historian, she is the author of *Artists of the American West*, a three-volume biographical dictionary, and *Congress in Its Wisdom*, an indictment of federal water management policy in the West, which subsidizes a small number of farmers and ranchers to the detriment of tribal nations and the fish that live in the rivers—or are trying to—chiefly salmon. Her knowledge of federal water policies is astounding—drawing connections between nineteenth-century mining surveys and flash points in modern political fights over water and grazing rights—and she edited a book of remembrances by Irene Stewart, *A Voice in Her Tribe: A Navajo Woman's Own Story*. Dawdy discovered that Wheeler's hidden agenda had to do with money and the land and mining, and that it began in San Francisco, a city that, on Wheeler's arrival, was "alive with mining excitement," to use Dawdy's phrase.

"Its capitalists," she wrote, "no longer enthusiastic about California's gold fields, had turned to Nevada's mountains of silver." Wheeler

was captivated, like everyone else. "If the prospect of wealth went to Wheeler's head," Dawdy wrote, "he was not alone in planning how to acquire it. If he was a tool of the mining entrepreneurs, so was Ord [his U.S. Army commander]." That first reconnaissance by a very young Wheeler, in 1869, was, said Dawdy, "a cover for prospecting, initiated by Ord to oblige the mining industry."

The obligation was to find gold, or silver, or anything else worth money, and in 1871, Death Valley, straddling California and Nevada, was still relatively less explored by white miners, its tremendous heat protecting it to some extent from wealth seekers. Before setting out, those under Wheeler's command (geologists, naturalists, and packers, as well as the photographer) signed over their power of attorney to Wheeler— "conveying to him the right to represent them in anything which might be found." It worked as a gag order, thus the extent of what Wheeler and his allies were up to was not established until the 1960s, when Wheeler's California mining operations came to light—specifically, a mining company called Wheeler and Lyons. Dawdy described the survey as something like a secret business trip that was sponsored by the government: "All of Wheeler's reports are to some extent misleading, partly because he had so much to cover up."

The lure of Death Valley silver had taunted prospectors, as it would have taunted Wheeler and company. When a group of prospective gold miners, some traveling from as far east as Mississippi and Georgia, cut through Death Valley as a shortcut, they ended up burning their wagons and barely surviving, but one claimed to have found a chunk of silver that was fashioned into a gunsight, thus creating the legend of the Gunsight Mine. In 1861 the mining activity of most interest to Wheeler would have been in the Panamint Range, near where Hahn disappeared, in the altitudes between four thousand and nine thousand feet. In retrospect, one of the first known reports connecting Wheeler explicitly with mining was in the *Mohave County Miner* in 1883, the paper reporting that Wheeler had surveyed Mohave County once, for General Ord, and then returned not to inspect the Fort Mohave Indian Reservation, but to establish a mining operation. The investors included Isaac Friedlander—according to a San Joaquin newspaper, the "most insatiable land grabber in the United States"—and John Koehler, first identified to the *Inyo Independent* as a "naturalist" but by 1883 a miner

and founder of the mining district. Also mentioned by the *Mohave County Miner* is Henry Lyons, a miner from San Francisco who was one of Wheeler's partners in the Lyons and Wheeler Mining Company that Wheeler incorporated in Washington, D.C. At the time, Lyons was listed as "capitalist" in the San Francisco directory. He lived at Lick House, a three-story luxury hotel on Montgomery Street, dining beneath crystal chandeliers imported from Venice.

Wheeler's patron and partner in Washington, D.C., was U.S. senator William Morris Stewart, and together the two men used the survey to establish mining rights, water rights, and rights to woodlands and other lands. As Wheeler raced across the Colorado Plateau with soldiers and topographers, O'Sullivan's photographs were like an alibi, part of a con job that involved forcing the geologists to set aside geology and consider mining alone. Stewart, known as "the Silver Senator," authored vigorously pro-mining mining laws still on the books today, though he was only the most prominent of the various senators looking out for California's and Nevada's mining interests. Prior to his term in Congress, he had worked in California, in mining litigation, and by the early 1900s he would become one of the most vocal proponents of reverse suffrage for African Americans, along with his legislative collaborator, Francis Newlands, who had organized the irrigation of millions of acres of Great Basin land under the Newlands Reclamation Act, damming the rivers that Clarence King had surveyed. In a 1909 article titled "A Western View of the Race Question," published in *The Annals of the American Academy of Political and Social Science*, Newlands wrote, "The blacks are a race of children, requiring guidance, industrial training, and the development of self-control, and other measures designed to reduce the danger of that race complication, formerly sectional, but now rapidly becoming national." In partnership with Newlands, Stewart used his secret wealth to found Chevy Chase, Maryland, a suburb situated far from the Black populace of downtown Washington, with property deeds that included racist clauses and used Rock Creek Park as a barrier to Black incursions.

Something else Dawdy mentioned in her book, almost as an aside, sent a shock through me as I read it. Anyone writing about Timothy O'Sullivan, she warned, would run into complications and would likely be forced to change their plans.

"The paucity of reliable information on O'Sullivan makes him a poor

subject for biographical treatment, leaving writers to engage in specula-
tion," she wrote.

The natural resources of the country

As I attempted to un-survey Death Valley and vicinity, to peel back the
layers of various self-fulfilling histories and baked-in settlers' stories; as
I worked through old notebooks I'd made traveling through the area
over the years and worked to speak to Indigenous citizens of the area, or
at least to learn something about them—as I did all this, at home and in
libraries, on occasional trips, and on the phone, the first thing I began
to understand was that the white settlers of Inyo County figured out
what Wheeler's surveyors were up to before most people did; it was what
the Shoshone and the Paiute and all the Native communities living in
the area had known all along. To see this, I went back through settlers'
old maps and surveys of Inyo County and vicinity in the years before
Europeans and then Americans came in great numbers, and I saw no-
tations, first by Europeans, French, and Spanish missionaries, then by
increasing numbers of land-interested visitors from the eastern United
States or the Midwest and often the South moving through what maps
described as *desert*, a term that comes from the Latin *desertum*, meaning
abandoned, forsaken, or left behind as waste.

Throughout the 1820s, Jedediah Smith, the renowned fur trapper,
mapped the area of Death Valley, trapped there, panned for gold, and
discovered Mono Lake to the south, as if it needed discovering. A party
of miners on their way to California for gold, starting out as gold min-
ers in Georgia or as gold prospectors in Ohio, fearing the fate of the
Donner Party, took a chance on a Death Valley shortcut and survived
only because it was winter. John Frémont, the celebrity soldier-surveyor,
christened the valley's largest water body Owens Lake (named for an
Ohio soldier in his party), and subsequent wagon trains used Frémont's
maps to settle the area around what was then still a lake, the settlers
drawn by coal, then silver, then lead, and, for Mormon settlers in 1854,
gold, each claim inspiring more maps that claimed more land. Cattle
were grazing in the area along the edge of Death Valley by the 1860s,
displacing so many Indigenous people that white settlers in Inyo County
mistakenly thought the past was blotted out, that a struggle was over.

"In the belief that Indian warfare was at an end, settlers began coming in a steadily increasing stream to the little settlements, and new places sprang up," says *The Story of Inyo*, published in 1922.

After the Civil War, new roads and railroads bring "rushes" to more new towns, switching out old names with eastern-influenced new ones: that's around the tine that Kearsarge Peak, looking out over Owens Valley from the Sierras, was renamed for the Union ship that sank the *Alabama*, and the Alabama Hills were named for the *Alabama*, a Confederate warship. In 1856, a team of surveyors was sent out by the U.S. Interior Department, and they were paid for every square mile of farmable or ranchable land they subdivided, leading them to exaggerate what was arable. As Wheeler marched across Death Valley, he was secretly claiming land in a way that followed the precedents set by local land grabbing in the past, and the local anger set the stage for Los Angeles covertly claiming what residents of Owens Valley considered *their* water, transporting it via aqueduct, 230 miles south, beginning in 1913. What seemed to them to be a stolen lake resulted in uprisings by the white settlers: in 1924, Owens Valley citizens occupied the aqueduct control gate in the Alabama Hills, near Lone Pine. They dynamited it in 1931 and again in 1976.

These same aggrieved settlers also managed to erase the Paiute and Shoshone past entirely, in the early 1920s characterizing tribal history as "a hazy Indian tradition," even though the First Cavalry had marched Owens Valley families away only a generation before. In *The Story of Inyo*, even petroglyphs are explained as "the some-time diversion of idle individuals of a primitive people," and the writer makes a point that most U.S. histories sought to hammer home in the early 1900s: that Indians rarely farmed, a lie that justified removal and discounted ties to particular places. The miles-long canals engineered by Shoshone and Paiute communities to flood huge tracts of the dry Inyo valley in order to increase the yield of plants and grasses were rationalized as merely accidental, or were ignored. These nations' deep, studied connections to the land were deemed backward. "They are totally ignorant of agriculture and depend entirely on the natural resources of the country for food and clothing," the historian wrote.

An anecdote from an 1861 California boundary survey highlights

these parallax views of the history before white settlers flooded the desert. The party of surveyors were riding camels and desperately low on supplies when they passed, first, a Mojave man out walking with a bow and arrow, then what they describe as a middle-aged woman out to get salt, a common undertaking in Southern Paiute territory. When I picture the surveyors passing longtime local residents, I picture a lost space expedition, the spaceship careening past shoppers in a grocery store aisle.

In my attempt to un-read the Wheeler Survey as well as U.S. surveys before and after, I was again seeing O'Sullivan's photographs as dispatches from the new theater of war, or of several wars. In high school I learned that Manifest Destiny was a shared national project, but from the vantage point of Death Valley in 1871, various groups are working on various projects, not necessarily sharing. As I worked to sort through water and land disputes in Death Valley and the Mojave Desert and the larger Great Basin region, I came across reports of a protest in the 1980s against the storage of radioactive waste in Ward Valley, on the southern edge of the Great Basin, a stretch of dry mountains and undisturbed land connecting Joshua Tree National Park with the Mojave National Preserve. Wheeler's surveyors would have been in the vicinity of Ward Valley in 1871 as they traveled to Camp Mohave along the Colorado River, where they would begin the next leg of their expedition. Ward Valley is a fifty-mile-long, north-south–running basin. It is bounded by the Piute, Little Piute, and Old Woman mountains on the west, and on the east by the Sacramento, Stepladder, and Turtle mountains, and if you have ever driven along I-40 in the southeastern corner of California, you pass through it, in the Mojave Desert, just west of the town of Needles.

The dispute over radioactive waste came in the midst of a renewal of what in Southern Paiute culture are known as the Salt Songs. As I have come to understand them, the Salt Songs, and the related Bird Songs, are another way that the Great Basin is mapped, though this mapping is more significant and detailed and older than anything by the USGS or Google. I do not pretend to understand them, but it seems to me that they are like the U.S. Army surveys turned inside out and upside down and rejected. They exist in a space that neither old nor new government surveys can perceive.

Salt Songs

In 1988, US Ecology, an Idaho-based hazardous waste treatment and disposal company, chose Ward Valley as a nuclear waste dumping site, planning to deposit waste in deep, unlined trenches. The nearby Colorado River aquifer, into which Ward Valley drains, supplies drinking water for the local communities as well as for millions of people downstream. The geologist working for the company argued that contamination would not leak into the river. Geologists not working for the nuclear waste site disagreed, as well as activists concerned with radioactive contamination more generally. An activist in the latter camp was Philip Klasky, a professor at San Francisco State University. "The fight against the dump," wrote Klasky years later, "became a protracted showdown between a handful of antinuclear activists, Indigenous and environmental groups, idealistic attorneys, renegade scientists, local residents and the five Colorado River Indian tribes against some of the most powerful corporations in the nation in alliance with corrupt elements in the federal and state governments."

The Colorado River Native Nations Alliance included Fort Mojave, Chemehuevi, Cocopah, Quechan, and Colorado River First Nations, all of whom refer to nearby Spirit Mountain as a place of great spiritual significance. The alliance fought the dumpsite with protests, blockades, vigils, and marches both near the site and in Los Angeles, in front of state and federal courthouses, as well as in Washington, D.C. In 1999 they staged a prolonged encampment, even after being evicted by the Bureau of Land Management, and after 113 days the BLM backed down. The encampment involved elders from the Colorado River tribes as well as tribal representatives from around the United States. A short while later, US Ecology backed down when the president of their parent company, American Ecology Corporation, said, "Ward Valley is dead." By "dead" they meant the dump proposal was dead, as opposed to the valley itself, the life of which in a backward way was affirmed, through the company's statement, as being a vital part of the ecology of the basin and of the sovereignty of the Native nations near it. At one of the many public hearings on the waste site, in a gymnasium in Needles, Arizona, local community members and elders from the region sang what are known as Salt Songs—in this case, several Salt Song singers approached

a microphone, singing during the time allotted for public comment. When it was over, Wally Antone, a Kwatsáan Bird Song singer from the Yuma, Arizona, area said, "Can you understand what we are doing here? This is our land, our sacred lands, our ancestral lands. We have been placed here by our Creator to protect the river. If you poison the land, you poison us."

While I was studying and driving through and once in a while flying over the land that O'Sullivan photographed as Wheeler surveyed, I heard versions of this story from several people. As I tried to get an idea of what the Salt Songs were, I came to understand that the songs were likely the oldest map I could imagine. Part of a cycle of about 150 songs sung by the Great Basin's Southern Paiute, or Nuwuvi, nations, the Salt Songs are related to songs sung by the greater community of Paiute people. They are sung from memory, having been passed down through generations, and though I won't pretend to completely comprehend what I've been told, the songs describe a route that in itself shows how to live in the basin: it passes important sites for water and plant-based medicines, routes to the ocean and mountains that are sacred, routes that allow the people to sing along with the world as the world sings to them. They describe a route to the afterlife along which people are in touch with the sentient world. In hearing about them, it struck me that the Salt Song singers detail ancient journeys of spirit mentors through a landscape that is simultaneously earthly and symbolic—that the songs are a spiritual and ecological atlas of the region that shows people how to survive with the land, as opposed to surviving against it.

"The Salt Songs are a cultural and spiritual bond between the Nuwuvi and the land, and represent a renewal and a healing spiritual journey," said Vivienne Jake, the late Kaibab Paiute activist. She grew up in the basin and worked for the Kaibab Paiute Tribe for forty years as a tribal council member, including as tribal chair from 1975 to 1977. She was a U.S. marine and later a social worker on the Hopi Reservation. She spoke of the Salt Songs to an interviewer shortly before she died, in 2016, after cofounding the Salt Song Trail Project in 2000.

Learning what I could, grasping for analogies, I came to see the Salt Songs as similar to a Homeric song cycle throughout the watershed of the Colorado River, though a cycle much longer than what Homer composed, sung in relation to a territory that is about four times the size

of the territory of the city-states that made up ancient Greece. At some point I thought I understood that part of the way to comprehend the songs was to understand the extent of sadness in the world, how difficult it is to survive. "I'm going to sing you these songs," one singer told a listener during a performance I watched. "But before I sing these songs, I'm going to break your heart."

A living thing

A person I spoke with in trying to learn about the Salt Songs was Philip Klasky, the professor at San Francisco State University who had been an ally of the Colorado River Native Nations Alliance back when the tribes were protesting the Ward Valley nuclear waste dump. Klasky helped tribes coordinate with non-Native activists and, with his research, helped communicate both the valley's ecological importance and its place in the Colorado River's Indigenous cosmology. When we spoke, Klasky recalled working with Vivienne Jake and others to record some of the Salt Songs and to make the documentary that recounted their rebirth, or renaissance—because of course they never went away. In an attempt to suppress Paiute culture, the Indian boarding schools, administered by the Bureau of Indian Affairs and the Department of the Interior, forbade children to sing the songs or to speak Great Basin languages. Beginning in 2004, Klasky worked during three summers with Vivienne Jake and Nuwuvi elders, men and women in their seventies and eighties who sat down with maps and, while singing, annotated each song's locations, a kind of reverse survey. "We spread out my AAA maps and they used Post-its, and it was wonderful," Klasky recalled. "They were interested in the landscape, the physiography, rather than the political boundaries."

The resulting map merely hints at all that the songs point out: ancient villages, gathering sites for salt and medicinal herbs, trading routes, historic events, sacred areas, and cultural landscapes, most not protected by land management policies, many threatened by resource extraction and other forms of environmental destruction. The circular route the songs describe moves through the Great Basin and the Southern Basin and Range, through California, Nevada, Arizona, and Utah, and it shows

the desert that U.S. surveyors described as a vibrant world, communities connected through watersheds and seasons. The Salt Songs, and related Bird Songs, describe a physical space that makes a thousand-mile circle through Southern Paiute land, as well as that of the Hualapai people and others; it stops at places known today as Ash Meadows, Eagle Mountain, Tecopa Hot Springs, Dumont Dunes, Salt Creek Springs, the Avawatz Mountains, and the springs near Baker, California—linking springs and underground waterways like a secret map or a view seen from on high, circling the intersection of rivers where the Great Basin and the Colorado Plateau intersect. "We understand the sacredness of a church or a mosque or a synagogue," Klasky told me, "but we don't understand that a Hopi must make a pilgrimage every year and keep the world in balance, that Mount Graham is sacred to the Apache. Dominant society has a hard time understanding the sacredness of sites because it's so outside the framework of a materialistic world."

Klasky eventually suggested that I get in touch with Matthew Leivas, a Salt Song singer, and the cofounder, with Vivienne Jake, of the Salt Song Trail Project, through which Leivas works in collaboration with Southern Paiute bands to keep the Salt Songs alive. Leivas is a Chemehuevi elder. This was back in 2017, and he was sixty-four at the time I spoke with him. In his lifetime, the Chemehuevi's federal tribal status was formally reinstated, along with some of the lands taken from the nations through land grabs and diverted streams, lakes drained and rivers dammed; his relatives had been displaced by Hoover Dam and Parker Dam, all of it land that Wheeler had surveyed and O'Sullivan had photographed. In the 1990s, Leivas told me, there was a spike in thyroid disease on the Chemehuevi Valley Reservation, and as Chemehuevi tribal chairman, Leivas helped shift the tribe's drinking water source from the Colorado River to water pumped from the local aquifer within the reservation. I had seen Leivas talk about his mother in the Salt Song documentary, about how she and her friends, not allowed to speak their language, sang these songs out of earshot of the school's authorities.

When I called Leivas up one day at his Chemehuevi Valley home, he was, he said, recovering from an illness, but he made time to talk with me. We talked for a while, and he told me about the organizing

that had saved Ward Valley in the past and the work that was ongoing: Ward Valley was again under threat, as were many of the sacred places the government was taking off the list of protected lands, opening them to mining and drilling and dumping. "The Colorado River, as I speak, has uranium, sewage, ammonium perchlorate, hexavalent chromium," he said. "You have pharmaceuticals coming down from Las Vegas, and this stuff is mixing, and it's being taken by the water all the way down to Tucson and Phoenix and New Mexico, and nobody cares about it. But it's a living thing, water!"*

It struck me again that he was framing the life of what was supposed to be a desert ("There is probably no more useless tract of land in the United States . . . ," reported *The New York Times* in 1994) in terms of water—water, Leivas emphasized, being the centerpiece of so many struggles around the world. As we spoke, protesters at the Standing Rock Sioux Reservation had established an encampment on the banks of the Missouri River, where an energy corporation hoped to run a pipeline beneath the Missouri, thus jeopardizing the nation's drinking water source. Just then, the pipeline's permits were under review by the Army Corps of Engineers, things tied up in court, though the pipeline would eventually be pushed through. Leivas was excited to see that, in their call for respect for Sioux sovereignty, the protesters at Standing Rock had put water at the center of their campaign—*Mni Wičoni*, in Sioux, or "water is life," was the organizing principle, a declaration of the rights of bodies of water like rivers and streams and springs. He predicted that doing so would continue to resonate with the work in his community and, he felt, with young activists everywhere, as it eventually did.

Something that strikes me now, as I look back on our talk, is the ways in which the events in Ward Valley and at Standing Rock were connected—or the connections I think I see now, not just between Native and non-Native activists organizing on behalf of the Colorado or Missouri rivers, but in the actions taken against them. In 1995 the Chemehuevi, along with the other Colorado River nations—the Mo-

* In the spring of 2021, tribal nations and land conservancies filed suit against a private water company that was planning to tap into an ancient well beneath Ward Valley that feeds Bonanza Springs, a sacred stream that is the largest stream in the Mojave Desert.

jave, Hopi, and Navajo—began their occupation of Ward Valley, which lasted for nearly five years, with sometimes five, sometimes five hundred, people staying in the valley. As at Standing Rock, members of the American Indian Movement, or AIM, guarded the Ward Valley encampment as it was surveilled by federal agents. Klasky, who died in 2022, recounted the morning the federal agents came to evict the occupiers:

> On the eve of the order to vacate, Bird Singers and Dancers began their cycle of songs at sunset. A row of men singing to the accompaniment of gourd rattles faced a row of women dancing in full regalia, in shawls and skirts of red and black diamonds. They sang all through the night. As the morning approached, federal officials advanced toward the line of defense. At the entrance to the occupied land, the rangers found the traditional singers and dancers surrounded by elders, old women in their 70s and 80s, protected by their young warriors, encircled by hundreds of Indians and other activists.

The officers consulted among themselves, then retreated in the face of Paiute elders singing Salt Songs and Bird Songs—and TV news cameras.

What linked the events as acts of resistance—or *survivance*, to use the Anishinaabe poet Gerald Vizenor's term—was the work each group did to inform themselves of their own history and the history of similar struggles. "We had to educate ourselves about nuclear waste," Leivas said, referring to when the Ward Valley struggle began, in the 1980s. "High levels versus low levels, the fallout from Nevada test sites, water being threatened after underground nuclear explosions. What's happening at Standing Rock is an outcry to the world at large, and what has happened since the beginning of the occupation by the United States of America is that Native people have had to adapt."

Looking back on our conversation, I see that he was offering me a new survey of Death Valley and the Great Basin in which water was not a purchasable resource, but a living thing that had rights of its own, without which human rights are impossible, not to mention humans. At the same time, he helped me to see: "You look back at the history of

the 1850s, and all the killing of Indians in California and the taking of scalps being paid for by the state and the feds, and the taking of land for gold, silver, uranium, and the taking of water. Well, water is a conduit and a connection to everything. It's life. And it's taking life if you contaminate it."

11

Black Cañon Colorado River, from Camp 8, Looking Above, 1871

(Smithsonian American Art Museum)

When I arrive with O'Sullivan at Camp Apache, after he has marched across the Mojave Desert and landed on the eastern bank of the Colorado River, I hear the words of Doris Dawdy echoing in my head. In her own resurvey of Wheeler's "Explorations West of the 100th Meridian," she saw Timothy O'Sullivan as a prominent blank spot on the canvas, a gap. Inspired by Dawdy, I engage in conjecture, adding some guesswork and theorizing, mixing in a few things I know. Something I do know: when marveling at O'Sullivan's Colorado River photos, it is important to keep in mind that the Colorado River expedition was a fraud. It was a fraud even though we frame it still as a survey, in history books and in museums where we hang the photos, in libraries where we keep the

maps. It was a fraud in the sense that it was unnecessary, even as a
survey.

The Colorado River, first of all, had already been surveyed by the
military on several occasions in the 1850s and '60s, most famously by
John Wesley Powell, whose trip down the rapids was considered daring
and reported on widely. Especially after Wheeler's surveying methods
were attacked in Congress as unrigorous and unscientific, Wheeler and
Powell were archenemies, and when you compare their survey styles,
Wheeler's first trip down the Colorado seems remarkably unambitious.
Powell was a Civil War veteran who, as a young man, had walked across
Wisconsin and, after floating down the Ohio River, rowed solo down
the Illinois River, then up the Mississippi, then into the Des Moines
River. He had lost an arm in the Civil War, and when he boated down the
Colorado, he famously ordered his men to strap him to the deck so that he
wouldn't be washed overboard in the rapids. Powell, one biographer noted,
saw the frontier as "rapturous," which is complicated in its own way, almost
suggestive of something carnal. Wheeler, for his part, simply saw his trip
as a chance to claim an important place in the incorporation of western
territory, a shot at fame.

The market from which Wheeler hoped to profit was the market
for western adventure. The stakes of the survey were thus exaggerated
in the press releases that (I would further speculate) were at this point
still being written by his attaché, Fred Loring, and fed to newspapers
locally and back east. "The ascent of the Colorado, with its tremendous
channels, will be the most interesting feature of the expedition, not ex-
cepting the Death Valley trip," a local newspaper noted, "but will be
hedged by almost insurmountable difficulties. Already Powell has found
the descent almost impossible."

Wheeler's ace in the hole was his photographer; though Powell had
already surveyed the river in 1869, he had no cameraman. On this trip,
Wheeler had O'Sullivan. The stereographs Wheeler would publish
would not dwell so much on the scientific or the geologic as recount
the trip as what it was, a hyped-up adventure. Thus, the very first item
on the itinerary of Wheeler's death-defying expedition up the Colorado
River was the making of a picture, taken as they set off on Septem-
ber 13, 1871, from Fort Mohave, a fort used in the U.S. war against the
Mojave in the late 1850s, a conflict that had been brought on, it is worth

noting, by an influx of gold-hungry white settlers. Given O'Sullivan's
own assessment of his assignment—or what I imagine it to be—I would
further speculate that as he set up his camera on the first day of the river
survey—here, a stereo camera, two lenses on his wooden box that could
produce a two-frame print to be viewed through a stereo viewer, the
IMAX of its day—O'Sullivan was thinking like a 1940s movie director
making a western about the conquest of a great river. The opening scene
appears to have been directed by O'Sullivan from the dock.

The start, from Camp Mohave, 1871 (New York Public Library)

That he made this picture from the dock or pier is, of course, specu-
lation too, but I do know from Gilbert's journal that the boat desig-
nated number one is manned by Wheeler and Fred Loring and three
Mojave men. Gilbert is in the second boat, and O'Sullivan will pack
up his camera and join him once the plate is exposed. In the third boat
is a topographer, the survey's medic, and three more Mojave men. The
fourth boat carries supplies and will turn back a few days in. The ste-
reographs when viewed all together would tell the viewer a story about
the river trip that Wheeler had likely composed in his mind. In the
opening scene, the wooden rails and cables running through the docks
echo the grid of a topographical map, as white men set out to chart and
claim things, their oars erect and expectant. They push ahead, then very

quickly stop, as one boat falls back and returns to the shore to retrieve the camera and the cameraman. Then they start out again, this time for real, or a version of real.

Against the current, Part 1

You can imagine them rowing now, pulling hard against the current, straining muscles and trying to find a steady rhythm, changing hands, moving oars, strains and pain. And as they row, there is more speculation, this time regarding the aforementioned description of Wheeler's impending trip down the Colorado as reported in a local newspaper, which I quote again: "Already Powell has found the descent almost impossible."

Powell's trip was, it's true, a *descent* of the river. In other words, his boats ran downstream. A descent of the Colorado was complicated and treacherous, to be sure, given the storied rapids, which were even more storied in the decades before much of the Colorado was dammed and its flow reduced to a trickle. Though rapids still exist where Powell descended the river, many of the sites O'Sullivan photographed on his 1871 river run with Wheeler are today beneath the reservoir created in 1935 by the Hoover Dam—Lake Meade, the largest reservoir in the United States, or technically the largest: it is being depleted rapidly as more water is drained for more development, for more irrigation and industry, and as historic droughts become more historic, lowering the lake every year, a crisis for the Colorado Plateau and beyond.

Aside from being complicated, Powell's downstream float made obvious logistical sense. Why row against the current? Why not run the boats with it? On this trip, Wheeler was doing the opposite, asking his men to row up the Colorado River, against the flow. I will speculate that this seemed to the men like a bad idea when they started out, and then, as they continued rowing, like an even worse one.

Destroying disunity

I will also speculate that O'Sullivan, despite the logistical complications involved, looked forward to this next step of the survey in terms of the photo-making possibilities, or looked forward as much as you can to

rowing relentlessly for weeks on end and then traveling by mule. He'd been thwarted in his plate-making by the tropical humidity of Panama, and the heat of Death Valley had made staying alive the primary concern, water required for photo processing almost a luxury. The Colorado, on the other hand, was already famous in the imagination of easterners, but not well photographed, or not yet photographed enough. From the standpoint of imagery alone, a Colorado River survey was a plum assignment, and it would have made O'Sullivan something like a speculator himself, hoping to mine the views in a way that would coincide with the crescendoing notion of what was beginning to be called Scenic America. Born just after the Civil War ended, Scenic America was the America that would be transformed into national parks convenient to railroads, the railroads offering tickets to vacationers. Scenic America was a postwar marketing plan with political aims: an America in which former Civil War enemies could unite in appreciation of the western landscape that they were making theirs. Just as western surveys point to the forced displacement of Native Americans and subsequent military occupation, they are also the progenitor of the roadside postcard-selling concession stand. When William Jackson, photographer for Ferdinand V. Hayden's survey, made plates of the part of Wyoming that would become Yellowstone National Park, his images led readers through the area like a tour guide, creating, in the words of Martha Sandweiss, "a series of consumable vistas, an approach still echoed in the park's carefully plotted roads, vehicle turnouts, and photographic viewing points."

Early photographers were the pioneers of Scenic America. After a California militia attacked the Miwok living in the Yosemite Valley, Carleton Watkins illustrated an empty space, a spectacular view of nature in a vacuum, thus assisting in Yosemite's parkification. In Yellowstone, while its park status may have protected it from mining per se, the photos then as now erased its Crow-ness, posterized the Cheyenne, and, like a smelter, converted the region of subalpine forests and geothermal activity into a resource for railroad tickets and hoteliers. A parks-fueled Scenic America could help facilitate a smooth incorporation of everything west of the Mississippi. These scenic nodes, when connected, made for one picturesque nation, the picturesque notably avoiding the less-picturesque sites of intense extraction (or prettying them up, or celebrating the work that went on) but sometimes including Native people who by the be-

ginning of the twentieth century were being compared to Egyptians in colonized North Africa, remnants of a fading empire being taken over by an up-and-coming one. In the 1890s, Edward Curtis began making his still-famous photographs of Native Americans, capitalizing on the spurious claim that Native America was fading away. Curtis's glass plate negatives were made with a misty lens. They are beautiful, gorgeously crafted—blankets covering clothing deemed too modern. They were admired by the powerful of the day, such as J. P. Morgan, who financed Curtis. They were also part of a project, begun at the time, to hasten what troops and settler raids and broken treaties initiated: Curtis makes distinguished views, noble poses, as if the subject were dressing for a special event, a treaty signing or an ethnographic survey or a funeral. A 1908 newspaper report called it "a more vivid, faithful, and comprehensive view of the North American Indian, as he is to-day, then has ever been made before, or can possibly ever be made again." "For the Indian is in the last stages of his tribal existence," the writer continues. "In a few more years, he will, as a separate race, have passed forever from the world's stage."

In 1865, Samuel Bowles, the editor of the Springfield, Massachusetts *Republican*, crossed the country by rail, traveling with the Speaker of the House of Representatives, filing dispatches, eventually publishing them in a book that exhorted Americans to cross the country, as he did, so that the country could at last heal from Civil War. It was a hymn to incorporation. Seeing the United States as one great Pacific-to-Atlantic nation, Bowles wrote,

> destroys disunion in the quarter where it was ever most threatening; it brings into harmony the heretofore jarring discords of a Continent of separated peoples; it determines the future of America, as the first nation of the world, in commerce, in government, in intellectual and moral supremacy.

This point of view stands in stark contrast with that of Charles Eastman, a Santee Sioux, to highlight just one of many voices that would have seen things differently from the way Samuel Bowles saw them. At about the time when Bowles was crossing the continent, Eastman was a boy, and he asked his uncle about the nation that had pushed his family out of what would be renamed Minneapolis just before the Civil War.

"The greatest object of their lives seems to be to acquire possessions—to be rich," Eastman's uncle said. "They desire to possess the whole world. For thirty years they were trying to entice us to sell them our land. Finally the outbreak gave them all, and we have been driven away from our beautiful country."

Against the current, Part 2

Another speculation regarding the Wheeler expedition's Colorado River trip: as they rowed, O'Sullivan and Gilbert, the geologist, were worried about how Wheeler—an easily angered novice commander who had mishandled the first part of his survey by either killing or losing people in a challenging climate—would do leading a crew of surveyors backward up a big, dangerous river, all while operating under the rules of war. As their small boats moved through the river's magnificent canyons, Gilbert (about whom I am also speculating, though to a lesser extent, given that he, unlike O'Sullivan, left a written account of his trip with Wheeler) was still not happy with the progress of a scientific survey that he had signed up for and assumed would be legitimate. He was likely somewhat happy—or at least relieved—to be assigned to a boat with O'Sullivan, who had a job to do and, after working with Clarence King and his team, was at least conversant with the interests of a geologist in the field. Just seeing the Colorado River canyon could keep a geologist busy. In the same way, the photographer and geologist seem to share interests in views and perspectives—reflections especially of the canyon in the river's eddies and backwaters. Often O'Sullivan's pictures seem almost pastoral: stylized images that depict calm, despite all the complications surrounding him, despite the tortured logistics, despite everything. Lengthening the time of exposure, allowing the racing river to smooth out in the blur of a long-opened lens, he flattens currents, makes turbulence creamy. He made several stereographic plates of a tremendous rock formation that Gilbert was calling Gibraltar, including *Gibraltar from Below—the Gate of the Black Cañon* and *Gibraltar from Above, looking toward Cottonwood Valley*. On September 22, the four-man survey team (photographer, geologist, and two Mojave rowers) made camp specifically so that O'Sullivan could make images of the canyon walls, since, Gilbert writes, "the portal is so impressive."

Wheeler's boat had gone ahead on September 21, and O'Sullivan and Gilbert had fallen behind to photograph and detail the geology. Gilbert noted the time and patience required to make a particular image under the right conditions—"delay being for O'Sullivan for a favorable light." Gilbert was excited to see what he could, in light of Wheeler's mad pace, and was generally amazed by the place, judging by the extent to which he furiously filled notebooks with descriptions: "This afternoon I examined the best exhibition I have seen of rock work by blown sand—on the talus of the cañon wall near camp." He also appears to have been impressed with photography's ability to illustrate the story of the rocks, as well as the photographer's ability to manipulate the scene to make a point. "O'Sullivan took photos at Camp Keg," Gilbert wrote, "and again further up at a point where a side canyon gives the impression that the main canyon is narrower than it is . . . Here we found a large pool of water that we made use of for reflections. Took a glass picture."

View Down Black Cañon, from Mirror Bar, 1871 (New York Public Library)

Judging from Gilbert's journal, the geologist and the photographer got along well—most likely, I imagine, because they were both good at what they were there to do. After another year with Wheeler, Gilbert will go on to work for John Wesley Powell, at last undertaking more serious geological research. In the years following, Gilbert will become a geologist's geologist, admired for his thoroughness and his

insights into the geologic composition of the Colorado Plateau. Eventually he becomes a founder of what in the early twentieth century would be called the New Geology, reading the landscape more broadly, under the auspices of what would become known as geomorphology. His thinking leads geologists to seeing water and land as working in concert. "Whereas geologic history was formerly read in the rocks alone," Gilbert wrote, "it is now read not only in the rocks but in the forms of the land and the arrangement of the streams."

But on Wheeler's exploration in 1871, Gilbert is stymied and frustrated and working in many ways to suit the photographer, whom he describes as good company even though he is, as has been noted by his companions on these surveys, often angry or at least frustrated, or perceived by the others as such. When I speculate, I think about Gilbert's disposition and then O'Sullivan's, and then I think about the river. I think about the river and the feel of rowing in it, having done my share of rowing in strong western rivers in my life, and a few eastern ones too. I think about the sound a boat makes in a river, the rhythmic sounds of the oars, and I think about how these sounds make you feel and think, alternately hypnotizing you, even as you struggle, and occasionally offering you mental clarity—a vision, I'd say, into your past, into old thoughts and places and the feelings that linger in those places.

When I speculate like this, I see O'Sullivan, tired from his frantic race to make pictures—scuttling for the right position, the right vantage point, high on a cliff or low on a sandbar—and then I see him rowing steadily against the current or resting, as others take up the oars, lamenting the river's tenacity. And eventually I start to imagine that in the white noise of the river, thoughts of previous assignments and earlier trips floated through his head. The rhythm of the rowing and the noise of the current allowed for travel in time, at which point I see him remembering the war. Did he remember standing in the Rappahannock River and seeing a Black family ford the stream in a wagon, fleeing Confederates forces and following the Union army as a young boy stared back at him from a horse? Did he remember guns, or—when the army engineers he was attached to in the spring of 1862 survived a bridge being destroyed by Confederate artillery and then rested in the river shortly thereafter—did he recollect the river as an ordeal and a balm? Did he remember making this picture?

North Anna River, Virginia. Soldiers bathing. Ruins of Richmond & Fredericksburg railroad bridge in the distance, 1864 (New York Public Library)

A visit to the National Archives

I wanted to read Gilbert's field notebooks, to see the penciled nota-
tions and sketches he made in the field with O'Sullivan in Death Valley
and along the Colorado River, and to do so, I made my way to the Na-
tional Archives, in College Park, Maryland. I took the train from New
York City down to D.C. and, first, walked around downtown, looking
for anything that remained from O'Sullivan's time, when, between west-
ern surveys, he was living in the U.S. capital with his wife, Laura. The
studio where O'Sullivan worked with James Gardner is gone, though
Ford's Theatre is still there. With Gardner, O'Sullivan photographed it
after Lincoln's assassination, making cartes de visite of the theater and
various sites related to the killing. Alan Pinkerton, the head of Lincoln's
secret service, granted the photographers exclusive access to the crime
scene and later to the executions. Gardner made what are considered
the first mug shots, the images printed on cards and posted or sold. (The
only print Pinkerton did not allow Gardner to keep was that of John
Wilkes Booth's corpse, though there are references to Gardner making
a plate of Lincoln's corpse too, likely in the company of O'Sullivan, his
photographic assistant at this time.)

From downtown, I took the Metro and then a bus out to the ar-
chives, which are in the city's suburbs. After a security guard photo-
graphed me, I was allowed upstairs to fill out request slips, and then I
waited, passing the time by studying the archival art and photography
on the walls. I examined a framed photograph of Edward Steichen that

was made on an aircraft carrier during World War II at the time when he was the most famous photographer in the world. It was taken while he was directing *The Fighting Lady*, a film that looks at the lives of navy pilots on an aircraft carrier, the USS *Yorktown*; the first half of the film portrays the tediousness of the battle and the interminable waits, the second half the terror, and it closes with footage of several pilots' burials at sea, the same airmen introduced in the film's first minutes. I had read about Steichen's film in a book that had recently been published, *Five Came Back: A Story of Hollywood and the Second World War*, which described the ways in which Hollywood filmmakers who filmed the war were changed by what they experienced. George Stevens made comedies before the war. In 1944 he followed troops into Europe and, as he did, came upon the Nazi death camps. Footage he made was shown at the Nuremberg trials. "After the war, I don't think I was ever too hilarious again," he said. John Huston, after his war experiences, was deeply depressed, and one night, while staying at the Saint Regis Hotel in New York City, he strapped on his service revolver and walked across the street and into Central Park, hoping to be mugged so that he could kill someone.

Inspecting the various artworks hanging in the archives reading room, I came upon a photo of an anonymous war photographer in Vietnam on the way to Củ Chi, the Vietnamese city famous for a huge network of underground tunnels built by the Vietcong to resist U.S. forces, and I suddenly remembered a day out on the Columbia River twenty years before. I remembered being in a jet boat exploring the river as it ran through the Hanford Nuclear Reservation, the site of the world's first full-scale plutonium production reactor, which produced the plutonium used to immediately kill an estimated thirty-nine thousand people in Nagasaki, Japan. (Radioactive liquid from Hanford still seeps into the Columbia today.) The boat was piloted by a wildlife ranger, who, it turned out, had served at Củ Chi: he was quiet, almost taciturn, though he seemed animated by his work as a ranger, and at some point in the long day he brought up his service in Vietnam, and then the tunnels at Củ Chi, where he had fought, only to say that the American tunnel fighters (or tunnel rats, as they were known) were told, given the intensity of fighting, that they could quit at any time.

As I waited in the archives, remembering that veteran and that

sunny day out on the Columbia River, it slowly dawned on me, observing markings on the hats and T-shirts and jackets nearby, that I was surrounded by veterans. Now I began to remember other encounters with men who had fought in Vietnam, moments when they described the intensity of battle, terrible scenes of death. I remembered that each time the descriptions had come suddenly. Once at Mass on a Sunday morning—after years of my just shaking hands with a man I knew, he suddenly burst into tears, recalling a strike on the ship he had served on in the Pacific. Another time, late at night on a train ride from New York to Oregon, a porter who had fought in Vietnam remembered the darkest details. The telling of the stories seemed to come out of nowhere. They erupted. And each time, as I listened, I didn't know for certain what to say or do or how to respond, but I remember them as powerful interactions. At some point I wondered if O'Sullivan said anything about what he had seen at Gettysburg or at Fort Sumter or when guns were shelling the soldiers he photographed in Virginia. What, if anything, did he say to the Mojave men, one of whom, according to Gilbert, had been wounded in a battle?

Where We Were in Vietnam

At some point, while waiting at the archives, I found myself hypnotized by a large drawing of a Vietnam battle scene, a pen-and-ink work titled *Extraction from a Hot LZ—Leaving Behind a Classic Ford and Our Innocence*. At the time, it was prominently displayed in the public research room. It was by Michael "Machine Gun" Kelley, an artist who volunteered for Vietnam and served for eleven months as an infantry machine gunner in the 101st Airborne Division, until he was severely injured by an exploding land mine, losing a lung. A helicopter that happened to be nearby got him to a hospital. (LZ stands for Landing Zone.) Revenue from sales of prints of *Extraction from a Hot LZ—Leaving Behind a Classic Ford and Our Innocence* were used to build the California Veterans Memorial in Sacramento in the 1980s. Back home in California, Kelley finished a graduate degree in art, became a prominent veterans' rights activist, and eventually published a book, *Where We Were in Vietnam*, a postwar survey detailing every military installation, landing zone, airfield, port, signal site, and vessel involved in the Vietnam War. Using military topographi-

cal maps, it also identifies terrain features, hills, valleys, and swamps, allowing the veteran reading it to place himself back in Vietnam.

"Veterans and military historians alike will benefit from his Herculean efforts to nail down precisely where everything was and where everything happened in America's long war in Vietnam," wrote Joe Galloway, a reporter who won a Gold Star for carrying a wounded soldier to safety while under fire—an American bomber had just dropped napalm on the U.S. command post and aid station. "If you can't find it in these pages, it can't be found."

When I got a hold of the book, I learned that the United States sometimes operated at airfields that were built first by the French during their occupation and later by the Japanese. I saw that there were many sites named in reference to the U.S. Indian Wars (Fort Apache, for instance, and Custer LZ), despite the forty-two thousand Native American soldiers in Vietnam: one in four eligible Native people served, 90 percent of them volunteers, in comparison to one in twelve non-Native citizens. I also read Kelley's introduction, in which he described being blown up by a land mine (". . . something has gone terribly wrong," he wrote, "and I was in deep, deep trouble") as well as the way he remembered the war, sometimes in bad ways, sometimes good ones, and almost always involving the way he interacted with the landscape, or so it seemed. "The smell of wet grass after a summer storm, the echo of a distant helicopter thumping its way through a morning sky, the image of a tree line silhouetted against a bank of rain clouds on a humid afternoon—any of these might carry us back in an instant," he wrote. "That said, it would be wrong for non-veterans to presume that such flashbacks are inherently unpleasant, wrenching experiences. Frankly, I am of the opinion they take veterans back to the good far more often than to the bad." Kelley committed suicide in 2011, when he was sixty-five. He worked for Sacramento County, where a fellow worker remembered his kindness: "When he found out that I was also a combat veteran, he reached out with compassion. He even gave me one of his prints of his artwork on the war. He was a kind and gentle person, who truly cared about his fellow man, and demonstrated it through his words, art and deeds."

As I looked around at more artworks by veterans, I was reminded of the fact that when television coverage of the Gulf War began, in 1990, at the dawn of the era of twenty-four-hour cable TV news, there were

increased reports of what could be described as post-traumatic stress symptoms among Vietnam veterans, brought on by even the smallest things—the smell of diesel, a gunlike sound, the light appearing a certain way in the sky. I mention these things because, as far as speculation goes, I want to imagine that O'Sullivan had fond memories of the war— interactions with other photographers (the brother of his soon-to-be wife, perhaps) or newspaper reporters or soldiers he traveled with for days at a time—just as he seemed to be enjoying a sense of camaraderie with his geologist boatmate. I also wondered what, if anything, O'Sullivan would feel when he saw Wheeler order a Paiute boy tortured or a Shoshone man shot. Would he write it off as an act of war? Would he just write it off? How would he see it or, more important, how would that feel?

Gilbert, who at twenty-eight was three years O'Sullivan's junior, had sold scientific equipment during the Civil War. He did not rant, as some of Clarence King's scientists had, about O'Sullivan's anger or his tendency to bore them with talk about the war—talk that King's scientists initially greeted with disdain, though I can only speculate on when these men did come to terms with his character, a camera operator from the lower classes: Did it have to do with those weeks in Nevada when, after he was appointed temporary head of the survey, he and James Marryatt, the cook, nursed them all back to health? This in turn causes me to speculate on whether these scientists didn't consider the extent of O'Sullivan's involvement in the war, which all of them, to a man, had managed to avoid. And then too: Did O'Sullivan ever get—to use the term they used in 1867, especially in relation to people who had been in the war—blue?

Some of the other terms used during the Civil War to describe people suffering from depression include *demoralized, downhearted, nervous, played out, used up, anxious, worn down, worn out, rattled, dispirited, sad,* and *badly blown.* Phrases used to describe the problematic health of veterans who returned from the Civil War included "irritable heart," "trotting heart," and "muscular exhaustion of the heart." What today we might call combat fatigue, or post-traumatic stress, was sometimes referred to as "sunstroke," and people were said to suffer breakdowns from acute melancholia or nostalgia. The term *nostalgia* is today associated with wistful feelings or melancholy, but at the time of the Civil War it had more gravity: it originated in the 1600s as a medical term that

described the physical illnesses people suffered when they were forcibly moved from their homes in times of war or disaster.

Oftentimes veterans had difficulty adjusting to their lives back home, which causes me to wonder if O'Sullivan's eight years of surveying away from home had to do with what he'd experienced traveling alongside a New York regiment of engineers or with the Army of the Potomac. Long after the war, Franklin Bailey, of the Twelfth Michigan Infantry, recalled his own rage in battle and was mortified after the fact: "O what a sight, it almost makes me shudder to think of it, although at the time, I did not think any more of seeing a man shot down by my side than you would of seeing a dumb beast kiled [sic]." George Alford, a member of the Sixth Michigan Infantry, was haunted by the deaths of his comrades long after the war ended: "When I am alone and get to thinking over the names and numbers of my own company that are now sleeping in the Sacred Soil of Louisianna [sic] unbidden tears will flow in spite of my stout heart that has been hardened in the Army." Dread and foreboding were characteristic among veterans. "He seemed to fear some impending danger," an observer said. In *Shook Over Hell*, a comparison of post-traumatic stress in both Vietnam and the Civil War, Eric T. Dean Jr. writes, "For many veterans, this fear, anxiety and restlessness were accompanied by a desire to be alone, sometimes an explicit fear of strangers or a fear of going outside, and sometimes simply the desire to go off in the woods as a means of getting away from people or as a way of perfecting one's defenses against imaginary danger." After the war, many Vietnam veterans moved to the Pacific Northwest, to Maine, to the woods, faraway.

I also ponder O'Sullivan's relationships with the scientists when I read that, repeatedly, veterans of both Gettysburg and the Siege of Petersburg—battles O'Sullivan photographed after and during, respectively—suggested that people who were not veterans could not understand what they had been through. "How little they did know," wrote one. Another wrote, "To tell you how we feel is impossible." An Indiana infantryman, James Stephens, framed this disconnect in terms of water and the sea: "[Indiana] has for the last three years nearly seemed as distant from and isolated to me as England. More than the Ocean with all its dangers has surged and rolled between me and my Earthly home since I left in '61. Since then I have thought of home in the future as if I were in a dream."

All of which got me thinking: O'Sullivan succeeded in portraying a river adventure for Wheeler, but are there aspects of the pictures that hint at something else, something we might not even imagine seeing?

Almost a perfect wreck

What was O'Sullivan thinking or seeing as he paddled up the Colorado River and watched as the boat in front of him crashed violently against rocks and was destroyed? What thoughts ran through his head? Did the scene remind him of another scene, of another violent event he'd been a witness to? I read about the surveyors' boat crash when Gilbert's old notebooks were finally brought out to me. I paged through each one of them slowly, admiring Gilbert's sketches, reading the notes from those long, hard days on the survey, first in Death Valley, then on the Colorado River and beyond—the notes written in pencil in a small, neat hand. I relished the journals as objects that retained a kind of aura from the expedition, their pages written in the very fields where O'Sullivan photographed, each notebook being carried in a boat on the Colorado River in 1871, a message to the future. I read as Gilbert grumbled about the progress in Death Valley, and then, when I read his entries on O'Sullivan, it was as if the camera operator were in the next room, performing a small kindness for the hammer-wielding rock scientist: "Sullivan made me a hammer sheath," Gilbert wrote.

By September 24, just a few days into their trip up the Colorado River, Gilbert notes that the lead boat—the boat Wheeler was traveling in—was not able to stay in the lead. "Overtook the larger party and let them go ahead again today," Gilbert wrote. Around this time, the supply barge was about to be sent back downstream, men and supplies were redistributed, and O'Sullivan and Gilbert were each put in charge of a boat. O'Sullivan named his boat the *Picture*, and Gilbert named his *Trilobite*. Gilbert refers to Wheeler's boat as *No. 1*, and it led the way through frequent rapids in search of beaches on which to spend the night. "We found camping ground so scarce that our search for it was prolonged into the night," Gilbert wrote in one entry. The rapids were getting more complicated, though this is not apparent in O'Sullivan's stereograph version of the trip, where everything appears under control.

Several of the crew members O'Sullivan photographed were Mojave.

Gilbert became fascinated by these men, taking notes on their hair and skin with fetishistic detail, and of course he described the geological formations they passed: "Writing at 10 A.M. I can see but one bit of the red wall, the view on all other sides being limited by the Potsdam (?) Sandstone or the underlying granite and metamorphic rocks," he wrote on October 19. "Here for the first time I see an Indian (Mitawava) dress his hair. The hair is cut square across in front so as to just shade the eyes. Behind it hangs to the middle of the back and is loosely trussed in a dozen ringlets."

Gilbert also realized that the Mojave crewmen piloting the barge were better at navigating the river than most of Wheeler's soldiers: "The superiority of the management of the Barge, as compared with No. 1, was conspicuous as they went up this rapid where everyone put his best foot foremost."

At one point, Gilbert counted fifteen rapids and noted that Wheeler's boat had gotten into trouble on the fifteenth, with a man injured. The next day saw fewer but faster rapids, and a Mojave man badly bruised his chest. Gilbert was worried that all the work navigating the river would mean no time for geologic observation. "Navigation occupied so much attention that I had little for the rock," he said. He also recorded that Wheeler couldn't manage his own craft.

And then on the eleventh day, approaching still more rapids, Wheeler lost control of his boat. No one was injured, but almost everything on board was washed away, food and notes and records of all kinds—according to Gilbert, the astronomical observations as well as Wheeler's notes and notebooks, and quite probably the notes of his young literary correspondent, Fred Loring, who will survive this river trip but won't make it back to Boston. Now Wheeler crowded everyone into two boats and put himself in O'Sullivan's boat after noticing that it had more provisions. On October 12, Gilbert wrote, "This book opens under a cloud at Camp 22 in the Big Cañon, for last night occurred the accident that lost valuable books & papers and this morning all hands are at work repairing & searching."

When Wheeler eventually wrote up his report to General Humphreys and Congress, he would describe the destruction of the boat as beyond his control. The water, he attested, gave no hint of what was coming—"This rapid seemed long—but not dangerous, however, but the

first boat going into it proved differently"—and resulted in damage that was swift, unavoidable, and life-threatening: "The first dash filled the boat with water, the second swamped it, and in this way the lives of two boatmen were endangered. The boat ran back against the rocks almost a perfect wreck," Wheeler continued, "and its contents were washed down below the overhanging rocks.

> A stout case containing my most valuable private and public papers and data for a great share of the season's report, which for the first time had not been taken out of the boat at a portage, was lost, as well as valuable instruments, the astronomical and meteorological observations, and worse than all, the entire rations of that boat. These losses could not be made good, and these disasters threatened to drive the cañon parties back to the barge station at the crossing, thus pronouncing the trip a partial failure.

It was, in other words, a disaster. After scouring the riverbank for papers and then caulking and repairing the two boats remaining, they at last passed over the rapids that had destroyed their third boat.

O'Sullivan apparently carried his own stereographic plates, the reason we have any visual record of the trip.

The expedition pressed on, against the current, which seemed to pick up. They were by now forced to row constantly. O'Sullivan continued to make plate after plate, on his large camera and on the smaller, stereographic camera. At one point Gilbert reported that O'Sullivan took a day off from photography, his hands too sore from rowing. Given Wheeler's obsessive pace, Gilbert himself lay around another day—"resting, or trying to"—though it did little good. "I still feel as though just out of a threshing machine," Gilbert wrote in his journal. He added, "since leaving Fort Mojave, the boat and crews have passed 208 rapids and covered 222 miles."

On October 18, Gilbert reported seeing a bright star.

Mere ornaments

When Wheeler's precarious, mostly for show, upstream Colorado River trip was over, he praised his own work. "The exploration of the Colorado

River may now be considered complete," he wrote in his report, exclaiming the survey team's arrival at Diamond Creek, their destination, on October 22.

Gilbert paid the two Mojave men he worked with—whom he refers to as Mitiwara and Panambona—to stand for a photograph. Doubtless due in part to his own boat's being destroyed, Wheeler chose to pose with O'Sullivan and his boat, the *Picture*, and his choice of a photo of himself and his photographer for final publication says something about

Boat Crew of the "Picture" at Diamond Creek, 1871

Back of the card, some men identified, some not

his esteem, if not for the photographer, then for the photographic work. And though O'Sullivan is about to photograph Native Americans with greater frequency for various purposes, with various intents, in these photos at Diamond Creek, the Mojave men are mere ornaments, despite being the best boatsmen in this poorly managed river run. In the official accounting on the card's reverse, they are nothing, not noted at all, making the image a typical page out of the U.S. photographic memory book of itself, names missing, people erased.

From the Colorado River, Wheeler pushed his men into the territories that would become Arizona and New Mexico—and I can imagine an exhausted O'Sullivan, after days of against-the-current rowing, lugging his equipment up out of the river and into Arizona, heading to the hills that Wheeler next wanted photographed. Wheeler pushed the survey to make the 142-mile trip south to Prescott in about a week. (It was during this time that Fred Loring, the survey's press attaché, was killed as his stagecoach headed back east.) From Prescott, the survey team was commanded to explore the mountains nearby, snow-covered at this point, another complication for the photographer. "O'Sullivan is in his element swearing at snow," Gilbert wrote.

Wheeler insisted that O'Sullivan and Gilbert climb the San Francisco Peaks, sacred to the Navajo as well as the Havasupai, Hopi, and Zuni. The Navajo refer to it as *Dook'o'oosłííd*, which can be translated

San Francisco Mt. from its base, 1871

as "the mountain with the top that never thaws." Looking out on the volcanic cones dotting the panorama, Wheeler commanded O'Sullivan to travel seven miles into the distance to photograph one cone in particular—to picture it, by Wheeler's orders, "as prominent as may be in a photo." When I speculate about what O'Sullivan is saying with this picture—if indeed he is saying anything at all—I sense him reporting on the nature of his own work, which is painstaking and laborious and crafty. The photograph he ends up with—his assistants and equipment in the foreground—pictures the peaks as well as the work entailed in making it.

Unflagging

One more speculation as at last rowing ceases and we move from water back to the land: it is my belief that by this point in the survey, just a few months in, O'Sullivan had a clear idea of what Lieutenant Wheeler was up to. After all, he'd been around a lot of military commanders, serving under them and sometimes making portraits of them, their vanity or lack thereof on display. Still, the meager record—journals, letters, recommendations—indicates that O'Sullivan managed to get along (on the surface, at least) with just about everyone he worked with, even if they were put off on occasion by his anger or what they described as his ceaseless talk about the war. This is not remarkable; it behooves the freelancer to have harmonious relations with his clients; it is an elemental survival tactic. And if I were to guess what the photographer was thinking after making it out of Death Valley without dying of thirst, and then off of the Colorado without drowning or losing all his precious photographic plates to the river, I would guess he was glad to be alive and employed and maybe, on arriving home in D.C., excited to make some prints from his glass plate images.

Given that some survey members had died of tuberculosis in Death Valley, I would also guess that around this time, O'Sullivan had become infected himself. The lung-infecting bacterial disease is spread by droplets that come from coughing or even talking, and the surveyors worked closely and camped together. Symptoms—a bad cough, pain in the chest, spitting up blood—are sometimes slow to appear, and perhaps over the winter or during the course of the next season he began

suffering night sweats or fever, or even fatigue. For certain, tuberculosis would kill him in just a few years.

After his Colorado River experience it almost seems as if Wheeler didn't have a plan, or had too many plans, and O'Sullivan was sent off on what comes across as a peripatetic voyage across the West, fluttering like a bird around vast portions of the Great Basin and now through the Colorado Plateau at the behest of his glory- and mining-obsessed commander. At the end of the 1871 season, Wheeler summarized the events up to that point—Death Valley and the Colorado River run and the subsequent explorations—and he singled out O'Sullivan for praise while reporting that most of the cameraman's work from that year would never be seen:

> The entire party worked with a will and were unflagging in their exertions, more especially those who were willing to continue the ascent after the third or damaged boat returned to the crossing. Mr. O'Sullivan, in the face of all obstacles, made negatives at all available points, some of which were saved, but the principal ones of the collections were ruined during transportation from Prescott, Ariz., via mouth of the Colorado, San Francisco, &c., to Washington, D.C., thus destroying one of the most unique sets of photographs ever taken.

RECORD OF CONQUEST

In which we consider, first, a few typographical details in a picture O'Sullivan made at Inscription Rock, in what is today the state of New Mexico, along with the details of O'Sullivan's citizenship and then the ways in which his birth in Ireland may or may not have inspired his own interactions with Inscription Rock and his photographs of citizens of the Colorado Plateau.

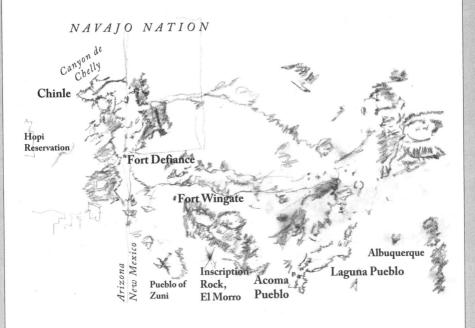

NAVAJO NATION

Canyon de Chelly

Chinle

Hopi Reservation

Fort Defiance

Fort Wingate

Arizona
New Mexico

Pueblo of Zuni

Inscription Rock, El Morro

Acoma Pueblo

Laguna Pueblo

Albuquerque

12

Historic Spanish Record of the Conquest.
South Side of Inscription Rock, N.M., 1873

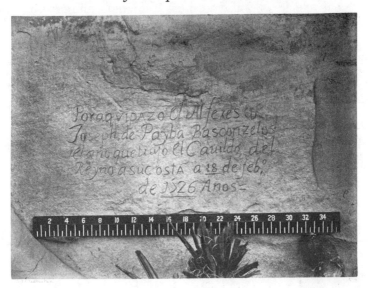

(New York Public Library)

The historic Spanish record of conquest isn't as simple as O'Sullivan's photograph makes it seem. This inscription seems singular, but it is merely one carved inscription among hundreds made on the side of what, given so many dates and signatures, is known as Inscription Rock. O'Sullivan's photo was made for the Wheeler survey in his second-to-last year in the West. Inscription Rock is one rock face on the side of a twenty-story-tall promontory on the Colorado Plateau—El Morro, a name that translates as "bluff" or "headland." El Morro is in the west of what was the New Mexico Territory and is now the state of New Mexico. If you are coming from Albuquerque, you drive about an hour south of Interstate 40 to see it on the southern flank of an ancient geologic

uplift known as the Zuni Mountains. The soft, easy-to-inscribe sandstone is the petrified remains of an ancient windblown dune field that, 150 million years ago, was one of several that covered northwestern New Mexico, northeastern Arizona, southeastern Utah, and southwestern Colorado. This is the area that today is referred to as the Four Corners and is, depending on your age, maybe best known in popular culture as the site of innumerable film and TV westerns or of rugged four-wheel-drive Jeep commercials, Jeeps being a military car turned recreational vehicle. It is also a center of uranium mining. One reason so many inscriptions have been made at this spot is that the rock face is adjacent to a water hole, a rock-sheltered pool that was thought by the first U.S. military survey to be a spring but is in fact a collection point for streams of melting snow. The water, kept cool by a rock overhang, made the site an important stop between the Acoma Pueblo to the east and Zuni settlements to the west, though today water for the U.S. National Park Service station is brought into the site, the streams having all but dried up. Here is O'Sullivan's picture of the entirety of El Morro, or a large chunk of it:

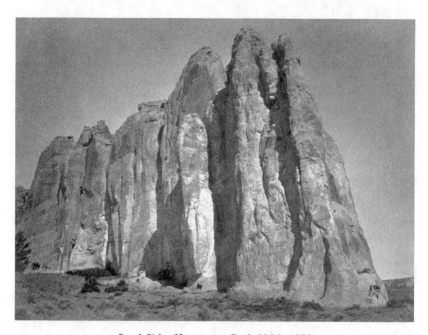

South Side of Inscription Rock, N.M., 1873

A note on the inscription

The inscription O'Sullivan photographed up close was written by or at the behest of Joseph de Payba Basconzelos. It reads: "Ensign Don Joseph de Payba Basconzelos passed by here on the 18th of February, 1726, the year that he brought the governing council of the kingdom, at his own expense." Basconzelos was part of the second phase of Spanish colonial rule in what is now the American West. The first phase began when the Spanish invaded the area of El Morro in the sixteenth century, ruling it as a colonial outpost. Then, in 1680, when a Tewa leader named Po'pay assembled Pueblo forces at a base near Taos, Pueblo fighters pushed the Spanish out. This was the first American revolution, a rebellion that precedes the one struck up by British colonists nearly a century later. The contemporary poet E. A. Mares, in a poem that takes the voice of Po'pay, described the victory: "We broke their arrogance / Like bits of dry straw." There was a second Pueblo Revolt, in 1696, and this time the Pueblo were defeated and occupied. Subsequently, more Spanish officials were now stopping to drink at the spring that collects at El Morro's base, many marking their names as well as the phrase *paso por aquí*, "passed through here."

Of course, all through this time there were conflicts involving Apache, Comanche, Ute, Diné, and Zuni communities, among others. There were also agreements. But the inscription in O'Sullivan's photograph notes the return of expelled colonial council members to Santa Fe from Mexico City in 1726, as orchestrated by Basconzelos. Mexico won its independence from Spain in 1821, and then, in 1848, when the United States took El Morro from Mexico, white settlers colonizing the Southwest began to mark the rock in English.

The inscriptions at El Morro are like fingerprints, placing at the scene of conquest the likes of Francisco Vázquez de Coronado, who, in 1540, signed the rock in the midst of not finding the mythical seven golden cities of Cíbola. A soldier named Lujan signed while assigned to a Spanish military expedition on the way to avenge the death of a missionary killed at the Zuni Pueblo in 1632. In 1692, General Don Diego de Vargas signed while attempting to reclaim New Mexico for the Spanish after the 1680 Pueblo Revolt. In 1716, a Spanish military commander paused on his march to battle Tewa people living in a Hopi settlement—rather than risk their own soldiers in fighting to the top

of a mesa, the Spanish burned the village's food in the gardens surrounding the mesa and killed the livestock. In a 1938 National Park Service survey of El Morro, the nearby Acoma Pueblo is mentioned in the analysis of what is deemed the oldest inscription on El Morro, made in 1605 by Juan de Oñate y Salazar, who is frequently credited with establishing the first European colony west of the Mississippi. He is less frequently remembered as a particularly brutal conqueror among brutal conquerors, notorious for a massacre of as many as a thousand Acoma people at Sky City. A few years after stopping at El Morro, Oñate ordered that the left foot of all Acoma men over the age of twenty-five be cut off, a reason why the statue in Albuquerque honoring him was protested during uprisings in the summer of 2020, then taken away. In 2023, a statue of Oñate was reinstalled in Española, ninety miles north. In both cases, people protesting the statue were shot.

The Americans continued where the Spanish had left off. Lieutenant J. H. Simpson, a member of the U.S. Army Corps of Topographical Engineers, signed the rock just prior to O'Sullivan's arrival at El Morro. Simpson was born in New Jersey and, after graduating from West Point, made his name in the Seminole Wars, four decades of fighting initiated by Andrew Jackson, America's patron saint of Indian removal—with the blessing of the Supreme Court. Before surveying the Southwest, Simpson oversaw the completion of the army's transcontinental railroad surveys, supervised by U.S. secretary of war Jefferson Davis: a preliminary step in that Caribbean-centered slavery-friendly empire pined for by Davis well before the Confederate secession. After signing in at El Morro, Simpson surveyed Navajo territory, just as O'Sullivan, in 1873, was about to do. Simpson's survey would quickly escalate into an attack on the Navajo in Canyon de Chelly. In his report of the 1849 trip, Simpson describes firing at the walls of the sacred canyon, destroying rock formations, and eating Navajo food, which, he complained, made him nauseous.

A note on the photograph

In showing up at El Morro, Wheeler was once again behind the times: the area had already been surveyed twice by the U.S. Army, in 1849 and 1851, both times by Lieutenant Simpson. In 1849, Simpson hadn't just noted Basconzelos's inscription; he inscribed his own name too. When

Wheeler arrived—concerned primarily with making his survey of the area somehow significant—he suggested that Simpson had read the Basconzelos inscription incorrectly. Wheeler argued that the "7" in the date looked more like a "5," though if you have ever seen it in person, you know that it certainly does not. What Wheeler characterizes as the uppermost line of the supposed number 5 is very clearly just a scratch in the rock. Judging from his correspondence, Wheeler appears to have ordered O'Sullivan to focus his camera on the minutiae of this inscription. With a five instead of a seven, Wheeler could offer a brand-new history of the conquest of the region, even if it was wrong, and Wheeler's notes indicate that he tasted glory in this possible rewriting of history—one possible explanation for why O'Sullivan made so many plates, each one seeming to come closer to making 1726 look like 1526. At some point around the time he photographed El Morro and the inscription that Wheeler was interested in, he signed the rock, making his own inscription.

A note on the name O'Sullivan, in particular the O

He signed the rock "T. H. O'Sullivan." That he signed it as *O'Sullivan* and not merely *Sullivan* is a point of note for some photo historians. I've heard at least one suggest that the name O'Sullivan was fabricated, that, according to a census made in Staten Island, his actual name was Sullivan, without the O. The O, goes this argument, was a flourish for effect, a stylized touch. But beyond a mere typographical detail, I see the O as more complicated, despite being a matter of one single letter. We don't know what his family considered the correct spelling of his name. Had there been an O, a census taker could easily have dropped it, thinking it superfluous and taking the opportunity to streamline, to Americanize a foreign name, bleach out its earthy foreignness, make it less what it was, which was O'Suileabhain. The O is Irish for "of," in this case the masculine version, and the name O'Sullivan can be translated as "the grandson of Sullivan." In the 1840s, an aspiring American—or, more accurately, *Irish* American—might have tacitly consented to the removal of the O, hoping to blend in with American culture. Mathew Brady, likely born in Ireland (as already noted) twenty years before O'Sullivan, is an example of a New Yorker who appears to have played down his birthplace, given the intense anti-Irish nativism of the moment. In Irish, Brady

might have been Mac Brádaigh or Ó Brádaigh. But the status of Irish-ness in America changes in the span of O'Sullivan's life. By the time he makes the first photos in South Carolina as an enlisted soldier em-bedded with General Egbert Ludovicus Viele, an engineer from New York, the Irish are fielding army units and carrying American flags alongside flags celebrating Ireland. O'Sullivan's timeline—from 1842, when he landed in the United States, to 1876, when he is done with fieldwork but still working in Washington, D.C., printing for Wheeler and King—mirrors Irish America's upgrade from un-American aliens targeted by nativists and Know-Nothings to True Americans, so-called, ready to join in with the American project, whether to put down federal rebellions as soldiers or, as citizens, to, as a group, stand back and allow violence to do its work on various citizens deemed lesser. In flaunting his *O*, or in reinstating it, O'Sullivan would be in step with other newly American Irish, the small typographical addition perhaps a small flag waved to celebrate full American citizenship, or at the very least a nod to the flavor of his Americanness.

Notes on the Irish in America generally

Prior to the 1840s, people emigrated from Ireland to the United States in dribs and drabs. An early burst in the mid-1700s were the so-called Scots-Irish, descendants of the Scottish Presbyterians who originally settled Ulster, one of the four traditional provinces of Ireland, as part of the English colonization of the island. The term *Scots-Irish* became es-pecially popular in the United States when the earlier immigrants from Ireland wanted to distinguish themselves from the increasing number of increasingly poor Catholic Irish, who arrived in greater numbers as evictions and food shortages in Ireland led to what would culminate in what in Irish is called *an Gorta Mór*, "the Great Hunger." During the most dire years of the Irish famine, from 1845 to 1855, a million people died and close to two million people emigrated from Ireland to America and Australia and another three-quarters of a million to Britain. Some-time around 1842, when O'Sullivan was two, his family arrived in New Orleans, where immigrants in great number were offered work digging the canals, a job made deadly by malaria and cholera.

The machinations of an expanding United States meant that the

Irish likewise stepped into the poisonous politics of slavery, and, as land clearance was accelerating in the American West and South, the Irish as a group were quickly forced to choose sides and, in so doing, chose wrong. In the same year that O'Sullivan likely arrived in Louisiana, sixty thousand Irishmen in Ireland—led by Daniel O'Connell, the Irish nationalist leader known in Ireland as the Liberator for his role in the emancipation of Irish Catholics under British rule—petitioned the Irish already living in America to side against slavery, in his *Address from the People of Ireland to Their Countrymen and Countrywomen in America,* or the Irish Address, for short. "The object of this address is to call your attention to the subject of SLAVERY IN AMERICA—that foul blot upon the noble institution and the fair name of your adopted country," the petition went. "America is cursed by slavery!" Recognizing the political stakes, Irish Americans quickly criticized the address, arguing, first, that it might spark bloodshed, the destruction of the union. In New York, John Hughes, the preeminent Irish bishop in America, asked if it was a hoax, while in the North *and* South, Irish societies quickly distanced themselves from it, noting that though they opposed slavery, the enslaved were nonetheless property—and worrying too about the loyalty of Northern abolitionists, the majority of whom were anti-Catholic as well as anti-Irish. "It is under the constitution and laws that our Southern fellow citizens lay claim to the involuntary services of their negro servants," one wrote. (Eventually, O'Connell backed down.)

By the time O'Sullivan was surveying the West, the Irish were everywhere in the country, farming in the Midwest and mining in the Far West—in the Comstock Lode, but also in the copper mines in Butte, Montana, and in Michigan—after building railroads and settling, yes, in cities. In eastern cities, as they strengthened their alliance with Democrats, the Irish were crucial to the notorious compromise that brought the radical terms of Reconstruction to an end, the pact sealed as O'Sullivan finished his last two years in the West. In 1872, Boss Tweed, the head of Tammany Hall, was succeeded by John Kelly, a onetime apprenticed mason who had become politically active in the 1840s while fighting off anti-Irish and anti-Catholic attacks. By 1874, Kelly, the son of Irish immigrants, was in control of New York's elections, as were rising Irish politicians in other big northeast cities. With the Irish now exploiting their power as an ethnic swing vote, white

workers in the North, buoyed by the political reconciliation of the North and South, took the racist bait that would forever hinder their own success, as well as the success of every American worker. W.E.B. Du Bois summed the situation up in his 1935 book *Black Reconstruction in America 1860–1880*: "When white laborers were convinced that the degradation of Negro labor was more fundamental than the uplift of white labor, the end was in sight."

And in the same way that business leaders in eastern cities made the battle between nativists, the Irish, and Black people manageable and perversely civilized—by decorating the Irish with police badges and arming them with nightsticks to "patrol" elections, for instance—so the Democrats in the South now took control of the Confederate states, federal troops withdrawn. If Reconstruction had rewritten state constitutions, increased Black suffrage, put in place Black political leaders—an assertion of federal power to protect the formerly enslaved and expand their citizenship—now, as federal power withdrew, Northern capitalists made friends with their Southern enemies so as not to, as *The United States Gazette* had put it in Philadelphia in the 1850s, "hinder the city of gains from the residence of capitalists who seek comfort and ease."

With the North and South back in business together, the War of Northern Aggression and the War of Southern Rebellion slowly transformed into the almost unifying Civil War, the peaceful title hiding the horror of violence against people of color as the violence resumed in the western territories against the Indigenous sovereign states. If the newly arrived Irish weren't exactly trusted by the Protestant white majority, they were trusted, at least, as the advance guard of western expansion. When Lieutenant Colonel George Armstrong Custer died—at what the U.S. Army calls the 1876 Battle of the Little Bighorn and what Plains nations call the Battle of Greasy Grass—at least five dozen men who died with Custer were Irish. Among them were a shoemaker from Longford, a carpenter from Kildare, a laborer from Dublin. Captain Myles Keogh was the only Irish-born officer at what wasn't a battle, but a rout. Keogh had served in a papal army, fighting in Italy in 1860. In Ireland at the time, fighting for a foreign military, especially that of a Catholic nation, was considered an act of aggression against England. When the British passed the Foreign Enlistment Act, prohibiting British subjects from joining a foreign army, it had the unintended effect of encourag-

ing Irish nationalists to join foreign armies that had anti-English lean-
ings. But in the American West, while fighting against the Cheyenne,
Shoshone, Comanche, Kiowa, Havasupai, Ute, Apache, Crow, Sioux,
Arapaho, and Modoc nations, among others, the Irish were fighting to
be Irish while also fighting to be American, a dual pledge of allegiance
that worked to the detriment of Native nations but could be tricky for
the Irish, depending on whether they were working for the capitalists or
organizing workers against them. Wrote David M. Emmons in *Beyond
the American Pale*, a history of the Irish in the West:

> If the legacy of the West was of conquest, then the Irish clearly
> had a limited role: they could be the blunt instruments of con-
> quest, the foot soldiers of the American conquistadors, but not
> themselves conquerors. This was a distinctly subordinate role,
> but it was all that could be expected of passive exiles not thought
> to possess the plucky individualism necessary to frontier con-
> quests. They would be the shock troops, first in time but last in
> claimant rights. There was a great irony in this. The agents of
> dispossession had themselves been dispossessed.

The picture I made of where O'Sullivan signed Inscription Rock

13

Aboriginal life among the Navajos, 1873

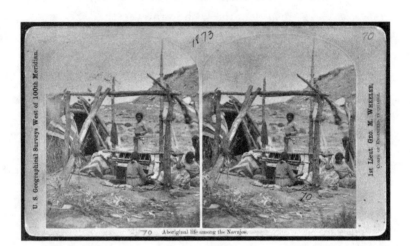

As we continue to march with Timothy O'Sullivan from El Morro and on into Navajo territory, as he enters the final stages of his work in the West and, as far as we know, his work anywhere, it seems fitting to wonder: When you sign the rock, do you see things differently? On becoming a full-fledged American—one body in the long assembly line that is incorporating the West, turning territory into property, water and the substance of the earth into commodities that fuel armies, and expanding settlements—does the way you frame a picture change?

Here is a photograph O'Sullivan made in 1873, in his second-to-last year moving through the West on contract with the U.S. Army—a photograph of a Navajo family working on what was, as defined in the 1868 Treaty of Bosque Redondo, the newly established Navajo Indian

Reservation, newly established in the eyes of the U.S. government, though long-established as the traditional Navajo homeland. O'Sullivan made the picture just after the Navajo, or Diné,* had returned to the area after having been forced off the land by the U.S. Army. When I see the photo, I think first about the particulars of Navajo history that led to this moment, a weaver making a blanket on Navajo home ground, everyday work resumed after years of negotiations to return to this landscape, and then I think about what it meant, if anything, that the thirty-three-year-old photographing western territories for the U.S. Department of War was, in 1842, a small boy in Ireland, at the very moment Irelanders were being forced to move.

This picture was made very near Fort Defiance, in Arizona, the first federal post built to control the Navajo Nation after the United States took control of the area following the Treaty of Guadalupe Hidalgo in 1848, part of the spoils of the Mexican War. The fort was constructed in 1851, though abandoned ten years later, after several battles against the Navajo in the 1850s and several treaties. In 1862 the Union army was back in the vicinity, fighting Confederate troops who had seized part of Arizona and New Mexico, but then, as the Confederates were quickly defeated, fighting the Apache and the Navajo. After the Dakota Sioux uprisings in Minnesota in 1862, the army went on the attack, reluctant to make treaties, rounding up Native communities and removing them, as they had in the East.

Brigadier General James Carleton, born in Maine and a veteran of the war with Mexico, had fought Mormons in the Great Basin and, in 1862, Apache fighters on the Colorado Plateau. That the body of the Apache leader Mangas Coloradas was mutilated under Carleton's command (his head severed by an army doctor, his skull exhibited) was said to be a turning point for Geronimo, an ally of the Mimbreño leader. Carleton turned next to the Navajo, who confounded him, their communities customarily dispersed and leadership decentralized. Carleton put Colonel Kit Carson, the famed explorer and Indian fighter, in charge of forcing the Navajo off their land with a search-and-destroy

Navajo is a Tewa word used to describe the Navajo; *Diné* is a word from the tribe's own language, meaning "people," and is the shortened version of *Nihookáá dine 'é*, which can be translated as "five-fingered Earth surface people."

mission that was not unlike Sherman's March to the Sea or the use of Agent Orange in Vietnam: Carson destroyed crops, denied Native people access to sources of water, and destroyed the long-haired sheep that Navajo herders had raised since the Spanish introduced them to the animal in the 1500s. (In the 1930s, U.S. agents went from hogan to hogan, killing the sheep, arguing that overgrazing would endanger the new Hoover Dam by adding silt to the Colorado River.)

When Carson arrived at a cornfield at the mouth of a great canyon—"one hundred acres of as fine corn as I have ever seen," he said—the celebrated colonel fed some of the corn to his horses but ordered everything else burned, including approximately three thousand peach trees and all the Navajo hogans, which were not unlike the hogan that O'Sullivan captured in this photograph. You can see it behind the wooden frame supporting the weaver's loom, his plate exposed a dozen years after Carson's pillaging. The canyon he pillaged was Canyon de Chelly.

Carson intended to keep the Navajo on the move, though some of them escaped his attack by using ropes and ladders to hide in the high ledges of the canyon; a Navajo leader named Manuelito managed to stay hidden from Carson with his wife and family for almost three years. The army next marched the survivors of Carson's raids to Bosque Redondo, in eastern New Mexico, not far from the Texas Panhandle. In the Navajo language, the place is known as *Hwéeldi*, which is translated variously as "the place of suffering" or "the place of despair." On what the Navajo refer to as their Long Walk, people of all ages traveled more than a dozen miles a day, completing the five-hundred-mile trip in a month. A Navajo story I have seen repeated in many accounts and collections of stories refers to a young woman needing to stop during the walk to give birth. Under the watch of U.S. soldiers, she sends her family ahead. Shortly after they separate, her family hears a gunshot in the distance behind them. She is never seen again.

At Bosque Redondo, the army planned to have the Navajo dig irrigation ditches and grow crops to sustain themselves, but the plan failed, and soon the eight thousand Navajo incarcerated in the camp were dependent on the army for food. Apache families were also imprisoned there, the Apache a traditional enemy. The camp boundaries were guarded by troops. Among what was the largest group of Native Americans ever forced into one place in the United States—9,500 Diné

and 500 Mescalero Apache, or Nde—infant mortality was high as disease spread through the camp. By 1868 the drinking water was severely contaminated and the corn crop had failed, yet the prison camp was still championed by General Carleton, the military commander of New Mexico, who saw it as a place to teach the Navajo and Apache farming, strip them of their culture, and prevent the raids to enslave in which both Navajo and Apache participated: in the convoluted logic of colonialism, the Union general saw the prison camp as enabling freedom throughout the continent by destroying slavery among the Navajo and Apache and Hispanic settlements. "The Indians upon the reservation, if properly cared for by the military commander, run no risk of being stolen or attacked." As a bonus, Carleton told Congress, the tribes could grow extra corn to supply the army as it fought Indians on the Great Plains.

In the spring of 1868, Navajo leaders successfully negotiated a return to Canyon de Chelly and its vicinity, the territory demarked by the four mountains that act as the points on a spiritual compass for the Navajo, places that describe the present world and its creation: in English, Blanca Peak, Mount Taylor, the San Francisco Peaks, and Hesperus Peak; in Diné, Sisnaajiní, Tsoodził, Dook'o'oosłííd, and Dibé Nitsaa. More than seven thousand people marched with horses and sheep in a ten-mile-long procession. By the time O'Sullivan arrived, four years later, Fort Defiance was the new headquarters of the local Indian agency, and the Navajo were rebuilding their lives in their homeland.

Mistaken zeal

Most likely it was Wheeler who captioned O'Sullivan's photo and identified the Navajo as aborigines. It was one of a series of photos in and around Fort Defiance that used some variation of the word *aboriginal* in their titles. The photos also demonstrate the ways in which the army engineered control of the so-called aboriginal population, in this case the Navajo, making O'Sullivan's glass plates something akin to modern-day surveillance photos. Then again, colonial powers have long used photography to contain and control the population, an early example being the British government in India beginning in the 1850s, when the colonial regime first photographed the country's vernacular architecture. Then, in 1857, after the colony's First War of Independence, British govern-

ment photographers made ethnological surveys, which feigned scientific importance but had the effect of identifying the people the government perceived as allies or enemies, an effort culminating in an eight-volume publication, *The People of India: A Series of Photographic Illustrations with Descriptive Letterpress, of the Races and Tribes of Hindustan*. It included the notorious photos made by Willoughby Wallace Hooper, a British photographer and contemporary of O'Sullivan's, who documented victims of the Great Famine of India that began in 1876 and killed upward of eight million people, one of several devastating famines under British rule at the end of the 1800s that were a result of policies of nonintervention. Hooper's photos, originally made for a souvenir book for British rulers in India, display a horrifying dispassion that reeks of the empire's cruelty.

 In the plate below, published alongside Wheeler's expedition report, suffused as it is with a dubious account of hardships and dangers, two Apache men—crouched with guns in hand—are depicted as menacing yet also under the control of U.S. soldiers. O'Sullivan does what his experience

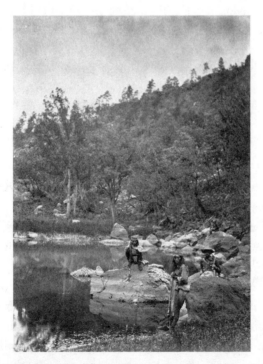

View on Apache Lake, Sierra Blanca Range, Arizona, with Two Apache Scouts in the Foreground, 1873 (Smithsonian American Art Museum)

with Mathew Brady and P. T. Barnum taught him to do: the American viewer at home sees the Apache as savages and so feels the danger, the tenuous balance of power in the western mountains. "Some of the worst, if not worst, Indians remaining in the United States were those encountered in the lonely marches, away often from either highways or trails, on this expedition," Wheeler wrote in his final report. The plate is an illustration of the ways in which the landscape both requires control and is under it; the armed Apache men seem to be contained not just by the lake but by two soldiers, one poised comfortably in the foreground, one on the rocks in the distance, guarding the scene from behind. It's another surveillance photo that also serves as entertainment for violence-hungry audiences in the East and scores points in the bureaucratic in-fighting erupting between the various western surveys: it emphasizes the Wheeler survey's effectiveness as a military survey, in contrast to a survey run by a civilian scientist such as Clarence King or Ferdinand V. Hayden, both of whom he chastised for making maps and charts that were based on "the theoretical considerations of the geologists."

Robin Kelsey, the art historian, noticed that instead of photographing the rounded boulders along the water's edge, O'Sullivan draws our attention to the flat, broken face of the boulder at the center of the photo—"cracks running helter-skelter across it," Kelsey writes. The rock's face is fragmented and unintelligible, like (Kelsey also notes) the description of Native American languages by Wheeler's writer-for-hire, Fred Loring: "Indian talk is something like baby-talk in its utter disjointedness." At the time, rock faces were associated with the character of Indians who lived among them, and Lieutenant Wheeler described nearby sandstone formations as "black, ugly, and frowning." Drainage openings, in contrast, were "friendly."

"This region was the stronghold of the Apache-Mohave," Wheeler wrote, "where they had hunted and fished for unnumbered generations, and more lately murdered to their heart's content."

The two Apache men were working most likely as guides, which, ironically, meant that the survey's well-being depended on their knowledge of the land. But in his report Wheeler uses their presence to attack politicians and white Indian rights campaigners, citing the murder of Fred Loring—who Wheeler claims, erroneously, was killed by Apache—and ignoring the persistent attacks against the Apache by U.S.

and Mexican armies through the early 1900s. Peace is impossible, Wheeler writes to Congress, and negotiations foolish: "This is one of the evidences of the mistaken zeal, of the then peace-at-any-cost policy, that was for so long a time applied to the settlement of the Indian problem."

"Unfortunately," Wheeler continued, "the bones of murdered citizens cannot rise to cry out and attest the atrocious murders of the far-spreading and wide-extending borderlands of the Great West, and while the fate of the Indian is sealed, the interval during which their extermination as a race is to be consummated will doubtless be marked[,] in addition to Indian outbreaks, with still many more murderous ambuscades and massacres."

In a way which betrays the savage

But is there more to these photos than what Wheeler intended? Another way to see the photos of Navajo people in and around Fort Defiance is as evidence of resistance. Even if Congress or viewers at home see these stereographs as evidence of the Indigenous population being subdued, the story was more complicated, given that the Navajo had contested their incarceration and negotiated a return to their homeland. The Diné in O'Sullivan's photos at Fort Defiance and Canyon de Chelly are on a reservation whose boundaries they themselves will begin to expand: today the Navajo Nation is the largest Indian reservation in the United States; if it were a U.S. state, as opposed to an independent sovereign nation, it would be larger than each of the ten smallest states. As the weaver works the loom, she is demonstrating a link to the past, to a time when Diné weavers arrived in the area in the 1300s and further back, to when the Diné were taught weaving by Spider Woman. In the Navajo spiritual and ecological cosmology, Spider Woman is the person who weaves the world, and she is an ancient presence in Canyon de Chelly. In O'Sullivan's picture, the weaver is also demonstrating independence and adaptability, producing materials for use and for sale: the design itself—lines and colors composed of references to the Diné Bikéyah, the Navajo homeland—references stories that speak of the past in that very place, stories that are transporting the Navajo into a future at the very moment the plate was exposed to make the image.

When I return to O'Sullivan's photo of the loom, I think, What if the photographer, as he framed his plates, saw something else aside from control and surveillance? It is not difficult to imagine the bustle of activity as this glass plate is being made, presumably in the vicinity of old Fort Defiance. But do the lines crisscrossing the picture of the weaver and her work—some of the earliest-known photos of Diné weavers—represent confinement, or has O'Sullivan noticed that his own crisscross patterning in the frame echoes the artist's design? Does the grid also echo the loom, intentionally or unintentionally? Does the loom highlight the weaver's industriousness and creativity? And note that one or maybe two of the people being watched is also watching the photographer, as was the case back in 1862 when he photographed a Black family traveling alongside troops crossing the Rappahannock in Virginia, moving from slavery to freedom. Does the viewer feel the commotion at the fort, the talking and singing that we cannot hear, the work to renegotiate life at home given occupation by a foreign army? Can the viewer feel what it is like to be watched or observed?

When O'Sullivan was at Fort Defiance, Diné weavers were beginning to experiment with yarns from Germantown, Pennsylvania, and from Germany; commercial yarns were part of the U.S. government annuities that the Navajo had negotiated. The Diné were weaving objects that were already highly praised throughout the United States and Europe, not necessarily as art but as an example of a supposedly primitive aesthetic.* Like their weavers, the Diné were in the midst of reimagining a life that was likewise simultaneously traditional and brand-new, and the weavers evidenced the vitality of Navajo culture. In another of the photos, two boys and a young woman appear to be posed by O'Sullivan inside the old fort, with their exquisite blankets, posed with their faces in portrait, the latter a touch O'Sullivan would have avoided if he were portraying "aboriginals" for Mathew Brady and P. T. Barnum. Recall that Brady photographed the Fijians who performed for Barnum straight on, the so-called cannibals staring into the lens. Statesmen, on

* It was not until 1931 that John Sloan and Oliver LaFarge helped curate what was called "the first exhibition of American Indian art selected entirely with consideration of aesthetic value." Sloan and LaFarge, in introducing the show, said, "We white Americans have been painfully slow to realize the Indian's value to us and to the world as an independent artist."

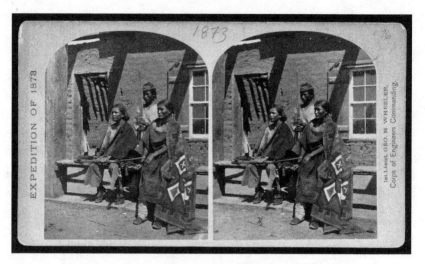

Navajo Boys and Squaw, in front of the quarters at old
Fort Defiance, N.M., now unoccupied by troops, 1873

the other hand, were depicted looking to the side, a classical and thus
noble pose.

Rather than appear as captives or hostages of the military occupa-
tion, O'Sullivan's subjects seem to have been interrupted in the middle
of something—of life, even—and they appear not just busy but engaged,
active in a world calling from just offstage. O'Sullivan's pictures of the
Diné at Fort Defiance contrast most obviously with the portraits made
thirty years later by Edward Curtis, whose images are sensuous and dra-
matic but are like frames taken from a motion picture about what eu-
genicists at the time deemed "the vanishing race." O'Sullivan's portraits
contrast, too, with photos made by Eadweard J. Muybridge in 1867, with
titles like *Deserted Village*, which made Yosemite seem just that, though
it was not deserted, but taken, with guns and rewards for scalps. (For
his famous locomotion images, sponsored by the railroad baron Le-
land Stanford, Muybridge worked with William Pepper, the University
of Pennsylvania's provost and a champion of scientific racism, who saw
Muybridge's work as a celebration of the Anglo-Saxon figure.) I wonder
if O'Sullivan's *Aboriginal life among the Navajos* fulfills Wheeler's orders
while subverting them, intentionally or otherwise, and illustrating lives
not in the past but fully present tense. The weaver at work, with finished

blankets to either side, is a portrait of productivity, a culture in process, though framed by the fencelike grid that O'Sullivan emphasizes, or seems to. By now it is obvious that I have no idea what O'Sullivan was thinking, but I can look at the photo and ask: Does the grid emphasize resilience or an imprisonment, or a struggle between the two?

To answer the question, or to speculate, I return once more to O'Sullivan's Irishness, to his transformation from Irish foreigner to American in the 1840s and '50s. The general circumstances of his photos of the Navajo and the Apache, Zuni, and Mojave, and of all the people whose territory the U.S. Army was surveying at the time, have a historical echo in Ireland, where, in the eighteenth century, transplanted English Protestant rulers distinguished themselves from the local aborigines—note that when O'Sullivan was photographing the Diné, the term was still used in the British press. From an 1886 report in *The Scotsman*: "The lower Irish race whether they are Celts or aboriginal pre-Celtic Irish are well known in the great cities and mining districts of England and Scotland where they are to be found the cause of a large proportion (one-half or one-third) of the worst crime." This language and the inferred relationship between "aborigines" and crime is mirrored in other papers across Great Britain in those years. The Irish, the London *Times* suggested in 1876, a year after O'Sullivan's Navajo photos began to be published by Wheeler, "make up for their innocence at home by an excessive criminality abroad."

In the British press, the late-nineteenth-century Irish aborigines were not unlike the Apache that Wheeler described—passionate and lacking self-control. "It is they," *The Scotsman* wrote, "who have demoralized the mob by their frightful examples of brutal assaults on men when down to the utter forgetfulness of romantic English and Scottish notions of fair play. It is not enough for an Irish combatant[,] as he is known in this country, to knock his man down, he must proceed to kick and stamp upon his opponent when helpless in a way which betrays the savage." (As Irish labor unrest increased in the 1870s, and while Irish nationalists agitated more vigorously for an independent Ireland, the chances of an Irishman's arrest for homicide in Scotland nearly tripled.)

By the time O'Sullivan was photographing American "aborigines," he was among the same people who, after the Great Hunger, had been forced out of their homeland and ended up in the American West,

killing Indians or maybe photographing them, perhaps seeing or maybe not seeing similarities between the land clearance of Ireland and the clearing out of Indigenous communities in North America, something like what the poet Eavan Boland called "the toxins of a whole history." "In this context," wrote the historian Ronald Takaki, "the Irish past foreshadowed the Indian future."

And though I am, as usual, only able to speculate as to whether O'Sullivan ever even considered the clearance of his own homeland, I do know that Indigenous peoples in North America thought about Ireland—that at least some of them saw the link between what had happened in Ireland and what was happening in the United States, especially the Choctaw and Cherokee nations. In 1847, at the very moment when Irish families like O'Sullivan's were arriving in the country as refugees, the Choctaw and the Cherokee arranged to send support to Ireland. At a meeting in a town called Skullyville, in the Indian Territory, the Choctaw collected $710 in support of the people suffering under the conditions that were reported on in the American press and in their own.*

* The way the American press characterized the relief aid that Cherokee and Choctaw citizens sent to Ireland contrasts with the way the Cherokee and Choctaw press described it—another thing to keep in mind when considering the way that a photographer born in Ireland photographed Navajo weavers working in a landscape to which the Navajo had very recently returned. The white press described the donations by tribal citizens as evidence that the Indigenous groups had been civilized. "What an agreeable reflection it must give to the Christian and the philanthropist, to witness this evidence of civilization and Christian spirit existing among our red neighbors," wrote the *Arkansas Intelligencer* in 1847, framing the aid as repayment to white Americans: "They are repaying the Christian world a consideration for bringing them out from the benighted ignorance and heathen barbarism." Meanwhile, coverage of the famine was ubiquitous in the United States, an early example of a global news story. *The Charleston* (South Carolina) *Courier* reported on the Irish town of Kilrush, where, it said, "thirteen thousand persons have suffered eviction, five thousand have been unhoused in the county of Limerick, and law processes are out for the demolition of one thousand houses more." *The American Flag*, a newspaper based in Matamoros, Mexico, described the British island-colony as "the Ireland of traitorous landlords and murderous evictions." Terms like *imperialism* had yet to be born, but the Cherokee and Choctaw donations were characterized as acts of something more like *solidarity*, a term that had just arrived in English lexicons, imported from France. In May 1847, *The Cherokee Advocate*, citing news accounts, "deplored" what it described as an "oppressed condition" forced on the Irish by England, where, they noted, ships full of food grown in Ireland were arriving in ports. "The Irish nation is tithed and taxed and rented until the energies of the

Conscious of separation

O'Sullivan was seven years old at the time the Choctaw were sending aid to Ireland. That same year, the docks of New Orleans saw the arrival of sick and starving Irish, sometimes corpses, bodies carried from ship to shore. In 1847 the New Orleans *Times-Picayune* reported: "Two-thirds of the immigrants who reached this place are in indigent, destitute circumstances, liable to contract the fever soon after arrival." J. C. Pendergast, the Ireland-born editor of *The Daily Orleanian*, described the Irish arriving then as "a different race of the Irish ten, 15, or 20 years since." It is estimated that a little more than 2 percent, or about forty-seven thousand, of the close to two million Irish passengers who traveled out of Britain between 1845 and 1855 died en route; the vast majority survived. But the tragedies that did occur—typically, when typhoid attacked a ship—were horrifying and widely reported, taken up by Irish nationalists in subsequent years, creating a term, *coffin ship*, that distorted the actual experience of crossing. O'Sullivan was eleven years old in March 1851 when the *Blanche*, one of the unfortunate disease-ridden ships, docked in New Orleans. "The passengers, of whom, it is stated (we believe with truth) there were five hundred on board leaving Liverpool, were huddled together like hogs in a spaceless and contracted pen—absolutely crowded atop of each other; filthy, foul, and feverish," Pendergast wrote.

In the same years the Irish were arriving, Cherokee and Choctaw citizens were settling in the territory that would become Oklahoma, and those who made the trip from the East were likely to be famished and dazed, recovering from the thousand-mile march at bayonet point to places the U.S. government had no right to send them—Kiowa territory, for instance. This contrasted with President Martin Van Buren's report to Congress in 1838 that the removal had been peaceful. "The measures authorized by Congress at its last session have had the happiest effects . . . ," Van Buren said, "and they have emigrated without any apparent reluctance."

people are subdued," a Cherokee writer said, "until there is no wonder that they suffer and die—these facts even thus succinctly stated, we believe will be of interest to our readers." The *Advocate* was published weekly, in Cherokee and English, from 1806 to 1907, when, on the ratification of Oklahoma statehood, Cherokee property was sold off. It resumed publication in 1975 as the *Cherokee Phoenix*.

One of the first histories that suggested an alternative to the official story came in 1897 from James Mooney, an ethnologist who wrote a history of the removals—"as gleaned by the author from the lips of actors in the tragedy," Mooney said. After interviewing survivors, he recounted the way the army raided a Cherokee settlement to begin the relocation, first building small stockades, or pens, in which they interned families. "From these," Mooney reported, "squads of troops were sent out to search with rifle and bayonet every small cabin hidden away in the coves or by the sides of mountain streams, to seize and bring in as prisoners all the occupants, however or wherever they might be found." Families were startled during meals, driven at gunpoint to the pens, the population concentrated in the camps, where they awaited the march west. "Men were seized in their fields or going along the road, women were taken from their wheels and children from their play," he wrote. "In many cases, on turning for one last look as they crossed the ridge, they saw their homes in flames, fired by the lawless rabble that followed on the heels of the soldiers to loot and pillage."

When James Mooney wrote his history of the removals, he was working for the Smithsonian's Bureau of American Ethnology, investigating various Indigenous communities to assist the United States in solving what was then widely referred to as "the Indian problem." In explaining Mooney's interest in the atrocities committed by the United States, his biographers note that his parents had emigrated from Ireland, and partly as a result, he thought of himself as an outsider, "conscious of separation from the mainstream of American culture." Biographers also noted that Mooney's father died when he was young, and Mooney's mother, who made her living as a housekeeper, raised her son as "an ardent Catholic," with, one writer noted, "memories of alien British rule." His daughter would note that he no longer practiced Catholicism as an adult (though he retained a priestlike prudishness in his translations of Native American songs, excising anything he deemed overly sensual). She contended that his interest in defending Indigenous nations was a matter of principle more than culture or nationalism. "He was respectful toward what deserves respect in all people, and wanted justice and truth to prevail," she said. "Since those who receive the most injustice are the minorities and the poor, his efforts for justice were mostly on their side."

Language was one of his primary efforts, beginning with what he considered his own language; he studied Irish folklore in the United States at a time when 50 percent of Irish immigrants were from Irish-speaking regions of Ireland. In 1907 he was a founder of Cumann na nGaedheal, or the Gaelic Society, in Washington, D.C., and he drew comparisons between Irish and Native American traditions—between, for example, the *caoineadh*, or "keen," the poem sung at traditional Irish death ceremonies and the death songs sung by Native Americans. "The *caoine* itself strikingly resembles the Indian death song," he wrote. (One of the ways the English defined Irish savagery was in depicting Irish death rituals.) The central question of Mooney's writing and research was, according to Pádraig Ó Siadhail, a contemporary Irish-language scholar, "How do oppressed people transmit the binding elements of their culture from one generation to the next? How do those who are defeated or dispersed nonetheless preserve identity and tradition?"

The United States banned the use of Mooney's work in 1918, after he used his government position to help sponsor the charter for the Native American Church of Oklahoma, agitating to allow Native people the use of peyote as part of their religious rituals. From then on, he was forbidden by the U.S. government to visit reservations.

A representative of one oppressed nation to another

When I picture O'Sullivan making his stereographic photos of the Navajo—preparing his plate, posing the men and women or asking them to pose, or maybe not asking anything—I see his head disappear beneath the dark fabric that blocks daylight as he ponders the upside-down view in his lens. I think of the light reflecting off the Navajo land touching an eye maybe born in the light of a place O'Sullivan himself might have at times called Éireann, and I wonder if he registered any parallels—between what might have been his own family's displacement, or the displacement of other Irish families, and the displacement of the families he was picturing. I see that the majority of Irish Americans in the United States did not line up to agitate for Native rights, nor did many other groups, and when they did, as in the case of the Quakers or New England reformers, their support was often tainted by their

views on ethnic and religious superiority. The point of Friends boarding schools was to destroy Native language and culture—to "break up the tribal mass," as Teddy Roosevelt put it.

I do know that even long after the time O'Sullivan made his photos of life among the Navajo, the Irish in Ireland would have been reminded of the parallels between their struggles for sovereignty and those of Native Americans. In 1923, after fighting for its independence from England, the newly born Irish nation went to Geneva to join the League of Nations, also newly established. It was the year that the United States arrested the entire government of the Taos Pueblo over a religious ceremonial dance, while, on the border with Canada, the United States, in concert with the Canadian government, continued to fight the Haudenosaunee, or the six-nation Iroquois Confederacy, over their long-standing territorial claims. In Geneva, the league accepted Ireland as a member while rejecting the Haudenosaunee, despite tribal leaders presenting treaties signed by the British government and the Dutch hundreds of years earlier, receipts of their existence as sovereign entities, as people united by history and culture. Also in evidence was the participation of the soldiers from the Six Nations in the war against Germany and its allies—forty men reportedly died—and, more generally, the use of the Iroquois Confederacy as a model for the league, as it had been a model for the authors of the U.S. Constitution. "We helped to make possible the League of Nations, and did our full share by your side in the great war," Levi General, a Cayuga hereditary chief, said at the time.

Levi General, also known as Deskaheh, spoke the languages of the Six Nations as well as English. In 1923, when the Canadian government acted to unseat the hereditary chiefs of the confederacy, Deskaheh learned French and was elected to represent his nation in Paris and Geneva at League of Nations meetings. In 1923 he traveled on a Haudenosaunee passport first to London, to protest Canadian Indian policies, then continued on to Paris and Geneva, where, denied a meeting, the Haudenosaunee representative rented out Salle Centrale, an old Swiss theater, and packed the house. "Now we mean to look to the League of Nations for the protection we so much need, to prevent complete destruction of our government and the obliteration of the Iroquois race which would soon follow," he told the crowd. English-language reporters covered him condescendingly. "Unadorned with feathers, beads or moccasins,

and wearing a sack suit and slouch hat, the big chief, although without tomahawk or war paint, is just as earnestly on the war path as his ancestors who fought the British red coats and French regulars in the American forests," the Associated Press wrote. And though the Haudenosaunee were eventually denied League of Nations membership, Ireland supported them, as did Panama, Persia, and Estonia, though the rest were dissuaded by British and American delegates, again working in concert. The year before, when Deskaheh went to Washington, D.C., to negotiate with the Dutch, Canada's Royal Canadian Mounted Police invaded his village, built their own barracks, prohibited Indigenous villages from cutting wood for fuel, beat numerous residents, and ransacked Deskaheh's home. He returned to North America in 1925, exhausted, and lived in exile from his home and family in the Tuscarora Nation, near Niagara Falls, dying a few months later.

Four years before Deskaheh spoke to sold-out crowds in Geneva, Manhattan-born Éamon de Valera, the newly elected prime minister of the Irish Free State, escaped a British jail and toured the United States to raise money and build support for his own sovereign nation. He failed to win the backing of Woodrow Wilson, owing to Wilson's support for the British, but when he visited the Lac Courte Oreilles Band of Lake Superior Chippewa Indians, in northern Wisconsin, he gave a speech and, like Deskaheh, was enthusiastically received once his comments were translated into Chippewa. "I speak to you in Gaelic because I want to show you that though I am white I am not of the English race," de Valera said. "We, like you, are a people who have suffered, and I feel for you with a sympathy that comes only from one who can understand as we Irishmen can . . . I call upon you, the truest of all Americans, to help us win our struggle for freedom."

"I wish I were able to give you the prettiest blossom of the fairest flower on earth," Joe Kingfisher, a tribal leader, reportedly told de Valera, "for you come to us as a representative of one oppressed nation to another."

The last time the historic Choctaw and Cherokee support for the Irish surfaced in the press was at the outset of the coronavirus pandemic, in May 2020, though in the American press it was recounted not so much in relation to the ways in which North American land was incorporated into the United States through land clearance and attempts to erase the

languages that existed in these places, but as a feel-good human-interest story, another of the disconcerting features that seemed to distract from the ways that access to resources are wildly different for different demographic groups in the United States. In the spring of 2020 the Navajo Nation reported the highest number of Covid cases per capita in the world, even more than densely populated New York City. The Irish began sending donations to the Navajo, to a fund organized by Navajo women. Irish citizens sent in two and a half million dollars in a month, to buy food, water, and cleaning supplies. "Irish Return an Old Favor, Helping Native Americans Battling the Virus," said *The New York Times*. The gift was put in terms of debt. "The Irish are repaying the generosity they received two centuries earlier from Native Americans," *The Washington Post* reported.

The U.S. papers noted that both nations had endured land clearances, but a dispatch by Naomi O'Leary, an Irish reporter for *The Irish Times*, alluded most directly to the history of violence that pollutes Navajo land, where the effects of Cold War uranium mining linger. In 2019 a study of 781 Navajo women showed that a quarter of them had concentrations of uranium that exceeded levels found in the highest 5 percent of the U.S. population that had any contamination at all—and that many newborns had equally high concentrations. "A third of homes do not have running water," O'Leary wrote, "and the legacy of U.S. uranium mining in the territory to build its nuclear arsenal has left groundwater contaminated, making basic hygiene difficult." O'Leary reported that the Navajo and Hopi, whose nations were approximately as big as Ireland, had only 13 grocery stores and 170 hospital beds for a population of 170,000. She also noted that Cassandra Begay, one of the Navajo women organizing the donations, broke into tears when she learned of the Irish donations at the outset of the 2020 pandemic. "We're going to make sure that money is used to get food and essential supplies and water to our elders and our families," Begay told O'Leary. "It definitely makes a difference, and we will always remember."

PART VIII

LOST

As O'Sullivan's work in the West ends, we wind down our own survey of his photography by examining two photos that look at the ways different surveyors ended up getting lost, the first surveyor being Timothy O'Sullivan, the second being the resurveyor—i.e., me.

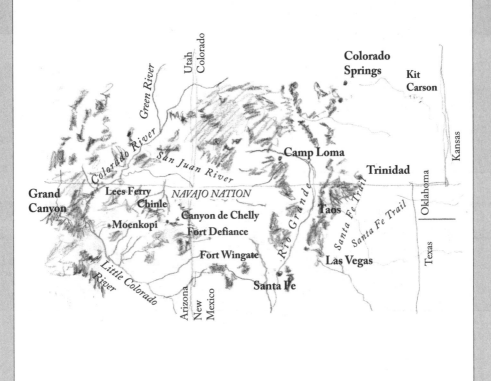

14

Ancient Ruins, Cañon de Chelle, N.M., 1873

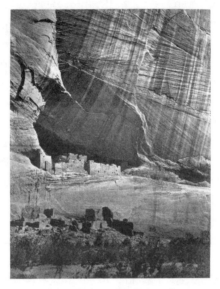

(New York Public Library)

O'Sullivan wasn't lost when he made this picture, but he was about to be lost in a way that, judging from the journal of the painter who traveled with him, made him more distressed than usual, or at least more distressed than anyone who traveled with him in the West had ever seen. When he made this picture, he was in Canyon de Chelly, a twenty-mile trip to the northwest of Fort Defiance, where he had photographed so many Navajo men, women, and children. He had just arrived with the painter, as well as a pared-down survey team: one topographer, a few packers, and the naturalist who called himself a naturalist but, it turned out, had less interest in flora and fauna and more in profitable deposits of ore that could be turned into mining claims for Lieutenant Wheeler, at this time working elsewhere in the Colorado Plateau. On

this trip, Wheeler had appointed O'Sullivan "executive in charge." It was a risk to allow a civilian photographer to command a survey team, but Wheeler was recklessly intent on surveying the greatest possible amount of territory, and judging from his personal investments in printing the photographs, he was increasingly impressed by the photographer's work. Despite the rush, O'Sullivan and his little team spent four days in Canyon de Chelly, which says a lot about how they were experiencing the place.

While the artist sketched, O'Sullivan made several plates and stereographic cards, the photograph at the start of this chapter being perhaps the best-known of the pictures he made in the West. Titled *Ancient Ruins, Cañon de Chelle, N.M.*, it was prominently displayed at the Museum of Modern Art's first photography exhibition, in 1937, and admired greatly by MoMA's then curator, Beaumont Newhall, who had learned of it from Ansel Adams. Over the years, I have seen prints of it on view in numerous museums, where, in the descriptions that accompany it, it is typically divorced from its military provenance, ties to resource extraction, and general whitewashing of Native American culture. On the first survey of the canyon, in 1849, the army, not surprisingly, saw it in terms of its strategy of conquest. "The mystery of Cañon de Chelly is now, in all probability, solved," wrote Lieutenant James Simpson.

> The cañon is, indeed, a wonderful exhibition of nature, and will always command the admiration of its votaries, as it will the attention of geologists. But the hitherto-entertained notion that it contained a high insulated plateau fort near its mouth, to which the Navahos resorted in time of danger, is exploded.

In 1858, three companies of mounted rifles, two companies of infantry, and what the army referred to as Mexican spies, or guides, entered with trepidation: "No command should ever again enter it." When Captain Albert Pfeiffer crossed through under Kit Carson's command in 1864, Pfeiffer, who had fought the Apache and the Navajo for years, wrote that Carson "accomplished an undertaking never before successful in war time."

With the Navajo having returned to the area, O'Sullivan's photos of the canyon are in line with Wheeler's larger goals: to consolidate control. Wheeler hypothesized the existence of an older civilization ("ancient

ruins of the best type"), as if the current civilization weren't there. This plate is one of several made at the time that are often at the center of the critical and academic debate over whether the photographer was a mere government camera operator or an artist—whether his work for the King and Wheeler surveys has artistic value on its own or acquired artistic value just because it was displayed in museums. Studying it, you see that O'Sullivan appears to have composed a straightforward representational view of an ancient dwelling site in the side of a cliff, a textbook image that would end up in textbooks a century or so later. This time, as he composed the plate, the striations in the cliffs themselves seem to do the job of the scientist's ruler, sectioning off the canyon wall like graph paper: gridded, it becomes part of U.S. territory, ready to be consumed, like a mapped-out suburban subdivision or a North Dakota county.

As you continue to stare into it, you find that in the almost impossible to see center left, two of the survey members stand on the ruins, each assuming the pose of an explorer or a conqueror. They are ostensibly there for scale—the canyon is huge—but what's striking is that they are not depicted at the usual scale of conquerors. The cliffs are swallowing them, and they are standing on the edge of a precipice themselves, the sheer canyon wall; behind them is an opening, a strange portal into the darkness that may or may not lead somewhere. It is possible that one of the men standing in the ruins was the painter, who had arrived a few days earlier, as recounted by the historian Doris Dawdy.

"On August 30, 1873, a frail, bearded passenger stepped from a buckboard at Fort Wingate, New Mexico," Dawdy wrote. "The man was Alexander Wyant, a prominent New York artist who had traveled west in search of adventure, new subjects for his brush, and improvement of his health."

A storm darkened the whole sky

It was common to bring painters along on government surveys for documentary and promotional reasons; sketches made in the field would be worked into more finished paintings at home, or so went the plan, and the resulting exhibitions would promote the survey's work, something Wheeler was above all keen to do. Clarence King's survey had brought along Albert Bierstadt, and Ferdinand V. Hayden traveled with Thomas

Moran, who painted Yellowstone. At the time Wyant arrived in the Southwest, he was thirty-seven years old, an up-and-coming and apparently self-taught landscape painter. "Wyant's early training in painting, if any, remains a mystery," wrote one art historian. The son of an itinerant farmer and carpenter, Wyant had begun as a sign painter in Ohio and, at twenty-three, traveled to New York to meet George Inness, the preeminent landscape painter of the day. Inness offered him introductions and helped him start his career, and by 1869, Wyant was a member of the National Academy of Design. "When he joined the Wheeler expedition in 1873, Wyant was a landscape painter with few peers," according to Doris Dawdy. "He was not, however, well off financially, nor was he in good health."

Wyant kept a journal of his trip to Canyon de Chelly that fall, and it serves today as one of the very few close descriptions of the operations of a western military survey. Dawdy transcribed it in 1980 and, as she worked out his hurried scrawl, came to believe that Wyant himself might not have wanted to look back on the trip, given how it ended. "The notebook itself is slightly curled from having been carried in a hip or vest pocket," she said. "The pages are discolored only on the outer edges, indicating that it has seldom been opened since Wyant made his notes over a century ago."

When read today, the journal feels immediate, as if you are jumping in alongside the painter as he departs for the West. He eats dinner in New York City, takes a ferry to New Jersey, and very soon is on a train through the low, green Appalachians, then across the Mississippi and into the Great Plains, and then at last across the western mountains, arriving at the Colorado Plateau, that elevated, mountain-dotted pool table that runs up the Great Basin's valleys and ranges and the rough muscles of the Sierras beyond. On the way to Trinidad, New Mexico, the artist describes the view, which is breathtaking, which, as it happens, I can confirm, having been through there once years ago: "When we were within 25 or 27 ms [miles] of T. the panorama was much more beautiful than any I have yet seen in my life."

At Trinidad, Wyant changes to a stagecoach. "Now we have a splendid six horse team," he wrote, "a splendid big driver who inspires you with a feeling that things are going according to the original plan . . ." This is Wyant at his happiest, and he will write with similar enthusiasm about his arrival at the Canyon de Chelly. Now, on a break, he and his fellow passengers climb a mesa, looking west toward the Sangre de

Cristo Mountains and east toward grasslands and plains. As I read his account, I remember the feeling I had on my own first trips from the East to the West, that of a trespasser, I guess, or at least someone who grew up east of the Mississippi: every new vista was like a revelation, a secret finally being told. "When once we were up here it seemed like another world," Wyant wrote. "All the plain below looked like the sea."

Wyant stayed for a few days at Fort Wingate, near what is today's Gallup, New Mexico. A military base established in the 1860s to control the Navajo, the fort would, eighty years later, store chemicals for the Manhattan Project: in 2007, Wingate High School students mapped the extensive radioactive contamination remaining in their community's soil a quarter century after tailings spilled from a uranium mill's disposal pond. At the time Wyant arrived at Fort Wingate, however, the fort was being used as a base by the army as they targeted Apache communities to the south. Wyant watched Navajo women working a loom and noticed a small unit of Navajo policemen being disbanded— "mainly because they don't want to go off from their reservation to fight Indians," he wrote. In this case, by "Indians," he meant Apache.

From Fort Wingate, Wyant set out by mule with O'Sullivan's unit, but not yet with O'Sullivan, who had gone ahead. Wyant is likely with the packers and soldiers and probably George Keasby, a miner masquerading as a naturalist for Wheeler's secret mining expedition, though again I feel certain that O'Sullivan knows what's going on. Also in the group: a cook, a man described as a Mexican packer, and a Navajo guide whom Wyant refers to mostly as Jo. (Wyant also spells his name as Icho or Sho, struggling with phonetics.) A wagon carried the small team's supplies. If Wyant relished the trip by stagecoach, he was more skeptical of the conditions on an army expedition, commencing his record of the trip with a snide remark: "After eight days of delay, I left for Fort Defiance with a part of O'Sullivan's party, that part which was least fitted by their habits for civilized society."

It was a rough start: a moonlight ride to a place he called Stinking Springs, only nine miles out. On the way, Wyant's overcoat and sketching bag fell out of the wagon. The survey team stopped and sent a man back to find the items, and when they returned with the coat and the bag, Wyant's drawing board and whiskey bottle had been crushed. Then a mule got sick, and the weather changed for the worse.

"A storm darkened the whole sky," Wyant wrote, "& a little farther on we found plenty of wood & made a fire before the rain fell upon us. We cooked ate & slept in a pouring rain. In the morning we breakfasted in the rain, then while some looked for the poor mule who was to lead us out of our trouble[,] the balance tried to get the balance of the team to start the wagon. They'd lost their chief & would n't budge the load."

Trouble

After Wyant met O'Sullivan the next day, he had little to say in his journal about the photographer who would technically be his commander for the next weeks, or at least nothing to say that was worth recording in his journal. Did he consider O'Sullivan a colleague in the pursuit of views, artistic or otherwise, or just as someone who would lead him to profitable sketches of the western views that New York markets desired? Either way, O'Sullivan is once again peripheral and out of focus as they leave Fort Defiance and immediately proceed toward Canyon de Chelly, entering the many-fingered canyon from its eastern opening. As Wyant noted their progress, he became increasingly interested in the landscape—mesas, arroyos, a mile-wide valley. By September 18 they arrived at Canyon de Chelly. Then, on the twenty-second, Wyant wrote in his journal: "Have been here four days & a half—Sketched & photographed three days, & in the morning we leave for some of the pueblos farther down the cañon."

It appears to have been a fruitful stay, evidenced by the absence of diary entries. Canyon de Chelly is spectacular at any time of year, especially if you arrive there from the south. As you cross the forested plateau, it seems to open up before you all of a sudden, like an aperture in the earth, a place where what's belowground seems to be on the surface, or in between. In the fall, when O'Sullivan and Wheeler arrived, the effect is heightened as the long shadows emphasize the deep canyon and all the expressive striations in the walls, as well as the little shelves and ledges where long ago shelters were built. Especially at dusk, when they are most visible, they are not so much stone ruins as pasts made tangible in rocks that are a million shades of red, in stone towers that tune in to the invisible harmonics of the vibrant darkening sky.

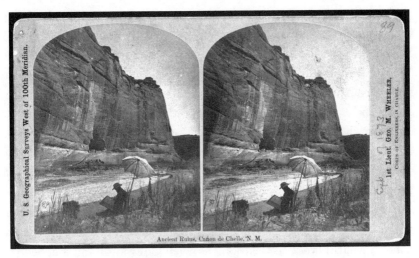

Ancient Ruins, Cañon de Chelle, N.M., 1873

At some point before they left the canyon, members of O'Sullivan's survey team climbed up into the White House Ruins, situated in the crease of the fifty-story cliffs. It is possible that this climb was the photographer's idea, since the men could serve as points of reference, as evidenced by the resulting plates; if you know how badly things are going to go for the surveyors over the next few weeks, this climb is unnerving. The ruins are today thought to have been constructed and occupied between 1060 AD and 1275 AD by ancient Puebloan people who are often referred to as Anasazi, a Navajo word meaning "ancient ones." Today the short hike to the White House Ruins is one of the few hikes that are allowed without a permit and a Navajo guide, though photographs of hogans in the area are restricted. The canyon itself is one of the most visited national monuments in the United States and is managed in cooperation with the Navajo Nation. Of course the 1873 survey was a territorial incursion, or even an act of military surveillance, and when I read about it from my vantage point here in the twenty-first century, things begin to feel even more disturbing. First, Wyant notices that their climb made Jo, the Navajo guide, uncomfortable, though they ignore the man's concerns. Wyant belittles him in his diary, and at this moment I'd like to point out once more that in 1873 not every white person in American is belittling Indians, even though a lot of them are.

"A fishing line was cast around a pole put there by the navajos, & thus a rope was drawn up by which O'Sullivan, Keasbey & Conway ascended to the abode of the witch—a navajo character," Wyant wrote. "They have a ladder by which their witch ascends but we did not hunt for it for fear of getting our guide into trouble. They say that one white man went up there once & died, when or how they didn't state."

Later that same day the surveyors ran into what Wyant describes as more trouble with the guide, whose advice the surveyors once again do not heed and whom Wyant again scoffs at in his diary. The incident happened as Conway, the packer, gathered firewood.

"While carrying it towards camp he picked up a piece of a human skull," Wyant explained, "whereupon Jo our indian guide said that the bone cursed the wood at the moment when Conway's hand touched the sacred fragment, & that if supper was cooked with it he—Jo—would have to get his supper with some of his indian friends."

Conway appears to have cooked the dinner. Wyant does not note Jo's reaction. Shortly thereafter, the party left the canyon. "The train is being packed & soon we will be off again," Wyant noted.

Their orders were to travel nearly three hundred miles north, to a camp at Loma in southwestern Colorado, or Ute territory. They would leave the Canyon de Chelly at its western entrance and head out into what was not completely uncharted terrain (in U.S. military terms), but semi-charted. It would require significant navigational dexterity to cross the San Juan River that separated them from the destination in their orders. By this point the team had water from springs, and they could get extra food from the nearby Navajo farmers. As they left the canyon, they came to the settlement at Chinle, a place-name that refers to the water flowing out of the canyon. "There's a great dance at Chinelia this week," Wyant wrote. Because it was fall, because one season was shifting into the next, the Navajo were celebrating their harvests. Again Wyant refers to Navajo citizens disparagingly: "There are but few Indians at the post now. It is their feast time. The time of roasting ears, melons, & peaches, & in that time it is not easy to get an Indian to do much but eat."

"The whole atmosphere is full of navajos," he said.

The crossing

The trip to Loma was expected to take ten days. Very quickly, they crossed Black Mesa, so called for the seams of coal that run through the area—it has been mined over the centuries and still is to this day, contaminating the local aquifer. Wyant continued to make notes and sketches, but he also complained more about Indians, though the tone of his account changed as their search for the correct route went on and as their search for water got more difficult. Proceeding toward Lees Ferry on the Colorado River, Wyant noticed the San Francisco Peaks on the horizon, *Dook 'o'oosliid* in Diné. On the same day, he came across a pile of rocks that he described as Hopi pillars, not knowing (or caring, apparently) that circles or spirals of stones marked places of significance to the Hopi. On October 1 the survey party suddenly loaded their weapons— "in consideration of the numbers of fresh moccasin track on that side." When they came to Moenkopi, a Hopi village, they ate melon and drank fresh water and calmed down. "The tracks were made by these Moquis who are very friendly," Wyant wrote.

When they arrived at the Colorado River, Wyant sketched the scene at Lees Ferry, home of Emma Batchelder Lee, one of John Lee's nineteen wives. Emma was running the ferry while her husband was away; at that moment her husband was being hunted by the U.S. Army for his role in the Mountain Meadow Massacre, an attack against a wagon train traveling from the East to California, orchestrated by members of the Nauvoo Legion, the militia founded by Joseph Smith, the Mormon leader, and reconvened by Brigham Young in his attempt to create Utah as a state run by the Mormon church. From September 7 through September 11, 1857, white vigilantes commanded by Lee slaughtered everyone in a wagon train full of families moving from Arkansas to California. Lee dressed himself and his militia members as Native warriors, intending to blame the atrocity on Paiute fighters. The settlers had gotten caught in the war between federal troops and Brigham Young's forces, a war that ended with President Buchanan pardoning all the Utah Mormons, except for the Nauvoo Legion, of all charges of treason and sedition. John Lee would be executed in southern Utah a year after Wyant's journal entry.

As they pressed on, Wyant continued to sketch, but O'Sullivan made

fewer and fewer plates, consumed, I have to think, by the worrisome job of leading an increasingly lost expedition.

Then their wagon broke down.

O'Sullivan quickly made the decision to cast off a large amount of supplies. In his appearances in Wyant's journal, he seems to have once again managed some sort of working relationship with nearly everyone on the march. "After watering the animals," Wyant writes, speaking again of Jo, the Navajo guide, "the navajo went to make himself a pair of drawers out of a cotton flour sack—O'Sullivan the same day gave him an old pair of pants which were a great delight to him, & which being dark echo his black hair in a way to make a picture of him—while I lay down in the sunshine to get the frost of last night taken out of me with my head in the shadow of a sagebrush. I suppose I went to sleep at once."

Though O'Sullivan was still pressing forward, he appeared to be in over his head; or perhaps Louis Nell, the topographer who was theoretically familiar with the maps, was to blame. Searching for a place to cross the San Juan River began to take on a tinge of hopelessness, and today, if you have even driven in the area where they were lost, you can imagine how hard it would be to find a way through the gorgeous infinity of the tableland if you didn't know the place. A 1917 geologic report described the entire Navajo reservation this way: "Satisfactory maps are lacking, roads are few, and trails are poorly marked, water is scanty and generally poor, and food for animals is scarce." Repeatedly O'Sullivan and Nell broke off from the party, climbing hills and looking for a way. By October 23, Wyant was exasperated. "This is the 10th day and we were to do it in four," he wrote. He was also increasingly sarcastic: "There are no disgusted persons about our camp. O—no!"

For the next three weeks, as they wandered Navajo land in Northern Arizona, Wyant complained—about his distrust of the Navajo guide, about being kept up all night by loud talking, by swearing, by wood being split to feed the fire. He fussed about being wakened to herd mules, about getting lost while herding them, about jumping half-frozen into his blankets by the fire. He moaned about waking up in the middle of the night because his feet were so cold, then waking up again because the packers were shouting for the cooks to help them find the mules, a big pot of beans left behind, boiling. "The jaws swag, the

kettles rattle," Wyant wrote, "& in an hour more you are invited to get out of bed & come to breakfast."

By October 26, Wyant's tone is desperate: "We dont know just where the crossing is, & we are on half rations, & soon we'll have none."

The packers raced off to find small springs and fill their canteens. The next day, O'Sullivan and Keasby went off one last time to find a place to cross the San Juan, and failed. It was around this time that Jo, their guide, left them, for what reason we don't know. Wyant despises Jo for this, though he seems to have not liked him much anyway, and he makes fun of O'Sullivan, who seems to trust Jo and whom Jo leaves holding the reins to his mule. When O'Sullivan returns to the lost party this time, he makes the decision to head back to Fort Defiance, via Chinle. This was against Wheeler's orders, but by that point in late October it was often raining or hailing, and suddenly it got very cold. The mules, with so little water, began to suffer, a very bad sign. There was hail and cold winds, and then snow began to appear.

Now Wyant became frustrated and worried. "I've saddled my 'Jim' & turned him out to take another mouthful of grass before attacking the road," he says. "I think by tomorrow we will have completed a circle instead of gaining our objective point."

But then, around October 31, everyone in the party began to recognize the features of Canyon de Chelly. I can only imagine how beautiful and welcoming the red rocks of the canyon might have been in the long shadows of the autumn day. As Wyant mounted his mule that day, his mood had changed, certain now that they were circling back. All of a sudden, seeing Navajo people pleased the artist. "We are surrounded by navajos whom we've seen before & our mules are filling themselves with navajo corn fodder . . ."

Double my wants

They arrived at Fort Defiance on November 4, exhausted and hungry. They spent the next three days recuperating, and at first, things seemed to be going well for Wyant. Governor Arney, the commander of the fort, hosted a dinner for him, O'Sullivan, and Keasby, the naturalist—Wyant referred to himself and the other two as "the three distinguished." They

ate roast beef, mashed potatoes, squash, green corn, biscuits, and mince pie and drank coffee.

"Once more we had plenty to eat," Wyant said.

The painter noticed that O'Sullivan had made tintype portraits of the governor's family, little gifts, as was O'Sullivan's wont. Do I see kindness there, or were these little bribes, the camera operator hoping for good treatment? The next day, they started out for Fort Wingate, where Wyant would depart for the trip back east. Their guide, Jo, re-appeared at the fort, a development Wyant took almost as an insult, which just makes me wonder if Wyant didn't have something to do with Jo taking off in the first place. The painter is overheated in his journal: "The most profoundly impudent act that has come upon my notice in life was that of our guide presenting himself in our camp here this A.M. as though nothing had happened—& that after telling some Indians in Chinalea that we had gone to hell. He is tied up at present. Just what O'Sullivan will do with the poor devil I don't know."

A very short while later, Jo managed to get free, and O'Sullivan and Keasby chased him for a while, then gave up.

"Jo was running for the higher stake, & won," Wyant concluded. "Goodbye Jo."

The following day, Wyant arrived at Fort Wingate. He was considering leaving for the East, but the commander gave him a room, and his new surroundings seemed to change his mind. After sleeping on the cold earth, simple pleasures had become luxuries, as did an offer from someone, either Wheeler or a patron, to paint, though to paint what or whom he does not say. "Have a comfortable fire, a nice bed—a bath—invitations to breakfast, luncheon & dinner indefinitely & an offer of money to the amount of double my wants."

While there, he noted a book on the fort commander's table, *History of the Intellectual Development of Europe*, by John William Draper, a scientist and philosopher who was born in England and, after emigrating to the United States, helped found New York University. As a photographer, Draper is credited with taking the first daguerreotype of the moon and the first daguerreotype of a female face, that of his sister. He was also one of the most widely read historians in America and Europe at the time, and the author of one of the very first histories of the Civil War. In 1867, Draper argued that the United States, by

then reunited by force, would take over Rome's role as the world's imperial power—unless, he cautioned, Americans mixed with lesser races. He predicted that Black Americans would very soon leave the United States: "In America the negro is an exotic: throughout a large portion of the continent he is not in harmony with the climate," he wrote.

"Thrown on his own resources, having to take care of himself," Draper went on, "it remains to be seen whether he will live as long as he did when his master took care of him."

In his last journal entry for that day, Wyant, his interest piqued, wrote a note to remind himself to read Draper. Then he went to sleep—up to that point apparently experiencing nothing unusual at all.

Between

"It happened between day and night," Wyant wrote.

That is the last line scribbled in his diary, written apparently after daybreak, and what happened was this: he had suffered what some accounts describe as a stroke, others as severe paralysis, and later as a brain disease—an attack that would today be characterized as neurological in nature. It was sudden and severe, so severe that Lieutenant Wheeler, O'Sullivan's commander, panicked and tried to hide what happened, fearing it would reflect badly on his survey. O'Sullivan was technically a civilian, and Wheeler had put a civilian in command of a military unit that had gotten lost and come close to starving. And it appeared as if Wheeler's survey had nearly killed a famous landscape painter after losing two guides in the previous survey seasons and killing several other people.

Wyant was incapacitated, immobile, and in pain, and Wheeler wanted him gone. To make this happen, he ordered the painter to be shipped out by train, like a package being returned. He was to be sent to his mother's home in Defiance, Ohio, named for the fort built during the Northwest Indian War by General "Mad" Anthony Wayne, though Wyant insisted that he be sent back to New York City. When he got to the city, his right hand and arm were paralyzed. For those and other reasons, it was impossible for the painter to paint.

When I think about that last line in Wyant's diary—"It happened between day and night"—I see it as a statement of fact that winds up

sounding more like a metaphor. Wyant had gone into Canyon de Chelly at the end of that summer as a cocky young painter, up and coming, the canyon his to make famous, whatever that meant. He disparaged the people whose experiences in the place were most extensive, to say the least, and then ended up getting lost. Wyant did not seem to know that it was Halloween on the day he reentered Canyon de Chelly; All Souls Day was a Roman Catholic Church holiday, well-known in communities that had been under Spanish and Mexican rule but also popularized throughout the United States by immigrants from Ireland in the 1800s. In Ireland, before the famine, it would have been celebrated widely as Samhain, the time in the Celtic calendar when the division between worlds was thinnest, the membrane most porous. But the painter would likely have noticed that fall was quickly turning to winter. The way I see it, when he came off the high ground at Chinle and reentered the river-carved canyon, he was, unbeknownst to himself, between the life he had lived in before Canyon de Chelly and a new life that he was stumbling into, paralyzed, with dead or angry nerves, robbed of his painterly skills. After Canyon de Chelly, he was broken, and to fix himself, he had to start over, which would require learning how to paint again and would end up offering him new ways of seeing the world.

15

Ruins in Ancient Pueblo of San Juan, Colorado, 1874

In his last season in the field, O'Sullivan spent a few hours photograph-
ing a series of ruins in northern New Mexico. The two-acre site sits on
a rise along the San Juan River, the same river he had been searching
for the previous season, when he'd been desperately lost eighty miles or
so to the west. The three stories of rooms and chambers are the crum-
bling remains of one of close to two hundred Chacoan towns that were
scattered throughout the San Juan River basin in what is today the Four
Corners region of the Colorado Plateau. In the 1200s, as many as thirty
thousand people lived in an area that an extensive archaeological report
in 2018 described as being the size of Ireland. In this photo, of what
O'Sullivan (or Wheeler) misidentifies as Pueblo ruins, we see a piece of
what once spread across two acres—a three-story, three-hundred-room

great house and storerooms for grain and water, holding enough for the four hundred people who lived at the site in the 1200s, who disappeared for no one in 1874 knew precisely what reason and for reasons that are still not certain now. An outbreak of disease? A strain on local resources in a particularly dry climate, perhaps even a flood, given the proximity to a river that, as a thirty-year drought lessened in 1299, might have suddenly overflowed its banks?

To make his photograph, O'Sullivan posed a packer in the ruins; I have seen this man alternatively described as Apache and Mexican, and the confusion points in part to the slippery definitions of citizenship in the Southwest and borderlands and to the capricious inexactness of borders and boundaries and definitions. Standing in the upper-right corner of the photo, the packer gives the picture a sense of scale, just as the length of the shadows offers a sense of time. O'Sullivan's presence is marked by his long shadow, made by a low-in-the-sky sun. It's a photograph of a past that is broken and crumbling but still tangible, and of a present that's not all there and fading as the sun sets, ruins and shadows and shapes haunting the wide-open field.

In terms of a viewer's experience, especially the experience of a late-nineteenth-century American viewer eager to consume vistas of the West, stereographs work best with an object in the foreground, something to entice the viewer's eye, and when done well, they are like miniature adventure movies, a reason why they were so popular in the 1870s, when families collected them to view at home and college students sold them door-to-door. In this plate, the foreground is there, yet it is also illusive, and as you move your eye across the ground, you are like a surveyor yourself, getting a three-dimensional sense of the work entailed in surveying, the drudgery of setting up a hundred pounds of equipment yet again, the trick of finding the angle that does the job. But then at last, the quiet, or even silence, converges when a scene feels right, as if you are tuned in, sensing the site's frequencies. You pause for a few seconds as the plate and the photographer are silently exposed.

Work is mostly what I see when I look at this picture, and I think of what it's like when you work on assignment: you are often out of the picture, though never completely so even if you want to be, even if that's part of your assignment. In the context of a photographer making pho-

tographs of the West for a living, this stereograph of ruins works like a receipt or an invoice: O'Sullivan managed to show himself working while simultaneously describing the work of the U.S. military as it cast a growing shadow over the West, transforming the territory of scores of different communities into one American-owned space. As for his own presence: he's there and not, in the world but also disconnected from it, a specter whose outline is shaped by the land itself.

At least one person making notes on the back of a print of the photo in the Library of Congress couldn't quite determine the subject of the picture, asking a question in lieu of giving it a title: scribbled in cursive on the back of the card are the words "Indian ruins?"

Which is a fair question. Does the stereocard depict Indian ruins, or the end of a day in the last year of eight long years of work? Is it a picture of a survivor not just of seven years west of the Rockies, but of thirteen years of war, starting with battles in Virginia and attacks in the Carolinas and time spent in what looked like ruins but were in fact artillery-proof mounds at Fort Sedgwick at the Siege of Petersburg, a place known colloquially as Fort Hell? Does it tell us something about what a place says to us, or what it means for a landscape to be in the scope of a soldier, whether of a camera or a gun? From a description of O'Sullivan's early pictures by the Smithsonian American Art Museum:

"His photographs of Forts Fisher and Sedgwick suggest the dismal psychological as well as physical effect of continual barrages of distant cannon fire on the soldiers behind the barricades."

From the standpoint of work and money, things were bad all over the United States at that moment, and they had begun to get very bad the previous year. In September 1873, at about the time when O'Sullivan was getting lost with Alexander Wyant a few days north of Canyon de Chelly, the Panic of 1873, as it became known, began. It was a five-year downturn so deep that it had the nation, on the eve of its hundredth birthday, wondering whether it could continue as a nation. Railroad executives started the crash, their corporations overinvested after endless expansion before, but increasingly after, the Civil War, and the banks and financiers that funded them followed them down. Jay Cooke had become famous as the businessman who bankrolled the Union army through the public sale of government bonds, but when the Northern Pacific Railroad crashed, he did too. (Cooke was destitute until he convinced the Mormon church and other backers to invest in the Horn Silver Mine in Ogden, Utah, an area that Clarence King had surveyed in 1869 and detailed in his survey reports.)

Wall Street was a "mad terror," and fortunes in New York and Philadelphia were swept away in hours as the conflagration raced through the continent, taking down banks in Chicago and then farther west. The president of the Bank of California committed suicide. The crisis quickly crossed the Atlantic, and, at home, businesses began to fail en masse. When U. S. Grant signed the Coinage Act of 1873, making only gold legal tender and thus demonetizing silver, those who suffered most were miners, farmers, and working-class people with debts—the Coinage Act became known as the Crime of 1873. Between three million and five million Americans were unemployed by 1875, and the wages that still existed were halved.

O'Sullivan, by 1874, would have worried about what was coming, and when he arrived home in the East that year, a headline on the front page of a Washington, D.C.–area paper set the tone. "Hard Times," it read. Accompanying it was a report on the area's desperate predicament: "It is stated that the pawnbrokers are doing four times the amount of business they were doing four months ago, and owing to the scarcity of money, are giving less than a third of the value of the articles presented."

A note on the artist

By the time O'Sullivan was photographing the Chacoan ruins along the San Juan River, Alexander Wyant was living in New York City again. He had moved into a YMCA on Twenty-Third Street, managing to survive when most New Yorkers were struggling to do so in a city where one-fourth of the labor force was jobless, charities were overrun, and police stations suddenly became shelters for as many as fourteen thousand people a week, the dank, body-covered basement floors swarming with rats, as Jacob Riis noted. The paralyzed painter convinced another artist to help him learn to paint again, though this time using his left hand. Joseph Eaton, a well-known portrait artist, instructed Wyant, who eventually managed to take on a few students himself, and as O'Sullivan photographed ruins along the San Juan River, Wyant slowly began showing his work again, early on in his recovery using a sketch he made in Ireland years earlier to make a painting called *View in County Kerry*.

You don't need a degree in psychology to imagine that the painter might have been depressed, especially given that neurologists today link depression to many neurological ailments associated with paralysis. "His illness made him introspective and taciturn," wrote his biographer, Eliot Candee Clark, in 1916. (Clark was himself a painter.) "We see him at his best in his pictures." Did the landscape painter's broken body change how he painted the world? Did it change how he saw and felt it? Or both? Before he went to Canyon de Chelly, his paintings were prized for their topographic accuracy. Afterward they were admired for their mood, as if he had switched from capturing how a landscape looked to how he experienced it. Eliot Clark described him as content to watch the sky, to make notes and sketches one day and paint them the next. "Apart from occasional drives he seldom ventured far from his immediate vicinity," Clark wrote. "This, however, seemed entirely satisfying." The painter also continued, Clark reported, to suffer physically. "He suffered greatly from bodily pain," he added. "Physical exertion became more and more difficult. He was therefore incapacitated for the occupations and enjoyment of a normal life. This drew him more and more to his work. This was his great passion, his unceasing desire until the end."

In a note on the painter's later work, Charles H. Caffin, an art critic

prominent in Wyant's time, admired what he described as "the ineffable loveliness of quiet," and wondered if it was the painter's bodily afflictions that caused him to paint the dusk, over and over. In 1902, in his book *American Masters of Painting*, Caffin wrote, "Out of the cool cisterns of the night his spirit would drink repose."

Wyant died on November 29, 1892, at age fifty-six, and after his death, when his paintings were shown in exhibitions, curators put his works into two categories, those that were painted before he went to Canyon de Chelly in the Navajo territory and those that were painted after. Some of the before paintings are annotated "*painted with the right hand.*"

A note on the author

At the thought of all that Wyant had to do to reimagine his own work self, I can't help but mention that I was working on my O'Sullivan re-survey when I, too, lost the use of one hand and, as a result, couldn't type, much less write. In a strange and for me powerful coincidence, I had to figure out how to work again while navigating all the things associated with paralysis and general neurological havoc, dead and angry nerves, a body that wouldn't operate. This happened as I had begun researching O'Sullivan in earnest after plotting each of my visits to his various survey sites, including Canyon de Chelly, which—even before I knew about O'Sullivan getting miserably lost or about Alexander Wyant's paralysis—seemed to me to be an important place to visit, especially since I had previously spent so little time on Navajo land.

It happened shortly after I visited my first site, the Snake River waterfall that O'Sullivan photographed for Wheeler in 1874, during his last season. I had flown west from New York, driven for a long day, spent some time wandering around the falls, driven back to the airport, and flown home, after which I took care of some other assignments that kept me busy throughout the fall. Then one day I woke up in our apartment and my feet were suddenly numb. Over the next few hours my legs and hands were numb, and by the time I limped desperately into an emergency room a short time later, I was numb everywhere. Very soon, pain radiated through my chest, my arm clenching, my hand

squeezing itself into an unopenable ball. Just as Wyant had described his malady as an attack—"It happened between day and night"—so I felt as if I were being taken over, invaded by something moving through my arms and legs and torso, consuming me even, and that it too had begun between day and night. I also felt that whatever was happening was bad and getting worse: whole swaths of my body were deadening, as if I were tightening into a knot that would cinch so tightly as to disappear, my body pulling itself out of the world.

It was all terrifying, to say the least, and after a spinal tap and scans and the impossible, life-threatening logistics of insurance, I was at last hooked up to an IV in the neurology ward, where, over the course of the week, I was intravenously infused with steroids. Lesions, I would learn, were suddenly forming in the material that insulated my spinal cord, and the goal was to stop them from expanding, as soon as possible, lest the signals running from my brain through my nerves be cut off while managing the functions of the systems and components of my body. The diagnosis, a few days later, was a rare neurological condition, transverse myelitis, an illness I've since seen mentioned only on melodramatic TV medical mystery shows, one of which used this horrifying-to-me preview: "Coming up next! Just hours after incapacitating pain stopped this marathon runner dead in his tracks, a horrifying disease threatens to take over his entire body!"

In the hospital that first night, my wife did her best to comfort me, holding the hand that still worked, but when she left to take care of our daughter, I spent the night blowing into an instrument that monitored my ability to breathe, one of the abilities, I was informed, my suddenly appearing lesions could compromise. It was all terrifying, and as I type this sentence, I can only imagine how terrified Wyant might have been, a broken body in the ramshackle fort, O'Sullivan unable to guide him back this time, the army abandoning him. More than anything, I remember the wind outside the hospital that night, the clouds racing by the window on a high floor. I also remember that despite the warm room, I was freezing in my numb skin. I would feel this way for many months, as if wind were blowing through the walls and through the room and through me. The term "out of touch" took on a new meaning that was hard to explain at the time, but in long retrospect it makes me

think that I was more exposed to the physical world, more vulnerable to it, or at least more aware. Lying in the hospital bed that evening and looking up and out the window behind me, I continued to watch the clouds racing across the sky. I mention my cloud-memory again because it is one of those moments that is locked in, as if it is not just an image but a sense memory, a still-developing perception that combines the fluorescent light in the room, my strange skin, the smell of alcohol each time I was injected or infused or bled for tests—all these experiences fixed onto some plate in the part of my mind that is my body, ready to be recalled or remembered when I see a similar sky, when the wind blows in just such a way.

I remember not sleeping, both because the steroids revved me up and because I was terrified, concerned about losing the ability to breathe, or whatever else the increasing deadness would take away. (Also, the doctors had not yet figured out what I had.) I scratched out a note with one hand, saying some things to our kids; I didn't want to be on a breathing machine, and I was worried about how the night would end. Just as Wyant appeared not to look back at his notes from the night he collapsed on Navajo land, so I have not looked back at those particular pages since, though so many other pages that I wrote in the months that followed were, when I did look, garbled and desperate, long passages that made perfect sense then but now look like lines lost at sea, floating away from the shore. I remember more winds, this time with leaves racing through the sky like debris in a tide. I remember the dark sky over old brownstones, the nurses' kind touch, and the man in the next room who seemed to be in terrible pain, until his labored breathing went quiet. Somewhere between day and night, they wheeled him away.

In the morning the pain had begun to subside, the steroids kicking in. But I was numb everywhere, and my chest felt increasingly tight, as if I were wearing a corset or a too-tight wooden barrel, and my left hand no longer worked. The hand didn't seem to exist except as a lump on the side of my body attached to a likewise dead arm, though it all looked the same, just as the rest of me looked the same. At the end of a long week, just before being released, I was wheelchaired into occupational therapy for instructions on how to dress, eat, and count money with one hand, everything I would need, it seemed, to just barely keep myself going. I

could not do any of these simple things, even though, if you looked at me, you might have guessed I could. Something I came to better understand around this time is that it's not always apparent to other people the ways in which a person is broken.

I could walk, but not without great effort, and sometimes a leg or two would become useless out of the blue, but my wife and our son helped me make it home. Everywhere I went, I was unbearably cold; even indoors, I sat shivering, bundled in coats and clothes, due, I surmised, to the deadness of the skin on my torso, and I endured strange jolts of what felt like electricity running through my neck and spine, as if I were a frayed electrical cord poised to short out. I was told that if I happened to notice bad things starting up again, I should immediately report back to the emergency room, a prescription that, owing to my catastrophic nature, kept me on edge. If I was a loquacious person beforehand, I was suddenly sullen and sad. When I did speak, I was manic, though of course I see that only now. Mostly I felt beat up, like damaged goods, or land that had been bombarded, or, yes, ruins. Would I ever even work again? Doing anything was difficult, and everything was exhausting, the jolts sometimes knocking me to the ground. Over and over I paged through books of O'Sullivan's pictures, looking for things I hadn't seen, plotting a return that took a long time.

A few notes on perception

When I discovered that Alexander Wyant repainted landscapes after returning from Canyon de Chelly, making very different paintings after becoming paralyzed in one arm, it started me thinking that when a person loses a part of himself—when they can't be who they were, or who they thought they were, owing to loss or damage or some complication or another—they are forced into a new relationship with the places they inhabit, or maybe with the world. There is a tendency not just to see but to feel the world differently, a necessity to establish a new relationship. I think of a surveyor who can't get access to a viewpoint any longer, and struggles, or, in a positive way, a topographer who is forced to find a new way to see a place, to climb to another vantage, the new view adding to the bigger picture in ways the topographer might never have seen.

For me, losing the ability to touch things (to feel them, much less grasp them) was, in addition to various other complications, fiercely dispiriting, especially as I had no idea if I would ever get any touch or even movement back. As it happened, after a little under a year of therapy, my hand began to move again, though it never recovered all its feeling. Initially, this meant that I could do things when I could see the hand and the task it was undertaking, but not when I couldn't see it. Finding things in a pocket is, to this day, still a complicated maneuver, often fruitless, as is buttoning a shirt without a mirror, given that my hand feels numb or frozen or gloved or, when I am down, dead. It's the difference between a hand that is me and a hand that I work with but is disconnected, the latter making me more like a machine operator, my hand the less animate machine. (It is particularly problematic when holding hot drinks, which requires more dexterity than a person with full touch perhaps recognizes and is the reason I spilled coffee, as re-counted in chapter 3, while I was surveying near Lee Vining on the east side of the Sierras.) But the loss of touch also filled me with amazement over the way connections work when they do, and indeed, it was on this amazement that I did my best to focus: all the ways that connections al-low us not only to zip a jacket or turn the page of a book but to sense one another and find our way through the world in ways that we not only take for granted but also cannot see—at least not with our eyes.

The fury with which I experienced these things, and with which they worried me—especially the electric shock–like jolts through a torso that was also generally deadened, the skin cold and numb—filled me with a desire to tell people about them, though in the cases when I did, the in-tensity with which I described them was off-putting, to put it mildly. My manic nature at this time meant that my wife had to watch me when I was with other people, otherwise I might get frustrated, then angry, like a wet plate photographer falling through icy snow and swearing at his mules or his fellow surveyors. And I felt a similar need to *not* tell people I worked for, lest I never be hired again, judged incompetent—or as hav-ing somehow, my worst fear, lost touch.

In the additional survey I found myself taking up—to investigate the literature surrounding paralysis, an investigation that, not surpris-ingly in retrospect, would send me toward stories of soldiers wounded in wars—I came across Jean Lhermitte, the pioneering neurologist for

whom my strange, shocklike spinal sensations were named.* He was born in 1877 at what would be the site of World War I's first and second Battle of the Marne, the second marking a turn in the war for French and American troops, seeing the death of nearly one hundred thousand soldiers, twice as many as were killed at Gettysburg. After medical school in Paris, Lhermitte, as a doctor in the field for the French army during World War I, specialized in the relatively new field of neurology. After the war, as a neurologist and psychiatrist, he studied the relationship between neurology and behavior and, in later years, mysticism. He is remembered today for his work on hallucinations, describing, for example, phantom limb pains experienced by amputees from the First and then the Second World War. In 1916, Lhermitte and his colleague Gustave Roussy published a book, *Les Psychonévroses de guerre*, that described what was then known in French as *l'hystérie de guerre* and in English soon referred to as "shell shock," a term no longer used by physicians but related to what is today described as the condition of persistent mental and emotional stress occurring as a result of injury or severe psychological shock, referred to as post-traumatic stress disorder. In surveying Lhermitte's work and its influences, what most interested me were the ways in which one of his most influential theories was taken up not just by neurologists but by artists and philosophers and eventually revolutionaries, each of whom explored the way soldiers or civilians, families, and even communities repair themselves through connections—with each other, with communities at large.

That theory is proprioception, the idea that the body sees itself, that it uses all its senses in a coordinated manner to locate itself in the world. It was hugely influential for Maurice Merleau-Ponty, who became fa-

* In reading about Lhermitte, I was, first, pleased to know that I was not being electrocuted, even if I felt like I was, and then surprised to learn that I knew a painting by his grandfather. I had seen it when I'd gone to find Wyant's paintings in storage at the Metropolitan Museum of Art, in New York. Léon-Augustin Lhermitte was a French landscape painter beloved by Van Gogh for the very way he captured the visceral sensation of things. "Tell Seurat," Van Gogh wrote to his brother, in the translation I read, "that in my eyes [Jean-François] Millet and Lhermitte are true artists, just because they don't paint things as they are—dead analysis, experience at second-hand—but as they themselves really do experience them . . ." "Dead analysis" and "second-hand"—as a then one-handed person who most days felt like a block of dead flesh, I took comfort in Van Gogh's words for the way they described what I was feeling, or not feeling, a disconnect.

mous for his interpretation of proprioception—or famous for a French mid-century philosopher, most of whom were not terribly famous in America, with the exception of Merleau-Ponty's friends Jean-Paul Sartre and Simone de Beauvoir. Merleau-Ponty described proprioception as our bodily interaction with the world, the very source of all knowledge and understanding. This contrasted with the source that other European philosophers called consciousness. I see it as the difference between understanding that your body's GPS is your brain or your mind and understanding that the GPS is your body itself. "One is not simply a body," Judith Butler writes in her work on Merleau-Ponty, "but, in some very key sense, one does one's body . . ." And given that Merleau-Ponty described proprioception as an unconscious act, when he wrote about it, the act of describing it was, for him, akin to revealing a brand-new landscape, one that, in terms of modern European philosophy, we had no idea we were living in, even though our bodies knew all along.

The world we see with our eyes seems to be everything, he said at the opening of a radio lecture he delivered in France in 1948. "Yet this is a delusion."

"In these lectures," he went on, "I hope to show that the world of perception is, to a great extent, unknown territory . . ."

When he was fifty-three, Merleau-Ponty died of a heart attack while at his desk reading Descartes. But throughout his life he worked to illuminate the ways that the world is in constant communication with us, and vice versa. He saw the world not in terms of borders and dates, but in terms of spaces and lived-in places and the ways that all our different bodies mapped these places. He wrote of memories not as things we create in our consciousness, but as the way our body looks back to touch the people and places we have moved with and through, places and things we have touched, that have touched us. Merleau-Ponty explored these ideas by writing about art. He concentrated on the paintings of Cézanne, who was once quoted as saying, "The landscape thinks itself in me and I am its consciousness." When I went back to look again at O'Sullivan's photos of the ruins, the ruins seemed less like ruins and more and more alive, a past that was then still warm, like an ember, or is today still resonating like the walls of a concert hall, the conductor's baton raised in the air.

*Characteristic ruin, of the Pueblo San Juan, New Mexico, on the north bank of the
San Juan River, about 15 miles west of the mouth of the Cañon Largo,* 1874

Notes on fighter jets, healing, and human relations

As I near the close of my survey, I have two last coincidences to relate,
both concerning Fort Defiance and Canyon de Chelly and the landscape
of the Navajo Nation generally, a landscape I was intent on visiting but
couldn't, given that travel had become complicated—many days, over-
come with exhaustion or frustration, or combinations of the two, I
couldn't gather the wherewithal to leave the house. In more ways than
one, such a state of affairs made for a kind of personal Panic of 1873, but
since I could not go to the Canyon de Chelly, I went to the library and
read all I could about the place, once again studying it from afar, and
though I read some things that struck me as insightful, it was a mostly
unsatisfying endeavor, in part because the bulk of what is in libraries
is written by people who are not Diné. I read the 1976 administrative
history of Canyon de Chelly National Monument, as written by the
monument's administrators, for instance, which reads like a history of
your life in your home as written by your landlord. Everything happens
out of frame: Diné leaders attempting to take control of their land, the
parks department and the Bureau of Indian Affairs resisting, working
to encourage tourists; the theft of relics from ruins sites, sometimes by
outsiders, but once, in 1903, by a U.S. government custodian who sold

them to a renowned curator: "Charles Day may not have been the best possible choice for this position. By early fall of the same year it was reported that he and his father, Samuel Day, had collected a large amount of 'plunder' from the cliff dwellings, which the elder Day sold to Stewart Culin of the Brooklyn Museum."

In 1945 the monument's custodian at the time (and the first to speak Diné) describes Navajo men returning from the war, greeted with ceremonies. I had to wonder if these were healing ceremonies, having listened to a recording of the Night Chant, called *Yébichai*, which lasts for nine days and nights and involves dance, sandpainting, and pollen blessings. In 1907, Washington Matthews, the Dublin-born army surgeon who John Wesley Powell assigned to Fort Wingate, made a translation of *Yébichai*. A long chant, Matthew's translation opens like this: "House made of dawn. House made of evening light. House made of dark cloud. House made of male rain. House made of dark mist. House made of female rain. House made of pollen. House made of grasshoppers. Dark cloud is at the door." The first section ends like this: "Happily may I walk. Happily, with abundant dark clouds, may I walk. Happily, with abundant showers, may I walk. Happily, with abundant plants, may I walk. Happily, on a trail of pollen, may I walk. Happily may I walk."

In the same year that the parks department published its administrative history, N. Scott Momaday, a Kiowa poet, published a poem that reads to me like a remembrance of his childhood near Chinle, the town where O'Sullivan left the canyon to get lost. It's called "To a Child Running with Outstretched Arms in Canyon de Chelly," and it speaks of a small child, smaller in the expanse of the canyon, where he is "embodied in delight" in the light and shadow that seemed to captivate O'Sullivan and Wyant, at least in making photographs and sketches: "The sand drifts break and roll / Through cleavages of light / And shadow."

Beginning in the 1960s and continuing into the 1970s, when Momaday wrote this poem, the U.S. Air Force began flying supersonic jets over the Canyon de Chelly. The sound waves from the jets' sonic booms destroyed sacred sites, causing rockslides that occasionally cut off access to trails in and out of the canyon. "I've even seen them move our front glass doors," a park ranger was quoted as saying in 1967. "Sometimes when they're really intense, they'll open a door." In the fall of 1966, twenty-six sonic booms were reported, one destroying a cliff in the part

of Canyon de Chelly called Canyon Del Muerto, where numerous remains are known to be buried. The Interior Department asked the Defense Department to stop the fighter jets from flying over the canyon and blasting it with sound, but the booms increased, to the extent that in 1967 the interior secretary wrote, "This is a growing problem, and one that carries with it the alarming threat of destruction or defacement of some of this nation's priceless natural and archeological heritage, as well as exposing thousands of visitors to possible injury." No mention was made of the Navajo families living there.

Guy Yazzie Teller, one of the Navajo farmers living in Canyon de Chelly at the time, watched as the jets caused repeated landslides around his home; he testified that he debated leaving his farm for safety reasons, a move that would have, in turn, put his family's financial health at risk. "Mr. Teller is a non-English speaking Navajo who believes in the old ways and he is now quite worried," a ranger wrote. "Thus, even in this 'remote' country, possible sonic boom damage affects not only physical features but human relations."

Five years and hundreds of booms later, the air force regulations changed to prohibit supersonic travel in the vicinity, but the booms continued, if less frequently.

One last note on vibrations

Around the time I learned about the air force's canyon-destroying booms, I was reading the work of Maureen Trudelle Schwarz, a cultural anthropologist who had studied Navajo cosmology as an outsider, like me, and had written about a completely different kind of vibration. In her attempt to translate some of what she learned, she wrote that, for the Diné, everything in the world is constructed of the same fundamental elements, all of which are vibrating and alive. In turn, all creation resonates with the world's vibrations. Vibrations are movements that are either easily perceptible, like wind, or less so, like the movements made by sound. Sound, in the Navajo spiritual and ecological cosmology, is akin to a fifth element, and each element has a sound. In the Diné worldview, everything in the world possesses the capacity for movement and for hearing, for feeling and for seeing. The world, in other words, is sentient. Schwarz quotes a Diné teacher, referring to the substance of all

things: "They speak, they hear, they listen, they understand." Another Navajo man told her, "So they believe that that vibration has to be there within the human body. You have to have that in order to keep your body, body, to be vibrant, in order to react to all the other elements."

Reading and thinking and wondering from far away, I mostly came to understand that I would be hard-pressed to know what to say about Canyon de Chelly, that I had no connection to it, no matter how much I mapped it out and surveyed it from afar. This was about a year and a half after I was first laid up. About then I got a call for a job near my home on the East Coast, at a campus in the Appalachian Mountains, a beautiful place to recover, I guess you could say. I took it, even though I was desperate to visit the canyon and this job would put me about twenty-five hundred miles away. I am glad I did, because when I showed up, it just so happened that a lot of people from the Navajo Nation were on hand, and I returned to that place for several years, each time meeting a few of the same Diné people, as well as a few more.

At various gatherings, Navajo students introduced themselves with reference to the clans of their matriarch and to the locations where their clans were from. One year, I met some teenagers who were organizing to protect the water on Diné land that was threatened by coal and uranium mining. Over and over I heard people address each other, as well as the people who came to hear them, in the language the United States had worked so hard to kill: *Yá'át'ééh!* Once, I was having some difficulty walking, making my way carefully down a hill with a Diné poet who seemed to be having trouble walking too—I learned that he had been bitten by a poisonous spider. When I think of that day now, I remember that it felt good to walk with someone who felt appreciative of even complicated mobility.

In my first year there, I met a high school teacher from Fort Defiance, where, in 1874, O'Sullivan and Alexander Wyant and his team had stumbled in, very hungry and cold and tired after becoming desperately lost in Canyon de Chelly. At the time, I was still recovering from my neurological attack in ways that were invisible, or that I thought were. My jaw must have hit the ground when I heard where she was from. Yet when I think of it, what I most remember about our conversations has less to do with Canyon de Chelly or Fort Defiance than with the clouds and various atmospheric wonderments we saw in the Appala-

chian Mountains around us, the mountains that, it began to occur to me that summer, were the geographic spine of the Civil War, and still a front in a war that, it was also slowly dawning on me, continued.

That idea—that our bodies were in conversation with places; that we communicate somehow with the places where we live and work; that those communications can feel returned, as if mountains are talking and remembering, storing ideas, like a chip or hard drive; and that those ideas might inspire contemplation, about ourselves or even our communities and how we are living in a place—had been introduced to me years earlier on a long walk in New York City, of all places, with a philosopher from Ireland. He referred me, at the time, to a book about the Apache language, *Wisdom Sits in Places*, written by Keith Basso, who worked with the White Mountain Apache community over the course of several decades to study the Apache language. "Hence," Basso writes in the study of that community's use of language with regards to landscape, "as numerous writers have noticed, places possess a marked capacity for triggering acts of self-reflection, inspiring thoughts about who one presently is, or memories of who one used to be, or musings on who one might become."

Spider Rock

It took me seven years to get to Canyon de Chelly. When I finally arrived, I was with my wife, and the canyon had just reopened to the public after the pandemic had closed it in 2020. We drove from California, where I had been working on a reporting assignment that ended the day before, and we were on our way back east. That trip had felt like a return to traveling great distances in the West, the way my wife and I used to when we first met and then moved to Oregon from New York. For me, it felt like a return to old ways, though the light was all new, and I was excited as we entered the canyon through Chinle, seeing farmers and trucks and a bunch of high school cross-country runners, running fast, talking, laughing. Apart from the road markers, we saw no physiographic sign of a canyon, no distant walls or rock towers. At that point it felt more like the Great Plains than the Colorado Plateau, and, looking back, the canyon was revealed to us like a mysterious answer.

It was a gorgeous early-fall afternoon. The visitor center was closed,

and there were no tours down to the White House Ruins, where O'Sullivan had photographed, but we were happy to drive the loop road and walk to the overlooks, moving between stands of juniper, noticing the tiny yellow lichen on the red rocks, looking down into valleys that seemed to contain their own atmosphere: the erosion that sculpted the walls made each canyon within the canyon like its own world, hidden below the regular one. The light from the setting sun seemed to be changing the rocks, or changing our view of the rocks, like a slowly turning kaleidoscope that kept adding new perspectives. At the lookout for Spider Rock, we saw the seven-hundred-foot sandstone spire cast a shadow, as if it were the center of a sundial, and as the shadow extended farther down into the sheer, red-walled canyon, the red walls became redder, as did the setting sun that was slowly replaced by an enormous full moon, making the night like day. I felt a sense of relief, even if I was still disappointed by how long it took me to arrive. Consolation came as I began to realize that my timing was accidentally perfect. I had arrived at the same time of day, the same time of year that O'Sullivan had, and I was leaving, also like him, a little less lost than before.

PART IX

RETURN TO THE FALLS

In which we examine O'Sullivan's return to the Snake River Falls in southern Idaho, a site seemingly of great importance to him, given that he visits twice, once at the beginning of his western tour, then again at the very end, making what are thought to be his last photographs in the West or anywhere.

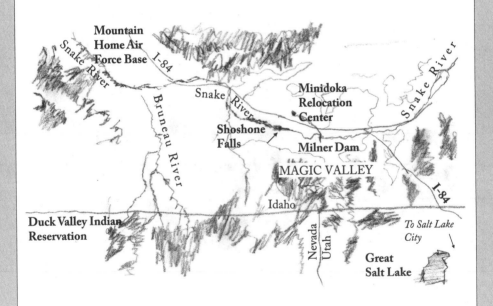

16

Shoshone Falls, Snake River, Idaho, 1874

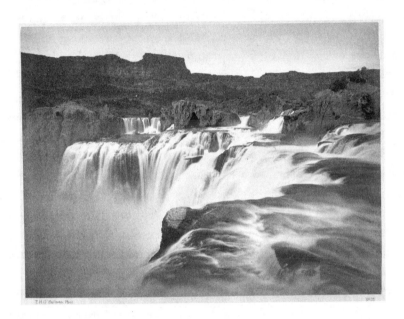

The very last place O'Sullivan set up his tripod in the western United States (or the very last place anybody knows of) was the only place he photographed twice: Shoshone Falls, a huge cataract on the Snake River in what was then the Idaho Territory. On each occasion he made several large plates and numerous stereocards—in 1868, with Clarence King during that first long season in the West, and then again in his last season in the field with George Wheeler. In 1874 he traveled there on behalf of Wheeler, only weeks after photographing himself in the ruins along the San Juan River. Both times he visited the falls, he was outside the territory that each survey had been assigned. It seems likely that Clarence King led him there the first time, though it is just as possible that King had learned of the falls from O'Sullivan, as a site prized by

photographers. It had already acquired a reputation as the Niagara of
the West. Each time O'Sullivan landed at the place, he made a frenzy
of plates.

By train and mule, and even today by car, the falls are a little less
than two hundred miles north of the Great Salt Lake, just beyond the
hills that separate the Great Basin from the Columbia–Snake River
drainage system. Approaching the falls from the south, O'Sullivan was
entering another drainage basin or, as I think of it, another world of
water, or straddling two. The headwaters of the Snake are in the hills
around Yellowstone Park and the Grand Tetons in Wyoming, and when
the Snake meets the Columbia, it joins with water from the Bitterroot
Range and the Columbia Mountains in Canada, a watershed as big as
Afghanistan. The water in the Pacific-bound Snake contrasts with the
Great Basin, where water, as we have noted, is retained in terminal lakes,
dependent on snow to refill them, an increasingly desperate proposition
today given the increasing demand for water in cities and in agriculture,
given the price attached to it by commercial markets. After marching
through the dry Colorado Plateau, after spending years photographing
great sandy alkali stretches and the windswept forests of the Wasatch
Range, you would be mesmerized by the tremendous rush of the Snake
River. I certainly was on my first visit, though to a lesser extent than
O'Sullivan must have been: since he visited, half a dozen dams are up-
river from Shoshone Falls. Still, when it isn't being drained or diverted,
the melting snow from the region's mountains races through a volcanic
chute in the high desert: the violent rage of a western river when free,
or almost, can be an energizing comfort, a consolation in its furious
surround-sound current.

In 1868, Clarence King cheated his way out of the terms of his Great
Basin congressional survey assignment by citing how important the
falls were to the railroad, and it was true that Jay Gould was building
his Northern Pacific into Idaho from Utah, though in the months af-
ter O'Sullivan arrived, the financial panic would send Gould and his
railroad line into bankruptcy. How O'Sullivan ended up there a sec-
ond time is not clear. Wheeler would have known about the falls, but
O'Sullivan had experience there, and he might have made the case that
the falls were the dramatic end to the story of Wheeler's great west-
ern exploration, the hydrologic exclamation point, highlighting not the

secret mining expedition or the army charting territory, but the story of an adventure through a land of marvels, dry landscapes being transformed into federal property. Already the War Department and E. & H. T. Anthony had published stereocards from the first seasons of the Wheeler survey. Using the falls as a bookend would have appealed to the-vainglorious commander, who, judging from his reports, followed along himself—as the photographer produced more plates, Wheeler became more enamored with his work, buying up supplies on his own to print what the army wouldn't budget for. O'Sullivan would have remembered the spray, the white water that a long exposure would make even more white, freezing a moment in time and extending it in the crashing blur.

In the early twenty-first century we speak of photographs capturing things, even if that's not exactly what they do, but I suspect that the Shoshone Falls captured O'Sullivan the first time he saw them, and when he left to roam the West for six years, the falls were with him like a picture he couldn't scrape off the plate in his mind. And when he returned to the falls, he was not the same camera operator. The world had changed, and, change being a given, it doesn't feel like speculation to say he had changed with it, as the army he had spent his life photographing was redeployed to battle Indian uprisings; as the Confederate states were poised to retake ground they had seemed to lose to the federal power, though this time with the North's quiet consent; as the country was plunged into a deep economic depression, workers taking to the streets. Suddenly all the images he had ever put on a plate or printed must have seemed like a double exposure, or a print on a print— the past and the future, the East and the West, both now superimposed.

Almost impossible

I too visited the falls twice, the second visit not originally planned. I planned the first trip at the very outset of my survey and started out from Portland, Oregon, only seven hundred miles downstream from Shoshone Falls (a short travel distance by west-of-the-Rockies standards) and familiar territory for me. Portland is where my wife's parents live, and where my wife and our children lived for a decade, where I was based when I worked throughout the West in the 1990s. On that first visit to the falls, in 2012, I left Portland just before dawn and drove

along the Columbia River, entering the Columbia Gorge as the sun did. The gorge and Shoshone Falls share the same geologic heritage: when an ice dam broke on a giant prehistoric glacial lake, an unimaginable rush of water carved a path through the soft basalt, canyons created in a matter of hours, like something out of the Bible—a contemporary theory that, in 1868, would have pleased the cataclysmic Clarence King and today reminds us that quick changes in the geosphere might be in our future. As I drove east, away from the rain-drenched, coast-facing slopes of the Cascades, forests of Douglas firs were replaced by the dry corduroy hills that lead to the high desert of the Snake River Basin in eastern Oregon and the alkaline foothills in southern Idaho.

Driving, for me, is like time travel, and as I continued along the Columbia, I could see a history being written by the power lines radiating outward from the Bonneville Dam and then the Dalles Dam and off into the hazy distance, the lines themselves extending and increasing with the growth of settlements, which had now become home to huge data centers, or server farms. The servers in their quasi-military compounds were mostly new since a decade earlier—unmarked and guarded by tall black security fences—as was the profusion of cryptocurrency miners. Servers, and the new miners using them, are, like the miners of old, attracted by the underlying geology: the height from which the source of the Columbia descends—twenty-seven hundred feet up in the mountains of British Columbia—means that it, like the Snake River that joins with it in Washington, excels as a turbine turner. The first federal dams not only irrigated farms but powered the aluminum plants that produced one-third of all the aluminum in U.S. aircraft during World War II, though, when I moved there, in the 1990s, overseas trade deals were closing the Columbia River's aluminum plants down. In the 1940s, as the war proceeded, the river itself was eventually engineered into a weapons maker, making munitions more powerful than any seen before—the Grand Coulee and Bonneville dams powering the plutonium production needed to build the first atomic bomb and the one dropped on the citizens of Hiroshima. "Without Grand Coulee and Bonneville dams, it would have been almost impossible to win this war," President Harry Truman said.

As I drove, I recalled an automobile trip in 1992, when I traveled the length of the Columbia from its source to its delta, on assignment, at one

point descending into the bowels of the Grand Coulee Dam, a fifty-story-high, mile-long band of river-spanning concrete. I remember the roar in the turbine room reverberating through my chest, a hint at the force in a twelve-hundred-mile torrent. The trip left me in awe of the system of dams that generate power and drain water from the river system, though twenty years later, as I headed to Shoshone Falls for the first time, I saw a river managed as a chain of lakes, salmon suffering and the river with it. When the salmon are all gone, we will have traded the life of a region for, first, winning a war, then powering our microwaves. I would point out that the dams on the Columbia-Snake system are operated by the same branch of the U.S. military that O'Sullivan photographed for under King and Wheeler, the Army Corps of Engineers.

With proper oversight and use

Nearing the halfway point to Shoshone Falls, I entered a wide-open, mountainless landscape of irrigated fields and sagebrush, and then suddenly, between the interstate and the Columbia, I passed a field filled with a thousand and one lumps of earth that resembled ancient tombs. The army calls them igloos, each about twenty-five feet wide, seventy feet long, and a few feet high, covering twenty thousand acres that appear almost ceremonial. I didn't know that they had held chemical weapons for dozens of years. Starting in the 1960s, the Umatilla Army Depot stored nerve agents and mustard gas, the latter in bombs and rockets, mines and aerial spray tanks. Conventional weapons were stored there too, shipped to Vietnam in the 1960s and '70s and to the Middle East during the Gulf War in 1991. Two years after I drove by, the weapons were incinerated, the depot was turned into a toxic cleanup site, and the igloos were left in place, home to rare plants and birds. During that time, the Confederated Tribes of the Umatilla Indian Reservation were buying back their territory in the area. Around 1855, each of the sovereign nations that make up the confederation—the Cayuse, Walla Walla, and Umatilla—heard the United States vow to protect their land, a treaty promising 500,000 acres, then watched them give that away, nearly 220,000 acres allotted to non-Native people, 30,000 more put up for sale—the end result being a checkerboard reservation. "We now have a chance to restore our land base," Chuck Sams wrote in 2014 in an editorial in *High Country News*.

Sams was, at the time, the publisher of the *Confederated Umatilla Journal*, in Pendleton, Oregon, and an enrolled member of the Confederated Tribes of the Umatilla Indian Reservation. His great-great-great-grandfather, Peo Peo Mox Mox, was a signer of that treaty as the leader of the Walla Walla people. In 2022, Sams was appointed director of the National Park Service. "With proper oversight and use," Sams wrote back then, "we will begin to make ourselves whole again."

At Umatilla, I left the wide steel-gray Columbia and followed the interstate southeast, the Blue Mountains on my right, the Wallowa Mountains framed in the window on my driver's side. The Wallowas were famously home to Chief Joseph and his band of the Nez Perce, until 1877, three years after O'Sullivan's last picture of the falls, when Chief Joseph stopped outmaneuvering the U.S. Army and the Wallowas were opened exclusively to white settlement. Since 1850 the Donation Land Claim Act had encouraged white settlement in Oregon's Native territory, another legislative stroke of white supremacy specifying that land be granted to "every white settler . . . American half breed Indians included." (A child born of a Native woman impregnated by a white man could own land.) Was it confusing during the army's war against Chief Joseph, his fighters, and the woman, children, and elders he moved with, for Americans to read in the papers that English-speaking Nez Perce fighters protected white children in harm's way during battle, taking them to safety even as their own families were at risk of being gunned down?

Everything I could see as I drove had been fought over, contested, surveyed, legislated, transformed from Native land to real estate or U.S. government property. I wasn't the first to see this, obviously, but now I was beginning to see the surveys' resonances in the irrigation circles of crops, in the overhead wires, in dam after dam built by the Army Corps—and back then I was beginning to feel it too. The West is a battlefield, as opposed to a place where settlers showed up, not that this is something the Confederated Tribes of the Umatilla Indian Reservation need to be reminded of. And if I once might have been dismissive of the West, thought of it as distant from the U.S. project, having grown up in the Northeast with its presumptions and arrogances—the white Indian rights activists who saw it as their mission to civilize the tribes; the abolitionists who advocated for abolition, then pushed the formerly enslaved

into resource-starved enclaves, or slums—now I saw the East as allied
with the South, as united in the post–Civil War rush to round up Na-
tive nations, then extract their resources. I was slowly understanding
that after Lee surrendered to Grant, the two sides moved west together,
with Timothy O'Sullivan documenting this reunion and realignment.
The army fought Native nations to give the land to railroads and min-
ing companies, and beginning in 1877, at the start of a rash of rail-
road strikes and then mining strikes, President Rutherford B. Hayes
redefined federal law. With the stroke of a president's pen, workers
were no longer protecting their property as workers, they were attack-
ing the government. Strikes were sedition, and the army, with the help
of the courts, became the strikebreaker. By 1895 a soldier studying at
Fort Leavenworth's Infantry and Cavalry School would write, "That
the army is on the side of the constituted authority and is in all things
merely a reflection of that power, which is essential to its existence, is an
assertion too apparent to be in need of demonstration."

By lunchtime, I was listening to the radio play songs about farms and
soldiers, booze and cars, and I passed Mountain Home Air Force Base,
home to the 366th Fighter Wing. Their mission: "Provide mission-ready
Gunfighters to conduct military operations anytime, anywhere." While
their F-15 jets had gone into battle all over the world, on occasion, when
the pilots fly drills out of the base, headed south into the Great Ba-
sin Paiute territory, the jets jam the satellite positioning equipment that
farmers use to guide their tractors and irrigate their otherwise dry fields.
Thus, on those occasions, the military is thwarting the farmers in their
battle to occupy Paiute and Shoshone land, rather than the other way
around.

The effort to resolve conflicts

That first time I saw Shoshone Falls, I had expected to feel the excite-
ment of a new survey, the beginning of an expedition, with the drama
that O'Sullivan pictured when Wheeler put boats in at Camp Apache,
when King entered the Sierra Nevada. Instead they made me terribly
sad. I did not know why, and though at the time I hoped it would pass,
I think of it now as a premonition

I parked and walked around the little park that's built alongside the

falls. I watched tourists take pictures and took some myself. The water was running low, or what looked very low, and that compounded my feelings. As I remember it, it seemed like a bad idea to start a western survey on a down note, a thought I laugh at now. I had set out in search of a revelation of some kind, when all I really saw was a river that was being drained, water diverted for irrigation or locked up in lakes behind the falls for power. It reminded me of a time when I went to see a fabled spring in some hills near New York City and found a tap with a spigot, the spigot shut and locked behind a fence. In this case, the trickle of the falls was the spigot for a river drainage the size of Kentucky.

I wandered around for a few hours, and then, just before driving back to Portland, read the historic marker, which was both recent and extensive but focused on the usual suspects. As it reads, the falls were a rumor until discovered—"No one knows who the first non-native person was to set eyes on them"—then named for the locals who were herded into a small patch of land. According to the marker, "Reservations were created for Idaho's Native American tribes as part of the effort to resolve conflicts." Chinese gold miners are mentioned, the hostility they encountered not so much. Prominently featured are farmers farming, rows of desert-grown potatoes in what will become the potato capital of the United States. Sun-drenched volcanic soils irrigated by the dammed Snake River will give birth to the capital of America's frozen french fry.

The frozen french fry owes its existence to the Desert Land Act, passed by the U.S. Congress on March 3, 1877, even though—to repeat what can't be repeated enough—the desert wasn't a desert at all. It was in fact land that the Shoshone and Bannock deemed home, and it became what is known today as the Magic Valley, a valley, it's true, but one that didn't appear magically. It involved an act of Congress, which, when Idaho was still a territory, gave away federal land to the Twin Falls Land and Water Company, which was backed by a banker from Salt Lake, a steel magnate from western Pennsylvania, and a farmer from Indiana. When the newly established Bureau of Reclamation built the Minidoka Dam in 1905, a city sprang up, as did that sea of potatoes, the crop that Mormon farmers had brought to the area while attempting to convert the Nez Perce.

The marker concludes: "Descendants of southern Idaho's first Native Americans continue to live in the region today, and have a strong

connection with their traditional homelands." Among the issues not mentioned: for about fifty years, Native people in Idaho were fighting the East Coast–based company that left twenty-two million tons of toxic waste on the Shoshone-Bannock Tribes Fort Hall Reservation. In 2021, after taking their case to the Supreme Court, the tribes won restitution.

Before I left the falls, I dutifully took out all my photocopies of O'Sullivan's plates and aligned myself with his box camera's vantage points. I climbed into his eye, or tried to. What I noticed immediately was the difference between the photos he made with King and those made for Wheeler on his second trip to Shoshone Falls. The undammed falls are majestic and massive when he makes his pictures for King, but whether through King's or O'Sullivan's doing, King and his men are kept in the frame, sometimes in the very center. Here, for instance, is King most likely, or one of his survey team, in a bowler hat, looking over the falls, pondering the abyss, or posed as if he is.

Shoshone Falls, Idaho, 1868

As O'Sullivan photographs, he appears to move toward the falls, making pictures that are closer and closer, but we are always given that

Shoshone Falls, Idaho, 1868

Shoshone Cañon and Falls, Idaho, 1874

sense of scale, using a human figure or a tree or anything, to act like a ruler, though the closer he gets, the more he loses his figures to the shadows, to the expansive mists.

Here again, in this view from the back of the falls, O'Sullivan inserts the team of scientists in the very center, though they are hard to see and easily mistaken for birds or insects, or maybe trees, as people and places are confused and combined.

O'Sullivan got closer and closer, or seemed to, though it would not be until he returned six years later that he moved almost into the falls themselves. He came back at the end of 1874, taking trains and trails up from Colorado, seven hundred miles from the Chacoan ruins. I wish I could have walked alongside him when he approached them that second time, to maybe understand the contrast between what he had carried in his memory and what he saw that autumn morning. The kind of pictures he made at the falls on this trip would be different, as if he were going deeper.

Swearing at snow

By the time I made my second trip to Shoshone Falls, eight years had passed. On my second trip I didn't bring any copies of O'Sullivan's Snake River pictures. All I wanted to do was take a photograph, for myself—to picture the falls, or try to. To do so, I brought along an old wooden box camera my wife had used years before. Also, I brought along my wife, or I should say we were traveling together, and in a deeper way, given all the complications I'd endured during eight years of speculating about the Irish American war photographer, she was still carrying me. Her box camera is a pinhole camera, meaning that there would be a little nineteenth-century photographic reenactment going on; rather than press a button or click a shutter, I would take the cap off the aperture and wait the appropriate number of seconds, a calculation that would hint at the wait O'Sullivan experienced as he exposed his glass plate. Likewise, we used Polaroid film of a severely out-of-date vintage designed for large-format cameras, so that we might experience the development of the image sort of as an 1870s landscape photographer did. I often thought about all the chemicals involved, especially on my second trip. Acids and sulfates and nitrates are harmful to a healthy

person, but given that O'Sullivan would very soon die from tuberculosis, I wondered if, as he stood staring into the falls, he could feel the rattle in his chest.

We arrived at the falls in the summer of 2020, having hurriedly driven from New York to Oregon. We drove across the country, something we have a lot of experience in doing, having crossed it dozens of times over the years. We slept a day and turned around. Much of the trip was spent trying to avoid the virus that was weeks away from killing more people than there were soldiers killed in the Civil War—that, in another year, would kill more than the number of American soldiers who died in the Civil War and World War II combined. Death was in the landscape, in other words, in a palpable and crushing way, virus breakouts reported on the radio everywhere we drove, hospitals full, as if there had been a war, and indeed if you mapped the advance of the virus, you could see it seizing on the history of divisions in the landscape as if they were battle lines. As Native American communities on reservations in the West suffered extraordinary losses during the pandemic, so in cities, where populations are divided along lines of race and class, mortality figures read like gory tallies in an undeclared but still-raging conflict. At the end of 2020, *Health and Human Rights Journal* reported that the mortality rate for African Americans was more than double that of whites. Meanwhile, forest fires had ravaged the Columbia Gorge, and the Northwest was suffering a heat wave that was melting highways and killing people, unprecedented disasters exacerbated by the fossil fuels burned to power the Industrial Revolution.

To return to the falls was, for me, like experiencing a stereo view that O'Sullivan's camera might have made, the same image twice, one almost imperceptibly different. At the site this time, the earlier visit was still ringing in my head—before I had been laid up and spent so long not just convalescing but rethinking how I experienced most everything, including landscapes. As we drove past the dams on the Columbia, past the Wallowas or the air base at Mountain Home, I didn't just sense the time that had passed, I was understanding the ways in which time itself was packaged as progress, as the improvement of the land, the magic making in the Magic Valley. What was real about time, or the time I thought I could feel, was what was in the catastrophic and gradually eroded panorama through which, as Ibn Sīnā had

written in the tenth century, we can see no vestige of a beginning, no prospect of an end.

That I felt like a different person perhaps goes without saying, and though I assume everyone would feel the same on returning to a place after an extended period, what I find startling on reflection is that I didn't feel sad the way I had the first time. Instead, I felt agitated, as if there was something more that I desperately needed to see. As I look back now, I am reminded again of that line the other surveyors used in describing O'Sullivan when he was working at a fever pitch, lugging equipment and sensitizing plates: "O'Sullivan is in his element swearing at snow," Gilbert wrote.

We had crossed the Snake River at the border of Oregon. Though the sky was clear, we could see dark clouds ahead. I became concerned; I had done a lot of waiting to return to the falls, and I didn't want torrential rain to prevent us from photographing the place. Just as we pulled off the highway into Twin Falls, the downpour started, though by the time we drove the few miles to the falls, it had blessedly turned to a drizzle. When we turned in to the little park, I could see that the water was higher and running faster than on my last visit, eight years before. Maybe the dams had been recently opened, or maybe there had been more rain. I did not know whether to credit the gods or the Army Corps of Engineers, but I quickly carried our camera to the viewpoint on the edge of the parking lot, in retrospect too quickly, and propped it on top of the railing overlooking the falls.

This time, as opposed to being sad and underwhelmed, I was impatient, and as I prepared to open the lens, I began to get flustered, as if on cue, to the point of inaction. I needed all my fingers to do the job, to make the appropriate photographic adjustments, and the deadened hand no longer had the necessary fine motor skills, a fact I had once again forgotten, as I often do. It is a symptom that even now tends to exasperate me no matter how familiar with it I am. For a long time I read this as a metaphor for my ability to get to the end of a book—that one of my hands is incapable of turning a page.

"Damnit," I said more than once. And then I swore some more.

At this point my wife intervened and repositioned the camera. Why she hadn't quit the survey after all the years, I can't say, but when I think back now, I see a lonely surveyor being slowly pulled back aboard a boat,

quietly rescued from a sand dune–like ocean. She talked to me patiently and slowed me down, which didn't seem to help, then finally made me thankful. She removed the lens cover, exposing the film to the falls. As the light touched the film, I counted off minutes and seconds and felt the rain on one of my hands and not on the other, and maybe I felt the rain more acutely on the hand I could still feel, or so goes my theory: that loss enables a person, makes for a sharper focus if you can find it, and sometimes—if it is allowed, if you can work yourself back to a good vantage point—it gives a person a chance to find a deeper sense of things.

Fresh from the camera, the old Polaroid film was gray and murky, the falls not yet visible, but a blurry blotch that might develop in time, or might not, given that the film had expired twenty-something years before, and after we walked quickly back through the rain, I tucked it away in a book, glad to have exposed the film no matter how it turned out. We got into the car and set out for the other side of the river, to see what was just behind the falls—or behind O'Sullivan's plates, as I was thinking of things—to where the river, starting with the Desert Land Act of 1877, had been diverted into hundreds of miles of canals.

Just like people

Just outside the park, we pulled over to check our maps in front of a church that was broadcasting Bible teachings around the world. We turned north onto a state highway that took us on a suddenly narrow bridge crossing the deep, mist-filled Snake River gorge. This is the canyon that Evel Knievel jumped, or tried to, a spectacle I remembered watching on TV in 1974, the onetime Montanan copper miner entering his missile-like rocket in his vaguely Confederate jumpsuit. I also remembered meeting him in 1991 in a restaurant in Butte, beat-up and tired. At this point the afternoon sun burst through the last lingering clouds, and the rain-soaked fields before us were golden and sparkling, as if the Magic Valley really was magic, or, as I felt it, ready to say something.

We had planned on a tight schedule; there was not a lot of time for detours. But driving out to Portland, I had become convinced that I needed to travel just upstream from the site of O'Sullivan's pictures, partly from staring at them for the better part of eight years and read-

ing the related maps, partly due to a remark by my mother-in-law that I kept thinking about on the four-day drive from the East Coast to Oregon: her high school friend in Portland, Oregon, had spent World War II in Idaho, with other interned Japanese Americans. The low gray-and-white clouds scattered like startled sheep as we drove along irrigation ditches between long lines of green, and in a few minutes we turned down an old road that led to an old guard tower, a remnant of the Minidoka Relocation Center. This was the place that, in the time since my first visit, I had come to see as the invisible backdrop to the photos of Shoshone Falls—a rude campsite where, from 1943 to 1945, a total of nine thousand American citizens of Japanese heritage were held at gunpoint behind barbed wire.

As we walked around, we were the only ones at the camp—a few preserved buildings, a stone foundation, an empty guard tower guarding a landscape that Clarence King described as sagebrush in the 1860s but is now commercial agriculture (potatoes, barley, sugar beets) nourished by a series of irrigation ditches, the ditches polluting the Snake River and the local water supply. There was a small, beautiful museum, newly opened but closed for the pandemic, and the site of an old baseball diamond. It was strange to be at the site alone; my wife and I had each wandered off separately, and as the clouds continued to race overhead, the emptiness was moving. In my own case, I did not understand how much of my past exploration of O'Sullivan sites I was bringing to my experience of this place, or how past experiences here seemed to reverberate, as if the basalt expanse itself were sensitized. I crossed the asphalt road, which was slick like a stream, and walked to the creek, which was raging with rainwater, swelling, and seeming to take into itself a blue that was deeper than what came from the sky and then was deeper still. I knew that the water was bound for the fields, to be dispersed through ditches, run through irrigators, but it seemed as if it were trying to go somewhere else. I stared at the creek and listened to it rage, and then I stepped back from the edge and went to find my wife.

Minidoka, I realized, was named for the Minidoka Dam, a Bureau of Reclamation dam that was one of the very first projects built just behind the Snake River—in 1904 the largest irrigation system in North America. The father of Margaret Wheat, the self-taught Fallon archaeologist, managed the Minidoka irrigation project after he had spent years

working with the bureau to constrain and control the Truckee River drainage in Nevada. That O'Sullivan had photographed the Truckee basin in his first days out with King made my visit to Minidoka seem like a full circle, and, for me, it connected the rush of the Snake River with the giant sand dune that, in O'Sullivan's picture, resembles a wave, the photographer adrift, lost in the sensation of the place, in its reverberations.

Between my first and second trips to the falls I had come to realize that the camp at Minidoka, like nearly all the camps built to hold and terrorize Japanese Americans, was situated within the territories surveyed by King and Wheeler and photographed by O'Sullivan. Each of these camps was built on a site that was, in bureaucratic terms, most in need of reclaiming, from the desert or its tribes or both; they were off the grid, in the sense that the grid had written them off. Minidoka was built on land managed by the Bureau of Land Reclamation, and BLM employees eventually managed the prisoners as they worked on the seventy-mile irrigation trench called the Milner-Gooding Canal, reclaiming Shoshone-Bannock land on behalf of the Twin Falls Land and Water Company.

Like all the camps, Minidoka was hastily constructed, initially without plumbing or toilet facilities, and the buildings were flimsy and full of holes. Coal stoves weren't enough to melt the snow that invaded through cracks in the poorly installed windows, covering the beds. As an adult, Mitsuye Yamada, a poet who was a teenager in the camp, described using mess hall butter knives to stuff newspapers and rags in the cracks in the walls:

> But the Idaho dust
> persistent and seeping
> found us crouched
> under the covers.

Machine-gun nests watched over barbed wire, and the prisoners in the cold, windswept valley strained to stay human in the face of inhuman conditions and fear: a person who walked to the perimeter fence risked being shot by guards who, owing to the tortuous mechanics of American racism, were listed by camp officials as white even if they were Black. (By white, administrators meant not Asian.) Yet prisoners

held dances, organized associations, and defended themselves—at one point protesting to the Spanish government, their appointed wartime defender according to the Geneva Convention, though camp authorities intercepted the protests and never forwarded them. As hard as the United States worked to separate the prisoners, to break up communities within the camp, the prisoners worked to organize, to connect with one another, more examples of what Gerald Vizenor terms survivance. Afterward, even American psychologists studying the incarcerated Japanese Americans understood that connections create health. From another poem by Yamada:

> This is what we did with our days.
> We loved and we lived
> just like people.

Dispersed

Just after we got back home to Philadelphia, I attended a gathering of former Minidoka prisoners—it was online, everyone reeling from the disconnection that the pandemic had wrought, the survivors of the camp noting parallels. David Sakura was eighty-five years old at the time and six when he was incarcerated at the Magic Valley camp with his mother and siblings while his father and uncles fought in Europe. He described visceral memories of the holding camp, in Puyallup, Washington, where soldiers forced his family into a stable; as they waited to move to Minidoka, his two-and-a-half-year-old brother cried incessantly. "All I could hear was his struggle for breath and this low animal guttural sound that was just the remains of his crying," Sakura said. Joni Kimoto remembered that her family had ten days to sell or give away their grocery store and all their possessions before they were moved to the Pacific International Livestock Exposition center, on the Portland waterfront, her memories of the time derived from what she had absorbed from her elders. "Your parents' memories kind of become your memories, I think," she said.

"We were the enemy," she added.

In the Magic Valley, even as Japanese Americans were locked up in their midst, Idahoans complained that the imprisoned citizens were

being fed for free. This criticism was a reenactment of the years during World War I, when workers from Mexico were encouraged to harvest sugar for the Utah-Idaho Sugar Company, and then, when the war ended, were left stranded, with no pay, no means to return home, like fish in a barrel of racist scorn. "These people are like the proverbial grasshopper that spent the summer with song and dance," *The Idaho Republican* wrote. (The paper acknowledged its bias, saying, "We do not like the Mexican people it is true.") Rather than luxuriate in free food, the families at Minidoka were ignored when the incarcerated parents pleaded for milk for their children or help with various intestinal ailments that spread through the camp. When men were hired from Minidoka to work nearby farms, some were paid hourly wages but denied entrance to local cafés and stores, signs in Twin Falls saying NO JAPS, though the prisoners were begrudgingly credited with saving numerous beet crops from failing.

State officials in Idaho, meanwhile, according to the *Idaho County Free Press*, accused the West Coast of trying to "dump what is their own problem onto the interior." But the opposite was true: the United

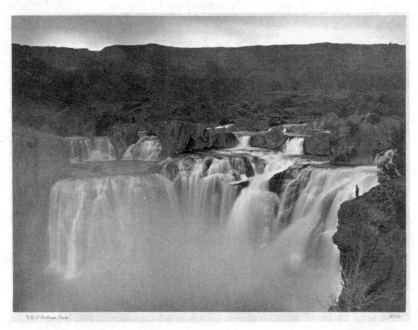

Shoshone Falls, Snake River, Idaho. Full lateral view—on upper level, 1874

States was not trying to concentrate Japanese families in one place but to disperse them. In 1942, when Peter Suzuki was thirteen, he was taken to Minidoka with his family from their home in Seattle and then, when he was fifteen, sent from Minidoka to finish high school in Michigan. His seventeen-year-old sister was relocated to Wisconsin. His brother went to war for the United States, in Europe. When his parents left the camp, the government relocated them to Connecticut. "After camp, we never lived as a family unit again," Suzuki said. This was the federal government's solution to what was seen as the problem of Japanese American communities. The parallels between the ways the Nazis dealt with dispersing Jews in Europe are instructive. Adolf Hitler was obsessed with the U.S. system of Indian reservations, while Dillon Myer, the bureaucrat in charge of the camps, referred to Dachau as a "German internment camp." Some Japanese detainees asked if they would live on reservations after the war, like Indians.

Behind O'Sullivan's pictures, or maybe within them, is the violent incarceration at Minidoka, white guards patrolling forcibly claimed Native land. When the families at Minidoka left the camp, they were scattered around the continent, and this was Dillon Myer's overall plan—to "distribute" and "disperse" and "scatter" the Japanese. He might have sounded like a sensible hydrologist or a cheerful landscape designer, but at that time *scattered* and *dispersed* were words associated with the prevention of disease and contagion. Running filthy water into fresh streams was a primary method of sewage treatment, and in this way the Japanese, when poured into the larger, purer American stream would become American. "Spread them thin," Myer said. Myer looked moderate in comparison with Earl Warren, the governor of California and, later, Supreme Court justice, who agitated to allow no citizens of Japanese heritage back into California. But FDR himself agreed with Myer: send families from West Coast cities to cities in the East, South, and Midwest—"not to be bunched up in groups as they were along the coast," Myer instructed in a 1943 press conference. (Police in resettlement areas worked to dissuade grouping or even socializing.)

Bureaucrats would one day express remorse, but since Myer's plan was, at the time, judged to be successful in resettling the Japanese, it was applied elsewhere. Myer eventually headed the United States Housing Authority, in charge of slum clearance, clearing away Black and

Latino communities and immigrant neighborhoods. And finally, after President Harry Truman repeatedly offered him a position as head of the Bureau of Indian Affairs—"a shitty ass job," Truman was quoted as saying—Myer relented, accepting the third time. He promptly fired officials who had been a part of a relatively progressive movement at the BIA called the Indian New Deal, a rewriting of codes to return to Native nations some legal authority over their own affairs. One of those fired was Felix Cohen, author of the *Handbook of Federal Indian Law*; critics said he gave too much power to tribal nations. Myer, meanwhile, aligned himself with the likes of Patrick A. McCarran, known as "Old Pat," a U.S. congressman who worked for years to give Paiute land to white squatters at Pyramid Lake in order to take away Paiute claims to water.

"An Indian ain't *got* no goddamn rights," McCarren used to say.

Myer's BIA policies were designed to "terminate" federal treaty obligations, aiming to shrink the Native land base by half. He sought an end to what he called the "Indian problem" by getting rid of Indigenous communities entirely, or diluting their concentrations in the West. He offered Native people bus tickets to cities, to scatter them from their homes. He spoke at white churches, urging congregants to adopt Native children, to take them from what he defined as broken homes—"to find families in all parts of the country." This policy—resettling Native children in white families—stayed in place into the 1970s, when the Indian Child Welfare Act was created, though in the twenty-first century, right-wing activists have been fighting to curtail the law's power, just as they work to curtail treaty rights and tribal sovereignty generally. Myer had opponents; Harold Ickes, who had once supported Myer, described him as "a Hitler and a Mussolini rolled into one." And Felix Cohen tried to draw the line between the rights of Native Americans and the rights of non–Native Americans, eventually writing an article titled "The Erosion of Indian Rights, 1950–1953" in *The Yale Law Journal*: "It is a pity that so many Americans today think of the Indian as a romantic or comic figure in American history without contemporary significance," he said. "In fact, the Indian plays much the same role in our society that the Jews played in Germany. Like the miner's canary, the Indian marks the shift from fresh air to poison gas in our political atmosphere; and our treatment of Indians, even more than our treatment of other minorities, reflects the rise and fall in our democratic faith."

But Myer proceeded, establishing codes to encourage Native Americans to assimilate with white America. In 1967, Earl Old Person, the longtime chief of the Blackfeet Nation in Montana, was head of the National Congress of American Indians, and he criticized Myer's termination policies. "It is important to note that in our Indian language the only translation for termination is 'to wipe out' or 'kill off.' We have no Indian words for termination," Old Person said.

"What is the 'mainstream of American life?'" he went on to ask. "I would not know how to interpret the phrase to my people in our language. The closest I would be able to come to 'mainstream' would be to say, in Indian, 'a big wide river.' Am I then going to tell my people that they will be 'thrown into the Big, Wide River of the United States'?"

By the time my wife and I got back in the car, it was dusk at Minidoka, and we inspected our Polaroid of Shoshone Falls. The old film had disintegrated in part over fifteen years or so, but it still worked, and in comparison with O'Sullivan's, it was difficult not to see the Snake River in ours as something almost paltry, the rapids slow and weak, the water dispersed and dissipated.

Shoshone Falls, 2020

17

Shoshone Falls, Snake River, Idaho, 1874

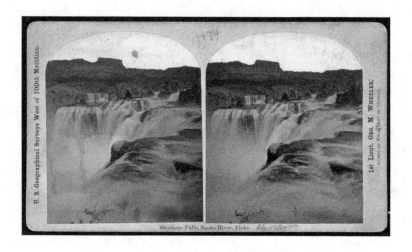

When we drove out of Minidoka and found our way back to the interstate and turned east toward home, I felt I was leaving right alongside O'Sullivan, who had made the same journey a century and a half before. I watched "the adventurous artist" (to use Clarence King's patronizing phrase) make his last plates, moving closer and closer to the falls after setting his tripod up in the eddies, nearer and nearer to the edge, and in so doing taking with him the viewer at home. I could feel the falls roar inside his camera's wooden interior as if it were the body of a violin, and then I watched the plates develop, at first confusing the white water and the sky, seeing the rocks as something else entirely.

I saw him pack up his chemicals and lenses and the plates he used

to make the prints he would try to sell to the picture-consuming public at large—pictures that might be, if he could pull the right bureaucratic strings, tools for his own survival in an economically desperate time. O'Sullivan's plates weren't simply ordinary views of the cataract, which, though increasingly famous, had yet to be fully capitalized, pictorially speaking. They didn't merely capture a moment in time or a place in the world. They were action photos, moving pictures in the era before pictures moved, capturing the weight of the rocks and the danger of the thunderous water—unbound, undammed, melted from glaciers and born of volcanic aquifers, even now challenging the idea of being dammed.

As we drove south and west, I watched the Irish photographer carefully secure his plates to his mules as he headed toward Salt Lake City, like us, though in his case his wife was in Washington, D.C., possibly also infected with the tuberculosis that was eating away at him. We passed through what Wheeler called "the broken mountains" between Idaho and the Great Salt Lake, and I saw the Civil War camera operator board the Union Pacific Railroad, bound for D.C. It was dark when the tall flames from refineries greeted us like votive candles as we passed the Great Salt Lake, the lake itself draining, evaporating, disappearing even on maps, and then we arrived in Ogden, where we took a motel room and saw the Wasatch Range that O'Sullivan had photographed, first for King and then for Wheeler, which I first saw when we moved from New York to Oregon, starting a new life, or trying to.

With the next morning's coffee, we followed the Uinta Mountains out of the edges of the Great Basin and down into the Colorado Plateau. We turned onto I-70 to enter a region that is, on the one hand, described on highway signs as a playground, full of hiking trails and campsites, of national parks and monuments and their scenic views, but is also a battleground for coal and uranium and now natural gas. More and more, the gas is fracked, or forced from the ground with chemicals—a technique pioneered by a Civil War general who, in 1865, used nitroglycerin in what he called an "exploding torpedo" to induce oil flow in the Allegheny Mountains. This mining technique, which has now spread throughout the continent, polluting water tables and streams, was an idea that came to that general at the battle of Fredericksburg, Virginia, where Confederate artillery rounds made huge,

woundlike excavations in the land. Of course O'Sullivan photographed Fredericksburg in the spring of 1864. He pictured artillerymen firing, setting up his camera next to a long line of guns:

Pennsylvania Light Artillery, Battery B, Petersburg, Virginia, 1864
(Metropolitan Museum of Art)

He also pictured the end result over and over, in this picture giving us some distance from the bodies, as if to protect us from exposure:

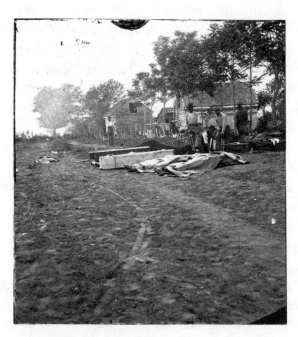

Fredericksburg, Virginia. Burial of Federal dead, 1864

As we crossed the northern tip of the Colorado Basin and headed into the Rocky Mountains and then the Great Plains, the delirium of days of straight driving made the front seats of our car like seats in an oversize photographic chamber, an old camera obscura on wheels. Picturing things through our windshield, I was an imaginary practitioner of the photographic arts, the windshield a frame, our selves the plates or even the film. With my imagined powers I could see the thirty-four-year-old about-to-be-out-of-work O'Sullivan looking out the windows of the Union Pacific railroad car, today shadowed by Interstate 70. Through the windshield I see the vistas O'Sullivan passed en route to King's and then Wheeler's survey, vistas he knew well from 1872, the year he worked alone for King, making wet plates along the railroad's route, picturing the Green River's canyon, but, as opposed to many photographers at the time, not the railroad.

As the twenty-first-century landscape rolled past us, as the nineteenth-century train stopped and started, as the veteran of the war in the East and the surveys in the West dozed off and woke again, I saw him recognize views he had seen, views he was surprised that he hadn't, views he found not remarkable at all—and I imagined him picturing all the various people he had worked with: the young ornithologist he rescued who'd passed out in the Carson Sink; the geologist with whom he rowed the Colorado upstream; the Mojave men he rowed with; the thickheaded military commander who made him row upstream and smashed a season's worth of glass plate negatives. And then there were the Union army soldiers, years of soldiers, waiting for battles, barely surviving them, or not surviving at all. As we drove on and I saw him more clearly sitting in the train, I imagined him thinking about his eventual arrival in D.C., seeing his friends, his new wife, eventually his parents in New York. A train trip, just like a trip in a car or a long march or walk, will take you through pasts and feelings you didn't expect to revisit, as if the places we see reach into us, react with the pasts we carry.

National sacrifice

Once, in my twenties, when I drove through the West—through the rhapsody of open spaces that I wanted to read but couldn't—I felt a joy that was, if not a patriotic impulse, then a response to a story that made

me feel good about the land, or at least okay or not so bad. But now, nearly forty years later, as I see our rental car moving through the lands of the Wheeler survey and part of the Powell survey and a few other surveys as well, I am seeing the ways in which war saturates the American landscape, the ways it is perceptible even if you can't see it.

As we crossed the Green River in Utah, then drove alongside the Colorado River in Colorado, the sky that filled the panoramic glass of our windshield looked clean and pure even if it was suffused with the methane that is the result of so much mining. On the highway, various fuels and fuel byproducts passed us in tanker trucks amidst cars stuffed with camping gear. At our first rest area on the Colorado Plateau, on a butte overlooking thousands of open acres of red rock, the view I could feel was like a stereocard of two different images. On the one hand, you saw the West of John Wayne westerns, barren, heroically empty, desperate for improvement by settlers; on the other, a view into a cauldron of war, a war fueled by the uranium-rich Triassic sedimentary rocks just below the surface of the Four Corners. Between 1944 and 1986, thirty million tons of uranium ore were mined on the Navajo Nation land, first for the U.S. Atomic Energy Commission and then, after 1966, for the commercial uranium industry, leaving the mines mostly open, toxic sites dug out by Navajo miners who were paid less than white miners (the BIA forbade Navajo workers from unionizing), many of whom died of tuberculosis and cancer, having had no protective masks. In 1979 a relative of a deceased Diné miner in Shiprock, Arizona, said, "Where the uranium slug has been dumped, children wade in the water. But break out in sores."

In the late 1960s, while I was being instructed to duck under my elementary school desk in preparation for a Soviet missile attack on New York City and environs, the National Academy of Sciences advised the Nixon administration to designate land in the Four Corners and the Black Hills as a "national sacrifice area," deemed expendable for "unrestricted energy resource development." In 1973, when it was pointed out that 70 percent of the land in the intermountain West was being leased to only fifteen multinationals (including Exxon, Mobil, Shell, and Sun), Congress momentarily paused its leasing—but then resumed in 1979. That was the same year that a dam holding back a hundred million gallons of radioactive liquid waste broke at Church Rock, New Mexico,

spilling into a tributary of the Little Colorado River, spreading contamination eighty miles into Diné farming communities. The Church Rock release remains the largest release of radioactive material in U.S. history, and yet, when the spill happened, the governor decided against declaring a disaster, for fear of discouraging uranium mining.

"The government and the companies entice the colonized people with money and jobs," wrote Winona LaDuke, an Ojibwe citizen writing at the time in what was her student newspaper, *The Harvard Crimson*, "but the people, caretakers of the Western Hemisphere, demand much more. The people demand a future free of radiation, abandoned mines and mills, a future free of the threat of genocide to their children."

Cool, deliberate

In Rawlins, Wyoming, O'Sullivan crossed the Continental Divide. The train and its plume of coal smoke followed the South Platte River and then the Platte itself to Omaha, where he changed trains at the Missouri River. Meanwhile, we drove out of the Rockies at Denver, where, for me, the view of the flat infinity of the Great Plains is always a surprise. An hour and a half outside the city, the interstate runs through a town called Limon, where I see the town fathers in 1900 going to great rhetorical lengths to note distinctions between the ways Limon executed justice and justice's execution elsewhere—most especially in the South. This new western town was promising, a local paper noted, "a show that the people of the South may take lessons from."

The "show" was the torture and murder of Preston Porter Jr., a fifteen-year-old African American boy who was accused of raping and killing a twelve-year-old white girl. There would be no wild mob, in the Southern mode. The mob would be patient, explicit, exacting. In this case, Porter had confessed, though only after being "sweated"—that is, made to answer questions while standing inside a tall, closely fitting coffinlike box for four days. "All Efforts to Make Him Break Down and Confess Have Failed," a headline noted. Subsequently, the boy told the men what they wanted to hear, reportedly to save his father and brother. The newspaper marveled: "No Indian ever maintained greater stoicism." Between 1890 and 1919, Coloradans lynched, according to one count, "a Jewish peddler, a Chinese laundryman, two 'Mexicans,' three African

Americans, and five Italians." If you were Black and lived in Colorado, the likelihood of being lynched was the same as if you were Black in Alabama or South Carolina.

I don't know how many people O'Sullivan saw killed while he traveled through Wyoming or Nebraska, or on his trips through the Southwest; I do know that while he was with Wheeler, he saw a Shoshone man shot and a boy tortured. I also know that he made a stereocard that was widely distributed by various publishers at the time.* The man being lynched is reportedly William Johnson, who was hanged in the vicinity of Petersburg, Virginia, at the outset of what would be close to nine months of fighting. (Two days before this photo was taken, 632 men from a Maine unit were killed in under ten minutes, surrounded by Confederate fire, the largest regimental loss of the war; O'Sullivan photographed the unit before they died.) Johnson was a member of the Twenty-Third U.S. Colored Troops and had been convicted of raping a white woman—a Confederate soldier's wife who lived nearby, according to vague and various descriptions that publishers included on the cards. Notes on a negative sleeve at the Library of Congress say, "Execution of Johnson a colored soldier for attempting to violate the person of a white lady within the lines of the Army of the Potomac."

Petersburg, Virginia. William Johnson, a Negro soldier, 1864

* A second version of the image, possibly made by another photographer, was distributed by Charles Taber & Company, a New Bedford, Massachusetts, art manufacturing company that sold photos around the country, ranging from a portrait of William Lloyd Garrison, the abolitionist, to Johnson's lynching, which Taber & Co. titled *Execution of a Colored Soldier.*

Johnson was reported to have confessed during a trial, though, like Porter's, his confession must be considered in context: among Union soldiers, executions were 21 percent higher for Black men, and Union officers were more likely to accuse Black soldiers of raping white women than of any other crime. The chances are significantly better than excellent that he was innocent. "There are occasional cases in which white men are lynched, but one sparrow does not make a summer," Frederick Douglass would say in 1883. "Everyone knows that what is called lynch law is peculiarly the law for colored people and for nobody else." In the moments before Johnson's execution, Union soldiers raised a white flag, signaling a cease-fire, at which point the line between the North and South temporarily vanished. The notes on one of several cartes de visite describes the scene: "A request was made of the Rebels, under a flag of truce, that we might be permitted to hang Johnson in plain sight of both armies, between the lines."

When they first saw the flag, the Confederates fired on the men surrounding the gallows, thinking the Union soldiers were about to execute a Confederate spy. In the shelling, a white New England officer was killed. But when the Confederates realized that the Union troops were preparing to hang a Black man, they put down their arms and, gathering up all the enslaved Black men working behind Confederate lines, paraded them past the gallows. The War Between the States paused to take up the war they could agree on, just as the states would reconcile to fight the Indian, just as federal power would stand back in the face of large-scale white vigilantism that sought to keep the West "pure."

It was hard not to think of the violence pictured in O'Sullivan's photograph of Charles Johnson as we passed through Limon and crossed the Sandy Creek drainage, just up the dry streambed from the site of the Sand Creek Massacre, where, in 1864, at least 150 women, children, and elderly Cheyenne and Arapaho were killed at a peaceful encampment. Just as General William Sherman was commencing his March to the Sea in Georgia, the U.S. soldiers in Sand Creek burned the village, taking body parts as trophies that wound up in Denver bars. If I had thought of it as a western massacre, distinct from the slaughter in the East, surveying O'Sullivan's photos helped me see that the leader of the party that killed those people in 1864—John Chivington, an Ohio-born abolitionist, minister, and Union commander who had fought to keep

the Confederates away from gold mines in New Mexico—considered massacring Native women and children as part of his responsibility as a fighter for the Union: to clear the West for settlement under Union terms. It would be a white West, and he would help make it that way, the army distributing guns to settlers and then more guns—guns and western expansion going hand in hand. "I have come to kill Indians," Chivington said, "and believe it is right and honorable to use any means under God's heaven to kill Indians."

A continuing memorial

We drove late into Kansas. Near midnight, in a lonely rest area, I read a wall plaque about John Brown, who was hanged by the United States for treason. The next day, we passed Fort Riley and saw a road sign indicating a buffalo soldiers memorial, but then we couldn't find it, for lack, it seemed, of additional signs along the local road. In Missouri, another sign announced the state's Confederate soldiers memorial, followed by more signs, and in a year that had seen so many Confederate monuments come down around the country, we wondered how this memorial to white supremacy had fared. A state road led us through sandstone hills that were stream-carved but now controlled by farms and on to the Confederate Memorial Parkway, then through the gates of a bucolic green park—lawns and trees and an ornamental pond, a family picnicking. Driving back to the interstate, as we passed a huge tractor dealership, I spotted the rows of bright green farm machinery and shuddered. On first glance the tractors looked as if they were lined up like tanks. I felt a sense of dread wash over me as I recalled that a delegation of Osage leaders had been summoned to Washington, D.C., just after the Civil War to negotiate land and mineral rights, having spent the war fighting the Confederates. On such occasions it was customary to photograph the delegation, then give them a tour of the armory—walking the visiting leaders through fields of guns and cannons laid out in rows.

Sherman's March (*cont.*)

We crossed the Missouri River that afternoon, then the Mississippi a few hours later, and now O'Sullivan's images in the West—mines and

conquests, ruins and people freshly returned to places they'd been forced to leave—began to blend with his pictures in the East. I thought about the ways in which extracted oils and gases were being moved from the West in pipelines that crossed eastern rivers, about how mining that had begun in the East and moved to the West was picking up in the East once again, fracking and all its resulting contaminants threatening eastern waterways, western oils pumped back across the Mississippi headwaters. I pictured O'Sullivan leaving one train at the Mississippi, crossing the river, his next train setting out across Illinois.

As we crossed into Ohio, thunderclouds greeted us, though in the thick, humid air, they never delivered rain. We passed Columbus's refineries in the dark and entered the region of vast shale deposits and old, unremediated coal mines that, aboveground, is the ridged and stream-hollowed Appalachian Plateau. On our car stereo, a Sioux activist was interviewing a poet from Atlanta, the city that was burned by General William Tecumseh Sherman. (Sherman was named for Tecumseh, the well-known Shawnee chief who resisted western expansion into what became Ohio.) The poet was considering the protests that had broken out a few weeks earlier in cities around the United States after more police shot more Black citizens that spring. Black protesters had been accused of, in a critic's words, "burning down their own house." "The problem with that," the poet said, "is Black people don't really own Atlanta," and he proceeded to offer his survey of the economic landscape, explaining that while Black Atlantans made up the bulk of the workforce, their rate of homeownership was low. At the same time, large corporations headquartered in Atlanta—including Coca-Cola, Home Depot, Delta, and Chik-fil-A—own significant areas of the city, as do the universities, which pay no taxes.

"The point is we *don't* own Atlanta," he said. "The capitalists own Atlanta. So when he says you can't burn down your own home, I don't think any homes are being burned down. It's a plantation that's being burned down. Right? If your people make up the workforce, but you don't own anything around you—you own no means of production—that's a plantation, definitionally."

Scenery Hill

In the morning, we entered Pennsylvania and crossed Washington County, once full of beautiful woods and bucolic side roads but by 2020 the most heavily fracked county in the state, with more than fifteen hundred wells in its 861 square miles, truck traffic dusting up what were once scenic routes, families testing positive for contaminants in their bloodstream, kids with bloody noses at school. In Scenery Hill, a town just off the interstate, the state Bureau of Safe Drinking Water suggested that because of chemical contaminants, anyone who was elderly or pregnant or had a compromised immune system ought to consult a doctor before drinking from the tap. As we drove, Royal Dutch Shell was completing construction on an ethane cracker plant just north of Pittsburgh. Ethane is abundant in the shale formations that comprise the Appalachians, and Royal Dutch Shell has proposed five cracker plants throughout the Appalachian regions of Pennsylvania, Ohio, and West Virginia, converting vast amounts of fracked natural gas into polyethylene, the most widely used plastic in the world. When they are all built, the Ohio River–centered operation will create a petrochemical corridor rivaling the one along the Gulf Coast's Cancer Alley, previously known as Plantation Alley.

What constitutes war? The cracker plants feel like unannounced and under-the-radar combat outposts on a new government-sponsored front line.

And where is O'Sullivan now? I see him on the train, crossing Pennsylvania probably, on his way to Washington. The East is familiar to him, though perhaps now in a new way. It's the place where he photographed battlefields, the countryside where he pictured the army building bridges across streams, or destroying them.

And I wonder, do the eastern fields now remind him of the West? Does he wonder if he had seen his past in the East while working out views in the western landscape?

A little over an hour east of Scenery Hill, in the waves of mountains that descend to the Atlantic Coastal Plain, we have entered the Chesapeake watershed. We pass Carlisle, home of the U.S. Army War College and prior to that of the Carlisle Indian Industrial School. The

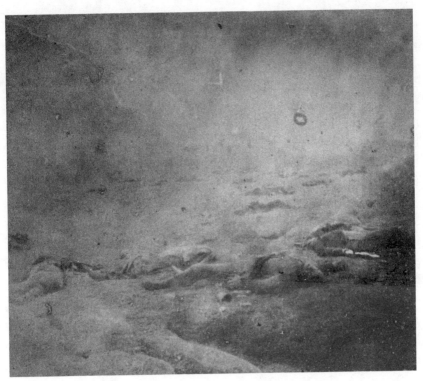

Variant print of *A Harvest of Death*, Gettysburg, Pennsylvania, 1863

Shoshone Falls, 1874

school was five years from opening when O'Sullivan rode past it on the railroad, and it would become the place where the army put into practice its mantra: "Kill the Indian save the man," in the words of Richard Henry Pratt, the cavalry officer who ran the school. The point, well into the 1980s, was to separate children from their families and their culture, but Pratt sought out the children of tribal leaders to hold them hostage as Native nations were pushed to sign treaties, and one of the first children Pratt brought to the school was One That Kills Horse, a ten-year-old boy who arrived on October 6, 1879. At Carlisle, the boy's hair was cut. He was forbidden to speak his language, was punished if he did, and when he died, a little less than two years later, he was buried in the yard of what is now the U.S. Army War College. A year after we passed there, in 2021, members of the Rosebud Sioux Tribe would come to take him back to his homeland along with the remains of eight other stolen children, including five who, like One That Kills Horse, were among the first brought to the school. "They were left here," said Ben Rhodd, a Potawatomi archaeologist who was working with the Sioux Nation. "They need to come home."

Periods of war

The interstate crosses the road south, to Gettysburg, and then it crosses the Susquehanna River, running down the long, crescent-shaped valley that Robert E. Lee tried but failed to capture in the summer of 1863. We could see south toward Three Mile Island, the nuclear power plant that melted down in 1979 and came close to contaminating all the land Lee had looked to control, from Washington to Philadelphia and then most likely beyond, to New York. Looking down the river into the haze, I was in a would-be war zone from which millions of people barely escaped, unbeknownst to them. The river is beautiful in the afternoon light, shimmering, seeming like liquid metal, making shapes of its own with the clouds, as if mimicking glass in a dark tent, the cameraman's work light allowing us to see the clouds of gray swirl into a tight crispness—fleshy grays, elusive blacks and whites, ghosts materializing in a current of metals and acids in the stream of fresh water.

In my mind's eye, pictures mingle, as if looking at the Susquehanna

through two plates at once, as if things are double exposed. War in the East mirrors war in the West, the coal miners in West Virginia are casualties in the same war as the coal miners in Wyoming, fighters on different fronts, where lungs and the land are polluted for less and less pay. State police and armed private security forces guard workers laying pipelines across Appalachian streams that connect petroleum deposits in the Northern Great Plains to cities in the East, where the property is for profit first and community second, and gun violence takes over city blocks, clearing out families for incoming investors and out-of-town developers. Each time a pipeline crosses water, the construction requires a permit from O'Sullivan's old unit, the Army Corps of Engineers, raising the question of whether the corps is engineering a defense of the land or, alternatively, just engineering a defense.

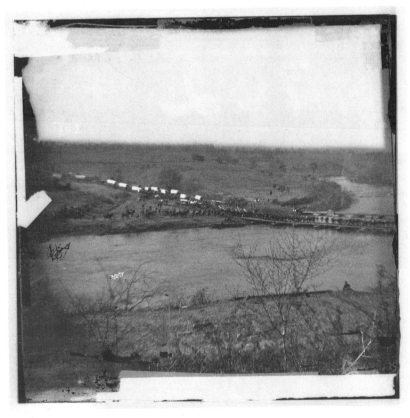

Germanna Ford, Rapidan River, Virginia.
Grant's troops crossing Germannia [sic] Ford, 1864

On the radio all through that drive, analysts and commentators were talking of the about-to-end war in Afghanistan, describing the conflict, two decades old, as America's longest war. But this is wrong, even according to the U.S. government, whose Federal Register denotes officially designated "periods of war." "Indian Wars," it says, "January 1, 1817, through December 31, 1898, inclusive," as if the Indian Wars ever ended.

CODA: STATEN ISLAND

I am the blind woman finding her way home by a map of tune.

When the song that is in me is the song I hear from the world

I'll be home. It's not written down and I don't remember the words.

I know when I hear it I'll have made it myself. I'll be home.

—Paula Meehan

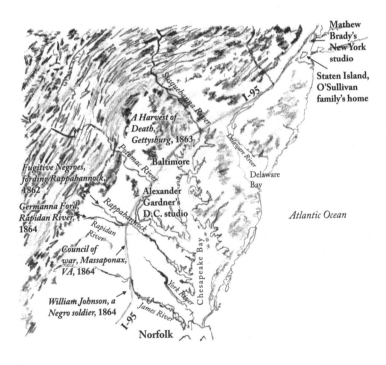

We live in the world, and the world lives in us. The land and all that's in it is part of us, inseparable from who we are and how we feel and what we will become. But how do we see the past around us? How does this history move through us, if it does?

These were questions I was pondering eight years before we drove back east from Shoshone Falls in the spring after my first big attack, when I was just beginning to understand how broken I was, though—mostly in retrospect—not understanding, except when my hand failed me or perhaps a leg decided not to want to walk, things I found frustrating and terrifying. At the time, I was trying to find a way back into my O'Sullivan survey, doing so by making short trips to Staten Island from our apartment in Brooklyn, where we then lived. Going to Staten Island was a matter of thinking about O'Sullivan's beginnings and his end, and I had it in my head that this was the place where, after so much traveling in the Appalachians and in the West, he hoped to make a new life with his wife, Laura, and their soon-to-be-born child, to start again.

Immediately after photographing Shoshone Falls, at the end of 1874, O'Sullivan returned to the East to live in Washington, D.C. That spring, he won a bid to print his survey photographs for Lieutenant Wheeler, fifty thousand stereocards and five thousand landscape views for $4,000. Then, in a note that may be among the only surviving pieces of writing attributed to O'Sullivan himself, he turned again to his old boss, asking Wheeler for permission to print up photos to sell himself—"to the end," he wrote, "that the general public might be able to obtain at a reasonable price these views that represent to some extent the country through which your several commands passed in the mountainous regions of the West."

I read the note as overly flattering but recognize that work for everyone was drying up at the time, even for Wheeler, who is coming under increasing criticism for his rushed fieldwork and will eventually die penniless, buried in a pauper's grave until a friend reburies him at West Point. O'Sullivan likely felt he had to lay it on thick for Wheeler—whose admiration of his own self was impressive—as well as for the various levels of army bureaucracy that would also have to approve. O'Sullivan continued: "It would be a matter of Pride to me having been engaged upon the spot in the production of most of these negatives in connection with your several arduous expeditions, to see that these pictures are produced in the highest style of the photographic art and that such means shall be adopted for their sale as will inshore [sic] that they will naturally reach those persons most interested in the prosecution of works of this kind."

Wheeler quickly endorsed the idea, but eventually the army refused. Meanwhile, piecework dribbled in for O'Sullivan. He printed for Clarence King, who sent a set of images to the Library of Congress and to the Centennial Exhibition in Philadelphia in 1876 and also commissioned O'Sullivan to print his own personal set, for another $97. He also made Centennial prints for Wheeler. But at the end of the year, things took a sad turn when Laura's child was stillborn. The couple buried the child in Rock Creek Cemetery and around that time, likely due to a lack of income, lived with Laura's family in D.C.'s Capitol Hill neighborhood.

Work would have gotten harder for O'Sullivan as his health deteriorated, but work would also have gotten more difficult for everyone as the country's economic condition continued to decline after a bank panic in Europe and the United States, followed by protests and breadlines—the beginning of what was to be called the Great Depression, until another even greater depression came along. In 1877, when the Baltimore and Ohio Railroad Company asked workers to take a 10 percent cut in pay, they went on strike, and railroad workers around the country, in solidarity, immediately did the same. The vast nationwide strike, unplanned by any single union, spread along the railroad lines like a flame traveling down a fuse, and soon other workers went on strike in solidarity with the rail workers. Militias were called out in Chicago and New

York, Pittsburgh and Philadelphia, and in cities around the country, but militia members often sided with the workers, who were neighbors and friends. The Great Railroad Strike of 1877 is also known as the Great Upheaval, an action in which a hundred people were killed; in Pittsburgh, a railroad executive attacked workers in a depot with a Gatling gun. Thousands were jailed, and it was the beginning of a wave of mass strikes that would continue until the early 1900s, when state militias were eventually reorganized as national guards, and armories were built in major cities to more efficiently quell labor unrest or uprisings of any kind.

In the same year as the general strike, O'Sullivan managed to borrow photo equipment from the army—equipment he most likely would have needed to survive—but then, before the year was up, Wheeler asked for it back. O'Sullivan is listed in D.C. directories in 1879, and people still seemed to want to hire him. Even Clarence King offered him work printing for the USGS, though in 1880 King paid him only $6.75 for the entire year.

Around that time, his old friend Lewis Walker died. Walker had been the photographer for the Treasury Department, and O'Sullivan applied for the job, soliciting various recommendations—from King, Wheeler, John Wesley Powell, Mathew Brady, and even Commander Lull, leader of the Panama expedition. O'Sullivan appears never to have burned a bridge, despite initially irritating his coworkers with profanity and anger, what was perceived at times as a lower-class demeanor. In his recommendation, Lull, the commander in Panama, called the photographer "an especially desirable associate." O'Sullivan got the Treasury job, but by this point it was too late. Tuberculosis had ravaged him, and Laura too. Just a few weeks after accepting the position, he resigned.

He and Laura moved to their respective parents' homes for care, not unusual at the time, when rest was considered a cure for an illness that was devastating the population—by 1900, what was called consumption had killed one in seven people who had ever lived. In just a few weeks, Laura died. O'Sullivan traveled to Washington for Laura's funeral and returned quickly to New York, telling friends he hoped to be back to D.C. by Christmas, expecting a quick recovery, but on January 14,

1882, he died on Staten Island at the age of forty-two. His death certificate identifies him as Timothy H. Sullivan, dropping the *O*, the cause of death listed as pulmonary tuberculosis. *The Washington Post* wrote:

> Letters have been received in the city announcing the death of T. H. O'Sullivan, Esq., which occurred on the 14th instant in New York State. He was at one time prominently connected as a photographer to the Wheeler surveying expedition. But a few months since, he was called to this city to attend the funeral of his beloved wife, a daughter of Mr. and Mrs. R. R. Pywell. Although not in the best of health when he left for New York, he fully expected to return to this city to spend the holidays. His many friends will be pained to hear of his sudden demise.

The whereabouts of O'Sullivan's grave on Staten Island are unknown. Nobody has ever found it.

I think I did, however, manage to figure out where he had bought some land and hoped to build a house. This is what I was investigating the first time I went to Staten Island to look for him, and when I went, I took the ferry. As mentioned, I was not in great shape. You will recall that at the outset of my survey I had been through some neurological difficulties that, among other things, affected my ability to keep warm. Propped up against a railing overlooking the water, I was bundled up as if for an Arctic expedition, even though it was spring, even though I looked fine. Fortunately, the harbor and its spring sky was like an old friend. It was soul-reviving just to cross the bay, and the railing of a boat is a good place to think about crossings and shifts, as the bay in New York Harbor turns rivers into seas.

On the boat, it struck me that O'Sullivan would have crossed the harbor first when he was ten or eleven, then crossed it scores of times as a teenager and as an adult. He would have crossed it working for Mathew Brady, then on his first trip to the West, with Clarence King, before the transcontinental railroad was completed, and then again when leaving and returning from the Darién peninsula on a navy ship. One of his last crossings would have been made to catch a train to Washington, D.C., for his wife's funeral.

He might even have remembered taking a ship from New Orleans to New York, as a seven- or eight-year-old boy. I know I remember being that age and visiting the seaport, tagging along with my father, who worked at a printing shop two blocks from the water. At the very least, O'Sullivan's parents certainly would have remembered the family's crossing from Ireland to New Orleans when O'Sullivan was an infant. The earth is another place entirely when you consider it from the vantage point of the oceans and the seas; and when you consider the scores of Irish people who crossed the Atlantic, you see people outside the bounds of states, reimaging themselves, breaking off and starting again, reenacting or reimagining and carrying their pasts, like seeds, into new places with new questions, a new soil. And though they were sometimes starved or sick with fever on the boats, they were also, in contrast with the passage of the enslaved, sometimes healthy enough to dance or sing—not infrequently, it was reported, making music, some sad, some not. An account from the early 1800s: "The greater number of our steerage passengers (in order to drive away the sorrow which a separation from their native land produced) entered into the greatest extravagance in dancing, drinking, singing &c."

And then, in 1850, an account in *The Illustrated London News*:

> The scene of a party of emigrants, male and female, dancing between decks—to the music of the violin—played for their amusement, by some of their fellow passengers, is not a rare one. Sometimes a passenger is skillful upon the Irish bagpipe, and his services are freely asked and freely given for the gratification of his countrymen and countrywomen—not simply while in dock, but, according to the reports of captains and others, during the whole voyage.

It is also recorded that dancing was used to send the Irish off on their trip from Ireland to North America at what were called farewell parties or American wakes, gatherings after which those departing were not expected to be seen again, dying a social death. It was another Sullivan, Seán Ó Súilleabháin, the Irish teacher and folklorist who, in 1967, published a study of these wakes, noting that dancing had occurred at funerals in Ireland for at least three hundred years. Dancing, he wrote,

helped pass the time during what was a long night. It seemed to placate the spirits and was, he wrote, "the attempt to heal the wound of Death and to do final justice to the deceased while he was still physically present." A dance called Building the Ship could involve four men sitting on the ground, arms outstretched, mimicking the shape of a hull. A contemporary dancer who has studied these wakes wrote, "Like boats, bodies are modes of transport, bearing spirits, dreams, and dances between worlds."

It later occurred to me that though it may have seemed to the crew or other passengers that the Irish passengers were simply singing and dancing, the dancers themselves expressed all those aspects of their history and shared community that human bodies hold, the way marshes hold sediments. Especially when I am on a boat, I sometimes think that we are all boats, floating, sometimes smoothly, sometimes not, through the currents and waves and wakes we have created, the currents and tides of our own communities.

The ferry pulled out from a pier in Lower Manhattan and set out into the gray-green water, the bow pointed toward the hills of Staten Island. The Statue of Liberty sprang up quickly off the starboard bow—it was still under construction in France when O'Sullivan went home to Staten Island for the last time, in 1881. On my ship, all the tourists raced to see the statue, the huge boat suddenly listing toward what is today considered a beacon to immigrants but was proposed by Édouard René Lefèbvre de Laboulaye, a Frenchman, to celebrate the abolition of slavery in the United States, even though, in 1886, the year it was dedicated, federal troops had been withdrawn from the South for nearly a decade, the Black population left to fend for itself in a guerrilla war waged against them. "Shove the Bartholdi statue, torch and all, into the ocean," wrote the Cleveland *Gazette*, an African American paper, "until the 'liberty' of this country is such as to make it possible for an inoffensive and industrious colored man in the South to earn a respectable living for himself and family."

When we docked, I walked slowly up a hill to the Richmond County Courthouse. In Staten Island's archives, history begins where the seventeenth century ends, and the 1670 deed that Dutch land purchasers used to terminate the Indigenous population's claims on the island is compli-

cated: the Dutch forced Munsee children to sign, and Staten Island is the only borough without Native place-names in official use. I worked along the shelf of dates and names, and with help from the clerks managed to find the deed to the plot of land O'Sullivan owned when he and his wife died, then a patch of farmland just up from the edge of the bay.

Now knowing the whereabouts of the spot, I came back to Staten Island a short while later. This time my wife helped me. We drove in our car, taking the Verrazano Narrows Bridge; it was a clear late-spring day, the very cusp of summer, and at the high point of the span we could see forever: rivers, tidal straits, the harbor on one side, the Atlantic on the other. I thought (as I often do) of that photo O'Sullivan had taken in the Carson Sink, his tripod set on a rise in the giant sand dune, the camera looking out on the sand that swelled like a wave in an ocean, his footprints leading back to the ambulance that resembles a boat adrift, the dune itself a body of water—or even, as I remember from visiting it, a body itself, afloat in the vast Great Basin's sky, in the rolling basins and ranges.

We drove toward the shore, coming to the old center of what was called Southfield in 1881, a then-independent town, and using the maps from the clerk's office, we got an idea of where O'Sullivan had planned to live. When his body was giving in to tuberculosis, his little plot was one of many real estate parcels newly broken out of an old farm, but when we visited, it was a neighborhood of small single-family homes, the farm a memory.

Standing in the middle of the quiet street, I took some pictures. On the old maps it looks like it's a nice spot, not too far from a few new homes, convenient to the then-new Staten Island Railway and to Richmond Road, a main route through the island. But it would also have been close to the bay, offering views with a sense of openness—in terms of space, an almost western panorama. There's a line in an ancient Irish poem, *"Buile Suibhne,"* or "Mad Sweeney," about a warrior who has suddenly fled the battlefield and is flying and flittering far away, maybe to try to recover or heal. He says: "There was a time when I preferred / the turtle-dove's soft jubilation / as it flitted round a pool / to the murmur of conversation."

We stood around for a bit, and then I wanted to drive to the water, to feel the distance to the sea from O'Sullivan's home that never was. Not

knowing the streets, we zigzagged our way tentatively toward the shore, accidentally coming upon a little patch of green, a freshwater pond, and what looked like a tidal stream—a city park, it turns out, called Last Chance Pond. A few steps off the road, fresh water gurgled, and I'm pretty sure I saw a turtle. It was a little oasis in what back then felt to me like time's relentlessness, connecting to streams that were on the maps O'Sullivan would have looked at in buying his patch of land, in thinking about a new life with his wife and maybe child, streams that are still there today.

We continued to drive toward the water, a little over a mile—and as we did, we began to realize that we were driving through an area that had suffered tremendous flood damage in the devastating recent storm, Hurricane Sandy. In the last quarter mile we passed flooded-out houses, ground floors propped up, old beach bungalows crumbling. It looked as if the ocean had been interrupted in the middle of violently whittling them away. On so many homes, yellow tape marked the front doors and porches, signaling danger.

And then, more quickly than I had anticipated, we came to the shore.

We parked and got out. It was a big, sandy beach, at that moment—a sunny and beautiful weekday morning—almost empty of people. We saw a few walkers, some abandoned beach chairs. It felt as if we were alone with the water and the sky, and when we stood on the beach and looked straight out, we were looking past the mouth of the harbor and off into the Atlantic Ocean, the infinite sea.

I snapped some pictures and for a moment felt a sense of accomplishment, as if I'd at last achieved a goal: I had checked off a survey site on my list, a big feat in those days, with the end of my survey an unimaginably long way away. It also felt as if I had arrived somewhere, like an ending there on the edge of a sea, but of course I had not. This was no ending, and in a way an ending wasn't to be. What happened was more complicated, less neat, harder—or maybe impossible—to explain, part of life off camera, in the still-liquid world, where we are exposed and developing, until we aren't. But I began to feel connected again as nerves recovered or regrouped—through touch, and also, as I managed to be less terrified of moving about, through human connections that, as my mania eventually faded, I began to make again. What happened that day was that we stood around and talked some—I had managed

to achieve a kind of calm—and I took more pictures. I think I can say that we both felt good in that spot, comfortable, happy, alive, or so it seemed to me. "This is beautiful," my wife said. Then, despite having never visited this place, I suddenly felt as if I knew where I was in the world and where I was going, and I could see a way to get there. I was overwhelmed, and I think full of joy. I wanted to stay on that beach forever or, if not, visit it always—as a place from which I could feel our lives from what was our before connecting to our life after, a place where the past and the future came together.

We stayed for a little while, walked around, stepped out to meet the sea when it rolled in, at that moment in quiet harbor waves, and we tried to, to use a phrase, take the place in. I also tried to just relax, for a second, anyway, and maybe I did. When we began to leave, my wife walked toward the car, and I was alongside her, but I stopped and turned around and looked back once more at the ocean. I snapped a picture too, or I thought I did. Now, I don't know what I did with it, and we've moved a few times since, each move wrenching, each one to an unfamiliar place.

But what I remember most clearly here at the conclusion of my long survey is not the tide, or the edge of the harbor, or looking out into the Atlantic Ocean. It is what I couldn't see, even though I could. What I remember is turning to see that my wife had already started off the beach. I perceived this at a time when I didn't ever want to be apart from her, when, more than ever, I wanted to be next to her and, as corny as it sounds, to touch, or touch as best I could, given strange numb hands. Now I could see her ahead, walking between what I picture in my mind's eye as two small sand dunes, part of a long battlement of sand, built, I assume, to protect the shore from another storm's waves. Yet I remember feeling very strongly that *she* was making that space in the dune, and that the blue sky that filled that gap was smooth and clear and pleasant—and somehow flowing through her. More than that, I felt I would now be safely passing through the space she had created, that everything would eventually be all right. And when I did pass through, I felt a shiver of happiness, even as I feel one now, remembering that place and remembering a day that seems so long ago but is still with me.

Bibliography

Fissure

Many years of reading about Timothy O'Sullivan began with Nancy and Beaumont Newhall's 1966 monograph, *T. H. O'Sullivan: Photographer*. John Szarkowski, a photographer who was the curator of photography at the Museum of Modern Art when I was first exploring O'Sullivan, wrote about O'Sullivan in *American Landscapes*, a 1981 monograph distributed by New York Graphic Society. A collection of photos that I referred to repeatedly over the ten years I took to write this book, and in the two decades before that, is Joel Snyder's *American Frontiers: The Photographs of Timothy H. O'Sullivan, 1867–1874* (Aperture, 1981), which I bought in 1990 and turned to repeatedly when I moved to Oregon and began making trips into the Colorado Plateau and the Great Basin. "What is known [of O'Sullivan himself] is slim, suggestive, and ultimately mysterious itself," Snyder wrote back then, and it still holds. Snyder's book included the first good chronology of O'Sullivan's life and was accompanied by an exhibition at the Philadelphia Museum of Art in 1981, which was controversial at the time: Snyder and his collaborators made new prints using O'Sullivan's old negatives and the old albumen print process, but in doing so they gained new insights into his camera techniques and manipulations of prints, pointing me toward phenomenological investigations. In the following remark by Snyder, I think of the Greek word *anaisthēsia*, meaning "without sensation": "Many of the photographs outreach the esthetic classifications of their day because they verge upon being anesthetic—they stun and they numb."

I also referred to James D. Horan's *Timothy O'Sullivan: America's Forgotten Photographer* (Doubleday, 1966), for decades the only book on O'Sullivan. It makes up in enthusiasm what it lacks in an accuracy that came about only as researchers went deeper into photographic archives in the 1970s and '80s. Rick Dingus's 1982 book, *The Photographic Artifacts of Timothy O'Sullivan*, was especially helpful for insights into O'Sullivan's photographic process, and to read it is to come close to assisting the camera operator. The most exhaustive and in many ways most exciting work on O'Sullivan is *Framing the West*. Toby Jurovics edited the book, the plates of which read like an IMAX movie. A four-minute, twenty-two-second video on the Smithsonian Institute's YouTube channel that features Jurovics, posted in 2010, is a great introduction to O'Sullivan's work. I

am grateful for recent conversations with Jurovics, who is the founding director
of the Barry Lopez Foundation for Art & Environment and prior to that was
a curator at the Joslyn Art Museum and the Smithsonian. (Jurovics, I learned
when we met in 2022, is a friend of Janet Borden, a gallerist whose photographs,
especially those of the late John Pfahl, have influenced my books over the years.)
Framing the West includes O'Sullivan's western plates along with insightful essays
by scholars and curators, like William Stapp, who is both and wrote what is the
most extensive chronology of O'Sullivan's life in the field—and what little is
known of his life at home in the East; it's the definitive chronology. I don't know
how many times I have photocopied Stapp's pages, carrying them with me to
archives and libraries and into the West.

Specific essays about O'Sullivan that I refer to in the opening pages and
throughout include "Strangers in a Strange Land: Timothy O'Sullivan and
Henry Adams" by Colin L. Westerbeck Jr., in the March 1982 issue of *Art-
forum*; "O'Sullivan's Modernity" by Andy Grundberg, in *The New York Times*
Photography View column, November 1, 1981, Grundberg's review of the ex-
hibition that Joel Snyder had organized in Philadelphia; and an essay by Robert
Adams, the great New Jersey–born Oregon-based landscape photographer (and
former English professor), that served as the introduction to *The American Space:
Meaning in Nineteenth-Century Landscape Photography* (Wesleyan University
Press, 1983). Adams wrote: "With the pictures in hand there is no escaping the
gravity of our violence; the record is precise, as exact as the ruler O'Sullivan
photographed against Inscription Rock in New Mexico." I referred to *Lincoln's
Smile and Other Enigmas* and *Reading American Photographs: Images as History,
Mathew Brady to Walker Evans* by Alan Trachtenberg, who, when he died, in
2020, was remembered by Laura Wexler: "He demonstrated how photographs
help actively to produce, not merely to reflect, U.S. history and contemporary
political life." Among Martha Sandweiss's writing on photography, I returned
over and over again to *Print the Legend: Photography and the American West* (Yale
University Press, 2004). Ansel Adams's remark to Alfred Stieglitz, suggesting
that O'Sullivan "out-surs the sur-realists," was written on March 21, 1937, and
I read it in various places, including in "'Surrealistic and disturbing': Timothy
O'Sullivan as Seen by Ansel Adams in the 1930s," an essay by Britt Salvesen,
currently the department head and curator of the Wallis Annenberg Department
of Photography at the Los Angeles County Museum of Art. Published in the
Journal of Surrealism and the Americas in 2008, Salvesen's essay argues that Ad-
ams's and the Newhalls' work to disengage O'Sullivan from surrealists and their
"disturbing" tendencies—anxious to claim him as a "straight" photographer, i.e.,
a documentarian, what they saw as an "American" trait—limits our understand-
ing: "To acknowledge that his pictures capture the inhospitable, frightening, and
puzzling aspects of the Western landscape would set the stage for a richer, more
inclusive photohistory, in which the medium's early practitioners could be seen in
relation to diverse followers." The scholar Maria Kunda has noted that, though
the surrealists are not remembered as anti-colonial today, from 1919 and into the
post–World War II period of colonial rebellions, they regularly critiqued impe-
rialism and pushed anti-colonial texts, in particular supporting Vietnamese and

Algerian struggles for independence. Rather than engage with their critiques, critics denounced the surrealists as "primitive."

Peter Barberie made his observation on the transfer of photographs from archives to museum in the entry entitled "Criticism" in the 2013 edition of the *Encyclopedia of Nineteenth Century Photography*. Rosalind Krauss's critique of the ways in which O'Sullivan's work—and the work of other nineteenth-century survey photographers—was being moved from archives into galleries and art museums was published in the winter of 1982 in *Art Journal*, in an essay titled "Photography's Discursive Spaces: Landscape/View." Jurovics's remarks on the intimacy of large-format wet plate collodion photography come from a 2010 presentation on O'Sullivan at the Library of Congress, along with presentations by William Stapp and Carol Johnson, stored on the Library of Congress website: "Framing the West: The Survey Photographs of Timothy H. O'Sullivan."

I assisted my wife in the winter of 1989 as she made a large-format photo to accompany a March 6, 1989, *New Yorker* report, "Annals of Transportation: Light Rail," by Tony Hiss, who more than anyone over the past ten years has helped me see ecological connections on the North American continent; see his book *Rescuing the Planet: Protecting Half the Land to Heal the Earth* (Vintage, 2022). (Coincidentally, my wife's photo of Forty-Second Street was superimposed with a photo of a light-rail train in Portland, Oregon, where my wife was born, and where we were then about to move, encouraged by our landlord at that time, a jerk.) Around the same time, my wife introduced me to *Second View: The Rephotographic Survey Project* by Mark Klett, Ellen Manchester, and JoAnn Verburg (University of New Mexico Press, 1984). All the rephotography books caused me to become fascinated with JoAnn Verburg's more recent work, which, to me, explores ideas of time as space: less of a stricture or minutes- or seconds-measured border than a fluid dimension. I read about the idea of social photography in Martha Chahroudi's 1987 essay, "Twelve Photographers Look at Us," in the *Philadelphia Museum of Art Bulletin*; and about photographs as "equivalences" in Nathan Lyons's essay for a 1966 exhibition catalog, *Toward a Social Landscape: Bruce Davidson, Lee Friedlander, Garry Winogrand, Danny Lyons, Duane Michals*, edited by Nathan Lyons in collaboration with the George Eastman House.

The Washoe Nation's work to clean up mining contamination on their land was reported on in *Indian Country Today*, in a September 12, 2018, piece by James May, headlined "Washoe Tribe Successful in EPA Superfund Listing," describing the way the fifty-year-old Leviathan sulfur mine, at the seven-thousand-foot level in the Sierra Nevada mountains, taints Leviathan Creek, which flows off the east side of the Sierras through Washoe lands and into the Carson River system. (It still does, though the state of California has purchased the land, exempting the mining company, Arco, from further reparations.) The report quotes the Washoe elder Eleanore Smokey, who remembered visiting the creek decades earlier: "My children used to play in the creek. A few weeks ago we took some children up there, and while we're not sure this (the site) is the reason, some of the children got sick after we were there."

For an understanding of O'Sullivan's photographic process, I visited the Penumbra Foundation in New York City, to study the wet plate process firsthand. In

studying the history of photography, I referred to the *Encyclopedia of Nineteenth-Century Photography*. The *Boston Medical and Surgical Journal*, published in Massachusetts in 1848, describes collodion as "liquid adhesive plaster." Collodion was used to coat Doremus cartridges, named for Ogden Doremus, a chemist who worked for Napoleon, in France, and Robert Draper, in New York. According to *History of the Explosives Industry in America* (Columbia University Press, 1927), work on the coating happened at Columbia College in New York, where L. M. Dornbach first blew up a building—then, in 1862, himself. Confederates may have used it in weaponry deployed in their submarines, but Earl Hess, in *Civil War Field Artillery: Promise and Performance on the Battlefield* (LSU Press, 2022), describes guncotton as experimental at the start of the Civil War and more widely used by the time the American army resumed its western battles. The development of nitrocellulose for weapons also led to the development of early plastics and film.

Harvest of death

I learned about the Irish in New Orleans in Earl F. Niehaus, *The Irish in New Orleans: 1800 to 1860* (Louisiana State University Press, 1965), which states, "The post-1830 Irish migration across the North Atlantic resembled a great trunk line, with one branch curving south and terminating in New Orleans." I also referred to *Ireland and Irish Emigration to the New World from 1815 to the Famine* by William Forbes Adams, published in 1967 (originally 1932 by Yale University Press). In 1837, in *The Americans in Their Moral, Social, and Political Relations*, Francis Grund, a Bohemian writer who had moved to the United States, wrote:

> In spite of its hardships, life in the New World was a more peaceful and orderly affair than it had been in Ireland. America had no replica of the burnings and the shootings, the bludgeonings and hangings that marked the bitter struggle for land at home, though something of the same spirit cropped up in the labor disputes on canal and railway work in the thirties.

I also read *Cities of the Dead: Circum-Atlantic Performance*, a tremendous book by Joseph Roach (Columbia University Press, 1996) that inspired me to think of contemporary cities as performances unto themselves, places where the people living there act out and even interpret old histories. Descriptions of battle scenes are in *A Strange and Blighted Land: Gettysburg: The Aftermath of a Battle*, a 2018 history by Gregory A. Coco, a Louisiana-born Vietnam veteran who, as an interpretive ranger at Gettysburg, led two- to three-hour tours. (He quotes an officer describing a dead soldier, a Confederate: "Poor fellow lay upon the field with his entrails scattered all about by a cannon shot . . .")

Information about art in antebellum New York came from *Art and the Empire City: New York 1825–1861*, edited by Catherine Hoover Voorsanger and John K. Howat (Yale University Press, 2000). I referred to Robert Wilson's *Mathew Brady: Portraits of a Nation* (Bloomsbury USA, 2014) as well as Trachtenberg's *Reading American Photographs: Images as History, Mathew Brady to Walker Evans*. I also consulted *Mr. Lincoln's Camera Man* by Roy Meredith (Dover, 1974), which

puts O'Sullivan in battle, making an exposure as a row of guns with Battery D, Second U.S. Artillery fires, the gunners telling him to hurry "unless he was anxious to figure in the list of casualties." "During the barrage," Meredith writes, "O'Sullivan developed his plates." Though Brady's business suffered, he still attracted well-known clients. Adlai Stevenson, Grover Cleveland's vice president, planned to pose for Brady on April 17, 1894, but Brady was hit by a carriage the night before while crossing Fourteenth Street in Manhattan, the driver fleeing.

That Americans, in contrast with the Europeans, fell quickly in love with the daguerreotype comes from Donald Keyes, "The Daguerreotype's Popularity in America," *Art Journal* 36, no. 2 (1976). I also read "'Doing the Rest': The Uses of Photographs in American Studies" by Marsha Peters and Bernard Mergen, in *American Quarterly* 29, no. 3 (1977), which takes its title from the Eastman Kodak slogan: "You press the button, we do the rest." J. D. DeBow's remark that New York City was "almost as dependent on Southern slavery as Charleston itself" is examined in *A Covenant with Color: Race and Social Power in Brooklyn 1636–1990* (Columbia University Press, 2000) by Craig Steven Wilder, a history professor at MIT—while researching this book, I am grateful to have spoken with him regarding one of two reports I wrote for *The New Yorker* about Confederate monuments in New York City: "Facing History," in the June 19, 2017, print issue, and online on August 23, 2017, "It's Hard to Get Rid of a Confederate Memorial in New York City."

In considering the life of Gardner, I consulted Richard S. Lowry's 2015 *The Photographer and the President: Abraham Lincoln, Alexander Gardner, and the Images That Made a Presidency* and Mark Katz's 2019 *Witness to an Era: The Life and Photographs of Alexander Gardner: The Civil War, Lincoln, and the West.* I also read *Alexander Gardner: The Western Photographs 1867–1868* by Jane Lee Aspinwall. That Gardner's photos can be seen as "a politically motivated project, rooted in the photographer's Chartist and Owenite beliefs," comes from Makeda Best's *Elevate the Masses: Alexander Gardner, Photography, and Democracy in Nineteenth-Century America* and puts his ideas in a transatlantic conversation with, for example, Edouard Manet's painting *The Battle of the Kearsarge and the Alabama*, picturing the Civil War naval battle that took place off the coast of France. (In notes for an exhibition of the painting at the Met in 2003, a curator writes that while Proust suggested that Manet saw the battle from a small boat, no evidence exists, though Manet had spent time training to be a sailor.) Best also writes, "In *Sketch Book* Gardner expresses a political philosophy in the format of the photographic book and also references a reform literary genre: the travelogue."

In understanding the largely failed attempt to try Confederate leaders for treason, I referred to *The Lost Indictment of Robert E. Lee: The Forgotten Case Against an American Icon* by John Reeves. President Gerald Ford's pardon of Robert E. Lee is discussed in the Spring 2005 issue of *Prologue*, a now-defunct magazine of the National Archives:

> On October 2, 1865, the same day that Lee was inaugurated as president of Washington College in Lexington, Virginia, he signed his Amnesty Oath, thereby complying fully with the provision of Johnson's proclamation. But Lee was not pardoned, nor was his citizenship

restored. And the fact that he had submitted an amnesty oath at all was soon lost to history.

More than a hundred years later, in 1970, an archivist at the National Archives discovered [it] among State Department records (reported in *Prologue*, Winter 1970). Apparently, Secretary of State William H. Seward had given Lee's application to a friend as a souvenir, and the State Department had pigeonholed the oath.

In 1975, Lee's full rights of citizenship were posthumously restored by a joint congressional resolution effective June 13, 1865.

At the August 5, 1975, signing ceremony, President Gerald R. Ford acknowledged the discovery of Lee's Oath of Allegiance in the National Archives.

I consulted William Frassanito's *Gettysburg: A Journey in Time* and *Gettysburg: Then & Now*, and a *Washington Post* report, "Civil War Historian Makes Gettysburg His Focus and His Home," published on June 29, 2013. I read Susan Sontag's December 9, 2002, *New Yorker* essay, "Looking at War: Photography's View of Devastation and Death," which begins by questioning a conclusion she made in 1977, that repeated exposure to an event through photographs makes that event less real. "Is that true? I thought it was when I wrote it. I'm not so sure now." The book that guided me through all the Civil War photography was Jeff Rosenheim's *Photography and the American Civil War* (Yale University Press, 2013). In 2013, I was on a tour that Rosenheim led of the accompanying show at the Met, though I fell behind the group, not up to it.

In exploring the racialized stereotypes employed by Alexander Gardner in what was often called the first photo book, I turned repeatedly to a brilliant book, *On Alexander Gardner's Photographic Sketch Book of the Civil War* (University of California Press, 2007), a beautiful collaboration by Anthony W. Lee and Elizabeth Young, an art historian and a literary scholar, respectively. I also referred to *Picturing Frederick Douglass: An Illustrated Biography of the Nineteenth Century's Most Photographed American* (Liveright, 2015), which includes essays by Zoe Trodd, Henry Louis Gates, Celeste-Marie Bernier, John Stauffer, and Kenneth B. Morris Jr., the great-great-great-grandson of Frederick Douglass and the great-great-grandson of Booker T. Washington. At the 1892 Chicago World's Fair, Frederick Douglass was heckled by white audience members when he delivered a speech, "The Race Problem in America," on Colored People's Day, an occasion on which fair organizers distributed watermelon through the crowd. Douglass said, "There is no Negro problem. The problem is whether the American people have loyalty enough, honor enough, patriotism enough, to live up to their own constitution . . . We Negroes love our country. We fought for it. We ask only that we be treated as well as those who fought against it."

I was introduced to the notion that "the Civil War was not civil and the south won" in 2015, the year I read an address William Pencak gave to the Semiotic Society of America in 2000, a version published in the Summer 2001 *American Journal of Semiotics* as "The American Civil War Did Not Take Place (with apologies to Baudrillard)." Pencak's essay set the stage for my understanding of more recent

work in this vein, including a book I consulted toward the end of my project, *Civil War by Other Means: America's Long and Unfinished Fight for Democracy* by Jeremi Suri (PublicAffairs, 2022).

I learned about the African American community before and after Gettysburg from Margaret Creighton's *The Colors of Courage: Gettysburg's Forgotten History: Immigrants, Women, and African Americans in the Civil War's Defining Battle* (Basic Books, 2005). I also consulted "The Invasions of Pennsylvania," an essay by Ron Soodalter posted on the *New York Times* website on June 26, 2013, in which he described lesser-known invasions into Pennsylvania by Confederate forces. The army's involvement in films is covered in a documentary by Roger Stahl, who, in an interview posted on the *World Socialist Web Site* said, "It goes all the way back to films like *The Birth of a Nation*. The army assisted the film, which gave them some leverage over the story. This was the early model for what became a massive public relations operation." John Reeves, in his book *The Lost Indictment of Robert E. Lee*, made me aware of Woodrow Wilson's remark on Robert E. Lee and the fact that Eisenhower had Lee's picture on the wall. I read of the Battle of the Crater in Kevin Levin's *The Battle of the Crater: War as Murder* (University Press of Kentucky, 2012)—a book about the ways in which the United States has worked to dis-remember the Black soldiers, just as Gardner's photos work to do. Levin quotes the Richmond newspapers endorsing and encouraging the execution of Black soldiers: "Strengthen your stomach with a little brandy and wine, and let the work, which God has entrusted to you and your brave men, go forward to its full completion; that is, until every Negro has been slaughtered." W.E.B. Du Bois's assertion that the North "went to war without the slightest idea of freeing the slave" is from his *Black Reconstruction in America*. "Gettysburg Residents Seek Black History Museum" by Kevin Begos appeared on June 26, 2013 in *The Philadelphia Tribune*, the oldest continuously published African American newspaper in the United States.

In researching the crossing of the Rappahannock, I benefited from reading the blog of John Hennessy, recently retired as chief historian at Fredericksburg and Spotsylvania National Military Park. Susie Melton is quoted in *The Negro in Virginia*, written for the Federal Writers' Project in 1940. I watched Mali Lucas-Green—a descendant of Moses Lucas and Mildred Lucas, two people who crossed the river at the time O'Sullivan pictured it—share her family's story in a presentation at the Fredericksburg and Spotsylvania Park on December 9, 2022, commemorating the 160th anniversary of the Battle of Fredericksburg. The details were recounted in a December 13, 2022, Fredericksburg *Free Lance-Star* story, "Descendant of Enslaved Couple Who Crossed the Rappahannock to Freedom Eager to Tell Their Story," by Adele Uphaus, which reports:

> As part of her self-education, she started visiting plantations and Confederate sites. "I was always treated rudely, as if I didn't belong there," she said. That changed when she visited the Fredericksburg and Spotsylvania National Military Park this fall. She felt "welcomed by the energy" of Maddie Hollis, the park ranger she encountered. Lucas-Green told Hollis that she was descended from enslaved Americans

who crossed the Rappahannock River to freedom near the site of the Battle of Fredericksburg. The two had a long and candid conversation. "We connected," Lucas-Green said. "That's the first time at a Confederate site that I felt that."

Remarks at the Gettysburg reunion are from *Reunion of the Society of the Army of the Potomac*, published by the society in 1885. Senator Ingalls's speech is in *A Collection of the Writings of John James Ingalls*. New Jersey governor Richard Hughes's remarks are in a July 2, 1963, *New York Times* report by Edith Evans Asbury, "Hughes Charges Moral Failure to Aid Negroes Since Civil War." At the same commemoration, Governor George C. Wallace laid a wreath at a memorial for Alabama Confederate soldiers, saying that they fought for the Constitution. "We stand among the descendants of brave men who fought for North and South, and we still stand for defense of the Constitution."

Soda Lake

For the itinerary of the survey, I am indebted to, as mentioned, William Stapp, the photographic historian and curator. Also helpful was *King of the 40th Parallel: Discovery in the American West* by James Gregory Moore (Stanford University Press, 2006) and *The Explorer King: Adventure, Science, and the Great Diamond Hoax: Clarence King in the Old West* by Robert Wilson (Scribner, 2006). On April 23, 2022, the *Los Angeles Times* wrote:

> Now, as part of an effort to present a fuller picture of the region's importance to the Indigenous people of Owens Valley, five local tribes have nominated 186 square miles of the lakebed for listing in the California Register of Historical Resources and in the National Register of Historic Places . . . At 119,303 acres, the proposed Patsiata Historic District would be the largest National Register site in California . . . It would join a growing number of national historic districts in California created to memorialize the traditions and history of Indigenous people, and their resilience and resistance in the face of genocidal policies.

A history, titled "The MX Missile Project," is a chapter in Martha Sonntag Bradley's 1999 *A History of Beaver County*, published by the Utah State Historical Society. In *Red Flag: Air Combat for the 1980s* (Presidio Press, 1984), Michael Skinner writes, "As part of the realistic scenario, pilots who were 'shot down' at Red Flag used to be hauled out of their cockpits upon landing and helicoptered back to where they ejected . . ."

The term "treasonous in their apparent refusal to learn English" is in "Slave Emancipation, Indian Peoples, and the Projects of a New American Nation-State" by Steven Hahn, in the September 2013 *Journal of the Civil War Era*, an article that influenced the Great Basin chapters, especially. Battlefields as meetings of future railroad executives is from *Railroaded: The Transcontinentals, and the Making of Modern America* by Richard White, and for the insights into the relationship between the landscape and corporations I turned to a report in *The*

Nation, November 1, 2021, "Land of Capital: The History of the United States as the History of Capitalism" by Steven Hahn, as well as "The Corporation and the Tribe" by Joanne Barker, in the *American Indian Quarterly* 39, no. 3 (2015).

In reference to workers who emigrated from China to build the railroads, I referred to *Beyond Silence: Chinese Canadian Literature in English* by Lien Chao. In *The Chinese in America: A History from Gold Mountain to the New Millennium*, I read an essay by Nancy S. Lee that described how the Chinese workers weren't just erased but diminished: "'Men slaved and sweated; some sickened and died, *but* [Lee's emphasis] the railroad pressed on.' The word 'but' redirects the emphasis in this sentence away from the men who slaved and died to the railway's unhindered progress." The relationship between James Joyce's character Gabriel Conroy in "The Dead" and Bret Harte's book *Gabriel Conroy*, about the Donner Party—is Joyce alluding to the Irish famine via the western tale of great hunger?—is postulated in Bonnie Roos's "Gabriel Conroy: The Nature of the Feast" (*The Yale Journal of Criticism*, Spring 2002). Governor Edmund Brown is referenced in *The Politics of Prejudice: The Anti-Japanese Movement in California and the Struggle for Japanese Exclusion* by Roger Daniels (University of California Press, 1977). Julie Schablitsky's report on archaeological work in the Donner camp, "Letter from California: A New Look at the Donner Party," is in the May/June 2012 issue of *Archaeology*.

To the dune

I read Margaret Wheat's *Survival Arts of The Primitive Paiutes* (University of Nevada Press, 1967) and her biography on Nevada Women, the website of the Nevada Women's History Project. The airfield in Fallon is named for a local resident, Bruce Van Voorhis, who died in World War II, flying alone during the Solomon Islands campaign. "Lt. Comdr. Van Voorhis took off in total darkness on a perilous 700-mile flight without escort or support," reads his Medal of Honor citation. He reached and destroyed his target in bad winds, pursued by fighters, then, caught in his own bomb blast, crashed into a lagoon. Michael Branch's essay was on *High Country News*' website in a feature called "Rants from the Hill," the January 7, 2013, post titled "A Prospect from the Singing Mountain": "To appreciate Sand Mountain requires leaps of imagination." The translation of Wuzzie George's prayer is in W. R. Miller's *Uto-Aztecan: Structural, Temporal, and Geographic Perspectives: Papers in Memory of Wick R. Miller by the Friends of Uto-Aztecan* (Universidad de Sonora, 2000). Catherine Fowler's reminiscences about Wuzzie George and Sven Liljeblad are from *The Northern Paiute–Bannock Dictionary* (University of Utah Press, 2012). Peg Wheat's interviews with Wuzzie George, "Oral history interview (1 of 2) with Wuzzie George, side B," are in the database of the University of Nevada, in the Margaret M. Wheat Collection. Jeniffer Solis's story, "Nevada Delegation Teams Up to Expand Fallon Bombing Range," in the December 8, 2022, *Nevada Current*, describes an expansion by the army that protected tribal land:

> Under the bill, the Fallon-Paiute Shoshone Tribe would receive $20 million for the establishment of the Numu Newe Cultural Heri-

tage Center, meant to preserve traditional knowledge, culture, and language. The bill would also award the Walker River Paiute Tribe a $20 million settlement as compensation for thousands of acres of tribal land contaminated and polluted by military testing and training exercises, as well as more than 18,000 acres of land held in trust for the tribes to replace those lost to the bombing range expansion.

In studying Sand Mountain, or Kwazi, I was privileged to speak with Donna Cossette, a resident of the area who works at the Churchill County Museum and Archives.

Pyramid Lake

The Humboldt Code is mentioned in Cheryl Walker's *Indian Nation: Native American Literature and Nineteenth-Century Nationalisms* (Duke University Press, 1997), which, in analyzing Sarah Winnemucca's book, describes the complications of individual political action in light of diaspora: "There must be some center. But there must also be a recognition of the incoherence, the instability, the inevitably exclusionary nature of all such centers. It is these features of 'nation' that Native American writings such as *Life Among the Piutes* help us to see most clearly." Ridgway reminiscences about Pyramid Lake in "Biographical Memoir of Robert Ridgway, 1852–1929" by Alexander Wetmore, presented at the 1931 annual meeting of the National Academy of Sciences. Frémont's career is summed up in a September 26, 2016, report by Chris Clark on the website of KCET, the Southern and Central California public television station: "Untold History: The Survival of California's Indians." On BenitoLink, a Benito County, California, nonprofit news website, Frank Pérez reported on December 2, 2019, that the Amah Mutsun Tribal Band—descendants of the Mission Indians of Missions San Juan Bautista and Santa Cruz—refused Governor Gavin Newsom's apology to California tribes, and, referencing Frémont's role in the Sacramento River Massacre, the tribe insisted that the state "change the name of locations that are named after persons who committed atrocities against the California Native Americans."

In thinking about the Pyramid Lake photos, I studied Robin Kelsey's *Archive Style: Photographs & Illustrations for U.S. Surveys, 1850–1890* (University of California Press, 2007). It's a book that helped me reframe O'Sullivan's work when I first read it in 2013, pointed out to me by Jill Desimini, whose writing on so-called abandoned lands has also informed my survey: see *Cyclical City: Five Stories of Urban Transformation* (University of Virginia Press, 2022) and *From Fallow: 100 Ideas for Abandoned Urban Landscapes* (ORO Editions, 2019). I also drew from Robin Blyn's *The Freak-Garde: Extraordinary Bodies and Revolutionary Art in America* (University of Minnesota Press, 2013), which posits the photos of extraordinary bodies as a critique of liberal capitalism, citing as a literary parallel Mark Twain's *Those Extraordinary Twins* and *Pudd'nhead Wilson*: "The novels confirmed that the only way to enjoy legal protections is to disown the autonomy and integration of liberal subjectivity and to become a 'corporate person.'" I also referred to "The Beauty and the Freak" by Rosemarie Garland Thomson, in *Michigan Quarterly Review*, XXXVII, no. 3: *Disability, Art, and Culture (Part*

Two), Summer 1998: "Spectacles such as beauty pageants and freak shows entail structured seeing. Unlike participatory rites such as Carnival, these visual spectacles enact what Susan Stewart calls 'the pornography of distance,' by founding a triangle composed of the viewer, the object viewed, and the mediating forces that regulate the encounter."

Mining

In looking at the history of mining, I consulted Richard White's *It's Your Misfortune and None of My Own: A New History of the American West* (University of Oklahoma Press, 2015). The note on cattle in Montana comes from *The WPA Guide to Montana: The Big Sky State* (Trinity University Press, 2013). Louise Amelia Knapp Smith Clappe's letters were published as *California in 1851–1852: The Letters of Dame Shirley* (Grabhorn Press, 1933). On the Comstock Lode's history, I referred to "History, Technological Innovation, and Potential for Industrial Archaeology of the Old Savage Mine Site, Virginia City, Nevada," by Sarah E. Cowie and Lisa Machado in *Nevada Archaeologist* 26 (2013), as well as *History of the Big Bonanza: An Authentic Account of the Discovery, History, and Working of the World Renowned Comstock Silver Lode of Nevada, Including the Present Condition of the Various Mines Situated Thereon* (American Publishing Company, 1876), by the inimitable Dan De Quille, the fabulist Woodward to Twain's Bernstein. Edmund Randolph's "Address on the History of California, from the Discovery of the Country to the Year 1849" was delivered to the Society of California Pioneers on the tenth anniversary of California's statehood. Patricia Nelson Limerick's note on power and resentments is in her 1987 book *The Legacy of Conquest: The Unbroken Past of the American West*, where she also writes about how settlers were captivated by captivity narratives: "It was an easy transition of thought to move from the idea of humans held in an unjust and resented captivity to the idea of land and natural resources held in Indian captivity . . . Land and natural resources, to the Anglo-American mind, were meant for development."

Also consulted: Daniel Cornford's essay "More Like Brutes Than Humans," in *A Golden State: Mining and Economic Development in Gold Rush California* (University of California Press, 1999) and *After the Gold Rush: Society in Grass Valley and Nevada City, California, 1849–1870*, by Ralph Mann (Stanford University Press, 1982). The idea that the engineering methods employed destroyed the piñon forests came from an excellent book by Ronald James, *The Roar and the Silence: A History of Virginia City and the Comstock Lode* (University of Nevada Press, 2012). Statistics about value of ore on Nevada Territory are drawn from *The Civil War Era and Reconstruction: An Encyclopedia of Social, Political, Cultural and Economic History* by Mary Ellen Snodgrass (Taylor & Francis, 2015), which notes:

> Three Irish immigrants—James Graham Fair of Clogher, John William Mackay of Dublin, and William Shoney O'Brien of Abbeyleix, Ireland—and one Irish American, James Claire Flood of New York, made $3 million per month from the Consolidated Virginia Silver Mine and the California Mine, enough money to earn the nickname "Bonanza Kings."

Notes on the cave-ins came from "Saga of Mining's Darkest Days—the Comstock Tragedy," an excerpt from an 1883 USGS report republished in *Mine Safety and Health* in 1979 (U.S. Government Printing Office).

Regarding Confederate invasions, I read "Causes of the Confederate Invasion of New Mexico" by Charles S. Walker, in *New Mexico Historical Review*, April 1, 1993, as well as the excellent and most helpful *The Three-Cornered War: The Union, the Confederacy, and Native Peoples in the Fight for the West* (Scribner, 2021) by Megan Kate Nelson (put under my nose as I worked my final drafts by David Diehl, a descendant, readers of my book on the New Jersey Meadowlands will know, of Meriwether Lewis). The letter written by Baylor to his Confederate commanders is in Congress's fifty-three volumes of reports on the war, first published in 1882, and can be found online under the title *The War of the Rebellion: a compilation of the official records of the Union and Confederate armies,* and is described as "Formal reports, both Union and Confederate, of the first seizures of United States property in the southern states, and of all military operations in the field, with the correspondence, order and returns relating specially thereto."

Nearly all the information regarding the archaeological digs in Virginia City comes from *Virginia City: Secrets of a Western Past* (University of Nebraska Press, 2012), in which Ronald M. James sifts through a decade of insights through digging—by volunteers, students, and academic archaeologists—into the historic boomtown. Among the key contributors is Kelly Dixon, who studied the Donner site in Washoe territory and, in 2006, wrote "Archaeology of the Boston Saloon," in *African Diaspora Archaeology Newsletter*:

> Descriptions of places like the Boston Saloon provide fodder for sanguine conclusions about life for African Americans in the West. Although racial prejudice was not as widespread in the nineteenth century West as it was in the Jim Crow South, it is important to bear in mind that the West was not a "utopian promised land" for people of African descent. Even so, African American families worked together to make better lives for themselves, as did groups, or communities of African Americans in the West. The chronicles of these individuals are numerous and complex.

The discovery of Tabasco bottle shards was widely covered in the press—e.g., "Apparently, a Hot Time in the Old (West) Town" in the *Los Angeles Times*, June 30, 2002.

Info on mining in Allihies comes from the Allihies Copper Mine Museum in Beara, West Cork, Ireland, and from "Miners in Migration: The Case of Nineteenth-Century Irish and Irish-American Copper Miners" by Timothy M. O'Neil, in *Éire-Ireland* (Spring–Summer 2001). O'Neil references Riobard O'Dwyer's genealogical studies of the Beara Peninsula, which cite considerable migration to Butte. In an essay titled "'What a Pity at the Very Source of Wealth': Strikes and Emigration, Berehaven Mining District, 1861–c.1900," published in a 2009 issue of *Saothar*, the journal of the Irish Labour History

Society, Michael O'Connell writes of the extreme poverty at the Berehaven mines, the workers agitating for better treatment before heading overseas, where they would again agitate. "The houses," *The Cork Examiner* wrote in 1868, "were so desperate that the reporter thought they might be abandoned." Not all Comstock miners were from the Beara Peninsula but, according to *Mining Irish-American Lives: Western Communities from 1849 to 1920* by Alan Noonan, "the greatest concentration of Irish miners was found in Storey County, Nevada, home to the silver mines of the Comstock Lode, and the town of Virginia City; in Lake County, Colorado, where Leadville developed into another large silver mining center; and in Silver Bow County, Montana, with its Irish dominated Coppermine city of Butte." The reference to the "lately revealed miseries of the Berehaven Miners" comes from "The Anatomy of Failure: Nineteenth-Century Irish Copper Mining in the Atlantic and Global Economy," by William H. Mulligan Jr., an essay in *The Irish in the Atlantic World* (University of South Carolina Press, 2010).

Clarence King

In addition to already mentioned references on Clarence King, I likewise drew from *Clarence King: A Biography* by Thurman Wilkins (Macmillan, 1958), as well as "Something Newer and Nobler Is Called into Being: Clarence King, Catastrophism and California" by Keith R. Burich, in *California History*, Fall 1993; "The Shiftless Belligerent Pike: An Early Western Emigrant Type as Described by Clarence King" by R. H. Pearl, in *The California Historical Society Quarterly*, June 1959; and "Clarence King: Scientific Pioneer" by Robert Berkelman, in *American Quarterly*, Winter 1953. Berkelman asks, "Was Clarence King a failure?" Then doesn't answer. *The New Encyclopedia of the American West* (Yale University Press, 1998), which I referred to continually, notes his year at the USGS, then says, "The remainder of King's life was anticlimactic." The idea that his own noninvolvement in the war may have been on King's mind comes from Geoff Cohen's essay, "'I Hear the Musketry of the Falls': Systematic Geology, the Civil War, and Nation Building," in *A/TQ*, December 2004. The idea that naturalists, as well as what we might call broadly interested literary geologists, came to be considered amateurs comes from *The Humboldt Current: Nineteenth-Century Exploration and the Roots of American Environmentalism* by Aaron Sachs, who noticed that King's friends were obsessed with failings:

> After he died, eleven friends contributed appreciative essays to a volume called *Clarence King Memoirs*, one of the most remarkable books I have ever read. The four-hundred-page tome contains a certain amount of fluff, of course, but the depth of understanding is palpable: these people clearly spent hours, days, trying to come to grips with the meaning of King's life.

John Tyndall's 1861 report is titled "The Bakerian Lecture: On the Absorption and Radiation of Heat by Gases and Vapours, and on the Physical Connex-

ion of Radiation, Absorption, and Conduction" and published in *Philosophical Transactions of the Royal Society of London*.

My exploration of King's secret life started with Martha Sandweiss's very excellent *Passing Strange: A Gilded Age Tale of Love and Deception Across the Color Line* (Penguin Press, 2009), part history, part detective story. In 2009 she presented the book to the USGS, mentioning that her original title referenced Clarence King, but her publisher and friends told her that no one knew who Clarence King was. To learn about Clover Adams, I read Patricia O'Toole's *The Five of Hearts: An Intimate Portrait of Henry Adams and His Friends, 1880–1918* (Simon & Schuster, 2007), as well as Gary Wills's *Henry Adams and the Making of America* (Houghton Mifflin, 2007). I found Vivian Gornick's essay on Clover Adams in *The End of the Novel of Love* (Beacon, 1997) to be deeply insightful, as well as moving. Somewhat serendipitously, in 2014, shortly after I began my survey of O'Sullivan, I moved to the neighborhood where King first lived with Copeland, which was being voraciously gentrified. I regularly walked past the navy yard from which O'Sullivan set out for Panama. The July 1, 2015, *Washington Post* reported on the Virginia Racial Integrity Act: "How a Long-Dead White Supremacist Still Threatens the Future of Virginia's Indian Tribes" by Joe Heim. On August 16, 1900, the front-page headline in *The New York Times* read "Race Riot on the West Side": "The police contented themselves with trying to protect the Negroes, and it was remarked by many witnesses of the riot that they made little or no attempt to arrest any of their assailants."

Salt Lake

The term *liquid intelligence* comes from Kaja Silverman's *The Miracle of Analogy, or The History of Photography*, in which Silverman cites Jeff Wall's 1989 essay, "Photography and Liquid Intelligence":

> Like most of the other writings that we return to again and again, it is full of seemingly unresolvable contradictions. These contradictions radiate out from the notion of "liquid intelligence," which links terms that are hard to think together and whose locus keeps shifting. Sometimes Wall attributes this intelligence to liquids, sometimes he situates it within chemical photography, and sometimes he imputes it to nature, the world, or even the cosmos. He distinguishes it at every point in his argument from another kind of intelligence: "optical" or "technological" intelligence.

The note on geologic variety in Utah comes from *Field Guide to Tectonic Evolution of Utah's Central Wasatch Range* by Ron Harris, a geologist at Brigham Young University. Gardner's quote comes from James Gregory Moore's work, infused with letters from a descendant of Gardner's who lives near Moore in California. Notes on Watkins are from Robin Kelsey's *Archive Style*. Albert Tracy's journals were published in 1945 in the journal of the Utah Historical Society. The history of the old resort I saw in the fog at the Great Salk Lake is recounted in a July 21, 2022, report in *The Salt Lake Tribune* written by Palak Jayswal, "Here's How the Great Sal-

tair Became a Relic." Among the various reports on the hydrological emergency at the Great Salt Lake are "Emergency Measures Needed to Rescue Great Salt Lake from Ongoing Collapse," by a group of scientists at Brigham Young University, on January 24, 2023: "Great Salt Lake is facing unprecedented danger. Without a dramatic increase in water flow to the lake in 2023 and 2024, its disappearance could cause immense damage to Utah's public health, environment, and economy."

Panama

An online exhibit at the National Library of Scotland—*"The key of the universe": Scotland and Darien, 1695–1707*—lists the dates of the colony and features maps and documents. I also consulted "'To Transmit to Posterity the Virtue, Lustre and Glory of Their Ancestors': Scottish Pioneers in Darien, Panama" by Mark Horton, in *Bridging the Early Modern Atlantic World: People, Products, and Practices on the Move* (Ashgate, 2013). "Address on the *Cumberland*" by Admiral Selfridge, 1885, is online at the U.S. National Archives website. I read *The Path Between the Seas: The Creation of the Panama Canal, 1870–1914* by David McCullough (Simon & Schuster, 2001), and the trip is described in Horan, albeit with a tangled itinerary. The video *Being Emberá—Indigenous Culture Needed to Protect Forests* describes the struggle faced by Indigenous Emberá communities in Panama. It is produced by If Not Us Then Who? Ligia Arreaga's case is detailed on the web page of Frontline Defenders, an international human rights organization founded in Dublin in 2001 with the specific aim of protecting human rights defenders at risk.

I read "Panamanian Indigenous People Act to Protect the Forest from Invading Loggers," an article by Guido Bilbao posted on April 2, 2019, on *Mongabay*, an ecological news service. I also referred to a short film, *The Defenders of the Darién Gap*, posted on April 1, 2019, on *Mongabay*'s YouTube channel. A description of the film notes that the Darién Gap is

> an area of intense land-use conflict, a dramatic situation marked by the encroachment of the palm oil business and the forest industries in Panama and Colombia, the cutting of illegal roads and the trafficking of drugs and people. Endangered by these predatory land and natural resource transactions and their ancestral way of life threatened by rampant deforestation, the indigenous Kuna, Emberá and Wounaan people have asked the government of Panama to give them title to more than 650,000 hectares (1.6 million acres) of this land to protect what remains of their forest resources. Among the indigenous people who are carrying out ambitious projects to stop the degradation of the Darién Gap are mappers, a drone pilot, a lawyer, bird-watchers, a journalist and reforesters.

Carlos Doviaza's work was also covered by Guido Bilbao in the Panamanian newspaper *La Prensa* and featured in a 2021 National Public Radio report by Sofia Moutinho, "How One Man—and a Creative Map—Made a Difference in Panama's COVID-19 Crisis."

Death Valley

I read Richard A. Bartlett's *Great Surveys of the American West* (University of Oklahoma Press, 1962), an early guide through the itineraries of the western surveys generally; Richard E. Lingenfelter's *Death Valley and the Amargosa: A Land of Illusion* (University of California Press, 1988); *The Story of Inyo* by Willie Arthur Chalfant (published by the author, 1922); *A History of the Lands Added to Death Valley National Monument by the California Desert Protection Act of 1994: Special History Study* by Harlan D. Unrau (Denver Service Center, 1997); and *Death Valley National Monument: Historical Background Study* by Benjamin Levy (U.S. Office of Archaeology and Historic Preservation, Division of History, 1969). The newspaper clippings kept in a scrapbook by the Wheeler survey are held at the Bancroft Library at UC Berkeley, but I read them on microfilm in 2013 while working in the Wertheim Study at the New York Public Library, a privilege for which I remain grateful to Jay Barksdale, then the room's administrator. On December 9, 1871, *Appleton's Journal*, in its obituary for Loring, wrote, "We offered the position to Mr. Loring, who accepted it with the greatest eagerness and enthusiasm. Such an expedition exactly suited his romantic and adventurous disposition, and Lieut. Wheeler and the rest of the party were delighted with the acquisition of so bright, buoyant, handsome, and gifted a comrade." *The New York Times* reported on Loring's death on several occasions, on November 25, 1871 ("The details of the Wickenburg, Arizona, massacre leave no possibility of doubt that F.W. LORING, of WHEELER's expedition, was killed by the Apaches"), and again on January 1, 1872, in "The Wickenburg Massacre; First Authentic Account from an Eye-Witness. Letter from a Wounded Survivor How Young Loring Was Killed." In reading about Loring—and in considering relationships generally on the survey teams—I consulted *Queer Cowboys and Other Erotic Male Friendships in Nineteenth-Century American Literature* by Chris Packard (Palgrave Macmillan, 2006).

I found all Doris Ostrander Dawdy's work not just helpful in understanding O'Sullivan but insightful in the deepest ways about the United States' formulation of the West—in her work on American artists in the West, on exploring the history of politics and water use, and even in her work in documenting the work of Navajo women and Native American artists generally. I relied heavily on her own Wheeler survey, *George Montague Wheeler: The Man and the Myth* (Swallow Press/Ohio University, 1993). I also read "A Western View of the Race Question" by Francis Newlands, published in the 1909 edition of *The Annals of the American Academy of Political and Social Science*. When I think of my work in the New York Public Library, Hunter College Library, Middlebury College Library, as well as the Brooklyn Public Library and the Free Library of Philadelphia, a note Dawdy wrote in her own acknowledgments rings true for me: "Librarians at these institutions made my hours of research pleasant and productive." A September 29, 2018, *Washington Post* story by Terence McArdle, "The Racist History of Chevy Chase, Long Home to Washington's Power Players," details Newlands's history in the D.C. area.

I was introduced to the Salt Songs by Frederic Murray, the instructional services librarian at Southwestern Oklahoma State University, in a paper he

presented in 2011, "Shifting Boundaries: Violence, Representation, and the Salt Songs of the Great Basin Peoples," in which he equated the Salt Songs with a Homeric song cycle. Murray and I spoke on the phone in 2017, and shortly thereafter Phil Klasky spoke with me when I called him out of the blue. I read his writing on Ward Valley, and I feel fortunate to have been connected by Klasky to Matthew Leivas. Klasky wrote many pieces on the effort to prevent nuclear waste from being dumped in Ward Valley, including a piece in the October 2000 issue of *YES! Magazine*, "Song of the Land," accessible online. The 1994 congressional hearings on Ward Valley are also available online, and a two-part summary of the work to stop the dump was written in February 2013 by Chris Clarke on KCET's website under the title "They Kept Ward Valley Nuclear-Free." Klasky worked on the Salt Song Project with Matthew Leivas (Chemehuevi) and Vivienne Jake (Kaibab Paiute), as well as the Cultural Conservancy, to produce a tremendously powerful documentary that I watched, *The Salt Song Trail*. Since I spoke with Leivas, Klasky passed away suddenly in 2022. A beautiful remembrance that includes the singing of a sacred Salt Song is featured in a program called *90 Miles from Needles*, season 1, episode 10, entitled "Remembering Phil Klasky and Ward Valley." "Our love to you Phil, from all the people who fought for Ward Valley," Leivas says.

The description of Ward Valley as the most useless valley in the United States was in the January 24, 1994, *New York Times* under the headline "A Test Case for Nuclear Disposal." On place-names, I consulted *California Place Names: The Origin and Etymology of Current Geographical Names* by Erwin Gustav Gudde and (updated by) William Bright (University of California Press, 2004). On Devils Hole, see "Regional Groundwater Flow in Structurally-Complex Extended Terranes: An Evaluation of the Sources of Discharge at Ash Meadows, Nevada," in the *Journal of Hydrology* 386, issues 1–4 (2010).

Up the Colorado River

I viewed Wheeler's Colorado River trip in a stereo viewer at the New York Public Library. It was like going to a movie about an adventure. I read about Edward Curtis there too, in Timothy Egan's *Short Nights of the Shadow Catcher* (Houghton Mifflin Harcourt, 2012). The June 6, 1908, *New York Times* described Curtis's prints project, offered then at $3,000, as a triumph, sponsored in part by J. P. Morgan: "Work on the Aborigine, a Marvel of Pictorial Record." In examining Curtis's photo of Kikisoblu, described as the last surviving child of Chief Seattle, as she dug clams and did laundry, critics have noted that it was illegal for a Native American to live in Seattle at the time, the nostalgia for the old city in a rapidly developing new one a driver of Curtis's nostalgic quest. A headline cited by Egan, extolling Morgan financial support: "Morgan Money to Keep Indians from Oblivion."

The short title of Samuel Bowles's book is *Our New West* (Hartford Publishing, 1869); the long one is very long. The directors who filmed World War I are described in *Five Came Back: A Story of Hollywood and the Second World War* by Mark Harris (Penguin, 2015). (Note that, as *Why We Serve*, the National Museum of the American Indian's 2020 book, explores, since 2001, 19 percent of Native Americans have committed to the armed forces, compared with

14 percent of all other U.S. ethnicities.) Michael "Machine Gun" Kelley's obituary was in *The Sacramento Bee* on January 12, 2011. It described Kelley's writing as "focused on demystifying aspects of the war experience." "Mike Kelley was a force of nature," said Marc Leepson, the arts editor of *The VVA Veteran*. "He was severely wounded in Vietnam, but through drive and determination he recovered and became a first-class artist and a forceful writer." I referred to *Shook Over Hell* by Eric T. Dean Jr., a comparison of post-traumatic stress in Vietnam and the Civil War. It is where I gleaned insights into the term *blue*; I am referring to his historical casework. Dawdy quotes Frank "Mickey" Schubert, a Vietnam veteran and a Department of Defense historian, who called Wheeler's 160-mile, 31-day boat trip "superfluous." "'Wheeler paid dearly for the unnecessary journey,' said Schubert . . . 'His impetuosity and publicity-consciousness seriously diminished the results of his first season's work.'"

Inscription Rock

I read a geologic history of El Morro, written by Shari A. Kelley, a geophysicist and field geologist with the New Mexico Bureau of Geology and Mineral Resources. I read *The Water Supply of El Morro, National Monument* by Sam W. West and Hélène L. Baldwin, a National Park Service publication, written in 1965, when it was suggested that the United States might be in dire need of water by 2000. I heard the Indigenous languages of Náhuatl and Quechua spoken in Philadelphia—among other places, on PhillyCAM, a community TV station, on a program called *Atrévete Philly*, hosted by Ruben Chico, a cultural activist and Náhuatl speaker, and Américo Mendoza-Mori, a professor of Quechua at the University of Pennsylvania. I read E. A. "Tony" Mares's poem in *Mestiz@ Scripts, Digital Migrations, and the Territories of Writing* by Damián Baca (Palgrave Macmillan, 2008). Note Po'pay's power source, as described by Mares: "My authority flows / Within and around the earth, / Within and around the mountains, / Like the waters flow / Through pueblo lands." "By writing from the perspective of Popé," Baca writes, "Mares metaphorically rereads his own history through the eyes of oppressed." A 1938 National Park Service survey of El Morro describes the various inscriptions on the rocks. Numerous contemporaneous news outlets reported on Oñate's monument in Albuquerque, including a June 15, 2020, *New York Times* report by Simon Romero, which states:

> At one point during the protest, Oñate's foot even made a surprise appearance. Three men wearing masks carried the bronze foot, taken all those years ago, to the entrance of Tiguex Park near the statue, and briefly held the foot aloft. One of the men was Brian Hardgroove, a bass player for the hip-hop group Public Enemy. Mr. Hardgroove, who lives in New Mexico and has worked as an artist in residence at the Santa Fe University of Art and Design, said he came to express support for solidarity between Native Americans and African-Americans.

In *Archive Style*, Robin Kelsey says this about the possibility of the five in the inscription being a seven:

The theatricality of this photograph may have been bolder still. The inscribed characters are surprisingly dark in the photograph. In person, as the inscription exists now, they seem quite light, especially the stray mark atop the second numeral of the year, which appears significantly more shallow than the characters around it. Over a century has passed since O'Sullivan took his photograph, but nonetheless, as a visitor to the site, I found it hard to imagine that someone could seriously entertain the notion that this stray mark belonged to the inscription. In light of these facts, it seems plausible that O'Sullivan or an assistant darkened the inscribed characters, as well as the stray mark, to make them more distinct and Wheeler's fanciful interpretation more compelling.

When I visited El Morro to photograph O'Sullivan's inscription, I learned that park rangers had darkened selected inscriptions with graphite in the 1930s, to make them more legible. They do not appear to have done so to O'Sullivan's, which is today obscured by trees. *The Irish Americans: A History* by Jay P. Dolan (Bloomsbury Press, 2008) parses the term *Scotch-Irish*. For a time, the term *Irish* identified both Catholic and Protestant Irish. "But as political and religious conflict between Catholics and Protestants both in Ireland and the United States became more frequent, and as Catholic emigrants began to outnumber Protestants, the term *Irish* became synonymous with Irish Catholics," writes Dolan. The waves of poor Irish Catholics during the famine migration coupled with nativists' anti-Catholicism meant that, Dolan writes, "in no way did Irish Protestants want to be identified with these ragged newcomers." For information about the Irish and O'Connell's repeal societies, I referred to Angela F. Murphy's "Daniel O'Connell and the 'American Eagle' in 1845: Slavery, Diplomacy, Nativism, and the Collapse of America's First Irish Nationalist Movement," in the *Journal of American Ethnic History* 26, no. 2 (2007), and to Noel Ignatiev's 1995 *How the Irish Became White*, a still-excellent book.

Many Irish writers point to Frederick Douglass's respect for Daniel O'Connell, and to O'Connell's reproach to slavery supporters, but O'Connell drew the ire even of Irish Americans when he made a political calculation to back England's bid to restrict Texas's statehood—in the transatlantic battle for control of cotton markets and markets in general, the issue of slavery fell by the wayside. Karl Marx, a *New York Herald* European correspondent, saw Ireland as an Achilles' heel for the British Empire but was overenthusiastic about Lincoln and the North (given the British ruling class's support for Southern plantation owners), yet predicting the imperial aspirations along the lines of what the Confederates envisioned and what post–Civil War United States enacted. "The populist rhetoric of American capitalism veiled a reality which was predatory and imperialistic even in the 1860s, and the war against the South was undoubtedly part of its imperial expansion," David Fernbach wrote in his introduction to Volume II of Karl Marx's political writings (Verso Books, 2019). In 1920, in *The Crisis*, W.E.B. Du Bois wrote, "The Irish people in the United States have often led in attacking blacks . . . This does not make less our desire for Irish freedom . . . It is the Oppressed who have continually been used to cow and kill the Oppressed in

the interest of the Universal Oppressor." For the Battle of Greasy Grass, I consulted *They Rode with Custer: A Biographical Directory of the Men That Rode with General George A. Custer* by John Melvin Carroll (J. M. Carroll, 1993). Regarding Irish American involvement in the western wars against Native Americans, I quoted from David Emmons, in *Beyond the American Pale: The Irish in the West, 1845–1910* (University of Oklahoma Press, 2012).

Aboriginal life

In considering O'Sullivan's Navajo photographs, I consulted Megan Kate Nelson's *Three-Cornered War*, helping me see the myriad points where the project of U.S. western incorporation coincided with Confederate goals. I referred to *Condition of the Indian Tribes: Report of the Joint Special Committee, Appointed Under Joint Resolution of March 3, 1865*. I read about Willoughby Wallace Hooper in Daniel Foliard's *The Violence of Colonial Photography* (Manchester University Press, 2022). In the foreword, Kim Ati Wagner, a historian of colonial India and the British Empire at Queen Mary University of London, writes,

> Despite the popular notion that photos somehow "speak for themselves" or are "worth a thousand words," images of colonial violence were never self-explanatory and the stories they told were never uncontested. What determined the meaning and significance of a photo was not simply what it depicted as much as the way its subject was depicted, as well as the manner in which it was framed, captioned, and presented for different audiences . . . Colonial photography cannot simply be examined as a two-dimensional image on a piece of paper but must be understood as an act and as an ongoing process.

While researching images of California, I read Rebecca Solnit's 2003 *River of Shadows: Eadweard Muybridge and the Technological Wild West*, an amazing book that connects Muybridge and Stanford to the invention of motion pictures and Silicon Valley and changes in our conception of time; among other things, it made me wonder whether O'Sullivan and Muybridge had ever met. LaFarge is quoted in *The Navajo Blanket*, a catalog of an exhibition at the Los Angeles County Museum of Art in 1972, written by Mary Hunt Kahlenberg and Anthony Berlant.

References to the Irish as savages come from *Certain Other Countries: Homicide, Gender, and National Identity in Late Nineteenth-Century England, Ireland, Scotland, and Wales* by Carolyn Conley (Ohio State University Press, 2007). I consulted *A Different Mirror: A History of Multicultural America* (Little, Brown, 2008), by Ronald Takaki, whose 2009 obituary in the *Los Angeles Times* noted that his suicide related to multiple sclerosis. "He couldn't deal with it anymore," his son told the paper. The Irish described as aborigines by English rulers is in Jacqueline Hill, "The Language and Symbolism of Conquest in Ireland, c. 1790–1850," *Transactions of the Royal Historical Society* 18 (2008). I contacted the Choctaw nation—pre-internet, around 1990, when I first moved to Oregon; remarkably (in retrospect), I picked up a phone and spoke to a tribal representative. Shortly thereafter, a Choctaw elder called me back. While driving across the country, I'd picked up a newspaper and, for the

first time, read about the Choctaws' involvement with the Irish famine. I marveled at the scholarship in Anelise Hanson Shrout's "'Voice of Benevolence from the Western Wilderness': The Politics of Native Philanthropy in the Trans-Mississippi West" when I read it online in 2016 in the *Journal of the Early Republic* 35, no. 4 (Winter 2015). More recently I read Padraig Kirwan's article "Recognition, Resilience, and Relief: The Meaning of Gift," in *The Journal of Transnational American Studies* 13, no. 1 (2022). Kirwan notes possible discrepancies in transcription: "For now, it is fair to say that the amount in question—whether $20,440 or $4,895— was surely sizable." I was led to the *Daily Orleanian* coverage of famine refugees by Joseph Roach. I read "'The Indian Man' and the Irishman: James Mooney and Irish Folklore," by Pádraig Ó Siadhail, in *New Hibernia Review / Iris Éireannach Nua* 14, no. 2 (2010). (Mooney's relationship with William Matthews is interesting to me, given the Dublin-born Matthews's work, though paternalistic and romantic, to present Navajo songs not as ignorant and simplistic—"a succession of grunts"—but as elaborate and flexible, a cultural connective tissue. Five years after Lieutenant George Wheeler would torture and kill Native people in Owens Valley, Matthews vaccinated Mono citizens against smallpox.) I also consulted Mooney's *Historical Sketch of the Cherokee* and his report in the 1888 *Proceedings of the American Philosophical Society*, "The Funeral Customs of Ireland." Robert G. Koch, in *The Crooked Lake Review* in September 1992, wrote "George P. Decker and Chief Deskaheh," which I read along with various *New York Times* reports, including "Iroquois Chief Asks League Recognition; Deskaheh of Ontario Says King George III. Treated with Six Nations as Independent" (December 23, 1923) and "Indians Startle Paris" (December 14, 1923), the latter noting that "a delegation of Arapaho Indians from Wyoming, clad in full regalia, arrived in Paris yesterday. . . . Chief Old Eagle . . . intended to ask the League of Nations to intervene with the U.S. Government so that Indians might have the same rights and privileges as other American citizens."

De Valera's trip for tribal recognition is discussed in *The Irish World and American Industrial Liberator* on October 25, 1919, and in the *Chicago Sunday Tribune* in the same period. From *The Liberator*:

> Chappewa Indian reservation, Spooner, Wis., Oct. 18—Eamonn De Valera, president of the Republic of Ireland . . . was adopted today by the old Indian tribe on their reservation in Northern Wisconsin and was named "Dressing Feather" or Nay Nay Ong Abe, after the famous Indian chief of that tribe who secured for the Chippewa their rights to the Wisconsin land under the treaty of 1854. The ceremony took place in an open field in the reservation in the presence of more than 3,000 Indians and white people and was interpolated by a weird series of Indian dances and speech-making . . . The ceremony was preceded by a memorial mass in the reservation church by Father Phillip Gordon, Chippewa priest, for the Indians who died in France.

The entry on Deskaheh in *The Canadian Encyclopedia* is written by Donald B. Smith and notes that six months before Deskaheh's death, the Canadian government organized a vote for an elected council to replace the traditional council:

"To this day, both councils exist. The elected chief and council are the only council recognized by Canada." Naomi O'Leary wrote "Donations Flood in to Help Navajo Fight Outbreak in Remembrance of 1847 Support" in *The Irish Times* on May 5, 2020. Uranium contamination issues faced by the Navajo are discussed in "America's Nuclear Past: Examining the Effects of Radiation in Indian Country," a statement given on October 7, 2019, by Loretta Christensen, chief medical officer, Navajo Area Office, Indian Health Service, U.S. Department of Health and Human Services.

Canyon de Chelly

Doris Dawdy discovered and transcribed the diary of Alexander Wyant; it was published with her notes as "The Wyant Diary: An Artist with the Wheeler Survey in Arizona, 1873," in *Arizona and the West*, Autumn 1980. I read *Geology of the Navajo Country*, by Herbert Gregory (U.S. Government Printing Office, 1917), and various other survey accounts, and consulted *Mormonism: A Historical Encyclopedia* (ABC-CLIO, 2010). John Draper's Civil War history is titled *History of the American Civil War: Containing the Events from the Proclamation of the Emancipation of the Slaves to the End of the War.* I consulted *The Navajo Blanket* by Mary Hunt Kahlenberg and Anthony Berlant, catalog for exhibition, June 27–August 27, 1972 (Los Angeles County Museum of Art, 1973).

Ruins

On the ruins that O'Sullivan pictured, I referred to *Aztec, Salmon, and the Puebloan Heartland of the Middle San Juan*—edited by Gary M. Brown and Paul F. Reed (University of New Mexico Press, 2018)—in which O'Sullivan makes several appearances. Studying the economic downturn in which O'Sullivan worked, I consulted "The Failure of the Movement by the Unemployed for Public Works in 1873" by Herbert G. Gutman, in *Political Science Quarterly* 80, no. 2 (June 1965); "The Politics of Economic Crises: The Panic of 1873, the End of Reconstruction, and the Realignment of American Politics" by Nicolas Barreyre, in *The Journal of the Gilded Age and Progressive Era* 10, no. 4 (October 2011); and Richard White's *The Republic for Which It Stands: The United States During Reconstruction and the Gilded Age, 1865–1896* (Oxford, 2017). On Wyant, I read *Alexander Wyant* by Eliot Candee Clark, a private printing in 1916, and *American Masters of Painting: Being Brief Appreciations of Some American Painters, Illustrated with Examples of Their Work* by Charles Henry Caffin (Doubleday, 1913). I also saw Wyant's paintings at the Metropolitan Museum, where they were in the visible storage areas, where I got very frustrated, being exhausted and not well, and remain appreciative to the too-patient guard who got me there. Details about Lhermitte are in "Jacques Jean Lhermitte and Lhermitte's Sign," *Multiple Sclerosis Journal*, 2020, and in "Jean Jacques Lhermitte (1877–1959)," a biography in the *Journal of Neurology*, August 2019. Merleau-Ponty's 1948 radio lectures are noted in *Merleau-Ponty's Philosophy* by Lawrence Hass (Indiana University, 2008). Judith Butler writes of Merleau-Ponty in her article "Performative Acts and Gender Constitution: An Essay in Phenomenology and Feminist Theory." Lhermitte's surge is an indicator of multiple sclerosis, as I can confirm, and it is

also called the barber chair phenomenon. In my experience, it is a kind of hallu-cination that is very real, and, like so much else involving multiple sclerosis, as it happens, it is invisible to everyone else.

Administrative History: Canyon de Chelly National Monument by David M. Brugge and Raymond Wilson (U.S. Department of the Interior, January 1976) is available online. "To a Child Running with Outstretched Arms in Canyon de Chelly" is in N. Scott Momaday's collection *The Gourd Dancer* (Harper & Row, 1976). The damage caused by sonic booms is detailed in chapter 10 of the admin-istrative history, entitled "Sonic Booms and People Problems, 1966–1974." A July 5, 1968, *New York Times* report from Canyon de Chelly also quoted an employee at Montezuma Castle National Monument, on the Yavapai-Apache Nation, where a tenth-century cliff dwelling was being destroyed. "Every time it booms," said Donna Byrne, "I run out to see if it's still there." I referred to Maureen Trudelle Schwarz's *Navajo Lifeways: Contemporary Issues, Ancient Knowledge* (University of Oklahoma Press, 2001). Schwarz, a cultural anthropologist at Syracuse Univer-sity, is, she writes, "looking at how Native Americans use notions about the body to reinforce collective identity." After Keith Basso died, in 2013, I interviewed people who knew him, including Cécile R. Ganteaume, a longtime curator at the Smithsonian's National Museum of the American Indian, who described Basso's forty years working with the Cibacue Apache people and his respect for the way they separated themselves from the mainstream of American society. "Although his work was very rigorous and very scholarly, he had the gift to let the humanity of the Apache people he was working with shine through his very sharp analy-ses of the way they spoke," Ganteaume told me in 2016 in the interview, which appeared on *The Land*, a podcast produced in association with *A Public Space*, the literary magazine. Ganteaume attributed Basso's deep understanding of Apache people's appreciation of the land to poetry, telling me:

> I believe he was a reader of the Irish poet Seamus Heaney, who re-cently passed away, and Seamus Heaney wrote a lot about the land and his family and his people's relationship with the land, and I think Basso was a keen reader of Heaney's work, and he was able to some-how use that to help him see and express how important the land can be to people who live close to the land.

In *The Photograph and the American Indian*, a 1994 book that surveys the collec-tion of Native American photographs collected at Princeton University, I was surprised to see a photo of a poet I met in Vermont, made while he was studying at Princeton.

Shoshone Falls

I consulted Brian Solomon's *Union Pacific Railroad* (Voyageur Press, 2020). On catastrophic floods, J. Harlan Bretz, in reports published between 1923 and 1932, proposed that a giant ice dam had broken, the contents of a glacial lake hundreds of miles north and west in Montana crashing through the soft basalt, creating a gorge, an idea ridiculed for decades, until the first aerial surveys of the area in

the 1950s. "We are now all catastrophists." On selling the stereocards, see Robin Kelsey's *Archive Style*. On April 4, 2023, in "Amazon, Despite Climate Pledge, Fought to Kill Emissions Bill in Oregon," Caroline O'Donovan reported for *The Washington Post* on Amazon's work to defeat attempts to restrain data servers' energy demand in the Pacific Northwest. Truman's remark regarding the Grand Coulee Dam is in George Sundborg, *Hail Columbia: The Thirty-Year Struggle for Grand Coulee Dam* (Macmillan, 1954). I referred to the Umatilla Army Depot entry in the *Oregon Encyclopedia*, written by Susan Badger Doyle:

> In 1962, the installation's name was changed to the Umatilla Army Depot, and it began receiving and storing chemical weapons, which continued to arrive until 1969. The chemical warfare agents VX and GB (nerve agents) and HD (mustard blister agent) were stored as liquid in various types of munitions and containers, including rockets, bombs, projectiles, mines, bulk containers, and aerial spray tanks.

On March 1, 2018, the U.S. Department of the Interior announced details on the implementation of the Land Buy-Back Program for Tribal Nations:

> This is the second agreement of its kind signed between the Department and the Confederated Tribes of the Umatilla Indian Reservation. In July 2017, the Department announced new policies and a revised implementation schedule . . . which provided $1.9 billion to purchase fractional interests in trust or restricted land from willing sellers at fair market value within 10 years. Since the Program began making offers in December 2013, more than 760,000 interests and the equivalent of nearly 2.2 million acres of land have been transferred to tribal governments.

Chuck Sams's article "We're Prepared to Buy Back Our Own Land" appeared in *High Country News*, on July 21, 2014. "Thanks to the Dawes Act," Sams wrote,

> approximately 100,000 acres of the Umatilla Indian Reservation were allotted specifically to non-Indians, and an additional 30,000 acres were put up for sale . . . The assumption was that once whites moved among our people, our Indian culture, religion, tradition, leadership and government would be eroded and soon phased out altogether. Indians would then vanish into the American melting pot.

I read *The Oregon Encyclopedia*'s entry, "Oregon Donation Land Law," by William G. Robbins. Section 4 of the Donation Land Law outlined the requirements for eligibility: "granted to every white settler or occupant of the public lands, American half-breed Indians included, above the age of 18 years, being a citizen of the United States, or having made a declaration according to law of his intention to become a citizen." "In effect," Robbins writes, "the Oregon Donation Land Law benefited incoming whites and dispossessed Indians."

Mountain Home Air Force Base's motto is on their website. For the economic state of the United States, I referred to Richard White's *The Republic for Which It Stands*, as well as *When Workers Shot Back: Class Conflict from 1877 to 1921* by Robert Ovetz (Haymarket Books, 2019). White cites Jerry M. Cooper, "The Army as Strikebreaker—the Railroad Strikes of 1877 and 1894," *Labor History* 18, no. 2 (1977). On January 25, 2021, the Idaho Farm Bureau passed a warning to farmers in the Magic Valley and vicinity: "Mountain Home Air Force Base officials are again reaching out to the state's agricultural community to let farmers, ranchers and others know that GPS devices may be impacted during upcoming military training exercises in the Bruneau area." The Desert Land Act still applies today, and the frequently asked questions are answered by the Bureau of Land Management on their website:

> *Is there a limit on acreage for which I may apply?* You may apply for one or more tracts of land totaling no more than 320 acres. *Where are the lands located?* The lands are located in the States of Arizona, California, Colorado, Idaho, Montana, Nevada, New Mexico, North Dakota, South Dakota, Utah, Washington, and Wyoming.

Details on U.S. Covid cases are from "The Disproportional Impact of COVID-19 on African Americans," by Maritza Vasquez Reyes, in the December 2020 issue of *Health and Human Rights Journal*. The Twin Falls land company is referenced in "The Legacy of 'Schodde v. Twin Falls Land and Water Company': The Evolving Reasonable Appropriation Principle," by A. Dan Tarlock, in *Environmental Law Review* 42, no. 1 (Winter 2012); *Water and American Government: The Reclamation Bureau, National Water Policy, and the West, 1902–1935* by Donald J. Pisani (University of California Press, 2002), which notes, "Within a decade of their creation, however, the line between government and private projects in the Snake Valley began to blur"; and *Congress in Its Wisdom: The Bureau of Reclamation and the Public Interest* by Doris Ostrander Dawdy (Avalon, 1989).

In the January 12, 2021, *New Republic*, Nick Martin, Indigenous affairs editor at *High Country News*, wrote "Indian Country Refuses to Be Corporate America's Dumping Ground," an essay that highlighted the Shoshone-Bannock Tribes' "rare victory against polluters": "Until America enters a space in which it can agree that these extractive operations need to be approached in a wholly different way, and possibly halted completely, settlements and appeals rulings will be the only hope many tribal nations have." To learn about Dillon Myer and the incarceration of Japanese Americans at Minidoka, I read *Keeper of Concentration Camps: Dillon S. Myer and American Racism* by Richard Drinnon (University of California Press, 1987). I referred repeatedly to the Densho online encyclopedia, as well as maps and photographs. The *Idaho Statesman* discussed the attacks on workers from Mexico, in "Historically, Mexican Workers in Idaho Faced Racism, Abuse," on December 20, 2021. I read Mitsuye Yamada's book *Camp Notes* (Kitchen Table: Women of Color Press, 1992). Regarding Gerald Vizenor, see for example a collection he edited: *Survivance: Narratives of Native Presence* (University of Nebraska Press, 2008).

I watched "Minidoka Survivors Panel," a ninety-seven-minute presentation, streamed on YouTube on January 17, 2021, the twentieth anniversary of the creation of the Minidoka National Historic Site. It was organized by the Japanese American Memorial Pilgrimages (JAMP), founded by Kimiko Marr and Marissa Fujimoto, two filmmakers who had incarcerated relatives who met at the Minidoka 2016 pilgrimage. On the panel was Paul Tomita, who was one of the Japanese incarceration camp survivors featured in a June 28, 2019, *Democracy Now* report on a protest at Fort Sill, Oklahoma, where, in 1942, seven hundred Japanese American men were interned; and in 2014, under President Barack Obama, and again in 2019, under President Donald Trump, the United States interned children seeking asylum from violence in Central America. I read Peter T. Suzuki's damning "A Retroactive Analysis of a Wartime 'National Character Study,'" in *Dialectical Anthropology* 5, 1980, no. 1; his piece in *Dialectical Anthropology* 6, 1981, no. 1, "Anthropologists in the Wartime Camps for Japanese Americans: A Documentary Study"; and "Remembering Japanese-American Internment," in *Anthropology News* on April 5, 2010, describing the social scientists who, when the Japanese reached out to Spain—a neutral party representing the prisoners, under treaty terms—rather than intercede for incarcerees when they suffered under imprisonment, reported them to the U.S. authorities. Suzuki taught urban planning at the University of Nebraska at Omaha. I drew other details about Idahoans' view of the Japanese incarcerees from Robert T. Hayashi, *Haunted by Waters: A Journey Through Race and Place in the American West* (University of Iowa Press, 2007), and about the environment of the camp from Connie Chiang's *Nature Behind Barbed Wire*, which includes photos that stand in contrast to Ansel Adams's pictures of Manzanar. Note that in Hayashi's book he cites one camp director as being convinced that the survivors suffered from a kind of trauma (my words): "A lot has happened to them."

For dispersion and sewage treatment, see, for instance: Joel A. Tarr, *The Search for the Ultimate Sink: Urban Pollution in Historical Perspective* (University of Akron Press, 1996). Dillon Myer quotes Truman ("a shitty ass job") in his July 7, 1970, oral history interview, kept at the University of California's Bancroft Library. I read Felix S. Cohen's "The Erosion of Indian Rights, 1950–1953: A Case Study in Bureaucracy" in the February 1953 *Yale Law Journal* after learning of it via a lecture, "Native American Lands and the Supreme Court," delivered on November 11, 2012, at the U.S. Supreme Court by Angela R. Riley, chief justice of the Supreme Court of the Citizen Potawatomi Nation of Oklahoma. Senator Patrick McCarran discusses his view of Native American rights in a report describing the Pyramid Lake Reservation by A. J. Liebling in the January 1, 1955, *New Yorker*. Says Liebling, "In my previous legal reading, admittedly skimpy, I had never encountered this theory, the Preeminent Right of the First Trespasser. But it is consistent with much Indian Law, a legal euphemism for the statutes imposed on Indians by whites while the whites were skinning the Indians."

On uranium mining and related exposures, I referred to Winona LaDuke's May 2, 1979, piece for *The Harvard Crimson*: "Uranium Mines on Native Land"; James Robert Allison's *Sovereignty for Survival: American Energy Development and Indian Self-Determination* (Yale University Press, 2015); *The Four Corners: A National Sacrifice Area?*, a 1983 documentary directed by Christopher McLeod;

and a report in the *Ventura County Star*, July 7, 2009, "Forgotten Nuclear Accident in Church Rock." I learned about Limon's history in "The 'Stern, Fearless Settlers of the West': Lynching, Region, and Capital Punishment in Early Twentieth-Century Colorado" by Labode Modupe, in *The Western Historical Quarterly* 45, no. 4 (2014).

Among the places to view the stereocard of Johnson's execution is in *Encyclopedia Virginia* online, under the heading "Public Execution of a U.S. Colored Troops Soldier." The caption it references includes this note: "A request was made of the Rebels, under a flag of truce, that we might be permitted to hang Johnson in plain sight of both armies, between the lines. The request was granted, and this is a photograph of him hanging where both armies can plainly see him," followed by the line "E. & H. T. Anthony & Company, a 'stereoscopic emporium' in New York City, published this gruesome image in 1864." In *John Brown's Body: Slavery, Violence, and the Culture of War*, Franny Nudelman wrote, "In this instance, military execution was not an opportunity to reassert the army's might in the face of the enemy. To the contrary, the Union army offered up the spectacle of William Johnson's death to Confederate troops in a gesture of prospective reconciliation." Frederick Douglass's "one sparrow does not make a summer" quote comes from *Frederick Douglass: Selected Speeches and Writings*, edited by Philip S. Foner and Yuval Taylor (Chicago Review Press, 2000). "The Sand Creek Massacre 150 Years Later," a three-part series by Kenneth Jessen, published on November 6, 2014, in the *Loveland Reporter-Herald* (Colorado): "On the evening of Nov. 28, 1864, Chivington's men moved out. They took with them four mountain howitzers that used exploding shells." For Native nations' delegations being toured through armories, see for example: Stan Hoig's *White Man's Paper Trail: Grand Councils and Treaty-making on the Central Plains* (University Press of Colorado, 2006). James McDonough's 2016 biography of Sherman says that his father named him Tecumseh in reference to the Shawnee leader.

I listened to the Atlanta poet Devyn Springer (see *Grayish-Black: Poetry from the Ribs* for poems and photographs) on the *Red Nation Podcast* episode "The Black Misleadership Class"; I had downloaded it in a Hampton Inn on the Great Plains and listened to it outside of Columbus, Ohio. "Fractured: The Body Burden of Living Near Fracking," the two-year investigation by *Environmental Health News*, published on March 1, 2021, was written and reported by Kristina Marusic. From "Rosebud Sioux to Receive the Remains of Their Children Who Died at the Former Carlisle Indian School," by Jeff Gammage, on June 26, 2021, in *The Philadelphia Inquirer*: "It comes at a moment of great reckoning, amid the national cries against white supremacy and the grief and outrage that's erupting over the discovery of children's remains in Canada." I also read about the Carlisle Indian School in the work of Jenni Monet, a writer whose great-grandfather was taken from the Laguna Pueblo to work in Newtown, Pennsylvania, as a laborer. Monet publishes *Indigenously*, a newsletter I read, and I have profited greatly from having coffee with her from time to time.

Staten Island

I first read Paula Meehan's poem in her collection, *As If by Magic: Selected Poems* (Wake Forest Press, 2021), a few years after seeing her read at the Irish Arts

Center in New York City, at a poetry festival curated by Belinda McKeon. I followed (as usual) William Stapp's chronology. The use of the Gatling gun against striking workers in Pittsburgh comes from Robert Ovetz's *When Workers Shot Back*. Dancing on the Atlantic voyage is described in *The Illustrated London News* on July 6, 1850, under the headline "Dancing Between Decks," a report I was led to by an essay by J'aime Morrison, a dancer, titled "Dancing Between Decks: Choreographies of Transition During Irish Migrations to America," in *Éire-Ireland* (Spring–Summer 2001). Morrison cites the work of Paul Gilroy:

> For Paul Gilroy the Atlantic passage is a circuitous route, a physical journey out of Africa and an imagined return, accompanied by "the movement of key cultural and political artifacts: tracts, books, gramophone records, and choirs" . . . By attending to [Irish] dance, I have made connections between the rituals of departure, the Atlantic voyage, and emigrants' arrival in America, because each of these events involved the physical body in a series of translations.

"Deed for Purchase of Staten Island, 1670" is at the New-York Historical Society Library and viewable online, and I first read about it in an essay by Andrew Lipman, in the winter 2015 issue of *Common Place: The Journal of Early American Life*, titled "Buying and Selling Staten Island." In considering both the psychological and the physiological implications of displacement, I referred often to the work of Mindy Fullilove, as well as my experiences in various classes and events offered by the University of Orange, in Orange, New Jersey, including those led by Robert Sember. In thinking about the latent effects of war or trauma more generally, I read Seamus Heaney's translation of *Buile Suibhne*, the twelfth-century Irish story cycle that Heaney titled *Sweeney Astray*, which was first published by Field Day, a publisher and theater company, then known for debuting Brian Friel's play *Translations*. In 1983 an interviewer asked him why he chose the text for translation and the particular Irish publisher, Field Day:

> The first thing, in a sense, is that accident of the rhyme—Sweeney-Heaney—is neat. The second thing is that the sense of being displaced in some way—which I had when I moved, a few years ago—seemed to me to reside in the Sweeney figure, and specifically . . . the Field Day venture began with Brian Friel's [1980 drama] *Translations*, which was about the loss of Irish and the implications of changing names, place names, and so on into English. It seemed to me that the Sweeney venture was a corollary and a complementary follow-up—it's to do with land and feeling displaced.

Acknowledgments

I am grateful to all the people who helped me make this book, including Jonathan Galassi, Scott Auerbach, Thomas Colligan, Songhee Kim, Maxine Bartow, Judy Kiviat, Samantha Keo, Debra Helfand, Peter Richardson, Brian Gittis, Laird Gallagher, and most especially Ian Van Wye. For editing and editorial assistance that kept me going over the course of my long resurvey project, more general thanks goes to: Abigail Walch, Mark Holgate, Chioma Nnadi, and Chloe Malle; Estelle Tang; Chris Knutsen; Thomas Gebremedhin; Valerie Steiker; Taylor Antrim and Lauren Mechling; Marley Marius; Sarah Brown; Abby Aguirre; Alessandra Codinha; Corey Seymour, Sally Singer, Megan Cummins, David Haskell, Susan Morrison, Zach Helfand, and Michael Agger. More thanks more generally to E. J. McAdams; John McGill; Charlie Butler; Jenni Monet; Elizabeth Felicella; Florence Kane and Michael Mraz; Colm O'Leary and Callie Garnett; Omar Ali; Tariq Ali; Katie Holten; James Marcus; Kassie Schwan and Brian Rose; Jim Leinfelder; Marnie Brady; Christina Nadler; Criss Moon; Emily Bartels and Claudia Johnson; Tyler Curtain and Jay D'Lugin; Karen Browne; Kate Marshall and Ian Newman; Brenda Healy; Justin Allen; Kellam Ayres; Lyndon Dominique; Jay Barksdale; Toby Jurovics; Brenda Marsh and Jonathan Weiss; Nancy Nealon; Edward Lai; Jonathan Perk; Serena Mulhern; Liz Greenspan; Randall Mason; Aaron Rourke and Rachel Sherk; Cassie Griffin and Jessie Wine; Marie Lorenz and Jeff Williams; Greg Radich and Camille Scheewe; Jill Desimini and Daniel Bauer; Linda and Donald Desimini; Belinda McKeon and Aengus Woods; Charles McGrath; Brigid Hughes; Colm Tóibín, Jefferson Hamer, and David Diehl; Ruth Steiner and Eamon O'Leary; and Kate Browne and Eric Etheridge. I'm indebted to all the students in the classes I got to be a part of during this project: in New York, in the Macaulay Honors science seminars at Hunter College, and, in Vermont, at Middlebury's Bread Loaf School of English. I am grateful to the Guggenheim

Foundation for awarding me a fellowship at all, not to mention during the coronavirus pandemic. In New York, I'm appreciative for time spent at the Wertheim Room, at the New York Public Library's Stephen A. Schwarzman Building. Likewise, I am grateful for time allowed to me by the Saint Colmcille House, in the Morningside Heights neighborhood of Manhattan. Other places where I was aided by librarians include the Brooklyn Public Library's Carroll Gardens branch; the Walt Whitman branch, on Saint Edwards Street, a most beautiful room; and the old Brooklyn business library, in downtown Brooklyn, gone now and reimagined as a library holding up a tower of condominiums. In Philadelphia, the Free Public Library's Parkway branch took me to the finish, its Calder banners greeting me each trip. Over all, I am indebted to Eric Simonoff, who guided this resurvey from the start—early on, doing so over breakfasts at Junior's, a restaurant in Brooklyn, very close to what was the trolley stop at which Clarence King would have switched from his famous scientist persona to his persona as Pullman porter, while living in Vinegar Hill, in a Black and Irish neighborhood. Thanks most of all to Sam and Louise Sullivan, as well as Marie Edland and Davis Sawyer. Throughout this project, I spent the most time in the studio of Suzanne Sullivan. Her touch is anywhere anything is any good.

Robert Sullivan is the author of numerous books, including *Rats*, *The Meadowlands*, *A Whale Hunt*, and *My American Revolution*. His writing has also appeared in *The New Yorker*, *The New York Times*, *Vogue*, and *New York*, and he is a contributing editor at *A Public Space*. He was born in New York City, worked for many years in Portland, Oregon, and now lives in Philadelphia. He is the recipient of a 2022 Guggenheim Fellowship.